Affective Performance and Cognitive Science

Nicola Shaughnessy is Professor of Performance in the University of Kent's School of Arts and is Director of the Research Centre for Cognition, Kinesthetics and Performance. Her research and teaching interests are in the areas of applied theatre, contemporary performance, dramatic auto/biography, cognition and performance and practice-based pedagogies. She is Principal Investigator for the AHRC funded project 'Imagining Autism: Drama, Performance and Intermediality as Interventions for Autism'. Her publications include *Applying Performance: Live Art, Socially Engaged Theatre and Affective Practice* and *Gertrude Stein*, for the Writers and their Work series.

Forthcoming from Bloomsbury Methuen Drama:

Postdramatic Theatre and the Political, edited by Jerome Carroll, Steven Giles and Karen Jürs-Munby
Theatre in the Expanded Field, Alan Read
New Dramaturgy, edited by Katalin Trencsényi and Bernadette Cochrane
Performance Studies in Motion, edited by Atay Citron, Sharon Aronson-Lehavi and David Zerbib

Affective Performance and Cognitive Science

Body, Brain and Being

Edited by

Nicola Shaughnessy

B L O O M S B U R Y

LONDON • NEW DELHI • NEW YORK • SYDNEY

Bloomsbury Methuen Drama

An imprint of Bloomsbury Publishing Plc

50 Bedford Square	1385 Broadway
London	New York
WC1B 3DP	NY 10018
UK	USA

www.bloomsbury.com

Bloomsbury is a registered trade mark of Bloomsbury Publishing Plc

First published 2013

© Nicola Shaughnessy, 2013

British Library Cataloguing-in-Publication Data

A catalogue record for this book is available from the British Library.

ISBN: HB: 978-1-4081-8398-4
PB: 978-1-4081-8577-3
ePDF: 978-1-4081-9315-0
ePub: 978-1-4081-8369-4

Library of Congress Cataloging-in-Publication Data

Affective performance and cognitive science : body, brain, and being / edited by Nicola Shaughnessy.
pages cm
ISBN 978-1-4081-8577-3 – ISBN 978-1-4081-8398-4 – ISBN 978-1-4081-9315-0 – ISBN 978-1-4081-8369-4 1. Psychology and art. 2. Art and science. 3. Arts–Psychological aspects. 4. Cognitive science. I. Shaughnessy, Nicola, editor of compilation.
N71.A375 2013
700.1'05–dc23
2013020880

Typeset by Fakenham Prepress Solutions, Fakenham, Norfolk NR21 8NN
Printed and bound in India

*For my parents, Alan and Mavis Goode as the scientists who created artists,
and in loving memory of my father,
Alan Roy Waterhouse Goode (8 February 1934 – 27 August 2012),
an engineer of the imagination.*

Contents

List of Illustrations

List of Contributors

Adam Alston
Lecturer in Theatre and Performance Studies at the University of Surrey, Uk.
Royal Holloway, University of London (PhD), UK.
Curious Directive, Associate Artist.

Natalie Bainter
Indiana University (PhD).

Rhonda Blair
Professor of Theatre, Southern Methodist University, Dallas, USA.
President of the American Society for Theatre Research, 2009–12.

Amy Cook
Associate Professor, Department of Theatre and Dance and affiliate faculty member of the Cognitive Science and Cultural Studies Programs, Indiana University, USA.

Anna Furse
Professor and Head of Department of Theatre and Performance, Co-director of The Centre of the Body, Goldsmiths, University of London, UK.
Artistic Director: Athletes of the Heart.

Marie-Hélène Grosbras
Lecturer, Department of Psychology, University of Glasgow, UK.

Erin Hood
University of Wisconsin-Madison (PhD), USA.

John Lutterbie
Professor and Head of Department of Theatre Arts, Co-director of the Center for Embodied Cognition, Stony Brook University, USA.

Josephine Machon
Senior Research Fellow in Contemporary Performance, Middlesex University, London, UK.

Bruce McConachie
Professor and Director of Graduate Studies in Theatre and Performance, University of Pittsburgh, Co-editor of the Cognitive Studies in Literature and Performance series, Palgrave Macmillan.

Frank E. Pollick
Professor of Psychology, University of Glasgow, UK.

Matthew Reason
Reader in Theatre, York St John University, UK.

Dee Reynolds
Professor of French, University of Manchester, UK.

Naomi Rokotnitz
Lecturer, Department of Theatre Arts, Tel-Aviv University.

Nicola Shaughnessy
Professor of Performance, Director of Centre for Cognition, Kinesthetics and Performance, University of Kent, UK.

Gabriele Sofia
Department of History of Art and Entertainment, Sapienza University of Rome and the Laboratory of Ethnoscenology Department of Humanities Paris Nord, France.

John Sutton
Professor and Deputy Head, Department of Cognitive Science, Macquarie University, Sydney, Australia.

Evelyn B. Tribble
Professor and Donald Collie Chair of English at the University of Otago, Dunedin, New Zealand.

Melissa Trimingham
Senior Lecturer in Drama, Theatre and Performance, University of Kent, UK.

Neal Utterback
Indiana University (PhD), USA.

Martin Welton
Senior Lecturer, Theatre and Performance, Queen Mary University of London, UK.

Acknowledgements

This book has been a collaborative tour de force and I am extremely grateful to all the authors for their contributions, for meeting deadlines, responding swiftly to queries and for engaging so enthusiastically with the project as a whole. Special thanks are due to the expert editors (Rhonda Blair, Amy Cook, Bruce McConachie and Evelyn Tribble), who offered guidance and advice to contributors and helped to steer the book to completion. I wish to acknowledge the ASTR working group for Cognitive Science in Theatre, Dance and Performance as much of this material has been rehearsed in this forum.

I am indebted to my colleagues who participate in the Centre for Cognition, Kinesthetics and Performance (CKP) at the University of Kent, without whom this book would not have existed. I am particularly grateful to the organisers of the inaugural CKP symposium Affective Performance and Cognitive Science (7–8 September 2012): Helen Brooks, Rosemary Klich, Duska Radosavljek, Melissa Trimingham and Angie Varakis. Many of the papers included here emerged from the symposium or the Roundtable at London's Institute of Contemporary Arts (12 September 2012). Frank Camilleri and Virginia Pitts also deserve acknowledgement for their contributions to CKP and for dialogues with me about this research. Patrice Pavis has been a source of invaluable advice and questions about our work. I am also grateful to my colleagues in other research centres at Kent who have shared events with CKP and whose perspectives informed my introduction, particularly Julie Beadle-Brown (Tizard Centre), Howard Bowman (Director of the Centre for Cognitive Neuroscience and Cognitive Systems), David Wilkinson (Psychology), Sarah Turner and Shona Illingworth (Sound-Image-Space),

The authors and publisher wish to thank the following for permission to reproduce copyright material: Reckless Sleepers, Philip Barnard, Marie-Hélène Grosbras.

This is an interdisciplinary collection and would not have been possible without the generous contributions of several scientists who have engaged in dialogue with me, presented papers for CKP, read and responded to papers and helped to shape the development of the project as a whole. Huge thanks to Nicky Clayton, Philip Barnard, Francesca Happe, Catherine Loveday and Vincent Walsh.

In addition, Rhonda Blair acknowledges the *Journal of Dramatic Theory and Criticism* for agreeing to reuse material already published; Josephine

Machon thanks Christer Lundahl and Martina Seitl for generosity of time and thought in their original interviews; Martin Welton wishes to thank Clare Whistler.

My thanks to Mark Dudgeon, my publisher at Bloomsbury Methuen Drama, who commissioned the book after hearing about the inaugural CKP symposium, and to Emily Hockley and James Tupper for seeing it through production.

Finally, I wish to acknowledge my family for the special roles they have played in this. Several of the contributors have experienced Nathaniel's cooking, Gabriel's art and Erina's music. Above all, I wish to thank Caitlin Shaughnessy and Robert Shaughnessy for the superb and caring editorial assistance which brought the book to completion.

General Introduction: Operating in Science Theatres

Nicola Shaughnessy

Performance and science: Debates and dialogues

In both the UK and the US, there has been a growing awareness on the part of the scientific establishment and government that many people view science with suspicion, and a concern that levels of scientific literacy are low. Discussions around improving scientific literacy have been driven primarily by economic arguments, combined with notions of enriching cultural health and intellectual life, and of enhancing democracy (Nicola Triscott).[1]

Devised work, full-length plays, children's shows, dance pieces: in every walk of theatrical life, science is proving an astonishingly fertile platform for dynamic and exciting art. Empirically it's clear to see that theatre can, and does, successfully represent the thrilling discoveries and experiments of science (Honour Bayes).[2]

The title of this book invokes a series of contentious dualisms and tensions between art and science, affective and cognitive theories, body and mind. The cover image, referencing René Magritte's 1928 painting, *The Lovers*, stages both oppositional and relational forces as two faceless figures face each other over a table with white sheets forming hoods, masking their heads. The sheets are tied and pulled by unseen forces as if to move the individuals away from each other but the bodies are working against the external forces, bending towards each other in complementary positions, their identities concealed as if they are seeking to establish and explore a relationship. The right hand of the figure on the right side of the table touches the cotton contours of the other's face, while his left hand touches the table for support. The figure on the left has both hands on the table, a point of contact between themselves and each other. They are positioned

in relation to each other, complementary but not identical in their postures and clothing. They are both observed and observing, states of 'being' as they explore the space between them. On the right hand side of the table sits a wine bottle, a third full, with an empty but used wine glass on the left. The bottle and wine are also in a complementary relationship, equally distant from the figures. There is something both sinister and moving evoked by the hooded figures who are both passive (like puppets pulled on a string) and active as they relate to each other. Magritte's 1927 painting *The Threatened Assassin* is also referenced by the masked bodies. If the hoods were black, the image would have very different connotations, but the whiteness is softening, and makes the reference to Magritte explicit; we think of lovers and conflicts, the complexities and paradoxes of relationships, being both together and apart, aware of self and other.

The image is from *Schrödinger*, the 2011 show by the Belgian live art company, Reckless Sleepers.[3] As the title suggests, the show takes its cue from quantum mechanics and Erwin Schrodinger's famous 1933 thought experiment, which problematised and transformed quantum mechanics theory and its application to everyday objects and conceptions of 'reality'.[4] In an exchange of letters with Albert Einstein, Schrodinger formulated his paradox concerning the quantum principle of 'superposition', whereby a quantum object can exist in simultaneous multiple states. Schrodinger's illustration of 'micro-macro entanglement' theorised an imaginary black box containing a cat and a radioactive nucleus.

A cat is enclosed in a steel chamber, together with the following infernal machine (which one must secure against the cat's direct reach): in the tube of a Geiger counter there is a tiny amount of a radioactive material, *so* small that although one of its atoms *might* decay in the course of an hour, it is just as probable that that none will. If the decay occurs, the counter tube fires and, by means of a relay, sets a little hammer into motion that shatters a small bottle of prussic acid. When the entire system has been left alone for an hour, one would say that the cat is still alive *provided* no atom has decayed in the meantime. The first atomic decay would have poisoned it. The ψ-function of the total system would yield an expression for all this in which, in equal measure, the living and the dead cat (*sit venia verbo* ['pardon the expression']) blended or smeared out. The characteristic of these examples that an indefiniteness originally limited to atomic dimensions gets transformed into gross macroscopic indefiniteness, which can then be *reduced* by direct observation. This prevents us from continuing naively to give credence to a 'fuzzy model' as a picture of reality. In itself this contains nothing

unclear or contradictory. There is a difference between a blurred or unsharply taken photograph and a shot of clouds and mist.[5]

In 1998 Reckless Sleepers built Schrodinger's black box as a theatre set, a space for both rehearsal and performance. The box is described by the company as resembling a model toy theatre 'with proscenium, entrances and exits from both sides and the rear double doors. The positioning of hatches and objects enhance its apparent depth. What is within exists in various superposed states as multiple interpretations and potential narratives collide.'[6] In terms of design, rehearsal processes and rule-based performance, scientific theory interacts with theatre-making in *Schrodinger*, while the complexities of this relationship are indicative of entanglements between the disciplines. Science is defined by the United Kingdom's Science Council as 'the pursuit and application of knowledge and understanding of the natural and social world following a systematic methodology based on evidence'.[7] The black box theatre, is also a site for experimentation and observation of human behaviour, in ways that are in some respects similar to scientific investigation but in others distinctively different.

As a company working in the context of experimental performance, Reckless Sleepers produce practice which might be regarded as 'conceptual', creating work which is exploratory and abstract, in which meaning is not dependent upon plot and character and the onus is on the spectator as interpreter of the work. The black box functions somewhat paradoxically as the container for material considered as 'postdramatic'; contemporary performance companies have consistently challenged the 'fourth wall' of naturalistic theatre, epitomised by the black box. 'Schrodinger's Box' is conceived by the company as 'a proscenium arch designed for a proscenium arch space, a box within a box'.[8] It is 'an enigma. Until it is opened and its contents observed, the cat within remains with potential states superposed, both alive and dead.'[9] The activities within the box, for the purposes of this production, are governed by quantum principles:

> If you are being observed in the box, you are not aware of other things going on around you, they influence you but you don't know why. Ordinary, classical physics doesn't work properly in the box. Time does not work properly or in a linear way […]
>
> The box functions as a space in which performers are observed and observing on multiple levels and from multiple perspectives:
>
> Never enter or exit the space across the line of the front edge. Events are magnified in the hatches at the front […] The doors and hatches of the inner chamber are for observation. As a scientist you may not enter

the space once an experiment is in progress. You may observe from the ceiling hatches or use them to introduce new objects or take others out.[10]

The show is described as being about 'thought experiments, cats, René Magritte, love, time, mathematics, observations, truth lies and alcohol'.[11] As a further enactment of quantum theory, the box was closed and stored in a garage after the 1998 production until, over a decade later, it was reconstructed and re-devised as *Schrodinger*. The re-devising process can be seen to be situated between the dead show of the past and the live version emerging for the future. The work within the box is 'nowhere' in the now and the here which is in between rehearsal and performance. Thus the new version involves a playing between the past and present of a previous and reworked production, its form and content bring science and performance into playful dialogue. Situated between the old show and the new is a book, emerging from the first phase of rehearsals to re-devise the production.[12] Thus practical processes are textualised and conceptualised, while the interest in the production generated by the book is cited by Wetherell as the genesis (and funding trigger) for the reincarnation of the work as *Schrodinger*.

The dualisms, conflicts, relationships and multimodalities within the production of *Schrodinger* (and the processes documented in *Trial*) mirror the themes of this book, challenging binaries and bringing into play scientific and performance theories and practices which interact in productive and creative harmonies and dissonance. In this introductory chapter, I will argue that the space in between disciplines and dualisms is where meaning is made as new epistemologies predicated on *process*, create bridges between different discourses, theories and practices. The 'mind/body problem' is being addressed through concepts such as embodied cognition, based in perception *and* action. As Georg Goldenberg explains:

> Cognitive science today gets increasingly interested in the embodiment of human perception, thinking, and action. Abstract information processing models are no longer accepted as satisfactory accounts of the human mind. Interest has shifted to interactions between the material human body and its surroundings and to the way in which such interactions shape the mind. Proponents of this approach have expressed the hope that it will ultimately dissolve the Cartesian divide between the immaterial mind and the material existence of human beings [...] A topic that seems particularly promising for providing a bridge across the mind-body cleavage is the study of bodily actions, which are neither reflexive reactions to external stimuli nor indications of mental states, which have only arbitrary relationships to the motor features of the action (e.g. pressing a button for making a choice response). The shape,

timing, and effects of such actions are inseparable from their meaning. One might say that they are loaded with mental content, which cannot be appreciated other than by studying their material features. Imitation, communicative gesturing, and tool use are examples of these kinds of actions.[13]

Imitation and communicative gesturing are, of course, material features of theatre, while the black box which constitutes the set for *Schrodinger* is a metaphor associated with both cognitive science and performance. In terms of the former, the 'black box' is the mind, the focus of the first part of the 'cognitive revolution' in the 1970s, fuelled by innovations in technology as artificial intelligence and computer science became the new models for generating knowledge. As Rafael Núñez summarises, 'the cognitive revolution directed researchers' attention precisely toward this "black box," positing that cognition and the mind were best explained in terms of information processing and symbol manipulation'.[14] Evelyn Tribble and John Sutton contextualise 'classical cognitivism' and its variants in their introduction which opens Part 1: 'Dances with Science'. Rhonda Blair also offers in Part 3 an account of the development of cognitive science and the implications for performance in her introductory essay, 'The Multimodal Practitioner'. The black box first generation of cognitive science research, preoccupied by computer analogies, has been charged with reductionism, conceiving of mental processes as computational systems and in so doing, separating mind from body, overlooking the physical features of the working brain.[15] The concept of 'embodied cognition', emerging from phenomenology, biology, cognitive psychology and cognitive linguistics, challenged the computational mind–body dualism and posited the mind as being embodied and situated. This second wave of cognitive science research turned its attention to the physical, sensory and neurological processes connecting action and perception, considering how our interactions with the environments we explore and experience create the pathways for developing consciousness, language and memory.[16] Understanding of the mind–body as an interconnected system, rather than disjointed components, emerged through dialogues between phenomenologists, philosophers and cognitive scientists. The work of the linguist George Lakoff and philosopher Mark Johnson considered how our earliest interactions with the physical and material world shape how we think and express our thoughts in language. Metaphors structure our perception, action and communication. The ideas articulated in *Metaphors We Live By* (1980) and *Philosophy in the Flesh: The Embodied Mind and its Challenge to Western Thought* (1999) became central to developments in cognitive linguistics and psycholinguistics and the theorisations

of conceptual metaphor and cognitive blending.[17] While these theorisations
have since been challenged, they remain a formative influence on the devel-
opment of cognitive linguistics.[18] Amy Cook's introduction, which introduces
Part 2: 'Touching Texts and Embodied Performance', provides an overview of
this work and its importance to theatre and the humanities. Interdisciplinary
collaborations facilitated the testing of hypotheses, empirical experiments
to validate or counter the theories and claims associated with cognitive
linguistics. Building on this work, Gilles Fauconnier and Mark Turner's *The
Way We Think: Conceptual Blending and the Mind's Hidden Complexities*
(2002) was a further landmark in the field, examining how and why the
cognitive processes involved in blending contribute to learning, perception
and action, shaping thought, identity, language and creativity.[19]

Interdisciplinary collaborations between neuroscience, psychology
and philosophy contributed further perspectives and approaches to the
burgeoning and multifaceted field of embodied cognition. In his *Embodied
Cognition* (2011), Lawrence Shapiro responds to the problem of articu-
lating a unified conception of the embodied mind by developing a
taxonomy, grouping the research into three broad categories. The first is
the hypothesis of *conceptualisation*, which 'seeks to show that an organ-
ism's understanding of the world – the concepts it uses to partition the
world into understandable chunks – is determined in some sense by
the properties of its body and sensory organs'.[20] The pioneering work of
the neuroscientist Francisco Varela, philosopher Evan Thompson and
psychologist Eleanor Rosch can be placed within this category, as can
the theorisations of metaphor emerging from cognitive linguistics. In *The
Embodied Mind* (1993) Varela *et al.* explore the synergies between mind in
science and mind in experience.[21] In this seminal text, cognitive science
converses with Buddhist meditative psychology, offering perspectives
which engage in new ways with other fields such as phenomenology and
psychoanalysis. The thesis is articulated as a 'circulation' between cognitive
science and human experience, offering new paradigms and languages for
exploring interactions and connections between disciplines. The concept of
'enactive' cognitive science was born, challenging and transforming tradi-
tional orthodoxies and offering new ways of conceptualising experience.
Varela's 'world building' conceptualisation, as Shapiro notes, influenced
scholars associated with his second and third categories of *replacement*
and *constitution* theorisations. The replacement project positions itself in
opposition to computational and representational paradigms as exemplified
in the work of developmental psychologist Esther Thelen, whose early work
on the importance of movement to learning in child development led to
dynamical systems theory. In the constitution camp Shapiro places the

philosopher Andy Clark [22], whose conceptions of 'embodied, extended and embedded cognition' show 'commitment to the idea that constituents of the mind might comprise objects and properties apart from those found in the head [...] mental activity includes the brain, the body, and the world, or interactions among these things'.[23]

Taking their cue from Shapiro, Evelyn Tribble and John Sutton comment on the pertinence and prevalence of dance metaphors in discussions of cognitive science. Their introduction for Part 1, 'Dances with Science', establishes the basis for partnerships between cognitive science and performance, the steps to be learned through sharing vocabularies and the need to understand differences and synergies through exploratory choreographies, a complex interweaving across and between disciplines, an exchange of theoretical and methodological approaches. The collaborative practices featured in Part 1, broadly informed by theorisations of embodied cognition, exemplify the thinking body, explorations of kinesthetic empathy, memory, identity and pain in performance.

In Part 4, enaction and dynamic systems theory are also the basis for Bruce McConachie's introduction, 'Spectating as Sandbox Play', the book's concluding section on audience and spectatorship (p. 135). Informed by insights from embodied cognition, McConachie examines how 'spectators use their material and social surroundings, as well as their bodies and brain to take action and make meaning during a performance' (p. 186). McConachie's analysis of how we perceive and respond to theatre in its different forms and the varying modes of spectatorship which shape our experience draws upon a variety of cognitive perspectives as he discusses attention, James L. Gibson's notion of 'affordances', and Jaak Panksepp's *Affective Neuroscience* to conceptualise emotional engagement in conjunction with Antonio Damasio's social emotion systems.

The chapters throughout this book engage with a broad spectrum of cross-disciplinary approaches to cognitive science, to inform discussion of texts and performance, the actor and training, immersive and participatory performance. The key themes of cognitive science interact with theories and practices of performance through discussion of perception and action, emotion and empathy, intersubjectivity, language, consciousness, memory, identity, imagination and creativity. Thus in the twenty-first century new terminologies and paradigms have moved beyond cognitive science's black box to conjoin thinking and feeling, body and brain as dynamic, complex and interconnected. The excitement and ensuing controversy surrounding the discovery of mirror neurons towards the end of the twentieth century has contributed to reconceptualisations and debates concerning 'theory of mind'.[24] The importance, relevance and applications of this body of work to the equally multifaceted modes of theatre and performance are the subject of this book.

Blinded by science? The critique of cognition

Science continues, however, to be charged with reductionism and although cognitive approaches are challenging Cartesian dualisms, the comments by Nicola Triscott which opened this general introduction are indicative of public perceptions of science as being positioned in an antithetical relationship to the humanities. Triscott refers to the 'deficit model' under-pinning the UK's Royal Society's 1985 report *The Public Understanding of Science*, and to its recommendation that the discipline needed to make itself more accessible to non-scientists.[25] The dialogue with the arts has been one means of facilitating this, creating 'relationships between theatre, science and performance' which have been described by reviewers as 'exciting, explosive and unexpected'.[26] Not everyone agrees; as theatre critic Lynne Gardner has questioned in a 2011 blog, 'Why does theatre plus science equal poor plays?'[27] Reflecting upon two 2010 productions, Jeremy Karaken's comedy *Sweet, Sweet Motherhood*, a play 'ostensibly about genetics'[28] and Snoo Wilson's *Lovesong of the Electric Bear* on the artificial intelligence pioneer, Alan Turing,[29] Gardner considers both to exhibit 'a squeamish attitude towards the scientific disciplines that inspired them'. She criticises the neglect of science in many of the plays supported by the Alfred P. Sloan Foundation, 'an organization with a nifty mission to encourage playwrights to tackle science, but with indifferent results'. The problem, she suggests, is that playwrights too frequently trivialise the science itself, focusing instead on the lives of the scientists as soap opera-style biographical dramas. Acknowledging that there are exceptions (her list extends from George Bernard Shaw's *The Doctor's Dilemma*, 1906; through Brecht's *Galileo*, 1943; and Dürrenmatt's *The Physicists*, 1962; to Tom Stoppard's *Arcadia*, 1993), she suggests that a more successful formula is one in which science plays a more central role, informing the dramaturgy, form and content:

> Rather than making the scientific stuff intelligible to the average layperson, perhaps writers should let it remain difficult, let the audience struggle a bit, allow certain principles to remain complicated and elegantly remote. And perhaps writers and directors can make use of the available theatrical technologies to render these theorems more vividly.[30]

Theatre staging science is the focus of Kirsten Shepherd Barr's 2006 study, *Science on Stage: From Dr Faustus to Copenhagen*. She suggests that 'a book about theatre and science is timely since both fields have long borrowed from one another for metaphoric explanations of what they are and what they do'.[31] The extensive history of theatre staging science is evident in

Shepherd-Barr's appendix, 'Four Centuries of Science Plays', but she notes a changing relationship in contemporary drama as science becomes a more prevalent and visible preoccupation. Recent work demonstrates increasing engagement with scientific concepts, complex ethical issues and an 'interdependence of form and content that relies on performance to convey the science'.[32] Her conclusion considers collaborations between theatre directors and scientists, while her study as a whole offers convincing evidence to challenge C. P. Snow's oft-cited concerns about a rift between two cultures. Michael Blakemore refers to 'putting on a play [as] a sort of scientific experiment',[33] while scientists have also turned to theatre as a practice-based medium for exploring theoretical perspectives. The mathematician John Barrow's collaboration with Luca Ronconi, *Infinities*, is cited by Shepherd-Barr; 'this kind of theatre' Barrow explains 'is looking for hypotheses, rather than starting with them. We don't know the final answer'.[34]

These relationships are being developed in a variety of ways, moving beyond the staging of science to other forms of interaction and exchange. Contemporary practitioners are increasingly working with scientific and medical material (e.g. Clod Ensemble's 'performing medicine' and Bobby Baker's use of live art to explore mental health). Further examples of companies engaging with science include Curious Directive, Third Angel, Unlimited and Desparate Optimists, among others. These are addressed in Paul Johnson's *Quantum Theatre* (2012), which offers an overview of interactions between theatre and science (from Aristotle to the Newtonian inspired naturalism of Zola and the Stanislavski's 'science' of acting) before focusing on case studies of contemporary performance practice, to develop his hypothesis that quantum mechanics can be used as a 'framework' for conceptualising particular modes of performance and that 'quantum theatre' embodies the principles of this branch of physics: 'A quantum theatre would display multiplied identities, allow for realization through the active observation of the spectator and would be playful in character'.[35] Reckless Sleepers' *Schrodinger*, as I discuss below, offers a particularly pertinent demonstration and is, more broadly, an illustration of the complexities and possibilities in the coupling between science and theatre.

Neuromania?

The title of Bruce McConachie's and Elizabeth Hart's 2006 anthology, *Performance and Cognition: Theatre Studies and the Cognitive Turn*, announces a paradigm shift, offering an introduction to what was becoming

a rapidly expanding field: 'We cannot fully describe the many plants and animals that populate this garden; nor can we take you down all of the paths that will allow you to explore its entirety. Further (to continue the metaphor), this garden is evolving quickly; new species and short cuts will soon invite fresh investigation.'[36] A quick stroll through the 2013 garden shows their prediction to have borne fruit. Developments in cognitive science have continued to influence theatre scholarship, informing and even transforming our understanding of performance processes, practices and reception. Cognitive approaches to theatre history have drawn upon, for example, dynamic systems theory, cognitive linguistics and gesture theory as a means of engaging with the past and different cultures of performance. The influence of an early pioneer, Edwin Hutchins, continues to be felt and acknowledged in the rapidly developing field of performance as an anthropologist bravely navigating some potentially hostile disciplinary boundaries in his study of cognition and culture. Situated between psychology and anthropology and drawing upon computational models of cognitive science to explore the cultural nature of cognition, Hutchins demonstrates the transformational potential of a cross-disciplinary approach.[37] Discussions continue to be diverse, wide-ranging and sometimes heated. Peter Meineck's work on 'the neuroscience of the tragic mask', uses mirror neuron theory and cognitive studies of emotion to speculate on the function of the mask in performance and its affect on the spectator.[38] Jill Stevenson's perspective on performativity and devotional culture explores synergies between cognitive science and medieval visual theories.[39] Drawing upon conceptual blending theory, Stevenson's analysis of the layperson's physical interactions with religious performances and devotional media offers a new reading of theatre history and also considers the implications of her insights for contemporary modes of religion in medieval cultures. Shakespearean studies have also been transformed through cognitive linguistics in Amy Cook's *Shakespearean Neuroplay*, while Evelyn Tribble uses distributed cognition to navigate the complexities of production processes in Shakespeare's Globe.[40] An earlier pioneer of cognitive approaches to Shakespeare was Mary Thomas Crane's study of image schemata: *Shakespeare's Brain: Reading with Cognitive Theory*.[41] Affective neuroscience informs dramatic criticism in the work of Naomi Rokotnitz, whose *Trusting Performance* explores social emotion and the importance of embodiment to knowledge formation, identity, intersubjectivity, communication and empathy.[42] Theories of extended and embodied cognition also underpin the study of 'performer-object' interaction in Teemu Paavolainen's discussion of affordances and image schemas with reference to Meyerdold, Grotowski and Kantor.[43] Discussions of actor training, directing and the crafts of performance draw extensively on

cognitive theory to consider the physical and intellectual processes engaged in performance, developing a vocabulary for analysing emotion, memory, reason and imagination. Rhonda Blair brings insights from neuroscience to reconceptualise acting theory and practice in *The Actor, Image and Action*[44] while John Lutterbie's *Toward a General Theory of Acting* deploys dynamic systems theory to explore different styles and techniques of performance.[45] A different range of historical scientific perspectives are engaged by Jonathan Pitches in his approach to the Stanislavsky tradition. Theorisations of spectatorship and reception have also turned to cognition, most notably in McConachie's *Engaging Audiences*.[46] The experience of spectatorship in post dramatic theatre and the affects of immersive and participatory performance on the partaker are the subject of Stephen Di Benedetto's *The Provocation of the Senses in Contemporary Theatre*.[47] Finally, the developing field of applied theatre and performance has engaged with cognitive perspectives to explore the processes involved in work which engages practitioners and participants in educational, community and social contexts.[48]

The garden of cognition and performance, to return to McConachie and Hart's metaphor, is not without its thorns, however. The terrain is difficult and complex to navigate, there are mazes to confuse and disorientate, we stumble across paths overgrown with weeds as old and resistant terminologies strangle the new. We struggle to prune looking for the right tools appropriate for the vast array of plants, related but different and we fail to label accurately, needing more precision in our terminologies to distinguish between the different varieties of similar species.

McConachie extols the empiricism of scientific methodologies and their association with evidence based models to test, prove and falsify. This, however, gives rise to concerns about hierarchical, top-down approaches whereby 'hard' science is used to validate 'soft' performance practice. Charges of reductionism and questions concerning the validity of theories and their misappropriation (particularly the vexed topic of mirror neurons) cause temperatures to rise in our cognitive gardens, threatening the plants we are trying to nurture. Angus Fletcher refers to the 'distinctly self-congratulatory tone' of cognitive inspired criticism,[49] while Philip Barnard calls for 'close scrutiny' of the claims made for mirror neuron theory in performance research.[50] Much of the scepticism may be due to misconceptions of cognitive perspectives and the need for performance scholars to communicate the provisional nature of scientific 'truths'.[51]

In 'The Written Troubles of the Brain: *Sleep No More* and the Space of Character', W. B. Worthen wields his axe, to challenge cognitive perspectives on performance.[52] Taking as a case study Punch Drunk Theatre's immersive environmental performance *Sleep No More* (2011), Worthen raises a series of

questions concerning the role of the spectator and the 'character of cognition'. The spectator in this piece is considered by Worthen to be 'depoliticised'. Wearing masks, they are anonymised, 'constructed within the spectacle as realist voyeurs, watchers and *readers*, not agents. At the same time, though, the choreography – in its abstraction, its frequently affectless behaviourism – foregrounds performance as a *doing*, here and now, a practice we share with the performers, perhaps most intensely in the unmasked private performances.'[53] Worthen makes a critical point here when he refers to the work as 'affectless'. The performance doesn't *affect* the spectator; body and brain are disengaged; the participants are passive, they maybe moving through the space but they are unmoved. The masks, Worthen explains 'provide a familiar theatrical anonymity, underwriting the agency to watch though not to act, at least not to act with the legitimate performers'.[54] This is demonstrated in the spectator's experience Worthen cites (as described by Todd Barnes): 'I suddenly become aware of the rules that govern the space: be touched but do not touch. Yet this immersive theatre experience seemed to rely on my participation. I felt the need to reciprocate her affection in some way, but I did not.'[55] There is no 'trusting performance' here, to use Rokotnitz's terms; the participant is disengaged and disembodied. Worthen's critique of cognitive blending and affordances not being appropriate to analyse this performance is problematised by the production itself and its uneasy positioning between traditional and contemporary modes of performance: 'A meditation on *Macbeth* and a response to the function of Shakespeare in contemporary performance culture, *Sleep no More* complicates the fatigued distinction between "text-based" theatre and "performance."'[56] Just as sitting in a seat isn't to be 'projected to the blend' so the spectator remains aware of her position behind the mask (which is compared to assigning seats in an auditorium); there is no blending. Questions concerning the appropriateness of cognitive blending theory to immersive and interactive modes of performance are addressed by the chapters in the final part of this volume, particularly Melissa Trimingham's 'Touched by Meaning', which explores how hapticity and affordances operate in multisensory participatory performance environments designed for working with autistic children.

Nevertheless, and as Worthen implies, spectating in contemporary modes of performance involves something other than 'the straightforward blending of literary character to performer described by Fauconnier and Turner'.[57] Contemporary performance involves a complex fusion of simultaneous states of presence. The performance vocabularies, as Worthen observes, draw attention to the 'doing', through, for example physical articulations while the 'depersonalised quality' of the choreography Worthen describes in this theatre without character, is also associated with the performed

neutrality of 'not acting' in this 'other' mode of production, where 'words signify as something else, as action'.[58] This is not, however, incompatible with cognitive theories of performance which help us to conceptualise the complex processes involved in thinking physically and in generating 'felt understanding' through the interplay between visual, auditory and bodily experiences. Moreover, as I discuss below, the dialogues between neuroscience and performance are impacting upon each other. Insights from the study of the mind are being practically applied to address challenges in contemporary dance choreography, as scientists collaborate with performers to develop new ways of working and new insights into memory and the imagination. In his witty critique of neuroscience and evolutionary theory, Raymond Tallis coins the term 'neuromania' to refer to reductive, simplistic, misappropriations of scientific theory which overlook the complexities, differences and uniqueness of being human.[59] Citing the philosopher Alva Noë, human experience is described as

> a dance that unfolds in the world and with others. You are not your brain. You are not locked up in a prison of your own ideas and sensations. The phenomenon of consciousness, like that of life itself is a world involving dynamic process. We are already at one in the environment. We are out of our heads.[60]

The dance analogy seems particularly appropriate to the interactions between cognitive science and performance as they affect each other.

Dead and alive: Science and art interact in Reckless Sleeper's *Schrodinger*

I return now to *Schrodinger* as an example of this iterative process, and as a production in which we see, simultaneously, theatre staging science, performance processes exploring scientific concepts and an 'affective' aesthetic.

Perspective 1: Postdramatic theatre or quantum theatre? How to make sense of non/sense?

> With frenetic energy five performers are consumed in their relentless and unforgiving task of testing the environment that they exist in. They are figures at the end of their tether, caught in a cycle of exploration that requires them to engage, through movement and scripted passages, with Erwin Schrödinger's 1933 quantum theory – which states that at an atomic level particles of light may exist in a single moment both in a

state of decay and not; and that a box in theory may therefore hold both life and death for a single entity in a simultaneous instance. For Reckless Sleepers, *Schrödinger* is about the immeasurable experiment: a series of contradictions placed alongside one another in an attempt to wrestle truth from juxtaposition. But is there a truth to be found? By its own cyclical nature, nothing can be resolved here; what little truth exists can only be found in the erratic live struggle to break free from the confines of the experiment. [...]

Schrödinger is an experiment in truth and lying; it is filled with glorious moments and tedious predictability. It engages and disenchants; on one level it is the best piece of action you may see in sometime, and on the other the worst example of theatre filled with dire drained acting. Actors fall through hatches from the ceiling, riff on themes of alcohol consumption, cats, mountains and waves of light. Bodies are thrown around the space and the majesty of the box is defaced in elegantly haphazard chalk scrawlings. After watching, it will leave you to wrestle with its problems and anxiety for days to come, which in many ways is where it really excites. The people at play in this world are like mice in a science experiment; they are forced to behave, to repeat and yet fight against this. The work is an unending battle for its participants but the central figure is the box; the closing image of which leaves its occupants wretched and used. The climatic finale is beautiful as soaked, shattered bodies litter the space of the cube; the sixth and most central character that has dominated all, now revealed as a living entity in its own right, stood before us covered in chalk handwriting and doodles, crying as water cascades feebly from every worn and tired orifice. We leave this world exhausted and frustrated. Knowing it is set to endlessly repeat we understand the drain it has had on its occupants; like the particles in a single moment they are stuck both vibrantly alive and dead. The box owns space, time and is a world of truth trapped in a blanket of lies. (Thomas Bacon)[61]

Perspective 2: About science: performance illustrating and informed by quantum theory?

This is not a show about quantum science. (Paul Johnson)[62]

I think in some circles we were criticised for not explaining quantum theory. I would like to say that we tried to make sense of it and in our own peculiar way by presenting a piece that includes many aspects of quantum theory. We do explain these concepts, albeit not in a classical way such as a lecture demonstration. (Mole Wetherell)[63]

Perspective 3: Affective performance

'I found it mesmerizing.' (Liz Moran)[64]

The initial stimulus for Schrödinger was a dualism as an exploration of the relations between truth and lies, as Mole Wetherell explains, 'the notion that when telling a lie the truth is also heard in your head led to research in Quantum Physics. Thought experiments, the means by which scientists explain complex concepts, were also investigated.'[65] This blending of two co-existing states and the positioning in between knowledge of the pretend and the real is also pertinent to the conditions of contemporary performance as described above, where spectators are acutely aware of themselves and their reality in the time and space of theatre. This is conceptually different to the willing suspension of disbelief we associate with illusionist theatre.

The work was influenced by Einstein's theory of relativity which, Wetherell explains, challenged classical science but 'makes particular sense in relation to theatre and postmodern thought. Events on two distant stars may appear simultaneous to one observer but successive to a differently situated observer.'[66]

In quantum theory, light similarly exists in two states – a particle or a wave. The notion of quantum entities experiencing more than one reality at a time underpins *Schrödinger*. Ensemble modes of working are also appropriate to quantum theorisations which privilege groups over individuals, exploring the probability of things happening with large numbers in particular circumstances. This is evident in the system of 'contacts' developed between people, space and objects whereby the contacts are quantified and mathematics becomes part of the creative process. Wetherell's explanation of this method, can be seen to conjoin effect and affect: ' "contacts" makes perfect sense when you understand the system ... but in isolation it would be difficult to understand what is taking place. Its rules produce emotional content without the necessity for *acting* emotional content' (my emphasis).[67] This does not lead to a theatre devoid of feeling, however, as evident in the 'Letter' sequence which explores the different temporalities and realities of letter writing, merging Einstein's letters to his wife with Wetherell's autobiographical perspective:

> Letters have great significance for me. It's the delay and that the whole world changes in the 2–3 days it takes for them to arrive. I also write letters that are never to be sent. Their intended recipient will not receive them. The letter in 'Schrödinger's Box' is two such letters put together.[68]

Wetherell refers to Christopher Bannerman's 'intuitive' and 'disciplinary' frameworks as an influence on the company's working methods, describing

devising as 'a rigorous process that requires experience, understanding of process and context, along with highly evolved conceptual skills'.[69] Practical exercises combine thinking and feeling, the real and the imagined and the interchange between the roles of observer and being observed, all of which are central to the play of shifting and multiple perspectives in *Schrödinger*. Magritte's paintings were a stimulus with performers 'studying an image and then attempting to articulate it in a physical way … the intention is to communicate a feeling of a picture, not to create a literal description of it'.[70] The conflation of both/and which underpins juxtapositions throughout the piece is central to quantum principles, creating the particular quality of knowledge associated with the uncertainty principle. While it is often thought that quantum theory tells us that we can't know things, the awareness produced through the paradoxes identified, create a different kind of knowledge, a different way of knowing, combining 'facts and the feel of something',[71] intellectual understanding and intuition.

Building bridges between the two cultures: Collaborations and multidisciplinary dialogues

In *Quantum Theatre*, Paul Johnson reproduces elements of Ihab Hassan's binary pairings to illustrate the differences between modernism and postmodernism, arguing that many of the features ascribed to postmodernism are also shared by the quantum mechanical paradigm:

Modernism	postmodernism
Form (conjunctive, closed)	antiform (disjunctive, open)
Purpose	play
Design	chance
Art object/finished work	process/performance/happening
Root/depth	rhizome/surface
Lisable (readerly)	scriptable (writerly)
Origin/cause	difference-difference/trace
Determinacy	indeterminacy [72]

This comes with a caution, as Johnson cites David Harvey's concern about presenting 'complex relations as simple polarization', when 'almost certainly the true state of sensibility, the real "structure of feeling" in both the modern and postmodern periods, lies in the manner in which these stylistic oppositions are synthesised'.[73] Johnson suggests, however, that 'the quantum

mechanical paradigm offers a method for negotiating not only between modernism and postmodernism, but also between the mental and the physical, and the individual and the collective.[74] Johnson connects this to the key concepts explored in performance studies which he identifies as 'ways of knowing, reporting and reproducing, suggesting a potential indeterminacy and multiplicity of reality'. This perception of interdisciplinary collaboration between performance and science providing the challenge to the two-culture binary is endorsed by the variety of theoretical, critical and performance practices featured in this book.

As researchers caught up in what has been referred to as the twin turns to cognition and affect, we are positioned between dualisms which might be productively reconceived as a continuum, challenging the hierarchies of top/down or bottom/up approaches. The pairings we most frequently encounter (and which underpin many of the debates within this volume) include:

Arts/science
Intuitive/disciplinary
Presence/absence
Live/mediated
Practice/research

Then there are a series of other dualisms we negotiate and often challenge as theatre and performance scholars:

Real/fictional
Observer/observed
Audience/performer
Active/passive

For Reckless Sleepers, 'passive/active' is identified as a method which creates productive interaction between different states:

> passive/active is the name given to a movement process involving two people, *one of whom changes the position of the other*. It is not a way of generating material although it is a way of making physical contact with another performer, and finding out what limitations there are.[75] (my emphasis)

This description of interaction and the reference to a process of change occurring through contact with another epitomises the research exchange between performance and science as they touch and affect each other. The challenge, however, is to find a shared language to create mutual understanding of disciplinary differences and synergies. As Shaun Gallagher argues:

There is still a need to develop a common vocabulary that is capable of integrating discussions of brain mechanisms in neuroscience, behavioral expressions in psychology, design concerns in artificial intelligence and robotics, and debates about embodied experience in the phenomenology and philosophy of mind.[76]

Reflecting on Harvey's reference to the 'structure of feeling' he identified in *both* the modern and postmodern periods' and his reference to the 'manner in which these stylistic oppositions are synthesised' in conjunction with David E. R. George's reference to 'all three of the forces which make up the theatre' we can identify the potential for synthesis in the spaces between the dualisms we are considering here:

Synthesising stylistic oppositions: what is in between?

Concept	In between	Opposition
Truths	Dreams	Lies
Fiction	Magic	Fact
Presence	Memory	Absence
Soft	Plastic	Hard
Open	Release	Close
Feeling	Knowing	Thought
Intuitive	Practice	Disciplinary
Performer	Participant	Audience
Observed	Laboratory	Observer

Thinking in threes: Towards new paradigms for bridging art and science

At the opening of *Trial* Mole Wetherell states that 'new science embraces the notion of "becoming" as opposed to simply "being" and this resonates with the acknowledgement of process'.[77] My use of 'being' in the subtitle to this volume encompasses processes, becomings, transitions and transformations as the practices, disciplines and modalties featured interact and 'touch' each other, affecting change.

The chapters in this book in various ways create bridging discourses, playing within intermediary spaces to explore and conceptualise the creative and critical middle ground in which the work is deliberately situated. The metaphors chosen by each contributor connect to each other: the collaborative dances of Part 1, the critical blending activities in Part 2, the multimodal practices in Part 3 and the sandbox play in Part 4. For the researchers involved in the 'Watching Dance' project (Mathew Reason et al.), the middle space of interdisciplinary enquiry required the development of new modes of methodological exchange; the autobiographical dance-based collaboration discussed by Anna Furse is poised between the embodied memory of the past and a continuing performance making process; 'retracing our steps' leads to new understandings of memory, identity and the thinking body. In the final chapter of Part 1, Erin Hood explicitly positions performance in between the perception and representation of pain; questioning Elaine Scarry's association of felt pain with 'certainty' and the pain of others with 'doubt', Hood identifies 'the middle space' of performance with the felt understanding and new knowledge that can shift understanding of selves and others. All four chapters engage in different ways with conceptions of embodied cognition.

In Part 2, Amy Cook draws upon conceptual blending theory as a means of weaving between science and the literary humanities, arguing that its application to theatre and performance 'confronts the complexity of a meaning-making event that includes the bodies of the participants' (pp. 88–9). The body is central to each analysis in this section and their mediation of different theoretical perspectives. Natalie Bainter explores the 'blush' in Thomas Heywood's *A Woman Killed with Kindness*, moving between affect theory, cognitive science and performance theory. John Lutterbie explores interconnections between dynamic systems theory and gesture research in a discussion of memory, thought and speech which connects to the practice-based research discussed by Neal Utterback in Part 3. Naomi Rokotnitz positions her analysis between play texts and their affect, similarly situating the body at the heart of her argument. Situated at the intersections between theatre, performance, cognitive science and affect theory, these chapters challenge conceptual categories while also touching each other through points of contact and exchange.

In Part 3, Rhonda Blair in her introduction 'The Multimodal Practitioner' also engages with affect and cognitive theories to consider their implications for acting and performance. The chapters in this section articulate practical modes of research enquiry: Neal Utterback's experiments with actors to explore the role of gesture and memory, Martin Welton's discussion of his collaboration with a choreographer to explore 'thinking through footwork' and Gabriele Sofia's account of the impact of movement-based work on

people with Parkinson's disease. All three chapters can be read as versions of 'research based practice' (RBP), as articulated by Pil Hansen and Bruce Barton as 'a 3rd Space of inquiry, one that brings the investments, expectations, and processes of these multiple areas into novel modes of exchange'.[78] RBP is defined against 'Practice-Based Research' as a 'systematic response to the enduring opposition between practice and research, in part through an effort to reduce the perceived contrast between product and process'.[79]

The final section of the book, Part 4, explores the in-between space of spectatorship with particular reference to participation as a mode of 'sandbox play'. Framed by McConachie's overview of cognitive approaches to audience research, these chapters explore the relations between performer and partaker in immersive, intermedial environments. Josephine Machon's articulation of (syn)aesthetics is one example of the new languages emerging to synthesise hybrid forms; Adam Alston provides a counter response to Machon, offering a very different perspective on his experience of the same production. Together, these chapters engage in dialogue, demonstrating the polyvalence of performance and its capacity to engage spectators differently. The final chapter, by Melissa Trimingham, draws upon cognitive theory to explore the imagination in autism, demonstrating the potential of performance as a methodology for scientific research, helping us to engage with the phenomenology of the autistic experience.

My conclusion draws upon the applied neuroscience of Philip Barnard with particular reference to the bridging paradigm articulated in 'Creativity, Bridging and Conceptualisation'.[80] Reflecting on his collaboration with the choreographer Wayne McGregor, Barnard describes himself as being challenged by a range of 'deep questions' that arise when thinking about cognitive neuroscience and creativity.[81] His work explores the 'big picture' macro theorisations, considering how the whole mental system works and the neural architecture of the brain, in conjunction with psychology's micro theories (the little pictures) associated with, for example, the specifics of memory, perception and imagination. Barnard's interest in the relations between embodied movement and emotion connected with McGregor's practice:

> [His] approach to movement creation involves dancers making a wide range of embodied mental transformations. He asks his dancers to create movement in response to task instructions that require a great deal of mental imagery and decision making, and then observes the dancers resulting movement, selecting and amplifying for potential re use.[82]

This connects with the visual and physical methods used in *Schrödinger*, particularly in relation to the Magritte paintings. Barnard's interdisciplinary

collaboration with neuropsychologists and sensory motor neuroscientists sought initially to understand how these forms of mental and sensory imagery support movement creation. As the research progressed, moreover, and drawing upon his work in applied clinical practice, the scientific perspectives were used to develop tools to help dancers identify and challenge habits, facilitating the development of more innovative physical vocabularies and original choreographic thinking.[83] There are synergies here with Hansen and Barton's research based practice model which stated its initial objective as being 'to challenge discipline-specific habits'.[84] Barnard's initial research questions investigated 'what dancers report thinking about while creating movement' and 'how their experiences change as a function of different task conditions'.[85] The conditions involved contrasting an 'active' state (in which dancers are free to move around) with a passive mode (imagining movement without moving). A further experiment used neuroimaging to record a dancer's brain activity while she simulated mental movement creation, responding to choreographic creation tasks typical of McGregor's training. The results revealed the extent to which the dancers' choreographic thinking prioritised mind over matter:

> the dancers' awareness was focused more than they had anticipated on conceptual rather than physical or bodily aspects. The very act of reflecting on, and categorizing their experiences provided the dancers with insights about their mental habits during innovative movement creation. Such insights provide conditions under which habits can be recognized and then altered to adopt alternative points in mental space from which to create movement material.[86]

Building on his clinical research in applied science, working with cognitive behavioural therapy and mindfulness to develop therapeutic interventions for mental illness,[87] Barnard developed teaching tools to help dancers recognise and overcome habitual responses, enhancing their potential for originality and innovation. While this collaboration clearly involved change for the dancers as applied science informed arts practice and Barnard also acknowledges 'a trace of the art in the science', he noted 'no direct trace of the scientific research done in this context on the artistic product'.[88] A further stage of his research explored the 'bigger picture' of McGregor's creative process in a quest to understand how the choreography is produced and the relations between sources, ideas and outcomes as a means of conceptualising and augmenting performance practice. Brain science facilitates understanding of the complex interactions between the visual, auditory and bodily subsystems which are engaged in the cognitive work of making performance. Barnard charted key elements and stages in McGregor's

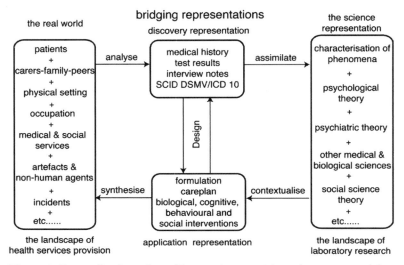

Figure 1 Barnard's adaptation of interacting cognitive subsystems models illustrates and conceptualises the relations between scientific theory and what he refers to as 'real world behaviour'. His diagram synthesises complex multiple components and has been adapted to theorise various psychopathologies as well as being used to map the mental processes involved in creativity (see Figure 2).

choreography, producing a schema to illustrate how creativity is distributed over systems, a process of reflection and data gathering which is referred to as 'Process and Concept Tracking'.[89] The model of the bridging process is an adaptation of paradigms developed in applied clinical science, responding to the challenges of finding shared vocabularies and registers for inter disciplinary communities of theory and practice.

A three-part diagram illustrates the processes and interactions between experiences and behaviours in the 'real world' of people and their representations in applied science. In the middle and 'centre stage' are two vertical boxes representing the two sorts of 'bridging representations' identified as 'discovery' and 'applications' connecting to each other (see Figure 1).

The model developed and applied to choreographic practice distinguishes between a box on the left containing 'representations of the world of contemporary dance [...] or any other landscape of artistic production', identifying the contexts and constraints, the conditions for production in the form of performers, spaces, audience, etc. while the right hand box is labelled 'representations of ideational sources' listing the knowledges,

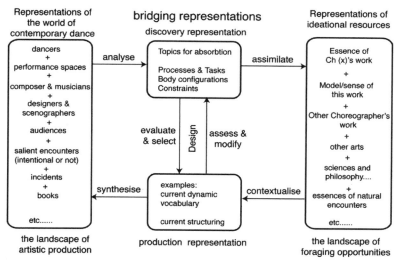

Figure 2 The bridging model adapted from applied science to illustrate and synthesise the complex processes involved in the development of creative work, from idea to artistic outcome which Barnard *et al.* refer to as 'process and concept tracking'.

stimuli and influences which artists draw upon and which is referred to as 'the landscape of foraging opportunities' (see Figure 2). The two boxes in between are labelled 'discovery representation' and 'production representation', similarly connected. The top box refers to methods and materials: 'topics for absorption' 'processes and tasks', etc. while the bottom is identified as 'production representation', containing the tools needed for making performance: 'current dynamic vocabulary' and 'current structuring'. Key terms link the boxes to each other, arrows that are labelled as specific processes (analyse, assimilate, evaluate and select, assess and modify, contextualise and synthesise).

Barnard's bridging paradigm is a flexible design for conceptualisations of interdisciplinary theory and practice and can be adapted to explore and analyse the relations, intersections and interactions between the different states, and intermodalities we negotiate as scholars and/or practitioners. Applied science contributes new paradigms and vocabularies to engage with the intangible elements of creative thinking and performance making and its traces are being seen and felt through new artistic pedagogies and aesthetics, while insights gained from practice-based collaborations in performance

contexts are informing scientific understanding of relationships between visual, acoustic and bodily modalities and the complex networks which constitute the mental architecture underpinning action, perception, emotion and imagination. Two of the chapters in this volume, moreover, demonstrate the potential of theatre and performance to engage with atypical cognitive profiles, offering insights into the experience of those who perceive differently.

I conclude with the words of Catherine Loveday, a neuropsychologist, talking about her collaboration with a film and sound artist, Shona Illingworth and the neurospychologist Martin A. Conway. The research, supported by the Wellcome Trust, explores memory and identity and the experience of amnesia as a personal and cultural phenomenon. Concluding a discussion of her experience of interdisciplinary collaboration between science and the arts, Loveday commented: 'I feel that my scientific knowledge is different, and richer and broader, because of this project.'[90] The chapters collected in this book similarly demonstrate the value of performance and science engaging in theoretical exchange and interactive practice. New paradigms and methodologies are emerging, new vocabularies and registers and new choreographies, as theatre and performance, cognitive and affective science dance together.

Part One

Dances with Science

Introduction: Interdisciplinarity and Cognitive Approaches to Performance

Evelyn B. Tribble and John Sutton

Performance studies and the cognitive sciences have much to offer each other. Research in performance and theatre can embrace such topics as memory, attention, skill and the mindful body, perception, temporality, emotion and more – all of which have been the subject of study by researchers in various disciplines loosely grouped under the umbrella of the cognitive sciences. This is an exciting time to be working in an integrative and critical spirit across disciplinary boundaries[1].

But working across disciplines is not always easy. It can be difficult to map the terrain of an unfamiliar discipline, to distinguish among settled consensus, emergent challenges to that consensus, outmoded or discredited theories, and work that is simply marginal to the target discipline. Our deep knowledge of our own disciplines extends not only to the content of research, but also to its conventions; we know implicitly what matters and what 'counts' as a credible research question and methodology for investigation, and this knowledge can be difficult to convey explicitly. But this deep familiarity with our home disciplines does not necessarily aid us in navigating even closely related fields. For example, in the field of English Renaissance Literature, some of the vicissitudes of interdisciplinary work became apparent during the early years of new historicist studies. The work of historian Lawrence Stone was taken by many first-generation new historicists as representing consensus about the family in early modern England, but in fact Stone's model was highly contested by a wide range of social historians. This situation led one prominent historian to describe the so-called interdisciplinary programme as 'one-way traffic'.[2]

Today the so-called 'cognitive turn' in the humanities poses even more challenges, both because cognitive science is itself a highly diverse interdisciplinary field, and because of the greater distance between the disciplinary assumptions and methodologies of the source and target fields. Few researchers are equally conversant with both disciplines, making it difficult

properly to evaluate interdisciplinary research. One response to this challenge is to build teams in which researchers with distinct areas of expertise meet around questions of common interest. Such an approach has the advantage of using the deep domain knowledge that is only made possible by long immersion in a particular subject area, while also testing new methodologies alongside researchers with different training and assumptions. Such collaborations take time, energy, tolerance and commitment, but can be hugely rewarding. The aim is to achieve the level of integrative teamwork found, for example, in the interdisciplinary collection of essays *Thinking in Four Dimensions: Creativity and Cognition in Contemporary Dance*, in which 'aesthetic theory, cognitive psychology, and dance criticism merge, as authors are appropriately driven more by the heterogeneous nature of their topics than by any fixed disciplinary affiliation'.[3]

In our own collaboration, a Shakespeare scholar works with a cognitive philosopher to develop an approach to historical cognitive science based on the framework of distributed cognitive ecologies. We have been working together, off and on, for nearly seven years now; while we continue to discover new challenges to integrative work of this kind, our ongoing interaction has also transformed our independent research in our specialist disciplines. We discover new complexity in our own fields as a result of thinking through old problems with the different perspective of each other's discipline, and we find new shared problems which are historical, cultural and cognitive all at once. What follows are some thoughts on going about interdisciplinary research in the cognitive sciences, aimed primarily at relatively new researchers in the field, and with emphasis upon potentially productive lines of enquiry for researchers and practitioners in performance studies.

Our initial point is simple: 'Cognitive Science' is not a monolithic entity. A corollary to this point is that the 'cognitive theory', while apparently a convenient shorthand, is not a meaningful term on its own. As we recently suggested, 'The contemporary cognitive sciences are not settled and inert background accounts of mind, or, worse, the brain. Instead, they are much less homogeneous, much more intriguingly messy and open, than that. These sciences are driven by their own ambitions to encompass and address more complex domains than reasoning – to deal with memory, affect, action, embodied expertise, motivation, imagination, moral decision-making, and the like – and, in some cases, to do so in increasingly contextualised terms'.[4] Cognitive science is itself an interdisciplinary and multidisciplinary field, riven by internal tensions and disagreements, and encompassing a wide range of disciplinary perspectives, many of which are not obviously compatible one with another.[5] It involves researchers in fields as disparate

as philosophy, psychology, linguistics, artificial intelligence, anthropology, neuroscience and linguistics, among others.[6] In turn, each of these fields is itself wildly diverse. Psychology alone, for example, includes sub-disciplines as distinctive as cognitive, developmental, social, clinical, personality and comparative psychology. Each such sub-discipline, unsurprisingly, employs dramatically different methods. Developmental psychologists, for example, can study anything from parent–child conversations in the family home, through rigidly controlled laboratory experiments with infants, to the neurochemical correlates of specific emotions in children's brain.

A shared interest in mind, cognition, and flexible intelligent action characterises research across these disciplines, but this does not take us very far, especially given the rapid development of diverse approaches to research within the cognitive sciences. Early, narrower definitions of 'cognitive science' identified the field with the claim that mental processes are certain kinds of information-processing activities, specifically computational ones.[7] While this so-called 'classical cognitivist model' remains influential,[8] the last 20 years have seen concerted internal challenges to this relatively restricted definition of cognitive science.[9] Institutional and disciplinary liberalising has left such classical cognitivism in place as one fruitful approach among many, but has also decisively opened up the cognitive sciences to address the embodied, affective, kinesthetic, situated, social and distributed dimensions of mind.[10] Critics from outside the field sometimes still identify 'cognitive science' with some stereotypical assemblage of rationalist, individualist, universalist, essentialist, nativist, logicist and reductionist views, but this is no longer historically or conceptually legitimate. Immersion in Margaret Boden's magnificent two-volume 2006 history of cognitive science, *Mind as Machine*, will engender a feeling for the great variety of more or less successful internal critiques of such classical ideas, and for the multiple waves of the alternative movements which have been revivifying the inter-disciplinary project since its inception.

Because there are such widely variant assumptions, methodologies and research questions among cognitive scientists, one commentator has argued that 'cognitive science… is composed less of a coherent body of knowledge than a differentiated and often opposed collection of claims'.[11] Researchers in the cognitive sciences disagree fundamentally, to take just one example, on whether the brain employs specialised and relatively encapsulated modules for specific tasks, or operates primarily by way of more flexible, permeable general-purpose mechanisms.[12] For these reasons, then, the term 'cognitive theory' as it is often used in the humanities lacks sufficient specificity. In literary studies, 'cognitive theory' is sometimes used interchangeably with 'cognitive linguistics', particularly with conceptual metaphor theory or the

model of 'blending' proposed by Gilles Fauconnier and Mark Turner, but the term potentially embraces all of the cognitive sciences and should not be subsumed into one or two contested sub-fields.[13] None of this means that there are no areas of consensus at all; considerable agreement on certain aspects of particular topics or specific cognitive domains can co-exist with ongoing disputes both about questions of greater complexity and about matters of theory. Such points of controversy or trouble are, of course, often fruitful points of entry or focus for the interested outsider; by setting specific ideas in the context of alternative views in cognitive science, the humanities researcher can not only avoid the accusation of cherry-picking, but also more confidently identify worthy opponents, rather than straw targets.

Responsible and productive cross-disciplinary research presupposes requires familiarisation with the shape, history and debates within the broader field of the cognitive sciences, as well as the particular sub-field of interest. For gaining knowledge of such debates, journals such as *Behavioural and Brain Sciences* and the more recent *Topics in Cognitive Science*, which regularly publish target articles along with a range of invited responses and critiques, are especially useful points of departure. Similarly, targeted special issues in journals about areas of current controversy are excellent ways to for a non-specialist to quickly map a field, as are journals dedicated to a particular domain such as *Emotion Review*. Books written for a general audience (e.g. Damasio, Ramachandran, Pinker), while useful resources for those unfamiliar with a scientific field, should be regarded as a starting point only, an entry point into the relevant primary literature.[14] It is also worth noting that many of these writers, gifted as they are, are sometimes venturing far beyond their own disciplinary expertise. Stephen Pinker's recent foray into the history of violence is only the most recent example, but many others could be found.[15] A further drawback to over-reliance on books of popular cognitive science alone is that it is often not part of the remit or intent of such works to state explicitly just which of the ideas they discuss or defend are still controversial, and how much so. This is one of a number of reasons to recommend that newer entrants to the field might also find a way in by way of some of the excellent textbooks on various parts of the cognitive sciences. Even where a textbook is written by an active participant in a research domain, with particular agendas and assumptions built in, it is at least meant to signal the status of the ideas it discusses, and offer fair evaluations of competing views. Humanists can retain and develop a critical and historical awareness of the potential normalising ideological force of textbooks as instruments of Kuhnian 'normal science' even while playing the apprentice themselves. For example, Andy Clark's 2001 textbook *Mindware: An Introduction to the Philosophy of Cognitive Science* sets the author's own

more radical ideas about cognitive technology and dynamical, action-based approaches in the context of the computational, connectionist and philosophical views from which they (partly) spring.[16] Introductory surveys and textbooks such as these can provide a foundation of reading and evaluating the scholarly literature. The point is not to become an expert, but to gain a sense of the shape and contours of the target discipline.

It can be as useful to find papers that challenge prevailing models as it is to find work that confirms them. For example, there are vigorous debates around Conceptual Metaphor Theory as espoused by Lakoff and Johnson, as well as intriguing recent work that has sought empirical confirmation of their hypotheses. Briefly speaking, Lakoff and Johnson argue that our conceptual categories are formed through our experience of embodiment. But some have argued that Conceptual Metaphor Theory (CMT) has a rather limited view of the body.[17] Some theorizing about embodiment and embodied cognition can leave the 'body' seeming depressingly inert and unconnected to the external world.[18] As Chris Sinha suggests, the embodiment thesis breaks with one aspect of dualism – the mind/body split – but instantiates another, 'leaving intact the dualism or opposition between the individual and society – ' a 'residual dualism that leaves it open to the dangers of collapsing into "neural solipsism"'.[19] But contemporary cognitive linguistics should not be reduced to conceptual metaphor theory alone; it includes a much more diverse array of empirical and theoretical approaches that seek to meet these challenges, many incorporating close attention to the microprocesses of bodily, affective, social and verbal interaction in methods that draw on ethnomethodology, conversation analysis, narrative theory and gesture research.[20] Further, the interest of Sinha and others in the relationship of language and material artifacts might well be of relevance to work in performance studies.[21]

The current interest in mirror neurons provides another useful test case. Consider Susan Keen's enthusiastic account of mirror neurons at the outset of her influential article, 'A theory of narrative empathy':

> We are living in a time when the activation of mirror neurons in the brains of onlookers can be recorded as they witness another's actions and emotional reactions. Contemporary neuroscience has brought us much closer to an understanding of the neural basis for human mind reading and emotion sharing abilities – the mechanisms underlying empathy. The activation of onlookers' mirror neurons by a coach's demonstration of technique or an internal visualization of proper form and by representations in television, film, visual art, and pornography has already been recorded. Simply hearing a description of an absent

other's actions lights up mirror neuron areas during fMRI imaging of the human brain. The possibility that novel reading stimulates mirror neurons' activation can now, as never before, undergo neuroscientific investigation. Neuroscientists have already declared that people scoring high on empathy tests have especially busy mirror neuron systems in their brains.[22]

Keen cites Vittorio Gallese, who indeed is one of the foremost researchers in the field. However, this account of mirror neurons presents the work as rather more settled and stable than it is. Humanities researchers would benefit from more familiarity with the ongoing nature of the debate over mirror neurons, which includes researchers sceptical about their function in humans. A recent symposium on the debate in *Perspectives on Psychological Sciences* provides an excellent account of the competing claims and counter-claims around mirror neurons.[23] The point is not to adjudicate or become enmired in such disputes, but to be aware that these are ongoing debates within an emergent field of research and its precise implications for other disciplines are not yet clear.

Moreover, although allusions to 'neural firing' and brains 'lighting up' have become common in cognitively-oriented work in the humanities, such references do not always advance the specific claims under discussion and in fact may overstate the implications of the very research upon which they rely.[24] We might be suspicious or uneasy when the disciplines seem to be getting on too well, lest each discipline end up simply re-describing the same phenomena in different terms. In a 2011 interview, Vittorio Gallese time and again rejected invitations to make grand claims about the neuro-biology of complex cultural phenomenon, pointing out that there is a 'huge gap' between MNT and, say, the history of mimesis in storytelling. At one point, Gallese noted that 'we are dealing with different levels, which nevertheless belong to the same manifold. Learning things from a different level of description can help, as I get a lot of help studying what the human being is, starting from the personal level of description, provided by writers and artists, or literary scholars, or philosophers or anthropologists.'[25] In cross-disciplinary work, researchers communicate not only across disciplines, but also at different levels of description and analysis. All human actions have a neural basis – how could they not? – but this is not always a relevant level of analysis. While Matthew Reason and Dee Reynolds refer to mirror neurons several times, their work amply demonstrates that it is possible to discuss empathy, audience reaction and expertise while remaining agnostic on the role of mirror neurons.[26] A recent relevant challenge to the current enthusiasm for mirror neurons has been vigorously mounted by Maxine

Sheets-Johnston, a philosopher of phenomenology with a background in dance.[27] Sheets-Johnston argues that 'mirroring depends on, is contingent on, our own kinesthetically experienced human capacities and possibilities of movement' (391). In focusing entirely on the 'neural firing', researchers neglect 'the sensory modality of kinesthesia', (396) which is produced by humans moving in the world.

Research of the kind done by Sheets-Johnstone reminds us that scholars in the humanities need not sell their own distinct expertise short, since methods and assumptions from our own areas can usefully intervene in pressing questions in the cognitive sciences. Work in the sciences should not be treated as an inert or agreed-upon backdrop to less settled questions in the humanities. So it is important both that we not overstate areas of consensus and that we remain aware of ongoing debate and emerging research in the target areas. The ideal, of course, is for the interdisciplinary encounter to give rise to two-way benefits, as we shuttle back and forth across the distinct specialist enterprises. Just as testing a cognitive theory against specific historical cases should help us sharpen that theory, so keeping an eye on existing debates in cognitive science may help us ask new questions about particular performances or cultural phenomena.

The need for such collaboration and insights have been recognised by researchers in the cognitive sciences themselves. In a recent piece, Ed Hutchins and colleagues argue that the cognitive sciences have too long treated culture as a kind of 'independent variable' that might be included in cognitive analysis when convenient; on the contrary, he argues, its integration is 'essential for the future health of the cognitive sciences'.[28] From the perhaps unexpected quarter of experimental psychology, a similar call has been made by Joseph Henrich and his colleagues, in a provocative paper entitled 'The WEIRDEST people in the world'.[29] From within the behavioural sciences, Henrich questions many commonly held assumptions about base-level cognitive mechanisms that have been put forward in the psychological literature. WEIRD stands for White European Industrialised Rich Democratic; Henrich *et al.* point out that a great many supposedly universal human cognitive mechanisms have been derived from studying a small and probably outlying group: American undergraduates majoring in psychology. Their work is based upon an exhaustive meta-analysis of cross-cultural studies that reveal that WEIRD subjects, far from being representative of the population at large, are outliers in many areas. Even such apparently base-level functions as visual perception can be strongly encultured. Such critiques within the discipline might also implicitly invite literary, performative and historical contributions to questions within the cognitive sciences. Historical and discipline-specific work too could help to tease out

the relationship between underlying relatively stable cognitive mechanisms and social cultural and historical particularities.

One possible example is the work of the psychologists Tony and Helga Noice, who have been studying the nature of actors' memories for many years, and are indeed among the very few seriously researching this question. The Noices have conducted ambitious and valuable qualitative studies of the memorizing techniques of contemporary professional actors. One of the real strengths of their approach is to design experimental models that make use of the expertise of trained actors, rather than relying upon studies using only novices drawn from the university student population easily available to experimenters. This method allows them to study memory in an 'ecological' way, outside of strict experimental conditions.[30]

Despite these strengths, limitations of the Noices' research remain, at least when seeking to extrapolate their conclusions to historical situations remote from contemporary theatre. They construct a 'general model' of acting cognition, arguing that actors remember not by verbatim memory practices, but by scanning the text carefully for beats of goal-directed dialogue and elaborating the lines in search of clues to motivation and ways to turn the dialogue into action. These are valuable conclusions, but the Noices do not fully acknowledge the extent to which the actors they study are embedded in very specific and historically situated material and social circumstances, entirely remote from, for example, the heated and time-pressured demands of the early modern playing system. Though such techniques may seem to be intracranial, they in fact depend upon a vast array of material and social practices. Moreover, the material practices are supported by social practices and modes of professional organisation, such as the hierarchical relationship of actors to directors; the demands of the technical elements such as sound, set and lighting; the search for novelty in staging classic plays; employment insecurity and the relative rarity of established companies that promote familiarity with fellow actors; the existence of competing methods of rehearsal and play preparation, which may require the actor to adopt unfamiliar practices in a new production; and so on. Lack of knowledge about how the contemporary theatre differs from that of the early modern period causes psychologists to confuse a particular set of practices with a general cognitive mechanism.

The model of Distributed Cognition or cognitive ecology that we prefer sees cognition as spread across more or less internal mechanisms such as attention, perception and memory; objects and environments; and other people.[31] These disparate resources are coordinated, in any one particular case, in ways that cannot be specified in general or in advance. As Lawrence Shapiro writes, summarizing Esther Thelen's position, 'cognition is embodied

insofar as it emerges not from an intricately unfolding cognitive program, but from a dynamic dance in which body, perception, and world guide each other's steps'.[32] Likewise, Andy Clark's enormously influential book about embodied and distributed cognition, *Being There* (1997), began from the claim that 'brain, body, and world are united in a complex dance of circular causation and extended computational activity'.[33]

Performance theorists may be pleasantly surprised to find dance thus in place as a guiding metaphor for certain approaches in cognitive science. But, as with the generic invocations of 'embodiment' we mentioned above, such abstract references to movement and dance need to be fleshed out in richer studies of particular skills and practices.[34] Some work closely related to the distributed cognition framework addresses the nervous system as a way of avoiding both the body-brain and the self-world divides. In developing the idea and methods of 'neuroanthropology', for example, Greg Downey studies culturally diverse forms and practices of balancing, inverting the body, or throwing in the context of specific practices such as capoeira and rugby.[35] Indeed it is striking that, in addition to the recent wave of inter-disciplinary work on neurocognitive and neuro-aesthetic approaches to dance,[36] ethnographic methods have come to take central importance in recent work on performance, dance and movement in the cognitive sciences, broadly construed.[37] As well as studies which also draw on phenomenology and dynamical systems theory, we would single out a research programme carried out by David Kirsh and his colleagues, in conjunction with the chore-ographer Wayne McGregor and Random Dance. A pioneer in the theory and methods of distributed cognition and cognitive ethnography,[38] Kirsh and his team collected extensive video, observational and interview data with all participants in the creation of a new modern dance work. Among a rich and impressive array of analyses and results, Kirsh and colleagues argue that dancers and choreographers are literally 'thinking with the body'.[39] As in many other flexible and intelligent human activities, the actions of dancers and choreographers are 'mediating structures' which transform their cognitive tasks and processes. For example, picking up on clues from interviews in which dancers would physically sketch out or 'mark' partial aspects of a movement phrase, Kirsh and colleagues observed and taxono-mised all the instances and roles of such practices of 'marking' in rehearsal. They went on to design ingenious experiments which demonstrated the surprising result that, for expert dancers, such bodily sketches of movement phrases are not only more advantageous than mere mental simulation in helping the learning of a phrase, but are as good as full-body practising. But in using less detail than in a full practice, dancers not only conserve energy, but also set up a kind of partial model or 'surrogate situation', in Andy Clark's

term, which allows them to focus or work on some specific feature of the movement sequence by minimising the level of nonessential detail.[40] In such physical representation, Kirsh and colleagues argue, bodily movements are themselves the vehicles of thinking rather than mere external supplements to it or reminders.

As a method for tapping the complex dynamics of distributed cognitive ecologies, then, cognitive ethnography offers a promising framework for mediating between the cognitive sciences and concrete studies of performance in specific cultural settings. We hope and expect to see performance theorists and cognitive scientists alike increasingly willing to invest the time, energy and commitment to open exchange of methods and ideas that will bring such projects to wider attention.

The chapters in this section explore a variety of partnerships between performance and cognitive science, demonstrating the different steps and choreographies of cross-disciplinary dances. In two of the case studies, dance is the form discussed in projects which bring together neuroscience, cognitive psychology, performance theory and practice to explore thinking bodies and enactive minds. While the couplings here also demonstrate some of the complexities and tensions involved in the first steps of bringing performance and science into dialogue, they also illustrate the potential for these interactions to be mutually beneficial, conceptually and methodologically informing each other.

The first account by Matthew Reason et al., discusses the 'Watching Dance' collaboration between neuroscience and dance research. The challenges of interdisciplinary modes of working are a focus of discussion and the importance of developing shared understanding of methodologies and vocabularies. Anna Furse's chapter also features a dance-based inter-disciplinary collaboration between two ex-Royal Ballet trained dancers, sound and video artists and a professor of Comparative Cognition. 'Our Informed Hearts' explores memory and identity through practice-based research informed by neuroscience. The literal and metaphorical dancing in this chapter, makes contact with other theoretical perspectives, reaching out to psychoanalysis as Furse draws upon physical and sensual experience in conjunction with a Bruno Bettelheim story to bring minds and bodies together. The body is also centre stage in the final chapter by Erin Hood who considers the potential of performance to represent the intangible through its physical, visceral and sensual modalities. Taking her cue from Elaine Scarry's oft cited claim that 'to have great pain is to have certainty; to hear that another person has pain is to have doubt', Hood suggests performance offers a middle space in which perceptions and representations of pain can be played with, thereby offering form

and substance to the neuroscientific theorisation 'we change pain as pain changes us'.

Taken together, the chapters in this section respond to many of the challenges we have raised in their dances with science, bravely taking some first bold steps towards new interdisciplinary methodological and theoretical approaches. This is an experimental choreography creating openings for the 'exchange of methods and ideas' we have called for.

Researching Dance Across Disciplinary Paradigms: A Reflective Discussion of the Watching Dance Project

Matthew Reason, Dee Reynolds, Marie-Hélène Grosbras and
Frank E. Pollick

Although sometimes conceptualised as, in C. P. Snow's famous description,
two cultures divided by both ideology and disposition, collaborations
between the sciences, social sciences and humanities are neither new nor
rare. Yet it still seems justified to suggest that in the field of academic
research there has been a recent upsurge in range and prominence of these
collaborations, motivated by growing interest from both sides of the divide,
and covering a range of relationships, interactions and objectives.

This chapter uses the experiences of one such collaboration, to explore
and discuss the opportunities and tensions of cross-disciplinary research.
The example is the Watching Dance: Kinesthetic Empathy project, which
ran from 2008–11 and was a cross-disciplinary project designed to inves-
tigate how spectators respond to and identify with dance. The authors of this
chapter are indicative of the disciplinary range of researchers involved in the
project, having backgrounds in performance studies and audience research
(Reason), dance studies (Reynolds) and cognitive neuroscience (Grosbras
and Pollick). At different points the project also collaborated with chore-
ographers and performers. Between us the three-year long collaboration
involved many insights and opportunities, but also experiences of cross-
disciplinary misunderstanding and frustration. Discussion in this chapter
engages with both the challenges and successes, in considering and exposing
the sometimes messy practice and compromise of collaborations that seek to
work across different research paradigms.

Arts and humanities/science collaborations

Cross-disciplinary collaborations come in many forms, and while presenting the Watching Dance project as an example we are not suggesting that it is illustrative of all such relationships. Indeed, collaboration while nominally about disciplinariness is also always about the interpersonal and therefore also always as much about people as it is about broader disciplines, paradigms or cultures. On our project, the fact that two of the neuroscience researchers were dancers (Corinne Jola and Anna Kuppuswamy) had a very significant impact in terms of developing a much more 'ecological' approach to the science research on dance. Before talking about this in detail, however, given the range of what is meant by cross-disciplinary research, it would first be useful to briefly situate the project against a broader context of arts and humanities/science collaborations.

The Watching Dance project was conducted with funding from the Arts and Humanities Research Council (AHRC) in the UK, which since 2009 has had as a key research funding theme titled 'Science in Culture' (although the Watching Dance project received its funding prior to this establishment of this theme). This theme

> aims to encourage mutual exchanges between the sciences and the arts and humanities that offer scope for developing new areas of research, methodologies, research frameworks, styles of thinking and/ or ways of working across the disciplines.[1]

The possible range of exchanges within such relationships is varied, and the extent to which they are 'mutual' or develop 'new' areas of research is often debatable. Perhaps the most common form of arts and humanities/science collaboration in this context involves arts practitioners being engaged (often through commission or funding) to assist in the public dissemination of science. Here the remit is often to make scientific knowledge accessible through the production of an artistic response to or representation of scientific findings. A prominent example of this within the UK would be the Wellcome Trust's Arts Awards, a funding scheme in their Public Engagement strand which aims to 'Support imaginative and experimental arts projects that create new artworks to investigate biomedical science'.[2]

Examples of work funded through this scheme include: a performance installation for children aged six to ten to explore vocal anatomy, the science of vocal sound and speech science; a sculptural installation created from white light sources developed in collaboration with psychiatrists specialising in the treatment of seasonal affective disorder; and a documentary film exploring the experience of renal failure, the science and pressures of diet restrictions, and the tension between home and hospital life.[3]

In examples such as these the scientific research and knowledge can be considered as the subject or content of the collaboration, with arts practice being in a sense the 'methodology' of representation and dissemination to a non-specialist public. The particular nature of the arts methodology in this context is fluid and ambiguous, a form of arts practice informed by experience of working with particular materials or media and by the informed but often intuitive 'reflection-in-action'[4] of the artist.

A second broad form of arts and humanities/science collaboration could be schematically characterised as the reverse. Here scientific method is employed to investigate some aspect of the arts. Writing from within the context of the Watching Dance project it is unsurprising that our greatest awareness of this is of cognitive scientists' increasing interest in using dance as a stimulus.[5] Members of the Watching Dance team also edited a Special Issue of *Dance Research* titled 'Dance and Neuroscience – New Partnerships'.[6] The norm in such cognitive science studies is for the scientific discipline to provide the methodology, the way of doing, while the arts are now the object of study. Or, often more accurately, the arts provide the stimulus material to investigate a more narrowly defined phenomenon.

The specifics of the scientific method employed obviously depends on the particular context, but the principles of scientific methodology are generally regarded as being grounded in the pursuit of empirical, measurable, objective, replicable and falsifiable data about the world around us. In terms of epistemology the scientific method is predominantly positivist, contrasting with the experiential or practical knowledge employed by the arts practitioner. At the same time it is worth questioning the easy assumptions of binary distinctions. Christopher Frayling, for example, describes how laboratory or experimental practice in the sciences involves the use of tacit knowledge, crafts practice, imagination and 'negotiating reality rather than hypothesizing about it' in a manner that would resonate with an arts practitioner working experimentally in a studio.[7]

There has been a significant growth in science research on dance over the last decade, motivated from within both the scientific and dance communities. The motivations for this are many and varied, including the development of technology, such as motion capture, that has increasingly allowed scientists to capture and analyse the whole body actions as typified by dance, although the extent to which the tools have determined the nature of these questions is a significant issue here. Even with the development of new scientific technologies there is a kind of technological determinism involved, whereby what is researched is determined by what can be researched, which in turn determines the questions asked. There has also been growing scientific interest in the areas of embodied cognition

in psychology and social neuroscience. These trends have made dance a relevant object of study, through which to explore questions of the significance of the body in how we perceive others and how the presence of others influences our actions and perceptions. For scientists dance provides access to individuals who can be considered as 'expert' in producing movement and in thinking about movement and is therefore a natural partnership. In these contexts scientists are often interested in dance primarily as a vehicle for studying specific types of movement rather than as an art form more holistically. The question of what neuroscience offers dance, and in turn what dance offers neuroscience, is an issue explored in greater depth in the *Dance Research* special issue.[8]

While in many ways a natural partnership, one tension is that while strongly motivated on both sides the nature of this motivation is not necessarily the same. From a dance studies perspective the interest is largely in the whole physical and cultural phenomenon; while science tends to be motivated by clearly defined questions and is also methodologically required to segment that whole into ever more identifiable components. While arts and humanities researchers are often driven to ask large questions at meta levels, at its core the scientific approach breaks complex things down to simpler problems that can be examined with precision. This is a fundamental element of the scientific methodology but one which can be perceived as reductionist. Science needs to be replicable, so even the most complex stimuli need to conform to experimental designs that can at least satisfy the condition that you would get the same data if you repeated the experiment. In arts and humanities/science collaboration this requirement to reduce the variables, and to eliminate chance and change between iterations can be problematic for theatre and performance practitioners.

The issue, of course is that outside of the laboratory, phenomenon can rarely be so controlled or isolated. It is consequently not always clear what the relationship might be between the small/local/specific event in the laboratory and the fully complex and less controlled conditions experienced in the real world. One example is one of the seminal pieces of neuroscience research on dance, Calvo-Merino's fMRI study on 'expert' ballet and capoeira dancers. This is a landmark piece of research and one of the inspirations for the Watching Dance project and yet from an arts perspective it was almost shocking and jarring to discover that what was called 'dance' in the research were extremely short (three-second) recordings. It would be an over-simplification to say that everything came down to this, but one of the recurring debates on the Watching Dance project became about duration. One outcome of our discussion on this point was that the neuroscience researchers on the project were motivated to confront the methodological

complexity of looking at longer stimulus material. This presented many challenges, particularly in terms of interpreting the findings within the context of existing neuroscience literature. In many ways in terms of developing methodologies one of the enduring benefits of the project was giving up on the 'short clip' approach, which forced examination of what can be done with other methods in brain imaging analysis that can use extended displays.

In considering these two broad types of relationships between the art and sciences in research, it is worth noting that neither fundamentally challenges the two cultures division at a paradigmatic level. In each relationship there is a clear division between object of study and methodological approach, which is seldom blended. It would be possible to argue that arts and humanities/science collaborations are often instrumentalised, with the art 'illustrating' the science to the public or science 'proving' a disputed thesis. The key epistemological paradigms of what constitute knowledge or expertise or methodology within each discipline remain unchallenged: art remains art and science remains science with neither paradigm fundamentally challenged.

One of the key interests, and indeed, challenges of the Watching Dance project was that it sought to go beyond these models of arts and humanities/science interaction and collaborate on a level that began at the point of project design, which included discussion on what constituted the object of study and that engaged in methodological dialogue, compromise and collaboration. Indeed, this chapter suggests that the easy part of cross-disciplinary collaboration is engagement with subject matter; the far more challenging element is engagement with methodology, as methodology implies an epistemology.

Through this process we at times developed relationships that might be termed inter-methodological, that is where contrasting methodological approaches are put into dialogue with each other in a manner that has implications on both pragmatic and conceptual levels. Inter-methodological research begins to truly challenge disciplinary boundaries, by not just putting different 'cultures' into dialogue but also raising (implicitly if not explicitly) questions about the nature of knowledge. This can be truly paradigm challenging and therefore can prompt responses ranging from confusion to rejection and derision from locations within either paradigm. Some of these we discuss later in this chapter.

A fundamental danger of inter-methodological research is that while it might be very specific and defined in its approach, it might still be perceived as somehow incomplete and inadequate when viewed from within strict disciplinary boundaries. By their very nature such collaborations are riskier;

treading new territories potentially challenges established and invested positions held by individuals and institutions – including university departmental structures, funding bodies and journals. In a time and resource-finite world, research that is facilitated by established funding agencies and publishers, and acknowledged by institutions (through promotion mechanisms), is going to be more popular. From the experience of the Watching Dance project we would suggest that funders are keener to support inter-methodological research than journals are to publish it. This is perhaps because while funding agencies have a remit to support new research and break new, potentially risky ground, journals are often tied to specific fields and have an implicit agenda to categorise and define that field, a process enforced by exclusion as much as inclusion.

The Watching Dance project has a particular interest here, as in its conception it did not sit within either of the two broad arts and humanities/science relationships described above. Instead, by employing approaches taken from the sciences, the social sciences and the arts in a concurrent manner it sought to be not just inter-disciplinary but also inter-methodological. In this it was not necessarily always successful, with research sometimes taking place in parallel rather than in a braided fashion. The project sought to explore and analyse a particular way of experiencing dance (kinesthetic empathy) by using disparate methodologies and by seeking to combine them. However it also aimed to do this in a way that engaged with how dance is experienced as an art form rather than as an artificially constructed laboratory equivalent. In part the challenge of the project was that this approach implicitly challenged normative forms of thinking for all concerned, even if this sometimes happened only in the moment, before we all returned to our own domains and normal service resumed. Here it is worth thinking a little more explicitly about what this involved in terms of collaborative practice.

Collaborative models

The Watching Dance project was cross-disciplinary from the start, as it involved using neuroscience techniques to explore dance spectators' neuro-physiological responses alongside qualitative social science models and more intuitive and philosophical engagement from dance studies. Beyond the specifics of cross-disciplinary research the project therefore involved collaboration, a fundamental but often overlooked element of any project involving multiple partners and participants. Indeed, what is striking in retrospect is that we entered into the project without a clear sense of what

it meant to collaborate across and between disciplinary boundaries, and without established models to follow.

In her book, *Creative Collaboration*, Vera John-Steiner writes:

> the achievement of productive collaborations requires sustained time and effort. It requires the shaping of a shared language, the pleasures and risks of honest dialogue, and the search for common ground.[9]

This, of course, is the case in all collaboration, but is particularly so in cross-disciplinary collaboration, where sometimes language and terminology can be very partisan and common ground can be contested. What is interesting is that John-Steiner's language about collaboration often entails increasing levels of merging of the individual or the particular into the shared or the common. This is the case of the movement from individual to collective authorship: where the I is submerged into the we and us; something that is perhaps even more fraught in disciplinary terms.

Here it is useful to review John-Steiner's taxonomy of forms of collaboration. The first is 'complementary' collaboration, which involves a clear division of labour driven by overlapping (but not necessarily identical) values and objectives. This is a discipline-based approach, and the form of collaboration which is the most common in arts and humanities/sciences engagements. It could be described as parallel processes of multi-disciplinariness in which the scientists do the science and the artists do the art. It is relatively safe, involving limited amounts of compromise and without fundamentally threatening disciplinary paradigms. John-Steiner's other models of collaboration increasingly problematise this relationship. From 'distributed' collaboration, which she defines as informal and voluntary collaboration motivated by similar interests and characterised by spontaneous and responsive working methods, to 'integrative' collaboration where roles are braided, and 'family' collaboration where roles become entirely fluid and an entirely shared sense of vision and trust is developed. A nicely evocative description of this is by Deleuze and Guattari, perhaps referring to their own collaborative processes, when they write of the ambition 'To reach, not the point where one no longer says I, but the point where it is no longer of any importance whether one says I. We are no longer ourselves. Each will know his own. We have been aided, inspired, multiplied.'[10]

In these latter forms of collaboration notions of individual authorship start to fall away to be replaced by a shared vision. Each of these levels of collaboration involve ever increasing levels of commitment and investment. John-Steiner's models of collaboration can then be usefully mapped onto disciplinary research practices and increasing levels of integration from multi-disciplinary practice (John-Steiner's 'complementary' collaboration),

to cross-disciplinary (where a greater shared vision produces a more 'distributed' form of collaboration), to inter- and trans-disciplinary practices which are increasingly 'integrative'.[11] In the context of disciplinary collaboration these also see the radical transformation of any sense of discipline – which would no longer be itself in Deleuze and Guattari's terms – to the extent of the construction of a new paradigm.

Of course each of these increasingly invested forms of collaboration runs, as John-Steiner notes, increasingly high levels of risk. That is risk of failure in the research and rejection or exclusion from established institutional, funding and publication practices. At the same time it is possible to argue that limited forms of collaboration, which John-Steiner terms complementary collaboration, might actually reinforce rather than challenge disciplinary divisions by confirming differences (in skills, outlooks, languages, etc.) as prescribed limits to integration.

The Watching Dance project was initiated with a shared set of research questions and therefore, in a sense, a shared goal. However, reflecting honestly, there was no pre-established clear conceptualisation about how to connect our different ways of investigating these shared goals or of what form of collaboration we were attempting. The result was that established skills, knowledges, but also positions within particular departments and geographic locations, produced a form of dispersed collaboration interspaced with moments when these were braided in the attempt to enable inter-methodological operation. These latter moments being a far more radical and disruptive act that perhaps required far greater levels of investment and commitment than we were always able to provide.

Case study

In order to illustrate and engage with these ideas further we will present a summary of a particular example of research carried out in Glasgow, 2009. This raised pragmatic issues of how to share working methods and theoretical issues of differing methodologies/epistemologies.

In this piece of research we wanted to see if spectators with more experience of watching a particular dance style had a different or stronger response in terms of kinesthesia and/or empathy. We chose ballet and bharatanatyam as examples of dance styles with clearly defined vocabularies. Spectators watched two dance pieces (which at four minutes each were long in neuroscience terms and short in dance terms) and one acted piece as a control (also four minutes).

As a putative neural correlate of kinesthetic empathy we measured how much the motor cortex of the spectator gets 'engaged' or 'primed' when they watch the performance and how this relates to their experience. We know that the motor cortex responds to watching as well as performing movement and so we expected to find a significant difference in the cortical excitability of the hand/arm areas when watching relevant movements. Excitability in this context means degree of readiness to stimuli of neuromuscular pathways. We also hypothesised that experience of watching ballet and/or bharatanatyam would impact significantly on spectators' responses and that spectators with more experience of watching the dance forms in question would show stronger indicators of kinesthetic empathy.

For the neuroscience we applied isolated pulses of transcranial magnetic stimulation (TMS is a way to non-invasively stimulate a set of neurons) over the motor cortex while spectators watched the live performance and measured the response in their hand and finger muscles using electromyography. The higher the response the more the motor cortex was active at the moment of stimulation. As bharatanatyam involves more fine finger movements and ballet more movements of the hands, we expected to observe a stronger effect in the finger motor area for bharatanatyam and in the hand area for ballet. Moreover we expected these effects to be much stronger for the experienced spectators.

For the qualitative audience research, we interviewed all the participants for approximately 30 minutes, with a semi-structured format. Much of the interviews were designed to elicit participants' 'talk' in an open and free flowing manner. However at times more directed or particular questions were asked. In particular we allowed ourselves to ask questions that were evocative and even playful. For example we asked all the participants a question phrased in the following way:

> This next question might not make sense, in which case just say it doesn't and we'll move on. But if I was to ask you to locate the experience in a part of your body – for example, is it a head experience, a heart experience, a tummy experience, a left toe nail experience and so on – would you be able to answer that?

From a science or social science perspective this is perhaps an overly leading question and it is certainly not unproblematic. In referencing this question in a cross-disciplinary paper submitted to a science journal it was criticised by one of the anonymous peer reviewers who described it as perhaps the most ridiculous and nonsensical question they had ever come across. Its intention, however, was again to elicit talk, this time in a playful and provocative manner. It also hoped to invite participants to reflect consciously and

actively on their experience. To actively think about what they had experienced and try and make a kind of sense of it. Tellingly participants largely had no trouble answering it.

The conducting in parallel of qualitative audience research and neuroscience research, therefore, required us to consider the relationship between spectator experience as articulated in dialogue post-hoc and cortical excitability at time of watching (which doesn't necessarily correspond to a conscious experience; spectators are not aware of their motor cortex being activated, as they don't move). An implicit but important question was therefore whether neuromuscular response as measured by TMS corresponds to subjective experience as elicited through talking in interviews, a question we'll talk about specifically in a moment.

Left to our own devices, both disciplines would have approached this study differently and ended up with results which would have been difficult to compare. As already discussed the scientists would have shown extremely short dance video clips (rather than a live performance) in much more controlled conditions. Both these elements have lead to challenges when submitting this research for publication, with the live nature of the performance meaning that movements could not be repeated absolutely identically between one repetition and another. Therefore the TMS pulse could not be time-locked to a specific movement in a reproducible manner across participants. The audience researchers would have talked to people about live dance performances programmed in theatres and which felt less like an artificial experiment. A fundamental issue here is in the degree of control over the viewing conditions which is needed for the neuroscience, which conflicted with the audience researchers' desire for a viewing situation embedded in social and cultural contexts. Both conceptually and logistically it was very difficult to construct a situation acceptable to both parties but in the end a compromise was reached.

Qualitative audience research adapted to neuroscience requirements by moving out of a theatre context and working with specially choreographed pieces to facilitate TMS in terms of time span (short pieces) and upper body emphasis. Neuroscience adapted to 'natural' viewing context – live performance, long sequences, two participants tested together – in order to at least approximate to theatre conditions.

The bharatanatyam piece was choreographed and performed by one of our team members, Anna Kuppuswamy, who is a trained bharatanatyam dancer. This was a mime piece: a popular 'padam' from the traditional repertoire describing the god Krishna's childhood pranks. The ballet sequence was a concatenation of three fairy solos from the Royal Ballet version of *Sleeping Beauty*: 'Breadcrumb Fairy', ' Enchanted Garden ', 'Lilac Fairy', and one mime

part from 'Lilac Fairy'. This was choreographed by another team member, Corinne Jola, in consultation with choreographer and dance scholar Seon Hee Jang from Sejong University, Korea and performed by a professional ballet dancer, Kimberly Lawrie.

Because TMS is best at reacting with brain regions that control the upper part of the body, the choreography emphasised movement in the torso and arms. Also elements of narrative and mime were included in the ballet in order to have some similarities with the bharatanatyam.

Broadly speaking, therefore, we reached a consensus as regards methods in terms of pragmatic approach. However, in terms of what data our methods gave rise to, and how we then approached this data methodologically, differences of a more epistemological nature emerged. To what extent were we looking at the same thing pragmatically but different things conceptually? Here we need to discuss the different forms of data we produced and how we approached analysing it.

In terms of the physical form and scope of the data, the audience research produced circa 120,000 transcribed words from 32 interviews. With this data we were clearly engaging with verbal accounts, which were produced in the context of one-to-one, semi-structured interviews where participants talk about their experience from the position of reflective consideration and conscious meaning making. In analysing this data we were therefore not necessarily accessing the spectators' 'original' experience of watching the dance in the moment in which it happened and were aware that the process of reflection and conversation impacted on what was said and how the memory of the experience was constructed.[12]

We used the software package NVivo to devise categories ('nodes') to facilitate analysis, starting off with nodes which were anticipated through our research questions such as 'familiarity' and 'unfamiliarity', 'connection to dancer', 'desire to move', 'embodied response'. However, close reading of the interview material also prompted us to add new categories, such as 'admiration of virtuosity', 'evaluation of quality' and even 'can't remember'. The latter was because lack of familiarity or understanding sometimes made it difficult for participants to take in or remember much of what they had seen. Another category that we added was 'motivation' as it became evident that what the participants were looking for in a dance performance had a huge effect on how they responded to what they saw. This impacted on our understanding of the original research questions.

We approached the interview data as providing 'thick' description of which we asked questions: how can we learn from this? What might we find out that could influence our initial premises/questions? We were open to refining our research question in the light of what emerged from the

interviews and in particular were actively concerned in refining our concept of kinesthetic empathy at a meta level in the light of this data – something that emerged as a subtle difference with the neuroscience research.

Indeed, from a science perspective a precise and a priori definition of kinesthetic empathy is of key importance to the research efforts. The issue is that the neuroscience has to be able to tie this to a measurable phenomenon. To demonstrate that the concept of kinesthetic empathy was useful, and not just a label or an ad hoc description, we need to be able to argue that our explanation of it had predictive value. Predictive means that from the definition of kinesthetic empathy one can either deduce unknown phenomenon or at least infer them. While over a series of experiments neuroscience can refine concepts, any one experiment is necessarily locked into testing a particular view. So, for example, the TMS experiment described above was looking for neurophysiological activity while watching that was similar to that which takes place while doing; with this connection being taken as (or as an approximation of) kinesthetic empathy. However, from an arts or philosophical approach there can be a schism here between the sharply defined phenomenon – here how particular regions of the brain respond to watching movement – and the aesthetic concept of kinesthetic empathy that exists not only within that phenomenon but also within culture and within discourse. In the arts research, therefore, there was a more discursive understanding of kinesthetic empathy as a concept shaped by language and culture going both backwards in time (e.g. influenced by the philosophical traditions of the term) and forwards as the research process impacted on our understanding of its object. Whereas in the neuroscience approach this (the object of research) appeared to be taken more as a given.

The neuroscience research ended up with 30 measurements taken during each dance condition and 45 taken during rest, for each of the 32 participants. Each measurement consists of a 120 ms long recording which we can plot as a graph of amplitude of muscle activity against time. The motor response, or motor evoked potential, occurs approximately 20 ms after the TMS pulse and appears as a sharp peak in the amplitude trace.

For the TMS data analysis starts with cleaning the data and excluding trials where the signal is not interpretable (because of electrical noise, participant movements, etc.). Then in this study the peak amplitude was measured automatically and averaged across the remaining trial within each condition. Therefore we obtained one value (mean MEP amplitude) per condition per participant. Then these values were averaged across participants in each group and we used statistical tools to compare the conditions across groups, i.e. within each group was there a difference between conditions? Was there

a difference between groups? To answer these questions we considered the average as well as the variance across participants.

Case study analysis

The TMS study showed that ballet spectators had stronger engagement of their motor system when watching ballet as compared to the other performances. In connection with the TMS study, participants were asked to rate retrospectively the level of enjoyment they experienced during each performance on a 1–7 scale. We observed that experienced ballet spectators rated ballet significantly higher than the other performances. In the other group of spectators we did not observe such a clear-cut pattern. We had expected the expert bharatanatyam spectators to show stronger engagement during the bharatanatyam performance, but this was not the case. One explanation of this is that due to difficulties in recruitment in participants our expert bharatanatyam spectators were less 'expert' than our expert ballet spectators. Furthermore, across all the participants we observed a positive correlation between the level of enjoyment and the motor response. Participants who reported enjoying the performance more also showed higher cortical excitability (see Figure 3).[13]

Looking broadly at the audience research, we also found a positive correlation for experienced ballet spectators with three nodes that we identified as key for kinesthetic empathy (desire to move, connection to dancer and emotional response). These were significantly more numerous in experienced rather than novice ballet spectators.

In terms of 'thick' description and also relating to wider audience studies research, we were also drawn to look at kinesthetic and empathetic responses not in isolation but as part of a network of factors which motivate spectators to watch dance and influence what they enjoy and why. It appears that kinesthetic empathy is indeed an important factor in audiences' 'pleasure'. For instance, spectators with lower levels of enjoyment made fewer references to their desire to move, their connection to the dancer, and their emotional response. The majority of experienced ballet spectators (6 out of 10) expressed high levels of enjoyment from the ballet and their responses frequently came into the categories (Nvivo 'nodes') of desiring to move, feeling a connection to dancer, and having an emotional response. By contrast, people who enjoyed the performance less made few references to these categories.

Consciousness: The value and challenge of talking to people

Early on in the Watching Dance project we hosted a cross-disciplinary forum where we sought to present our methodological approaches to an audience consisting of cognitive scientists, arts and humanities researchers and dancers/choreographers. During this event one exchange served to highlight some of the cross-methodological challenges, particularly, as discussed above, the relationship between subjectively reported experiences and data gathered through neuroscience research.

During the forum we presented some initial reflection on material gathered from interviews and participative workshops held with dance audiences. During this we discussed how the methodology was formed by a core interest in researching the 'experience as considered important by the spectators themselves'.[14] Among the reflections in this early stage of the process were a number of questions about whether kinesthetic empathy was something individuals experienced consciously or reflectively as well as in the moment of the experience through embodiment. For example we explored how some participants described particular movements in detail, loading them with meaning (sometimes emotional, sometime connotative) and asked whether this seeing, identifying and investing in movement was a marker of kinesthetic empathy.

It would be fair to say that this data was inherently ambiguous, with a 'natural' fuzziness that goes with complex lived experiences and the use of language in a context not controlled by a set experimental framework. In the discussion about this, one of the invited participants from cognitive neuro-science commented that although fascinating this material was meaningless as individuals have no privileged access to their objective experiences. Essentially this echoes a widely held view in the sciences that often what people tell you about what they see, remember, experience, etc. is influenced by social and other factors. Not least to influence and suggestion from the researcher themselves. As a consequence there is a certain scepticism, not from the scientists working on the project team it should be said, towards the value of listening to what people tell you.

At the same time through the course of the project we became increasingly interested in the possible connections between analysis being produced through neurophysiological research and through audience research. In particular we were interested in moments when the different strands of analysis provided similar perspectives upon the same elements. One of these is the example presented in the case study above, where experienced

ballet spectators showed distinctive characteristics when watching ballet in both the neuroscience and qualitative research. We speculated that this may indicate commensurability between subjective experience and its 'neural substrates' that merits further exploration.

Another instance is from an occasion when the project team again worked together (inter-methodologically, as well as cross-disciplinary) to develop a situation where neuroscience, audience research and reflective practice methods could operate closely together. In this instance we commissioned choreographer Rosie Kay to produce a short performance in which the same movement sequence was performed to different soundscapes (electronic, Bach and no music). Our objective with this was to set up the circumstances in which both neuroscience (through a video recording made of the performance) and audience research (through audience participants) could explore the relationship between sound and spectators' perception of dance movement.[15]

Here we employed the technique of functional magnetic resonance imaging (fMRI) to measure brain activity while participants watched those four-minute long videos. We observed that during the section without music (when only breathing and footsteps are audible), compared to the music conditions, there was increased synchronisation among observers in the parietal and occipotemporal cortex, brain regions that are known to be engaged in relation to body movements perception, suggesting the possibility of a greater influence of the body. What was striking was that this suggestion was supported by the audience research, which through analysing audience members' self-reflective conversations found evidence of similar corporeally focused experience and a heightened sense of the physical presence of the performers. We described this in terms of the breathing section triggering a shift from a predominantly visual mode of perception to experiencing a proprioceptive sensation or body-to-body affect.

In addition, however, the audience research also suggested that the impact of this greater corporeal sense of perception – including a greater sense of their own body, as well as that of the dancers – was articulated both negatively and positively by different spectators. Often the nature of the experience of the breathing section was described in very similar language, but the evaluation of whether this was pleasurable, whether it was enjoyed or disliked, was very different. For some spectators this proprioceptive or contagious body-to-body affect was an important element of the kinesthetic empathetic experience of dance; to others it disrupted the visual experience and pleasure of grace and flow. This divergence in evaluative/emotional engagement with the breathing section is not something that it was possible to comment on from the perspective of the fMRI data. Speculatively,

therefore, the intersubject correlation revealed by fMRI was accompanied by a parallel, and not uniform, process of aesthetic or experiential evaluation.

In terms of scientific understanding of the potential of reading qualitative insights alongside quantative analysis, there is some appreciation of its value, particularly in relation to complex stimuli. McKinlay, McVittie and Della Sela, for example, state that 'qualitative forms of analysis might provide clinical pyschologists with additional means of making sense of their data'.[16] In other words if you are studying complex stimuli the listening to what people tell you provides you with some confirmation of interpretations of the data objectively measured as well as providing insights and inspiration for future research. This might include instances of confirmation, as in the Watching Dance project, but also and perhaps less obviously, moments where what people say isn't consistent with the data. Here the challenge for scientific researchers is not to dismiss this inconsistency as irrelevant due to the unreliability of qualitative methodologies, but instead to engage with the material and possibility complexity of the nature of the experience being researched.

Concluding remarks: Collaborative and disciplinary research

Within the Watching Dance project the nature of the data produced and also the techniques available to us to analyse were radically different in the neuroscience and audience research. This was particularly because while utilising social science methods the audience research was conducted from within an arts tradition that also drew upon theoretical and conceptual discourses in dance and performance studies. These differences in themselves construct different epistemological frameworks which drive responses and approaches, and this is where it becomes more difficult to connect across disciplines.

From within the performance studies community one of the most prominent and forceful advocates of the need to engage with a cognitive science approach in arts research has been Bruce McConachie. In criticising his own discipline for having historically largely ignored the sciences, McConachie argues strongly for a movement in arts research away from what he terms 'master theorists' (consider here a list of canonical thinkers from Barthes to Foucault to Marx) whose ideas have dominated the arts in the late twentieth and early twenty-first centuries. For McConachie these theorists are inherently problematic as they are not epistemologically coherent and not methodologically falsifiable: 'what experiments or logics,'

he asks 'would the master theorists accept as a basis for the falsifiability of their ideas'.[17] McConachie advocates instead a movement in arts research away from 'its reliance on largely a-scientific theories, to theories that have undergone the rigorous evaluative procedures of good science'. McConachie's forceful advocating of greater engagement with the cognitive sciences is something that the Watching Dance project obviously and actively supports. However, we would want to add more weight to his passing recognition that a-scientific theories can 'extend the explanatory range of our [scientific] discussions and conclusions'. In particularly it is essential to acknowledge the vital presence, in a truly mixed-methodological ecology, of approaches and perspectives that challenge the absoluteness of the positivism paradigm.

The arts absolutely must engage with the methods and methodologies of scientific research, and not just in the cognitive sciences. However, while working in parallel across disciplines (that is multi-disciplinary) is relatively straightforward, it is more challenging to think outside and beyond and across disciplinary boundaries in a manner that is truly cross- or even trans-disciplinary. There is, in this context, something more valuable in Amy Cook's description of how 'performances studies should not simply "use" research from the sciences to "validate" our theories' and that arts researchers should not 'abandon the authority of our knowing'.[18] Maxine Sheets-Johnstone is another performance researcher who engages very actively with cognitive science while advocating that the conversations between the two should not be hierarchical or absolute: 'a veritably enlightening conversation between art and science will be found not in reductionism to the brain but in an exploration of dynamics inside and out, a natural engaged-in-the-world dynamics'.[19]

With the Watching Dance project we learnt to recognise the sometimes entrenched nature of our own disciplinary dispositions and try and work with knowledge of them, rather than denying their existence. As a team we felt it important to engage in collaboration and conversation where neither discipline was instrumentalised by the other, but instead aimed for a model between partners and where what matters is shared exploration of issues and questions.

Truthfully some of this we only understand after the event, when able to sit back and think and reflect and find patterns in what we did when at the time we were too close to the experience to know what the experience itself was. And that in itself might be an illustration of Sheet-Johnstone's dynamic lived-in-the-world conversation.

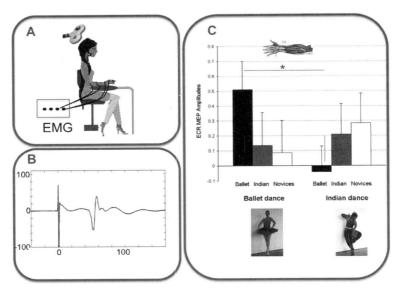

Figure 3 TMS study. **A.** Experimental set-up. Participants seat comfortably, with their arm rested, while they watch the performance. Electromyography (EMG) electrodes are attached to their right arm and fingers and connected to an EMG amplifier. Isolated pulses of TMS are delivered through a coil positioned over their motor cortex, that is the part of the brain that controls upper limbs movements. This induces a very small twitch detectable with the EMG. **B.** EMG trace obtained after a single TMS pulse. The strength of muscle activation is plotted, in microvolts, as a function of time, in millisecond. Time 0 corresponds to the stimulation (marked by an artifact). The activation, also called motor evoked potential (MEP), occurs 23 ms later. The amplitude of this response is an index of motor cortex excitability. **C.** Results. Averaged MEP amplitudes (normalised to amplitude at rest) for experienced ballet spectators (black bars), experienced Indian dance (bharatanatyam) spectators (grey bars) and novices (white bars), when they watched a ballet or a Indian dance performance. Ballet spectators showed significantly enhanced MEPs when they watched ballet as compared to Indian dance.

Retracing our Steps … On *When We Were Birds*, a work in progress

Anna Furse

Dance first and think afterwards … It's the natural order.
Samuel Beckett, *Waiting for Godot*, Act 1[1]

For the ancient Greeks, in a pre-printing age, memory was an art, a means by which to store human knowledge as elaborated in Frances Yates's seminal work *The Art of Memory*.[2] In the past two decades, memory studies have taken root as an interdisciplinary field of academic enquiry across many specialisms. Memory as a topic could not be but interdisciplinary – encompassing as it must the cultural, the individual, the social and political and the biomedical. By its very nature this must integrate disparate and diverse approaches, and thus memory studies today involve and include both the humanities and the sciences: literature and art as well as history, politics, media studies, geography, psychology and neurosciences.[2]

If the field of memory studies today is interdisciplinary, for the performance maker memory remains pragmatic – a *sine qua non* of praxis; for in order to perform a score, a text or a dance, the performer must have learnt and stored this knowledge in order to repeat it.[3] This occupational fact – the storage of action in the psychophysical memory of the performer – is key to the practice-based research project that forms the basis of this chapter. This project, with my production company Athletes of the Heart,[4] incorporates (*sic*) movement memory (and associated and tangential memories accessed by such action[s]) in order to grapple with understanding of certain behavioural phenomena. It draws on information about memory processes to which the fields of neuroscience as well as psychoanalysis might contribute perspectives on our central question: what happens in the act of retrieving a forgotten or atrophied learnt embodied action, that also carries with it emotional significance? We remain cautious in assuming a positivist outcome to such questions, and will insist on remaining open to all possible interpretations in considering not 'What is a body?' but rather

'What can a body do?'[5] Noting the increasing authority the neurosciences hold over the humanities, Blackman and Venn propose in their paper on affect, that the 'turn to affect' has particular importance for the field of body-studies. One consequence of the heightened interest in the non-verbal, non-conscious dimensions of experience is a re-engagement with sensation, memory, perception, attention and listening.[6] The body is here, and for our project, considered as a complex process rather than the either/or of a biological versus a social entity. Our project thus – and with *faux naiveté* even – embraces a range of possible explanations for the event that sparks our questions. It is interdisciplinary research that looks through several apertures into the subject matter so as to attempt to elucidate better *what is going on* in an act of specialist and skilled physical recall.

I write this during the early stages of a research into memory and dance by two women who have just reached 60 and who trained together at the Royal Ballet School in the 1960s. My collaborator Esther Linley and I lost touch in 1971 when I left to pursue academic studies and a theatre career while she went on to a professional career as a ballet dancer, playing leading roles in European companies. Typical of her political consciousness since childhood, she abruptly gave up ballet in 1982 following the Sabra-Shatila refugee camp massacre in the Lebanon by Israeli troops. She had lost faith overnight in the meaning of ballet as an aesthetic and as a form. In this crisis of faith, she quit tutus and moved into *Tanzteater*, founding Austria's first dance theatre ensemble, a form through which she felt able to speak about the world, engage with meaningful content, and still dance. By the time I met up with her after 20 years, following a Royal Ballet colleague's untimely death from AIDS/HIV in 1992, Esther was Head of Department for Contemporary Dance at Linz University, a respected choreographer and a key player in the Austrian cultural scene. On my way to Prague for a staging of my play about Freud and Charcotian hysteria,[7] we fell into each other's lives again. Our project – *When We Were Birds* – is a reflection of our re-encounter, and of the way we each think now and reconsider our past, our training, our bodies and our womanhood from our perspectives today. If it is a memory project, among other things it explores, through enfleshed recollection, the affect of growing up in the hermetic world of ballet while struggling to participate in the swinging sixties – 'chicks' striving to be swans.

When We Were Birds will be a performance/video installation. This is triggered at source by a Bruno Bettelheim story from his experience of the concentration camp Buchenwald *The Informed Heart*:

> Once a group of naked prisoners was about to enter the gas chamber [...]
> the commanding SS officer learned that one of the women prisoners had

been a dancer. So he ordered her to dance for him. She did and as she danced, she approached him, seized his gun, and shot him down. [...] isn't it probably that despite the grotesque setting in which she danced, dancing made her once again a person? [8]

Bettelheim's book is more than a memoir. It is a forensic examination of dehumanisation and how concentration camp inmates were coerced (indeed trained) to become collusive in their own disintegration through the systematic deconstruction of identity. The project to obliterate the entire Jewish identity attempted by the Nazis was cultural as well as racial genocide. Nazi 'techniques of power' (Foucault)[9] on a grandiose scale assumed that memory, personal and cultural, must be crushed out of the individual and community before any form of institutionalised dominance could be secured. Inmates were not only passive recipients of abuse and torture, but laboured as slaves, worked quite literally 'to the bone'. They massively outnumbered their captors. Mass obedience, and in some cases abject collusion, based on both fear in a brutal environment, together with the systematically enforced loss of any social/historical social context (families split, personal belongings and clothing confiscated, names replaced with numbers and so forth), were vital to maintain Nazi domination (this is the crux of Bettelheim's analysis in his book subtitled *Autonomy in a Mass Age*). Where there is no identity there is no memory (and *vice versa*), *ergo* individual identity was the first point of attack (a numerical tattoo replaces a name, ethnicity/culture/sexuality becomes a sign sewn on clothing, while Bettelheim recalls how prisoners were forced to self-abuse verbally and have their perception removed – literally – by the confiscation of their spectacles, even before they were taken inside the camp gates).

We are made of our memories. We not only remember past experience but our consciousness and present actions are in turn informed by our memory archive. Memories are both produced out of experience and in turn recreate it. Memories connect us to our place in our history and might therefore also provide us with a moral compass. As Antze and Lambek assert, memories 'are acts of commemoration, of testimony, of confession, of accusation. Memories do not merely describe the speaker's relation to the past but place her quite specifically in relation to it.'[10] The ethnic cleansing process the Nazis engineered was the intentional obliteration of a race *via* the erasure of its cultural memory as operated on the agency of the individual, while strategies of abuse were designed to prevent a slave revolt.[11] It is precisely on this memory/identity nexus and how movement memory triggered an individual act of revolt that our research focuses.

Torture operates on the body to inflict pain and reduce resistance thereby. If one strategy of the concentration camp regime is to render the inmate voiceless, this loss of the *power of speech* is a consequence not only of brutalities inflicted but an expression itself of loss of identity. As Scarry notes, intense suffering tends anyway to obliterate language: 'Intense pain is [...] language-destroying; as the content of one's world disintegrates, so the world of one's language disintegrates; as the self disintegrates, so that which would express and project the self is robbed of its source and its subject.'[12] The story of the tortured dancer compounds several motifs relating to identity, to language and to the body. She has been muted. She is also, and crucial to the story, a former professional mute, *expressing herself through her body*. She is starving and near-death. She is naked. She has been dehumanised by the camp regime. She has been habituated to brutality – a key technique of a punitive regime. She is ordered to dance. She dances. Something happens, it is implied, *because she is a dancer*. What interests us is not so much the emotions she might have experienced but her drive: that *the action of dancing* (remembering the past in an embodied experienced sequence of actions) triggered an act of revolt. In short, action enabled her to become conscious, to contextualise her condition – and take action. It is the connection between action and taking action that intrigues: how, as Beckett would say, 'natural' movement here interacts with conscious thought and how memory and identity are brought into being through dance.

The matter of whether the mind or the body acted first in that split second when the dancer danced, recovered her self and grabbed the gun (indeed if we can separate the mind and the body at all) lies at the nub of our questions. These might be answered differently by a neuroscientist or a psychoanalyst, even as some such disciplinary definitions are in certain quarters defying distinction (new theories are emerging to find potential synergy between psychoanalysis and neurosciences,[13] while the neurosciences are themselves in fact a relatively new and comprehensive branch of science – emerging in the 1970s – transcending previous disciplinary boundaries, e.g. neurobiology, biochemistry and physiology). We are engaging with an interdisciplinary group of advisers outside of our artistic discipline because we are working with the question of memory in a specifically heightened, and tragic, context as a reference point for our own embodied search into our own histories. Crucially, we are exploring impulse, instincts and reflexes: the human performing an action pre-consciously, assuming that it is in-the-doing that the mind becomes instantly conscious and aware. In short, we are preoccupied with how literally moving (back in time) can unlock memories and bring them to consciousness, whether memories are 'true' (in terms of accurate), how we

act from retrieved memories and how our subjectivity nuances, articulates and provides images for these.

Rhonda Blair, in her pioneering work on cognitive neuroscience and acting *The Actor, Image and Action* speaks of the work of the impulses in actor training and argues that the findings of cognitive neuroscience can 'move us past some historical and cultural conventions, as well as habits of thought, that are counterproductive for actors'. She proposes, that in the creative theatrical sphere it is time to redefine our sense of action and image/ination by divorcing it from vocabularies of twentieth-century psychology and cultural production that have limited our capacity for exploring and embodying theatrical material. The science provides a way of acknowledging and using for our benefit the contingency and fluidity of experience and consciousness.[14]

Blair's argument is that character is neither fixed by text nor can be attained by the actor in any pure believable representational activity without recognising the presence of the actor herself, her embodiment, her process of 'living through' a character, of performing a set of choices, a score of actions. She continues, in a vein that resonates with our project:

> This work also requires that we redefine our relationship to certain psychophysical experiences, for sometimes what may typically be seen as an emotional or physical issue in acting is actually, on a deeper level, better understood as a physical, or body-state, issue [...] character becomes a dance performed by the only discrete identity there is – the actor.

In short, Blair suggests, the performer's body might provide a far more accurate scoring device than the psychological and intellectual and even psychophysical approaches to what is loosely referred to as desirable 'truth' (verisimilitude) in theatre. Dancers, in contrast to actors, when not playing classical character-based roles (that tend anyway to be an acting gloss over set choreographed steps and include coded mimetic actions) are trained to work from the body-state as a primary consciousness in any action. Dancers, in short, always operate to a physical score, even if they are creating it in-the-moment as in improvisation. The issue is where the performer's mind/attention is at the moment of action. Blair's insistence on moving beyond traditional models of actor-training *via* psychology to focusing on the doing/body-state might be compared to various dance and movement training methodologies in which action is produced not by mimicry of classical example but by thought/suggestion combined with somatic information.[15] In Jerzy Grotowski's work on instinct and his work in 'paratheatre' (in which I participated twice in the 1970s), he abandoned altogether the proxemic, social, and commodity relationship between actor and audience. Instead, groups engaged in action-based spontaneous exchange for durational projects

both indoor and in nature in a search for what Grotowski considered to be both our atrophied physical potential and the recovery of human communal spiritual regeneration *via* the concept of Holiday (Holy Day).[16] Grotowski, like Blair, was departing from Stanislavsky's school of psychological realism throughout his research into the reflexes in his quest for a meaningful – and socially/spiritually necessary – theatre in post war Europe.[17] He too was interested in 'what the body can do' in the sense of putting the body into *extremis* to see how we would respond. In retrospect, it is perhaps the very specific context in which he was researching that gave rise to his profound and controversial questions on the function of the actor in society.[18]

In our project, in reference to the Bettelheim concentration camp story, we are exploring the question of spontaneous reflex as triggered by remembering learnt movement. We are investigating both what we remember and how we remember. We are pitching ourselves physically into this while focusing consciously on the process of retrieval being a re-creation of what once was, translated through our ageing dancers bodies. By each recalling the same memory – a dance, a piece of music, a place or an event – we discover precisely how different our perspectives can be. We are starting to build a vocabulary for this, struck by how vivid our movement memory can be when triggered by a familiar piece of music for example; but, conversely, how hazy other (less dancerly) memories might be. Throughout, we are conscious of our limited capacity to reproduce today what we once knew how to execute perfectly, and of how the time span between our shared experience as young women and our meeting now in studio and site so many years on, informs our thinking, on reflection. As theatre artists, in our empirical research, we are inevitably also working metaphorically in how to communicate our findings. If metaphor is the way we think/reflect/express in the sense that the mind itself is embodied, language being the evidence of this (Lakoff and Johnson),[19] the neuroscientist Stephen Rose, arguing against reductionist models in discussing memory and metaphor, proposes that:

> Brains do not work with *information* in the computer sense, but with *meaning*. And meaning is an historically and developmentally shaped process, expressed by individuals in interaction with their natural and social environment. Indeed, one of the problems in studying memory is precisely that it is a dialectical phenomenon. Because each time we remember, we are in some senses do work and transform our memories; they are not simply being called up from store and, once consulted, replaced unmodified. Our memories are recreated each time we remember.[20]

In the case of our dancer at the gas chamber, presumably, she was remembering the patterns of a known dance. The narrative leads us to speculate

as to how her senses and consciousness transformed this movement memory – recreated it indeed – into what was to become an instantaneous act of assertive revenge.[21] Was it the movement as a neurological activity itself that made her respond actively *via* the brain in cognitive reaction to her condition or was it the fact that dance, as Peggy Phelan would say, 'like psychoanalysis, helps join the body to time?'[22] And that the time this dancing joined her to was the here-and-now of her condition as deracinated, abused and abject Other, brutalised, enslaved and near-death, finding in this moment of self-awareness (remembering-herself-as-she-was) the physically expressed possibility of her refusal to submit? Bettelheim suggests that by dancing (again) she was instantaneously using her memory to 'place herself in relation to her past' (Antze and Lambek) and put herself at the same level as her captor – a flash of dialectics in the midst of horror, degradation and death. So, was the dance-memory a mnemonic trigger to mend a broken self, providing spatial, relational and physical reference for the individual to recognise herself, both metaphorically and literally as dancing-at-death's-door? Did dancing itself 'free her' because dance lifts us anyways from quotidian activity into heightened psychophysical energy – i.e. dance emancipates? Did that moment bring the mind and the body into sync and if so, what might she have been thinking? In short, was this dance itself, naked and emaciated, for a guard at gunpoint, a *metaphor* for resistance and liberation? (Bettelheim construes her action as existential: 'Exercising the last freedom [...] this dancer threw off her real prison'.[23]) These questions cannot possibly be conclusively answered, only imagined. However, clearly our subject was able to *think* in that instant about guards and about guns and how to shoot to kill: bullets aimed at flesh destroy the present forever.

According to Phelan the body has its own mind, as it were, lacking 'faith in narrative order. The uneven join between the body and consciousness is packed with the expansive ooze of the unconscious.'[24] It is here in this uneven join, this 'ooze', and because of the uncertainties around the question of consciousness, memory and the working of the mind and the brain, that our project takes up residence. The question of memory and how it is activated is certainly more complex than being reducible to a simple synaptic neurotransmission. Rose posits that 'memories are system properties, dynamic, dependent, for each of us, on our own unique individual history. What they absolutely are not is 'stored' in the brain in the way a computer stores a file. Biological memories are living meaning, not dead information.'[25] Rose insists that memory is an 'active not a passive event, and draws on a variety of cognitive and affective processes'.[26] What the dancer's story might suggest is that something crucial to her embodied sense of self, sutured to memory in the act of recalling learnt movement, transpired as she danced. To say she

'found herself' (having been tortured into 'losing herself') is a metaphorical term for the connection between physical and mental activity, between loss of memory and recovery of memory in the act of reliving past behavioural habits (conditioned reflexes in the body through a dancer's training) and, presumably, the social identity her dancing afforded her in her pre-camp past. Thus in this catalytic spontaneous action that motivates our project, we have on the one hand the 'ooze' that seeps in the interstices between body and the conscious mind, and on the other, the 'cognitive and affective processes'[27] of a memory being reassembled in a flash in the lived experience of a near-dead dancer *retracing her steps* (*sic*).

With *When We Were Birds* we seek to explore such questions by pitching our own dancing selves into the quest. As alluded to above, a binary and positivist approach might lead to either a psychoanalytic interpretation, referring us to the realms of identity and memory storage (Bettelheim became a psychoanalyst) – an exploration of cause and affect in what Phelan calls the 'psychic choreography' of psychoanalysis – or, conversely, to a neuro-scientific investigation, offering understanding from the perspective of the brain function in terms of properties, structures and processes, devoid of the story of that individual dancer and her context. From an artistic perspective, neither on its own would satisfy. The dancer's act in question itself is too extraordinary, fascinating, complex and at the same time too poetic to rely solely either on symbolic narrative or reductive science. Our project needs both and more: a search to comprehend not only how memory is lived and re-lived, but also what makes particular memories trigger particular mental responses. It also might leave room for what cannot be explained. It is to this end that we are engaging with our own dancing memories (as well as social/ political and emotional ones) to seek some kind of narrative sense to the idea of *having once been the young women dancers we once were* then, in contrast to – and from the reflective perspective of – now, and to contemplate together *what this feels like, now*. Moreover, as a practice-based interdisciplinary research process, predicated on the concept of embodiment, our project can be seen to address the paradox Ami Klin and Warren Jones identify: 'although psychoanalysis focuses a great deal on instinctual needs and responses to the world, it shies away from dealing with the basic unit of its philosophy – that is, how bodily sensations and experiences become symbolic tools'.[28]

Twenty years ago we shared an abiding fascination with the Bettelheim story. As we broach it, now, with maturity, we are not interested in inter-preting it in dance-theatre terms but in how to use it as a reference point to delve forensically and creatively into our own dance-memory and the memories associated with the vocational and highly specialised world in which we grew up.[29] It is not so much because we identify with it that we are

drawn to the story, but because we each somehow know in our bones that dancing, and the dances we each remember, tug us back into a much broader raft of other associated memories – of engaging with regimens of self-control: rigorous training, our relationship to our bodies (dieting and eating disorders), to our sexuality, to our sense of schism between the women we sought to be and the women we trained to portray on stage, and to the harsh cruelty of the Royal Ballet system at the time itself. That we suffered to be beautiful is a truism. There are scars.

Practice is central to such research. We have spent time retracing autobiographical 'sites of memory',[30] such as the day spent at White Lodge (the junior Royal Ballet School). Captured on video (by Lucy Cash), this evocative visit proved alternately exhilarating and upsetting. Having not returned there for 40 years we were welcomed into the deserted (it was school holidays) elephantine building[31] where the headmistress had unlocked all the doors, inviting us to roam freely. We drifted, in Situationist mode, drawn to the building's nooks and crannies. Intense memories lay dormant – in corridors, dormitories and classrooms. We broached the vast Pavlova Studio in which we had trained each and every morning. Overcoming a paralysing sense of awe and anxiety I joined Esther in this extraordinarily 'full' space – full of so many memories, so much sweat, blood (the feet) and tears. Finding our way to our 'place' at the *barre* (as dancers we tended to return to the same spot, each day, by choice) we instantly impulsed into some *barre*-work. The video shows us astonished and laughing that we are in perfect sync. Our collaborator Graeme Miller had sourced some vinyl records of ballet classics and pop songs of the 1960s. As the scratchy out-of-time player pulled scraps of the great classics out of us – *pas de deux* and *quatre* from *Swan Lake* and some male/female partnering – the *Giselle* recording suddenly reached the 'mad scene' at the end of Act 1. Esther (who had played the eponymous heroine professionally) spontaneously decided to try it out. The video shows her tearing the clip out of her hair as she begins to piece together this acting/dancing scene in which the young peasant girl heroine is duped by the man she loves, goes mad and kills herself. The scene is in fact all about memory as Giselle listlessly picks out a few steps she and Albrecht had danced together. The footage captures the metamemory of Esther-remembering-Giselle-remembering. We witness a woman of 60 transform into a lost young girl, expressing the epitome of the eternal feminine of this Romantic ballet. Illuminated by the process of concentration and re-living, Esther recalls every gaze, every angle of the head, with only very occasional lapses in which she seeks my prompting. This scene has now become central to our project.

Overarching the entire research is the idea that the dance information stored in mine and my collaborator's body is, neither, value-free. If ballet

is a text, written on our bodies, then As Bryan Turner puts it, inevitably: 'The critique of the text of the body therefore leads to a critique of power relations within society.'[32] Given what he calls the 'complex texture of the body in society and society in the body'[33] the ballet body is saturated with ideology, each movement and gesture itself reflecting this. The ballerina folds and refolds herself as the quintessence of feminine compliance to the spectator's gaze for

> Classical ballet celebrates the mathematics of perspective, the proscenium stage being its architectural praxis [...] If a hierarchy is represented on stage by the sequencing and orchestration of a spectacle [...], this is reflected in the class-system of the tiered Italianate theatre buildings. Cultural meanings regarding gender, ethnicity, ability, race, class and so on are the warp and weft of balletic narratives and its highly stylized and codified movement vocabulary [...]. Ballet compresses and represses sexuality and its values. Expressed in a geometry of rapture, pliability, and impossible levitation, the ballet dancer is Bahktin's classical body 'cleansed [...] of all scoriae of birth and development' *par excellence.* He lifts; she flies, light as a feather, on *pointe* and off, striving to give us the vicarious thrill of weightlessness and ethereality. Her lightness of being makes him seem heavier and *vice versa.* She is perceived to defy gravity, her limbs stretched and folded in a seemingly impossible origami. In the ballerina 'the chaos of body transmutes into rational form [...] her movements turn mess into symbol.'[34] Actually, though she may not be 'mess' and 'chaos' at bodily source but, rather, complicated and intricate, she certainly transmutes, converting organic complication into something leaner, non-reproductive (the ballerina's ideal body is anorexic) and more linear than the layperson can ever be.[35]

When Esther and I remember our former selves as young aspiring ballerinas, we are, with hindsight, able to reflect on these issues, while finding in the actual movement memory itself both joy and actual physical pain. As our older bodies attempt some movements, the unnatural efforts of achieving 'perfect line' in ballet are accentuated and brought into relief. Even if 'there has never been a "natural" body: a time where bodies were untainted by cultural practices,'[36] the human body was surely not made for the particular 'thousand natural shocks/That flesh is heir to'[37] in our case. Ballet methodically unmakes and remakes the raw material of the body in order to produce the emaciated purity of the ballerina, an idealised ethereality that masks the phenomenal athletic strength and stamina required.

In one episode of memory work I brought to the studio a bag of memorabilia from White Lodge days. I have not touched these objects for

years. One of these is a ballet-uniform blue belt from when we were 15 years old. It has two sets of hand-sewn hooks. Eating-disordered at the time I had lost an inch from my waist in a matter of weeks. In either measure, the belt is minute. I have learnt in the course of our research that Esther herself, naturally long limbed and very slender, spent years on a diet of white wine and eggs as a professional, a fact hardly credible when you look at her natural proportions. Orbach insists that our bodies are not given but made, not just from our genetic predisposition and make-up but that 'Everything in our early experience shapes our bodies. Every culture marks the body in specific ways.'[38] Ballet is its own culture. Its regime disciplines the body into neuromuscular compliance. This training at an early age has shaped not only our bodies as they are now, decades on, but our proprioception and our memory. It is into this sometimes painful territory that we have begun to gain ingress by putting ourselves into locations as well sensations that 'take us back'. At the end of the first week's filming of object-memory, movement memory and sites of memory, we emerged poleaxed with exhaustion, mental and physical. Then the grief came, an overwhelming depth of sadness that could not quite be either rationalised or named and that will doubtlessly be understood in time and through the confrontations of our research.

Our principal scientific collaborator is the cognitive neuroscientist Nicola Clayton (unusually with a second career as a tango dancer and teacher). Clayton's work is concerned with the evolution of cognition and she incorporates both biology and psychology on pioneering studies of what she calls 'mental time travel'.[39] A pioneer in re-evaluating animal and human cognition, she is Fellow of the Royal Society and currently scientist in residence with Ballet Rambert. Given her own unusual embodied perspective on dance, we shall be investigating our material empirically with her. She will join us in the studio to observe us remembering dances as well as view the video material we are gathering. We also plan to correspond in writing as the dramaturgy for the installation starts to take shape. From the psychoanalytic field we have invited as 'dialogists' the pioneering psychotherapist and social critic Orbach, whose work with eating disorders and body image has been groundbreaking.[40]

Our project's ultimate aim, rather than to 'solve' the mystery of that key Buchenwald dancing event in drawing on the psychoanalytic and the neuro-scientific, is to explore whether and how these disciplines might engage in dialogue and debate, thereby stretching and challenging our perceptions as our work progresses. As artists we are able to play with ideas and test them out against our own lived experiences, throwing ourselves into the ring of 'uncovery mode' while

To speak of memory as narrative is not to imply a set of fixed and bounded texts. We are at once author and reader of our stories, acts that are continuous unless pre-empted. The meaning of any past event may change as the larger continuing story lengthens and grows in complexity. As readers we are continuously re-exploring the significance of earlier episodes of the story in the light of what transpires later, as we are caught up in the hermeneutic spiral of interpretation.[41]

We have only just begun to retrace our steps (*sic*) and are finding inevitable lacunae, gaps and blocks that at times we can fill for each other while at others that remain stubbornly inaccessible. What is certain as we develop this research, is that we are starting to understand how both tangible (and in our case danceable) memory can be – and how unstable, and that when we move spontaneously into familiar recollected space and actions, our minds, as both author and reader, are simultaneously burst open to what has been buried for decades. It is in this that we are connected to our subject at the gas chambers, recognising ourselves as we dance, anew.

Uncertain Knowledge: Representing Physical Pain through Performance

Erin Hood

This action begins where words fail me … Using processes of measuring and cutting, the skin is (re)marked.

Kira O'Reilly, *Ssshh … Succour*[1]

This chapter involves a dialogue between performance and neuroscience concerning the relationship between conceptions of physical pain and representations of physical pain. As a complex aspect of consciousness involving many areas of the brain, pain resists complete understanding. Attempts to grasp it through a singular representational lens, like metaphorical association or objective description, lead to misunderstandings about how pain and aspects of self are connected. Investigating the successes and failures of metaphor and objectivity reveals that pain is best approached through a multidimensional representational lens. By expressing pain through an embodied, subjective and multidimensional representational network, performance can give form to the emerging neuroscientific view that we change pain as pain changes us.

A review of pain treatment literature turns up a range of contradictory conceptions of pain. Since pain medicine emerged as a specialty in the 1960s, many researchers and clinicians have defined physical pain as either 'sensory' or 'psychological', either 'real' or 'imaginary'.[2] Other researchers and clinicians, including gate control theorists Ronald Melzack and Patrick Wall, question the accuracy and effectiveness of envisioning physiological and affective components of pain as entirely separate.[3] Representing the second perspective, pain physician John Loeser asserted in 1985 that 'the distinctions between sensory and psychological, cognitive, physiological, and behavioural are not conducive to an increase in our understanding of the problem of pain. In fact, they have created our dilemma.'[4] Over the past two decades, time-based brain imaging technology (fMRI) has provided empirical evidence for the notion that sensory and affective aspects of pain

interact with one another.[5] This emerging neuroscientific research posits physical pain to be a dynamic blend of physiological, cognitive and affective components.

The emerging conceptualisation of pain builds on the conventionally accepted notion that pain experience always involves cognitive awareness of the aversive sensation as well as an affective response to it.[6] Neurologist Howard Fields explains that the emerging conceptualisation envisions these cognitive and affective responses as more than reactions to a physiological signal. Instead, cognitive and affective responses participate in shaping and reshaping the physiological component of pain.[7] Through pain modulatory networks, aspects of self such as memories, attention and expectations interact with physiological components of pain in a non-deterministic manner. Aspects of self are, therefore, non-causally involved with how pain changes. Fields acknowledges that 'a complete [neurobiological] under-standing of contextual influences on pain is many years in the future'.[8] As the neurobiology of meaning advances, performance can contribute to the development of an interdisciplinary language to discuss how the meanings we make of pain can transform the pain itself.[9]

Pain resists objective representation because it is always in production. Pain also resists representation because of its interpretive nature and its inability to be referred onto an object in the external world. The latter two representational failures are touchstones in biomedical literature and cultural theory. In biomedical literature, brain imaging specialist Irene Tracey explains that there cannot be a reliable anchoring standard for representing pain because the physiological, affective and cognitive factors that influence pain's interpretation are too variable across individuals, not to mention within an individual over time.[10] This variance is why two people can experience the same pain stimulus, but one could genuinely report a three on the Numeric Pain Intensity Scale while the other could genuinely report a six.[11] In cultural theory, Elaine Scarry explains in *The Body in Pain: The Making and Unmaking of the World* that pain further resists representation because it is an interior bodily experience that does not reference an external object in the world. According to Scarry, physical pain is unlike other emotional, cognitive, or sensory states that take an object, for example 'hatred for, seeing of, being hungry for', because pain does not reference anything but itself.[12] These obstacles to representation work together to frame pain as a private experience that cannot effectively be shared with others.

Yet, as Sara Jane Bailes suggests in *Performance Theatre and the Poetics of Failure*, representational failures can prompt the development of different ways of looking and different ways of making, which can spur generative effects. Whereas Scarry articulates important points about the devastating potential of

representational failure, this chapter critiques conventional notions of representation in order to articulate what embodied and subjective ways of looking and making can reveal about physical pain. Kira O'Reilly's performance *Sssshh …
Succour* activates an alternative form of representation rooted in performance. Her programme note clarifies that the work 'begins where words fail'. This starting point allows O'Reilly to demonstrate that performance can communicate aspects of pain that metaphor and objectivity miss. In the 40-minute piece she calmly uses a medical scalpel to make a series of cuts on her own body as spectators stand watching in close proximity. By asking spectators to witness pain that she intentionally creates, O'Reilly brings subjective relationships with our own pains and the pains of others into sharp focus.

Through her emphasis on representational failure, O'Reilly takes up Cathy Caruth's interest in the possibility of a more pragmatic approach to the inaccessible. Writing about traumatic experiences, Caruth speaks to the urgency of creating new ways of listening to and recognising what would 'under traditional criteria, be considered to be false'.[13] *Succour* demonstrates that performance can provide a visceral approach to the inaccessible. By bringing the body and contextual factors into the representational process, *Succour* demonstrates that performance can allow us to 'see' things about pain that cannot be recognised when objectification is the representational goal.

Embracing pain's resistance to conventional representation, this chapter begins to investigate how metaphor, objectivity and performance each contribute to and complicate understanding of pain. A brief explanation of the neurobiology of pain will provide context for the following analysis of how these three methods for representing pain affect how we conceptualise between pain and self. Maintaining that pain and consciousness are too complex to be fully understood, but following Caruth on the value of alternative modes of communication, I argue that O'Reilly's *Sssshh … Succour* focuses attention on our relationships to pain by approaching it through embodied and subjective ways of looking and making.

Understanding the non-causal connections between pain and self

In isolation, neither metaphor nor objectivity can effectively communicate the complex relationship between pain and self. Metaphorical association overdetermines the connection to the extent that the person becomes the pain. Objective description underdetermines the connection to the degree of assuming it is non-existent. A brief explanation of the neurobiology of pain will clarify that a connection between self and pain does exist. At the

same time, emphasising the complexity of the connection will control the dilemmas of agency implicit in acknowledging this connection. Explaining that the connection between pain and self is not causal enables a way of recognising the connection, while clarifying that we cannot yet, if ever, be certain about the many layers of chance and responsibility at work in the creation and modulation of physical pain. Dilemmas of agency implicit in the emerging neurobiological view of pain underscore the value of keeping pain's embodied, subjective, and multidimensional qualities in sight.

In contrast to the emerging neurobiological way of thinking about pain, the dominant neurobiological theory does not envision an interactive connection between the physiological component of pain and aspects of self.[14] In the dominant paradigm, pain begins with an aversive stimulus, either an external agent or internal pathology. The stimulus spurs a reaction that takes place between peripheral nerve receptors and the brain. For example, the first time O'Reilly's scalpel breaks her skin in *Succour*, disturbed nerve endings send pain signals to the artist's brain. The brain reacts by sending an appropriate amount of pain back to an appropriate location on her body. As the performance continues and the cuts accumulate, other disturbed nerve endings send other pain signals to her brain and the brain reacts by sending more pain to her body. This mechanistic process constitutes the objective dimension of the pain experience. According to neurobiology, this mechanistic reaction stays within the confines of the central nervous system; it does not require higher-level brain activity that takes place in the brain's cortex.[15] Therefore, aspects of self like memory, attention and expectation are officially absent from physical pain's creation and modulation in this dominant way of understanding pain.

In this paradigm, unique aspects of self do react to pain even though they do not create or modulate it. In contrast to the objective reaction, subjective reactions to the pain signal do involve higher-level brain activity and require the cortex. First, the discriminatory response involves recognising the pain sensation's particular qualities and discerning its bodily location. For example, the discriminatory response allows a person to recognise that a stove is exceptionally hot and that it is burning his hand. Neurobiology stipulates that the discriminatory response mostly involves the somatosensory cortex located in the rear brain.[16] Second, the motivational response activates one's desire to take action in order to terminate pain. According to neurobiology, it is mediated by the limbic system, which includes the cingulate gyrus and the anterior insula of the frontal cortex as well as the amygdala in the subcortex.[17] Finally, the evaluative response enables the subject to consider how body damage associated with the aversive sensation may impact his short-term or long-term future. The brain areas involved in mediating the

evaluative response remain unknown.[18] Aspects of self, like unique personality characteristics or intentional choices, influence these reactions; but, according to the dominant neurobiological view, the reaction does not feed back into the subject's physiology. This lack of interaction implies that the subject who shapes the subjective responses does not influence the physiological component of pain.

The dominant conceptualisation's premise that each of the separate dimensions of the pain experience arises from the same original pain signal supports the conventional notion that pain is always caused by a discrete stimulus. For example, when the scalpel first breaks O'Reilly's skin, a pain signal enters her body, serving as the discrete stimulus. Initially, peripheral nerves detect each pain signal. Upon the signal's initial detection, a primary afferent neuron picks up the signal and sends it to the spinal cord, where it travels to the thalamus (along the spinothalamic tract), which serves as a gateway for pain, as well as for other types of sensory input. At the thalamus, the single pain signal diverges along separate pain pathways, which simultaneously carry the signal to both the somatosensory cortex and the limbic system. Through this process a single pain signal gets routed through what the dominant conceptualisation understands to be several discrete pain pathways. What happens along one pathway constitutes the discriminatory response to pain. Activity along another pathway constitutes the motivational response, and activity along yet another pathway constitutes the evaluative response. But, these responses do not feed back into the pain signal because what happens in one pathway does not neurobiologically interact with what happens in another pathway. The pain pathways are envisioned as separate.

When such a bottom-up process constitutes the entirety of pain perception, contextual factors are not brought to bear on the pain perception process. In this view, O'Reilly's cognitive awareness of her decision to cut herself in an art context does not affect the quality or intensity of the sensations that she experiences. Similarly, her emotions about why she cuts and how others respond do not modulate what she physically feels. O'Reilly's relationship with her pain is understood to be separate from its physiological dimension. Elements of self are absent from pain's conceptualisation.

Alternatively, the emerging neuroscientific view of pain explains the creation and modulation of physical pain as a complex blend of many components. It understands pain as a process that has so many contributing factors that it exceeds the logic of causality.[19] In this view, reactions to the pain signal interact with top-down processes like attention, expectation, learning and mood to constitute pain modulatory networks. Especially relevant for chronic pain conditions like phantom limb syndrome and

fibromyalgia, this conceptualisation explains how pain can exist when a causal stimulus is absent.

By bringing top-down factors into models for understanding pain, the emerging conceptualisation makes aspects of self factors in how pain develops, but allows them to remain non-deterministic. Fields explains how these top-down factors overlap with bottom-up processes:

> Brain regions comprising the limbic system (the cingulate and prefrontal cortex, the medial temporal lobe and amygdala, and the hypothalamus) connect via neurons in certain brainstem structures that descend to and control the dorsal horn neurons that receive inputs from the primary afferents that specifically respond to noxious stimuli. The structures in this pain-modulating circuit are linked by ... endorphins ... and the evidence is compelling that the circuit mediates the pain-relieving effect of powerful narcotic analgesics such as morphine.[20]

Factors that influence pain perception are bidirectional. Fields gestures towards some implications of this neurobiological model when he summarises that, '[i]n addition to suppression of pain, neurons in the circuit can *facilitate* pain'.[21] Through the overlapping of bottom-up processes, which usually originate from a stimulus, and top-down factors, which are constituted by aspects of self, physical pain becomes wrested away from causal logic. Due to the presence of multiple participating factors, pain becomes an entity much greater than the sum of its parts.

Representing pain

As a mode of representation, metaphor can effectively represent qualities and meanings of pain experiences. However, it is not equipped to articulate the complexity of how pain and self are connected. Pointing out the advantages and limitations of understanding pain metaphorically demonstrates that it is a powerful, but partial, representational tool. Deborah Padfield's *Perceptions of Pain* demonstrates the effectiveness of metaphor to aid in the communication of pain. Emphasising a visual vocabulary, Padfield's project provides 66 photographic images, made in collaboration with 11 patients in treatment at a residential pain management programme in the UK.[22] For instance, one photograph associates a bisected apple with one man's perception of his own body in pain. The apple's insides stand in for the otherwise hidden insides of the man's body. The apple's light brown and mushy core suggests that the man's insides are deteriorating and that they feel vulnerable to the touch. By pointing out this associative likeness the visual metaphor communicates

aspects of the man's pain that could not be discerned through verbal self-reports or empirical imaging techniques. *Perceptions of Pain* exemplifies how metaphorical association can productively work outside the registers of objectivity to enable profound communication about sentient experience.[23] Physician and medical anthropologist Arthur Kleinman's observation that the metaphors people with chronic pain develop over time 'can be remarkably communicative', confirms that significant value lies in the ability of metaphorical association to make aspects of pain understandable.[24]

Despite this value, the representational failure of metaphor lies in the fact that important differences remain between physical pain and the object that stands in for it. Collapsing this gap permits the person in pain to get lost in the association. Ironically, other aspects of the person become less visible as features of his pain become more visible. For example, when a decomposing apple stands in for a human in pain, important details that influence physical pain like past experiences, current circumstances, and desires for the future fade from view. The rotting apple comes to stand in for the whole human, and the man becomes nothing but his pain. When important differences between the human and the apple are collapsed, then the pain takes on too much agency. Pain consumes how the person is seen, eliminating affective and cognitive factors. This representational style thereby obfuscates the emerging neuroscientific notion that aspects of self affect how pain changes in a non-deterministic manner.

Whereas obscuring the person in pain is an oversight of metaphorical association, it is an intentional feature of objective description. Objectivity strives for independence from contextual factors that influence how we look. History of Science scholars Lorraine Daston and Peter Galison explain objectivity as a method of rigorous description that requires 'seeing without interference, interpretation, or intelligence'.[25] In the biomedical domain, this style of representation requires taking subjective insights of both doctor and patient out of attempts to understand pain.

Although eliminating subjectivity from the process of understanding pain is of course impossible because of the inherent subjectivity of all perceptual experience, attempts towards objectivity can provide insight into how pain works on individual and conceptual levels. Tracey explains that verbal self-reports that measure pain across multiple dimensions can reveal important information about an individual's pain.[26] The McGill Pain Questionnaire, for example, asks patients to describe or narrate their pain in terms of its location in the body, its intensity, and whether it is deep or superficial, burning, pricking, throbbing, stabbing, aching, shooting.[27] By categorising various qualities of pain the McGill Questionnaire can help make distinctions among different types of pain, for example between

trigeminal neuralgia and atypical face pain.[28] Despite its representational failure to entirely separate pain from an individual's subjective perception of it, the way multidimensional self-reports organise information about sensations can make the diagnostic process more effective.[29]

Tracey also explains that brain imaging techniques provide an even more objective approach to pain because they are not reliant upon a patient's interpretation of sensation. Rather than describing or measuring intensity or qualities of pain, time-based imaging can make visible the areas of the brain that are involved in the full pain experience. By showing that an affective factor like anticipation makes areas in the prefrontal cortex and the limbic system co-activate, imaging can provide evidence that physiological, affective, and cognitive responses are in interactive relation. Extended description and analysis of brain imaging is well beyond the scope of this essay; however, it is clear that time-based imaging can provide insight into how pain works. Despite the nascence of this representational technique, its potential to break down pain's many component parts into identifiable units is a step towards improving understanding of the complex relationship between pain and self.

Objectivity's representational failure is wrapped up with its desire to find an origin for pain. This desire stems from the belief that all pain arises from a discrete stimulus and that all disease has a locatable origin. [30] Looking for a physical origin of pain is a flawed pursuit because a physical origin does not always exist. As the emerging paradigm indicates, physical pain is made between the brain and the body and between the person and the world. It is always changing according to how body, brain and world interact.

When totalising focus is given to physical manifestations of disease, then less attention goes towards the relationship between the person and the disease. Foucault encapsulates this phenomenon in his assertion that modern medicine was born when doctors stopped asking patients 'what is the matter with you' and started asking 'where does it hurt?' The desire to 'look' at these in-between spaces, prompted by the emerging view of pain, encourages a revision of the primary question asked by doctors to pain patients. A return to asking 'what is the matter with you' suggests a problematic causal relationship between pain and self. To account for the non-deterministic connection that the emerging conception suggests the two questions have to be revised into a question more in tune with the problem of pain. Instead of asking 'what is the matter with you' or 'where does it hurt', understanding pain depends on asking patients how they relate to what they feel. In other words, improving understanding of pain requires focus on how the body and brain together make meaning function.

Refining this focus requires interdisciplinary interaction. Through interdisciplinary collaboration, performance can contribute an explicitly

subjective representational form that draws attention to the spaces between mind and body and between self and others that are central to how physical pain changes. Performance generates knowledge that more conventional forms of representation do not emphasise. It generates embodied knowledge because, unlike metaphor, performance keeps the embodied person in sight. It also generates subjective knowledge because, unlike objectivity, performance emphasises the contextual factors present in the representational process. By highlighting that embodiment and subjectivity work together, performance provides a way of recognising that there is a connection between pain and self and that the connection is complex, not causal.

Performance represents by taking what Daston and Galison call 'a presentational approach to the real'.[31] They invoke the phrase to describe developing modes of scientific image making. The concept can also be applied to performance-based means of representing physical pain. Taking a 'presentational approach to the real' implies a performative critique of conventional modes of representation. The heart of this critique moves beyond the idea that the most valid forms of representation help us learn about reality by objectifying it, to instead assert that we can learn about reality by manipulating it. Daston and Galison explain that taking a presentational approach to the real bypasses intentions to accurately depict what 'naturally' exists, to focus on how entities 'can be made, remade, cut, crossed, or activated'.[32] This focus emphasises the role of subjectivity in the representational process, and it can lead to new insights about a range of phenomena from the nanoscale molecules of scientific images to the pain experiences of living bodies. Performance also adds an emphasis on embodiment to the 'presentational approach to the real's' emphasis on subjectivity.

Kira O'Reilly's performance *Sssshh … Succour* demonstrates the ability of performance to take a presentational approach to the embodied realities of physical pain. Performing at the National Review of Live Art in 2001, O'Reilly begins *Succour* by walking nude into the centre of a small gallery space. Spectators stand, tightly framing her throughout the performance. She sits in one of two towel-covered chairs and engages each audience member in mediated eye contact by picking up a hand mirror and looking at them through it. After this ritual acknowledgement that performer and spectators are sharing time and space, O'Reilly begins the process of measuring that she highlights in *Succour's* programme note. In this reference to more conventional processes of medical measurement, O'Reilly critiques medicine's rational approach to understanding bodies, pain and trauma. She uses medical tape to mark precise circles from her left ankle to the top of her thigh and then completes the gridding of her skin by taping long lines down her leg. Handling a scalpel, she deliberately

makes a diagonal cut across each of the fleshy spaces. She continues the processes of measuring and cutting on the right side of her body from lower abdomen to just above her breast. At the end of the performance's 40-minute duration, O'Reilly removes the medical tape and absorbs the blood from her body with a towel. She picks up the hand mirror to again engage spectators in mediated eye contact before standing to walk out of the gallery space.

Succour displays pain in a way that keeps O'Reilly's subjectivity and her embodiment in sight. It is clear throughout the performance that O'Reilly, as a cognitively aware and affectively feeling subject, plays a central role in the way this pain experience is created and represented. She designed the quality of the cuts and the look and tone of the show. Her focus on her task and lowered head prevent a clear affect from being read, but the provocative action incites affective connection to the performance material from both artist and spectators. Importantly *Succour* puts cognitive reasoning and affective feeling in conversation with the physiological response of O'Reilly's body. As her cuts accumulate an unpredictable amount of blood emerges from the measured squares of skin. Spectator Keith Gallasch describes that her body becomes 'a picture of living fine red lines and random dark trickles'.[33] Although each square of skin was the same size and was cut the same way, each square of flesh bled differently. The body's unpredictable response to each of the equally measured interventions suggests that the body's physiological response has subtleties and that these subtleties cannot be detected through conventional methods of looking at bodies. *Succour* demonstrates that performance-based ways of looking can convey the co-presence of cognitive, affective and physiological factors. This way of looking can highlight that although we can have a sense of how they influence one another, the intricacies of their connections are beyond the realm of intelligibility.

In her deliberate processes of measuring and cutting, O'Reilly brings her own embodied subjectivity into conversation with medicalised treatments of bodies in pain that prize rational understanding. Her body's response to these measured interventions do not seem to yield useful knowledge. However, an ambiguous knowledge circulates through the performance. Neither symbolic nor empirical, embodied knowledge works against interpretation to call attention to the fact that bodies in pain operate through a logic that is not always reducible to rational terms. The tension between rationality and irrationality that surfaces in this performance gives form to the in-between spaces in which pain materialises.

As a means of representation capable of giving form to aspects of pain that cannot be realised through singular and disciplinary-specific techniques

of representation, performance is not necessarily oppositional to objective description or metaphorical association. Peggy Shaw and Suzy Willson's *Must: The Inside Story* demonstrates that instead of rejecting these more conventional representational styles, performance can incorporate them. It can draw from the positive potentials of metaphor and objectivity, while keeping the body and the person in sight. Caruth's claim that 'there is no single approach to listening to the many different traumatic experiences and histories we encounter', can be extended to the notion that there is no single approach to representing pain.[34] Enabling multiple modes of representation to work together is a promising way of expressing the emerging neuroscientific notion that pain is an always-changing blend of physiological, cognitive and affective components.

Must puts metaphor in conversation with objective representation all the while emphasising Shaw's embodied subjectivity. *Must* is about Shaw's relationship with her own embodied history. Describing the narrative of her bodily experience as 'a journey through the shadows of a city. A map', Shaw poetically reflects on moments in her life, including pained ones like falling off a balcony and childbirth.[35] She presents her body to spectators in metaphorical terms, comparing the theatre's curtains to a body's blood vessels, broken bones to cracked and mended pottery, and her own embodied history to a map. As Jill Dolan has pointed out, these associations connect the inside of her body to the outside world.[36] They suggest that the ways her body changes are intertwined with her worldly experiences. As these metaphorical associations are made, Shaw's embodiment remains in sight. At some moments lighting frames her external features, and at other moments objective images of internal features like capillaries and blood vessels are projected onto the performer's body. As the performance continues, Shaw also takes a presentational approach to the real. She is less interested in presenting her body or her history as it exists than in showing that her body and her subjectivity have been made and remade as they've interacted with each other and the world.

The co-presence of metaphor, objective representation and performance-based representation suggests that the most effective way of knowing a body, or a body in pain, depends upon balancing different types of knowledge. Shaw's insistence that '[t]here are different ways of seeing inside me: You could guess what's in here. You could x-ray me. You could touch me. Or you could believe what I tell you', reinforces this idea.[37] Drawing on the strengths of each representational act enables *Must* to depart from the conventional biomedical conceptualisation of the body as separable from self and subservient to it in favor of a view of the body as bound up with lived experience and aspects of self. There is potential for Shaw and Willson's multifaceted

approach to expressing our relationship to our always-changing bodies to be developed to express our relationship to our always-changing pains, and the pains of others.

Conclusion

The intentions motivating association and objectification are different from the intentions driving performance-based representation. Through qualitative comparison and precise description, respectively, association and objectification aim to externalise the interior in order to make pain rationally comprehensible. Such efforts to make physical distress comprehensible have value and practicality. Yet, pain itself is constituted by a certain amount of incomprehensibility. Using association and objectification as the only methods to understand pain sets it up to be misunderstood. Through its emphasis on embodiment and subjectivity, performance can externalise the interior in such a way that directs attention towards how we relate to our own bodily realities and the bodily realities of others.

As Caruth suggests about trauma, understanding pain requires different ways of thinking about what it means to understand.[38] Scarry's famous claim that 'to have great pain is to have certainty; to hear that another person has pain is to have doubt', is so resonant because of the impossibility of feeling exactly what another person feels.[39] Yet, equating knowledge with certainty constructs a troublesome barrier between what we can know about our own sentient experiences and the sentient experiences of others. Embracing the middle space between certainty and doubt, performance can focus attention on types of knowledge that are more embodied than objective in order to improve understanding of physical pain and how it operates.

Touching Texts and Embodied Performance

Introduction: Texts and Embodied Performance

Amy Cook

Cognition is not what I thought it was. It is not cold and unemotional. It is not disembodied. It is not separated from an environment. It is not a mental process. It is not even in the individual. Although these claims are not without debate, there is growing consensus that thinking and making meaning is not how we imagined it.[1] This conceptual shift has been marked by attempts to come up with new words; enaction, embodied cognition, extended mind, mind/body, are just a few candidates to help us refer to that which we want to distinguish from a history of 'cognitive science' that perceived the brain as a computer, with data coming in, processing and representations occurring between the neurons in our skull and then 'thoughts' coming out. According to this view, actors must 'get out of their heads' in order to find their instincts and their emotions and dancing is something that unlocks the wisdom of the body.

I have struggled with the yoking together of the terms 'cognitive' and 'affect' in the title of this book because I fear that this combination suggests that they are complementary terms – rather than overlapping theoretical areas – and masks the fact that what is needed is new language. What both areas are pointing to is the richly complicated reaction to fiction and performance. Affect theory has forced into scholarship the centrality of a work's affective reaction; cognitive theory seeks to connect what we know about the humanities with research in the sciences about how we know. Although most cognitive scientists (certainly those popular with humanities scholars) understand cognition as deeply enmeshed with the emotional system, this is not adequately reflected in the language. Our language reflects (and thus rehearses and repeats) the Cartesian split of heart, mind and body. One reason to bring humanities scholars together with scientists is to improve the language use on both sides of the academic split. To provide an assessment of what a text or performance means without undertaking an exploration of how it means this to the human beings for whom it means, seems

impoverished scholarship at this point. The chapters in the following section are all heeding the call to hold together – without losing all of the specificity of the cultural and historical contexts richly investigated in the theoretical paradigms of the past – the text in performance and the embodied mind of the spectator.

Embodied cognition is not something that requires work or movement: it is what we do when we add up the money in our wallet, hand a friend a tissue, or pick up our coffee. The problem is not with making our thinking or our performing more 'embodied'. The challenge is coming up with the language to articulate what it has been all along but we have missed some of the nuances because our language looks for bodies and minds. The paradigm shift that keeps trying to arrive is about re-categorising what we are talking about when we talk about thinking, or meaning, or touching, or feeling, or embodiment, or performance. This requires close reading and creativity and a facility with metaphor. All the money in the sciences cannot do what those of us in the arts and humanities can do: give us new ways to see and stage – and thus to understand and to use and to develop – the implications of embodied, embedded and extended minds.

This is what I used to imagine when I thought about what it meant to think: the visual information supplied by the chair in my office generates a picture in my head of 'chair' which I then use to access memory of past behaviour with chairs, and I think, 'I should like to sit down.' This desire, registered by my little thinker, is then translated into the motor information necessary to sit down. Seated in my chair, I see wind blowing the leaves on the tree out the window and I know that the season is changing. I see a note that says a friend called and my brain translates those letters into the mental code that tells my brain what 'called' means. This seemed intuitively right for many years, and not just to me. One obvious problem with this is that there is no 'little thinker'; we have no evidence of a central command control centre creating representations of that which we see. Even if there were, it does not explain how the symbolic representation of 'chair' in my head matches the external reality or my use of the chair. It doesn't explain how I come to categorise my chair as something I sit *in* and the window as something that separates the inside from the out. The power of the container metaphor to structure my experience – and my language – is unexplained in traditional, literal, representational theories of cognition. How do I come to say that I see the wind moving the leaves when clearly I cannot see the wind? How do I shift my attention from the chair to the wind? How am I able to make the chair (or the tree, or the leaves) into a figure pulled out from the noisy ground of all the visual stimuli in my office?

Perhaps part of the confusion comes from the different kinds of things we say we 'know'. I know when the person I am talking to is sad. I know when

something bad is about to happen onstage. I know chair. The first involves emotions and empathy and a clear need to feel into the knowledge referred to – few would argue that thinking about another person's emotional state could be solely logical. The second is a dynamic cognition that folds past, present and future together. The third, though, is referential – a chair is a chair – and less obviously embodied, but understanding how we understand chair is one thing scientists have not been able to teach a robot to do. This is referred to as the symbol-grounding problem: how does a representation acquire meaning? A chair has no meaning independent of what we do to or with it. According to Alva Noë: 'we ought to reject the idea – widespread in both philosophy and science – that perception is a process *in the brain* whereby the perceptual system constructs an *internal representation* of the world. [...] What perception is, however, is not a process in the brain, but a kind of skillful activity on the part of the animal as a whole.'[2] Cognition is what happens when I sit in the chair.

The meaning of the thing is the actions afforded by it. In other words, as Anderson notes:

> 'chair' is not a concept definable in terms of a set of objective features, but denotes a certain kind of thing for sitting. Thus is it possible for someone to ask, presenting a tree stump in a favorite part of the woods, 'Do you like my reading chair?' and be understood. An agent who has grounded the concept 'chair' can *see* that the stump is a thing for sitting, and is therefore (despite the dearth of objective similarities to the barcalounger in the living room, and despite also being a tree stump) a chair.[3]

If one had to refer to an internal definition of chair as thing for sitting it would not allow the listener to see immediately the stump as chair; she 'must know what sitting *is* and be able to systematically relate that knowledge to the perceived scene, and thereby see what things (even if non-standardly) afford sitting. [. . .] grounding "chair", that is to say, involves a very specific set of physical skills and experiences.'[4] Research has shown that visual perception of an object includes the action afforded by those objects. In the forest we see the chair in the stump immediately – it requires no more imagination or creativity than seeing an Eames as a chair.

If embodied cognition locates thinking in the whole organism, as insepa-rable from the actions of that organism, embedded cognition argues that cognition uses the environment. The prop table organises what is needed by the actor so that between scenes the actor does not need to look at the table, remember what he needs for the next scene and search for it. The stage manager marks the paper on the table so that the prop goes in the same place every night – often tracing the edge so the hammer goes where the hammer

silhouette is. This allows us to travel 'information light', using prompts in our environment to guide our actions in the moment. We can take advantage of this – as the stage manager does – and alter our environment to support the offloading of cognitive tasks, which David Kirsh and Paul Maglio call 'epistemic action' as opposed to 'pragmatic actions' which make an environmental change because it is desirable in and of itself, not because of what it affords.[5] We create tight feedback loops between our actions and the world it is acting on and with in order to operate quickly and efficiently. Extended cognition sees these 'coupled systems' as cognitive in their own right, taking the mind beyond the body. In this view, thinking is what happens between agents and their environmental tools, coupling seemingly discreet units in a system that extends what and where we imagine the 'mind', or what Andy Clark calls the 'ancient skinbag'.[6] If our environment becomes part of the cognitive act, I am only as smart as the system that surrounds me.

Telling stories involves representation and pretend – 'think when we talk of horses that you see them' – and, since Coleridge we have spoken of an audience's 'willful suspension of disbelief' in making these stories real. But, as I (and Bruce McConachie) have argued elsewhere, this presumes that disbelief is the default position from which we depart in order to make sense of the fiction onstage.[7] We do not assess the truth-value of a story prior to (or separate from) reacting. We feel sad when our friend speaks of being at the end of her rope, sad when the actor playing Lear comes on with the limp body of the actress playing Cordelia, and sad when our dog dies. To argue that normal situations that evoke emotions are reality-tested is to presume that 'reality' is important to emotions. Information may be framed within a context that affords and constrains different reactions – watching a play or witnessing a car accident – but the meaning of the event is not separate from our actions. The fact that we use fictional pieces of information to construct a non-fictional account of a situation that generates our emotions does not decrease or alter the emotions we experience. Stories, both true and false, guide the meaning we make of the world around us and our emotional reaction to it.

These stories are communicable; we take it for granted, but the fact that I can tell a story about an old king and his daughters and be understood is unique among living creatures. As Benjamin Bergen points out, although other creatures, such as bees and whales communicate, none of them tell stories:

> A bee can waggle its abdomen until it falls off, but it will never communicate anything beyond what its programmed to – it can't say that the weather's likely to clear up, that it had a decent night's sleep, or that

it's looking forward to the weekend because it has a hot date with a hydrangea. Human language, in contrast to all other animal communication systems, is open-ended.[8]

We can refer to something in the world – the bee – or something not in the world – a unicorn – and be understood; this is possible in part because our language does not depend on correspondence between something out in the world and a word used to describe it. If it did, we could not speak of unicorns or utopias. Central to this insight is an alternative understanding of categories, an expanded role for metaphor, and an appreciation for the efficient and creative work of compression. Categories are based on prototypes and fuzzy boundaries and are not defined by objectively assessed shared properties. Nowhere in our brain is there a circle labelled 'mammals', containing animals that give birth to live babies, nurse their young, have hair, have three middle-ear bones, a neocortex and are warm blooded; we may have a prototype for 'mammal' or 'marriage' that includes some animals or some relationships but not others. As Lakoff argues, we organise the items in our world into categories and 'tend to attribute a real existence to those categories' but categories can mask differences and create similarities.[9]

Moving from a literal meaning theory of language – where language is a system of correspondence between a word as sign or symbol and something out there in the world – to one which views meaning as embodied, metaphoric and conceptual – has extraordinary implications for literary and theatre theory, since it counters Saussure – and thus much of Derrida and Foucault, as F. Elizabeth Hart has argued – but also returns the body to a historicised, politicised, relativised understanding of contingent meaning.[10] The conceptual metaphor theory of Lakoff, Johnson and Mark Turner argues that we project information about our experience in our bodies onto more abstract concepts in order to understand the more abstract in terms of the concrete and physical.[11] Our experience crawling from one side of the room to the other in the first year of life shapes our conception of life as a journey with a beginning, middle and end – and possible detours, rough patches, etc. When pouring water into a glass we notice that it goes up the more we pour so we use that to understand the stock market going up or the crime rate falling. In this view, it is not that we use metaphor to suggest meaning; metaphor is how we construct meaning.

Gilles Fauconnier and Mark Turner have shown that some things are not metaphors but rather blends of more than two concepts or 'mental spaces'.[12] Conceptual integration theory (or blending) suggests that we use compression in all of our thinking and speaking as a way of connecting

networks of associations, from the concrete and physical to the abstract or theoretical. We compress and selectively project information from two or more mental spaces to create a third blended space that can contain emergent properties not available in the input spaces. This is not a combination or a blurring of two ideas, it is a complicated network evoked and integrated to create a new idea. Maps are an excellent example of compression: we compress a large and infinitely detailed physical environment into a scale most useful for driving, say, or tracking wildlife. As Mark Johnson reminds us, maps are not actually there: 'We do not experience the *maps*, but rather *through them* we experience a structured world full of patterns and qualities.'[13]We do not experience maps, rather we experience what the maps make it possible to perceive. Conceptual blending theory seeks to understand the way in which language creates emergent structure – novel ideas, creative leaps and powerful associations.

A turn towards blending theory in the humanities should answer questions important to the humanities; it should be a methodology that unlocks the play and performance experience as a whole. I am not interested in being a disciplinary tourist, but rather a disciplinary ambassador. I want the work being done in the sciences to address and understand the questions we are asking and answering in the humanities and I want the humanities to address and probe the research being done in the sciences. Both cognitive linguistics and literary studies aim to understand language in a rich and embedded way and this makes this combination of fields, I believe, particularly fruitful for dialogue. F. Elizabeth Hart boldly claims that blending theory will

> be the aspect of cognitive linguistics that has the most lasting impact on literary studies, and here, in brief, is why: theirs is a theory of meaning that acknowledges the postmodern problematics of interpretation (the view of where we've been) while at the same time addressing our need to comprehend the mechanics of even imperfect meaning and interpretation (the view of where we'd like to go).[14]

What she is speaking to is the dead-end of poststructuralist conceptions of language but also the incredible importance of contingency in meaning. Conceptual blending theory can expose the conceptual structures that keep problematic narratives and paradigms in place and offer a tremendous tool to those of us wanting to know how and why stories are told by bodies onstage. There have been several important works integrating blending theory into literature, though fewer examining its impact on theatre scholarship.[15] An application of blending theory to theatre and performance confronts the complexity of a meaning-making event that includes the

bodies of the participants, unlike literature, for example, where the character's body remains constructed out of words.

Natalie Bainter begins her chapter, 'An Exercise in Shame: The Blush in *A Woman Killed With Kindness*', by referencing Eve Kosofsky Sedgwick's analysis of shame as a performance and continues by arguing for an appreciation of the very situated and embodied blush required of this performance. Affect theory provides a way of rendering visible the work done through affective investment or evocation. To understand shame, for example, as a social process that stages 'lines of connection between people and ideas' is to move it outside the individual and to understand it as a force at work within and among a social group. Bainter (leaning on the affect theory of Tomkins and Sedgwick) situates the blush of shame in Thomas Heywood's play as generating at once painful individuation and relationality: the moment reveals, for the main character, the 'lines of interest' between her and the other characters and these entanglements speak to social discourses around marriage, money and friendship. While Heywood's character can blush theoretically, when the actor actually blushes, there is an embodied reaction at work within the actor and among the spectators. Bainter laces together affect theory, cognitive science and performance theory to think about shame – and the staged blush in particular – as a constituting element of the theatre.[16]

John Lutterbie's contribution asks us to re-imagine the performance event – whether the performance of every day life or the staged spectacle – through the lens of Dynamic Systems Theory (DST). Originating in mathematics and chaos theory, DST complicates a traditional linear narrative of cause and effect by seeing systems at work as complicated ecosystems. A perturbation in the system may affect many elements of the system that will then cause further perturbations and adjustments. Our actions are in flow; we are 'wayfarers' through an event, adjusting our actions, our gestures, our language, according to the flow of the dynamic system of which we are a part. DST, for Lutterbie, offers a way of thinking about the self in relationship with its environment that avoids the language of subconscious psychology or ideological control, without necessarily debunking the role that memory or social structures play in our lives. Lutterbie laces together research on the interconnectedness of gesture and thought with DST to analyse the way performers might make meaning, in the moment, with their whole body. As Lutterbie asserts: 'gesture does not illustrate or augment the spoken word but is instrumental in the formulation of thought and the articulation of discourse'. Shifting our perspective to see an ecosystem, a process in flux, might alter how we imagine the performance of self in everyday life.

Naomi Rokotnitz examines two contemporary plays about the failing bodies of towering intellects and unveils the way in which performance can foster intellectual flexibility and generate expansive empathy. More than an application of cognitive science research to the study of literature, Rokotnitz's chapter theorises 'performance-studies as a form of scientific inquiry'. What she suggests is that through engaging with the performance of these plays, the lives of the bodies coming to their ends, the audience is able to learn a richly personal, and scientific lesson about wisdom and healing. In her chapter, 'Between Faulty Intellects and Failing Bodies: An Economy of Reciprocity in *Wit* and *33 Variations*', Rokotnitz reads the plays at the same time as reading the reception of the plays on their audiences; it is not just that these plays are about coming to wisdom through illness, through the staging, the audience can experience the elevation that the characters experience, without the physical demise.

The chapters in this section take bodies very seriously. The actor called upon to speak the playwright's words communicates with and through his or her body – wait. No. To say that the actor communicates with and through her body suggests that meaning is separate from the body and that the body is an instrument or conduit. This is not quite right. These chapters use the insights found at the intersection of theatre, performance, cognitive science and affect theory to put pressure on our conceptual categories. One looks through time – and cognitive science and affect theory – at the performance of a blush in Thomas Heywood's play *A Woman Killed with Kindness*. Another takes seriously the variations and swerves from the score in performances of every day life and thus processes the rich conceptual content within gestures given the dynamic systems theory that makes sense of the open-systems within which we live. The third reads two contemporary plays as staging embodied cognition. Each pushes us to re-imagine text that can touch us, performance that escapes us, and bodies that stage us.

4

An Exercise in Shame: The Blush in *A Woman Killed With Kindness*

Natalie Bainter

Shame, in its everyday occurrence, as Eve Kosofsky Sedgwick has argued in *Touching Feeling*, is theatrical performance. As a form of exposure indicated by the 'fallen' face or the rosy blush, 'shame effaces itself; shame points and projects; shame turns itself skin side out; shame and pride, shame and dignity, shame and self-display, shame and exhibitionism are different interlinings of the same glove'.[1] The diffusion of a blush articulates shame across the skin in the same way that a dramatic climax courts a revelation or unveiling. But what happens when the blush is actually brought *into the theatre itself*? Just what can one do with a blush onstage? As a performance event – one which, presumably, requires rehearsal – the blush produces a rich nexus of epistemological concerns that require the engagement of a variety of disciplinary fields: namely, Affect theory, Cognitive Science, History of Science, and Theatre and Performance studies. Thomas Heywood's early modern domestic tragedy, *A Woman Killed With Kindness*, constellates the interests of these diverse fields in a particularly fascinating way by dramatising the humoral body – its instability, sociality and instrumentality.

The blush in Heywood's play is an excellent place to study the 'premodern ecology of the passions'.[2] It can tell us something about the historical relationship between shame and the early modern experience of the humoral body, and also about the relationship between the humoral system and the perceived powers of the early modern actor. In her book, *The Body Embarrassed: Drama and the Discipline of Shame in Early Modern England*, Gail Kern Paster argues that for materialist historians looking to recover the early modern body, drama offers a particularly rich archive because 'it promoted a new form of commercial enterprise, depending for signification on the self-conscious relationship between, and control over, practiced bodily behaviors and the professional mimesis of affect'.[3] Although Paster herself does not examine the blush or *A Woman Killed With Kindness*, the play, both performatively and thematically, upholds her assertion that 'the

experience of bodily shame [was] a form of social discipline in early modern English culture.[4] *A Woman Killed With Kindness* concerns itself, as the title would suggest, with the destructive power of the passions on the humoral body, marked by 'its physical openness but also by its emotional instability and volatility.[5] The bodies that populate the play's narrative are plagued by all sorts of physiological disturbances: fiery lusts and rages, unbearably painful bouts of melancholy, and most striking for my purposes, burning blushes that paint flesh with the intensity of shame.[6]

But if for Heywood's characters blushes indicate a part of the struggle to control the humoral body, for his actors, they could paradoxically become prompts for incredible displays of virtuosity and skill. Joseph Roach's groundbreaking book, *The Player's Passion*, argues that 'the science of acting'[7] in the seventeenth century, informed by humoral science and medicine, ensured that the virtuosity of an actor was determined by his perceived ability not merely to exhibit emotion, which anyone could do, but to demonstrate control over it: '[the actor's] art requires him to set his bodily instrument in expressive motion, not by freeing his actions, but by confining them in direction, purpose, and shape.[8] This privileging of control and measure over outright display sprang from fears about the moral and health risks associated with the profession of acting, to the bodies in the audience, but even more so to the body of the actor. Roach suggests that for someone like Heywood, who was such a large proponent of the early modern theatre, it was important to de-emphasise the dangers of the stage and instead highlight its instructive capabilities.[9] Just as Roach indicates that the unwieldiness of the actor's body as a humoral being became the ground for his art of control, Paster explains that the hallmark vulner-ability of the humoral body, be it actor or everyman, can also be inflected positively as 'a demonstrable psychophysiological reciprocity between the experiencing subject and his or her relation to the world.[10] *A Woman Killed With Kindness* cleverly navigates the difficulties of experiencing and staging emotion by thematising the problem of affective management itself, beyond the constantly threatened boundaries of the humoral body in everyday life and stage performance, by revealing that body to be situated in a network of relations with the outside world.

If, as Blair, Cook, Rokotnitz and others have argued, theatre and science can both benefit from experiments that seek to discover how empathy, the theatre's 'stock and trade', works in its particular environment, and how performance can effect changes and create bonds in the embodied minds of its audience members and actors, then a performance of Heywood's play could be a crucial test case.[11] *A Woman Killed With Kindness*'s tragic plot and inherent didacticism tells us that it seeks to teach something to its audience,

and yet, as many critics have argued, it is notoriously ambiguous in terms of its moral centre.[12] This ambiguity is reflected in the blushing faces of various characters in the play, indicating shame for wrongdoing that could make audiences in a performance context empathise with a variety of different characters for different reasons. The play's instructive tint that lacks a stable empathic target is precisely what makes it so productive for those looking to bring together the fields of Cognitive Science and Theatre and Performance Studies, in order to find out how we do emotion in the theatre and on the stage now.

What is truly exciting is that recent scientific research about shame, embarrassment and blushing suggests that these emotions and their associated expressions are 'prosocial',[13] and/or 'commitment devices'[14] that might very well aid the trust-building and empathic processes of the theatre. This would mean that plays which 'do' shame and blushing, like Heywood's, offer a fruitful ground for those researching not only the workings of theatre and performance but also the expression of these particular emotions in a group context that goes beyond 'the dyad in a lab'.[15] Above all, what seems to coalesce around the blush is the possibility for exploring what may very well be, as Robin Bernstein has argued, a fundamentally constitutive relationship between theatre and shame that we have good reason to study because of shame's potential consistency across these discourses and time periods – its communicability, its productive capacity in terms of identity and social bonds, the strong case it makes for an embodied mind that thinks/feels together in the way it is experienced, its phenomenology – all are features that inflect Sedgwick's claim in the other direction, namely, that the theatre too, is lined with and depends upon the operations of shame.[16] In other words, following the blush onto the stage could transform the way we in Theatre and Performance Studies understand the theatre.

A Woman Killed With Kindness is explicitly a drama about shame – a newly-married woman, Anne, proclaimed to be a shining example to women everywhere on how to be chaste and virtuous, cheats on her husband, Frankford, with his live-in best friend, Wendoll, after what is surely one of the strangest and least titillating seduction scenes in English literature. The husband, devastated by this betrayal from the two people he loves most, instead of a harsher punishment that would involve physical harm, banishes her from their household, forbidding her to see him or their children as long as she lives. The best friend disappears, never to be heard from again. The exiled wife vows, in vain hopes to cleanse herself of sin, that she will never again ingest food or drink. As can be expected, this vow has fatal results, and as she lies on her deathbed, she is forgiven and reconciled by her husband just before her last breaths, killed by his relative kindness in light

of her transgression. Meanwhile, moving in tandem with this main plot, a nobleman, Sir Charles, engages in a hunting contest with Anne's brother, Acton. After being accused of cheating by Acton's servants, Charles kills two of Acton's men in a frenzy of unexpected violence. Disgraced, Charles is thrown in jail. After several unfortunate decisions that lead to Charles being penniless but released from jail, he is tormented by Acton, who has villainous and lustful feelings for his chaste sister, Susan. Charles is prepared to offer up his sister to regain his place and estate and pay off his debt to Acton, when a strange transformation brought on by her Susan's virtuous character turns Acton from hateful lecher to love struck admirer. The two are married, and Charles is saved.

From the outset, it is clear that Heywood's *A Woman Killed With Kindness* sets up a lesson meant to instruct and to shape the audience. It has all the surface marks of a didactic play – people do wrong according to the social structures that govern acts and behaviours and are punished for their transgressions. At the level of the text, the assumed misconduct of characters manifests in their verbal exclamations and bodily displays of shame, which usually take the form of a blush. The most simplistic reading for shame in *A Woman Killed* takes the didacticism of the play to heart: by cuckolding Frankford, Anne and Wendoll are guilty of wronging him and of deviating from the systems of friendship, property and marriage and therefore *should* feel ashamed, just as Sir Charles should be ashamed for killing Acton's men and for all intents and purposes losing his family's estate. By this logic, the play presents its lesson by dramatising instances of shame made available by the prevailing social systems, seeking to perfect its audience and their own affective investments in the world, while maintaining such systems: women, love your husbands and be true to them; husbands, love your wives but keep close watch over them; male friends of husbands, don't overstep your bounds. However, if we concentrate on key moments where this shame actually marks bodies – the play's blushes – in light of recent work in Affect theory, the seemingly straightforward lesson of Heywood's play gives way to a certain murkiness regarding just who is is fault for the way these tragic events conclude. Who indeed. In fact, the play seems to dramatise a lack of self-knowledge when it comes to understanding how one's individual feelings are part of larger social arrangements that compel feelings to flow in certain directions. Blushes transform *A Woman Killed*'s seemingly straightforward stories of shame into a homiletic on mismanaged affection, revealing it to be not only the theme of the play but also, through performance, a kind of cautionary tale that can enact and produce its own corrective.

A Woman Killed is filled with humoral bodies out of sync and out of whack, to the point that the prevailing representation of humanity found

in its scenes seems defined by extreme fickleness and the ability to be easily swayed by passion.[17] As Frankford laments after finding Anne and Wendoll out, 'Man, woman, what thing mortal may we trust/When friends and bosom wives prove so unjust?'[18] Quite significantly, most of these bodies are *male*, seeming to refute the early modern sensibility that the bodies of women were most susceptible to seizures of passion.[19] From the rages of Sir Charles that lead to murder and defamatory speech; to the fires of passion that prod Wendoll against his own better judgement to dishonour the lady of the house and disgrace her husband, his best friend; to the sick body of Nicholas, which seems much more than tenuously connected to that of his master's; to the rapid hate-turned-lust-turned-love of Acton for Susan, the bodies of Heywood's men are precariously out of joint. There seems to be something rotten about the structures that fashion the bonds between men, in the sense that the affective investments that connect them to each other appear to be weak, ill, and too easily exchangeable.[20] At a moment when the scientific model of the body viewed any influx of passion as harmful, and health was indicated by careful control and direction of emotion, the bodies in Heywood's play suggest that even before the acts of adultery that make up its plot have been committed, all are far from well and good.

How are we to read moments of shame in a play with such a noxious and unruly affective landscape? If shame's customary function is to mark one's emotional undoing by a misdeed in the realm of the social, how can that logic apply to such a disorderly social body? If all shame can reveal is evidence of an individual's realisation that they have behaved badly, than *A Woman Killed*'s blushes remain unremarkable, but if shame is itself a way of accessing the social, then these reddened cheeks have much more to tell us. In *Blush: Faces of Shame*, Elspeth Probyn says that although understood primarily as a negative emotion, shame, and its physiological marker, the blush, actually serves as a productive instance to re-evaluate one's place in the world. Following the arguments of Silvan Tompkins about affect and emotion as they are rendered by Eve Kosofsky Sedgwick and Adam Frank, Probyn begins with the 'initially startling idea that shame and interest are intimately connected.'[21] Probyn reads interest as 'constitut[ing] lines of connection between people and ideas ... an affective investment we have in others', and moments of shame as when 'we feel deprived' because 'that investment is questioned and interest is interrupted.'[22] Most significantly, 'only something or someone who has interested you can produce a flush of shame', so that to be ashamed 'compels an involuntary and immediate reassessment of ourselves' as we are connected by lines of interest to that something or someone.[23] In a play with so many faces of shame, and so many moments of bodily distress, Probyn's claims provide a way to read *A*

Woman Killed's blushes as potential challenges to the systems of marriage and property it presents over the supposedly empowered or oppressed deeds of its characters, or even their good or bad behaviour; they multiply and complicate the possible targets of audience members' empathy. The ends of such potential in performance are all dependent, as we shall see, on (our) interest.

From its very first blush, it becomes clear that with regard to reasons for a character's shame, the play provides more questions than answers. Approached by Wendoll, her husband's best friend, who confesses that he is beside himself with guilt for the passion he harbours for the lady of the house, Anne skillfully and correctly fends him off by reciting all the reasons why his affections cannot come to fruition. But almost as quickly as she provides these explanations, her 'soul [begins to] wand'r', and her body seems to turn against her:

> I ne'er offended yet.
> My fault, I fear, will in my brow be writ.
> Women that fall not quite bereft of grace
> Have their offences noted in their face.
> I blush and am ashamed. (6.152–6)

Why is Anne blushing? What reason has she to be ashamed, when she's behaved exactly as she should? The simplest answer, that she is ashamed because she's thinking adulterous thoughts in response to Wendoll's seduction, seems unsatisfying, given how resistant she is to his advances, and the clarity of her logic as to why she can't reciprocate suggests that she is wisely wielding reason against what might be a potentially overwhelming wave of passion radiating from his body, so as not to be swept away herself.[24] As Andrew Fleck and Danielle Clark have argued, the blush is a notoriously tricky sign to read in the early modern period, because it can signal both guilt and innocence or shame and modesty, and often both simultaneously.[25] That the blush tends often to 'signify in both directions' is certainly true, but I believe that merely to acknowledge its ambiguity does not get us any closer to what is really interesting – *why* the blush does that here in this particular narrative.[26]

Sedwick's work on shame after Tomkins is helpful here. According to Sedwick, a moment of burning shame makes 'a double movement … toward painful individuation' and 'toward uncontrollable relationality'.[27] At the same time that one feels an unbearable sense of self and one's body exposed – 'It is me who did this shameful thing' – one also cannot escape the gaze of those against whom one has transgressed – 'These are the people I've wronged from whom I want to hide because I am ashamed.' Moreover,

Sedgwick explains that the connection between these two modes – individuation and relationality – is realised in the moment of shame, and felt, as the boundaries that make up one's body burn precisely because they are being percieved with white-hot clarity by others. It seems to me that Anne's blush projects, as if her skin were a screen, the social discourses that tie her, Wendoll and Frankford together, and her own place in each of those discourses: friendship, marriage, landed aristocracy and householding. Her blush makes the lines of interest between her, Frankford and Wendoll apparent in their arrangement for the first time, and reveals how they have become entangled in the conflation of these discourses, which, while not necessarily mutually exclusive, require different and carefully managed affective investments.

At least one facet of this entanglement concerns how the bonds created between Frankford and Wendoll bring their bodies closer together than that of him and his wife after Wendoll becomes a permanent fixture of the house. Whereas Anne is an 'ornament' to adorn and set off the perfection of Frankford's life, Wendoll has become a part of his flesh: 'My husband loves you ... He esteems you even as his brain, his eyeball, or his heart' (6.114–15). Anne's language here makes Wendoll not just any part of Frankford's body, but a vital one, and she continues what Wendoll, in his guilt, says of their relationship several lines previously:

> He cannot eat without me
> Nor laugh without me. I am to his body
> As necessary as his digestion,
> And equally do make him whole or sick. (6.40–3)

This suggests that at the least, Wendoll aids Frankford's body in its everyday operations, as if he were a kind of prosthesis. More dramatically, this also suggests that Wendoll animates Frankford's body with good or ill spirits, altering his very constitution in the way that food, disease or the elements could. Both characterisations make Frankford rather vulnerable and somewhat powerless in his capacity to perform the everyday operations of life without Wendoll, some of which constitute his relationship with his wife.

While inviting Wendoll to become a part of his house seems to be an exercise of Frankford's power through generosity, it actually diminishes that power when Wendoll is made, for all intents and purposes, to replace him.[28] Frankford offers Wendoll servants, horses, room and board, and the chance to be his 'companion' while commanding Anne to 'use him with all thy loving courtesy' (4.78). All these things seem relatively harmless were it not for the fact that Frankford is frequently not at home, and Wendoll soon

becomes a 'present Frankford in his absence' (6.79). Combined with the bodily and prosthetic metaphors, this makes for a constantly diminishing and disappearing Frankford, and an ever-more present and potent Wendoll. Even more telling, Wendoll articulates his relationship to Frankford in the language of marriage. He describes his image being lodged in Frankford's 'bleeding heart', and that same heart as 'joined and knit together' to his own (6.50). That his body should be flooded with feelings for his master's wife seems to make sense, given that their hearts have become attached: the same blood, which carries the passions, flows through both of them. This makes Frankford's condemnation of Anne when he discovers her adultery – 'It was thy hand cut two hearts out of one' – apparently inaccurate; he should have said three (13.185).

If Anne's initial blush opens up the possibility of critiquing a system that would allow Frankford to so mismanage his relationships, then his own blush confirms its instability. On catching Anne and Wendoll sleeping together, Frankford is touched by shame that reveals his own part in their affair:

> Spare thou thy tears, for I will weep for thee;
> And keep thy countenance, for I'll blush for thee.
> Now I protest I think 'tis I am tainted,
> For I am most ashamed, and 'tis more hard
> For me to look upon thy guilty face. (13.84–8)

The sense of connection between the three people is highlighted here by language of contamination and exchange, characterising their roles and the feelings that go with them as interchangeable. Frankford's blush seems to indicate how 'shame illuminates our intense attachment to the world, our desire to be connected with others, and the knowledge that, as merely human, we will sometimes fail in our attempts to maintain those connections'.[29] However, this makes Frankford's punishment of Anne and her striking response all the more sinister: by banishing her from the house, Frankford strips away all of the components of Anne's affective investments in social relations – those with her husband, her children, her servants and her guests.[30] In other words, he cuts the lines of interest that bind her to life.[31]

Anne's self-starving simply continues what Frankford's punishment begins, and given the entanglement of bodies and feelings cited earlier, it too makes a kind of chilling sense. Her starkest moment of shame opened up the possibility for a kind of self-transformation, although I would not call it a celebratory one. Probyn argues that 'for an anorexic consumed by shame, self-loathing, and tragic pride', a consideration of 'the affective complex in which [he/she is] imprisoned' seems a much more productive

direction towards treatment than an assessment of his or her drives for sex or food.[32] The affective complex that holds Anne consists of the entanglement which tied Frankford, Wendoll and her hearts together, and her desire to maintain these affective connections while simultaneously subtracting the bodily operations in which these connections are felt in light of rejection. According to Probyn, 'shame produces a somatic temporality, where the potential of again being interested is felt in the present pain of rejection. It's a strange hope but a powerful one.'[33] It is not the drive to death that causes Anne not to eat, but the desire to remain connected to those with whom her bonds were cut – a desperate attempt at an affective overhaul.

All this leads up to the most mysterious and unstable blush in the play, whose appearance demands an immediate assessment from the onstage characters, and the audience as well. Just prior to Frankford's last moments with his estranged wife and consequently, her last minutes on earth, Anne demands those at her bedside to interpret the root of her shame via her face:

> Blush I not, brother Acton? Blush I not, Sir Charles?
> Can you not read my fault writ in my cheek?
> Is not my crime there? Tell me, gentleman. (17.55–7)

Charles replies that 'Alas, good mistress, sickness hath not left you/Blood in your face enough to make you blush' (17.58–9). Anne's sick body stifles her blush and her shame 'like a friend', while still registering its power.[34] Anne's question is ultimately about the evidence of her shameful deed: if there is no blush to indicate her shame, has she been absolved? If the blush's previous appearance put the composition of her social relations in relief, then its failure to appear now signals how successfully she has been severed from them. But it is also possible and tempting to read Anne's unblush as a form of 'no body, no crime': if we cannot see the evidence of her wrongdoing now, is it possible that she is somehow not to blame? Unlike the other two blushes, which heavily implicate the play's characters, this felt blush that cannot be seen seems also to make the audience astonishingly complicit; it demands we assess if Anne is guilty or not, if her shame is warranted, and if she should be in the position that she's in. Namely, it asks directly who we should empathise with and why.

Anne's unblush presents the most difficult performance challenge in Heywood's play, a challenge that is amplified by the humoral understanding of the body. It asks the actor to be overcome by strong negatively experienced emotion but for his body not to evince that experience at the level of the skin. In fact, it asks the actor to express the opposite physiological response to the one that is expected: rather than allowing a redness to bloom in his cheeks, the actor must blanch or remain excessively pale here, and yet still communicate

that the character feels sincerely and profoundly ashamed. In performance, Anne's question makes the actor, to use Roach's phrase, 'call attention to his virtuosic physiognomy' – a breathtaking finale to a play filled with blushes, and – if actually achieved – a triumph of the actor's control over the unruly humors in his body.[35] If we take Roach's claims to heart about the effectiveness of an actor in the early modern period as amounting to their ability to stifle passion, and therefore radiate its effects all the more powerfully, then this moment in performance could potentially shame the audience in profound ways, both because it concerns the expression of shame, and also because it may cause the audience to reasses for whom they had been feeling.[36]

According to Roach, 'within a given role an actor could be expected to effect sudden, highly visible transitions between passions in the length of a speech or even a single line', such as switching pale pallor to a blush, but calling up such passions was considered highly dangerous, given that although a passion can be 'shaped into outwardly expressive forms' once unleashed, it 'cannot be suppressed'.[37] After such passions were summoned, they required some amount of stifling and proper channelling, because left unchecked, they could disturb the 'equilibrium, balance, and proper mixture' of the humors, and cause great distress to the body and mind.[38] Therefore, plays that called for rapid shifts in passion and for particularly violent, intense, or negative emotions threatened the body of the actor and those around him, for 'the actor is the source and focus of a process, an action that begins with his own body and quickly extends beyond it'.[39][40] But if the body of the actor and his auditors are so entwined, then how could a display of passion such as the blushes in Heywood's play not function as the kind of gateway to illness and immorality that the anti-theatricalists so feared?

In order to appease those who would say that the morality of the theatre is questionable because of what it can do to the bodies of those who frequent it, then, actors and playwrights should strive to produce and direct the right measure of emotion, the 'inward delight [and] soft smiles' suggested by the prologue of Beaumont and Fletcher's *The Knight of the Burning Pestle* rather than 'outward lightness [and] loud laughing', for example.[41] In her article, 'What Was Performance?' Mary Thomas Crane explores the various understandings of performance, acting and the processes of the theatre in the early modern period. Crane explains that the anti-theatricalists constantly expressed the theatre's danger in terms of its ability only to 'show' or 'display' a powerful illusion or representation that could profoundly alter the audience's affections and cause them to lose touch with the moral reality.[42] Conversely, for those who defended the theatre's practices, especially those ones who also trod the boards, performance operated through 'a process that produced a material improvement in the skills of those who practiced it', and

as a form of instruction for the audience via 'the kinesthetic experience of their performance'.[43, 44] Therefore, through repeated performance, not only did the acting simply get better, but the potential for the actors to instruct and perfect their audiences increased as well. This characterisation of the actor's power upheld the humoral model of the body that Roach explains was prevalent in the early modern period, while adding the suggestion that that through repetition, performance could be an exercise in perfection.[45]

Actors then, need to provide the affective flexibility necessary to satisfy the performative goals of the time, and to keep the spectators in thrall at the theatre, while exercising their moral muscles. Hence, *A Woman Killed With Kindness* provides just the right text to animate into an instructive performance, because it demands a relatively large amount of virtuosity from its actors – dancing, playing musical instruments, acting, flying into sudden rages, quite a fair amount of blushing and blanching – and it expressly points to those moments in the text.[46] Roach explains that the humoral system provided a better way to account for 'blood draining from an actor's face or a fire sparkling in his eyes and raging crimson in his cheeks – on instantaneous command and at precisely the proper moment' than other historically-situated scientific understandings of the body, and as Paster claims, it also solidified the cultural significance of the actor's craft, who employed 'an affective and physical control so masterful as to quell, if only for a time, the inner turbulence of his own humorality'.[47] Thus, the good actor perfectly modeled the management so crucial to the humoral system's view of health. With pliable actors acting as fitness instructors, leading the audience in exercises and modelling the right measure of affective tension, stress, movement and intensity, the danger of all the passion in Heywood's play becomes its biggest asset.

As a moment of shame that suddenly fleshes forth the social field, Anne's suppressed and final unblush, and the boy actor who effects it, compels an assessment of the audience's members' interest, in both the characters on stage and their own part in the systems being dramatised. Rather than determine a singular way audience members will proceed in their investments, this moment of shame serves as a kind of affective exercise that could potentially restructure such investments along several different axes of interest. For example, we might switch alliances from one character to another – from Frankford to Anne as tragic hero, or vice versa – or our investment in ideologies themselves – friendship, householding, marriage, landed aristocracy – might shift. There are ways to read interest into all of the characters, if only because they are so variable in terms of affect. Although Anne's act of self-starvation does serve as a kind of admirable determination and self-control not otherwise exhibited by the other characters, surely the play's tragic conclusion allows us to evaluate whether that act was a bold and

heroic choice, a symptomatic result or fatal error. After her death, Acton's lament to Frankford explicitly makes reference to the complex set of affective investments that resulted in Anne's shame:

All we that can plead *interest* in her grief
Bestow upon her body funeral tears
Brother, had you with threats and usage bad
Punished her sin, the grief of her offence
Had not with such true sorrow touched her heart. (17.130–4, my emphasis)

In other words, had Frankford punished her in a way that did not deny her the affective connections made visible in her shame, she would not have died of affect.[48] It would seem that the one thing made clear by the play is that affect *can* kill a person, but in a more complex way than that which the physicians of the day describe.[49] The way emotion is dealt with is not simply an aspect of someone's temperament or even his or her individual health. It is a moral concern, not just because the seizure of passion makes one personally vulnerable, but also because affect is the lifeblood of the social body, attaching us together in arrangements into which we invest our affection but which also direct where our affections will flow. Heywood suggests that those simply looking for structures to direct the emotions rather than those that would conjure them up need beware of the consequent bonds and contingencies induced by such direction.

A *Woman Killed With Kindness*, then, reads as a clever parable of the humours: rather than only alerting us to the danger of their ability to unexpectedly seize the body, it also dramatises the danger of discounting the particular ways in which our capitulation to systems of power and behaviour organise and direct feelings. Feelings are no less real for having been partially organised from without – they make up the sinew and muscle of worldly relationships, and they animate social life, so that to cut these ties is to make the very body sick, even to kill the desire to live. Unsurprisingly, for Heywood, the theatre provides a kind of antidote to this problem, in the sense that it works directly at the level of the body to effect a process that realigns the interests of its audiences towards perfection in the form of greater self-knowledge about their affective investments, so that they can be managed in a more deliberate way. If the audience can indeed 'record' the process begun by the actor 'in the red-leaved table[s] of their heart[s]' (6.125–6), then the performances of shame elicited by Heywood's play could humiliate the spectators too, illuminating relations that previously remained invisible, those attachments whose pull they were not yet aware of, felt only at the level of a flush on the skin.

Wayfaring in Everyday Life: The Unravelling of Intricacy

John Lutterbie

Experience is a dynamic process of navigating the pathways of ... possibilities. Experience depends on the skills needed to make one's way.[1]

We are wayfarers, wanderers and nomads. Although we praise decisive action, direct communication and well-planned itineraries, we know with relatively little reflection that life is seldom so accommodating, and that giving meaning to events requires the compression and consolidation of experience, excising the noise that permeates our lives. Remembering trips to the grocers or the hardware store, we tend to think in straight lines, connecting one point to another. When Sophia New and Daniel Belasco Rogers used GPS to map their movements through Berlin in an act of 'obsessive self-surveillance' and traced the data onto a map of their neighbourhood, the vagaries of walking the city became clear.[2] While routes may be consistent how we navigate them can vary considerably from one trip to another. Actors prepare a score that will allow them to repeat performances more or less precisely from night to night. They know however that they will need to adjust to unexpected variations during performance. The audience will respond differently; other actors will – intentionally or unconsciously, significantly or slightly – alter the contours of their performances. Each of these changes will cause a deviation in the course that was set in rehearsal. Scientists, who study human behaviour, calculate statistical averages to draw conclusions from their experiments; recognising deviations exist they nonetheless privilege the norm in order to make truth claims. Considering performance in the theatre or in everyday life requires a different approach, one that embraces meandering from the path if we are to appreciate the nature of complexity.

This claim is not intended to be critical of the prerequisite that experimentation is reductive, because the use of cognitive science in the arts and humanities depends on the insights gained in the laboratory.[3] But when we

turn our attention to lived experience, the complexities cannot be easily set aside. In the remaining space, I want to outline a theory that takes into account the multiplicities of daily life, by considering the interleaving of different modes of expression in the emergence of behaviour. However, given the complexity of the project, it is necessary to adopt a metonymical approach, in hopes that the limited parameters of the discussion will allow conclusions to be drawn that are transferable to other realms of experience. The focus is on gesture, and the argument set forth by David McNeill, Susan Goldin-Meadow and others that understanding everyday activities depends on understanding that people are dynamic systems. To this end a brief overview of Dynamic Systems Theory (DST) will be followed by a discussion of gesture and its relation to speech in the formulation of thought in expression. Concluding remarks will suggest that this model of multi-modal expression is relevant to all aspects of human activity, onstage or on the street, and can be seen as a foundation for understanding creativity.

Dynamic systems

Tim Ingold, in *Lines: A Brief History*, differentiates between wayfaring and mapping. The latter is based on connecting the dots between locations based on the now refuted claim that the shortest distance between two points is a straight line. The concept of wayfaring, on the other hand, recognises that getting from point A to point B (even if it is ostensibly a straight line) runs up against a variety of obstacles, from changes in the environment to encounters with other beings and the vagaries of the wayfarer's physical and psycho-logical state. I turn to this distinction as a way of differentiating between systems that are closed or linear and open or dynamic. Like connecting the dots, closed systems are not influenced by outside forces but are self-contained and, as long as there is not a break in the sequence, will lead to the same result every time, as when a light switch is turned on. Dynamic systems are not so predictable because they are continually responding to the influx of data from the environment, whether internal or external. Spurring a horse causes the animal to shift from a trot to a gallop, while reining in brings it to a stop. Nervousness at the beginning of a talk will dissipate as the speaker gains confidence, or intensify if insecurity reigns. Open systems are not self-contained, but are influenced by shifts in the environment.

A dynamic system can be reduced to four structural elements: control parameters, attractor states, perturbations and phase shifts. Control param-eters, sometimes called boundary conditions, define limits that contain the range of play available within a system. Discussing humans, Shaun Gallagher

focuses on two types in *How the Body Shapes the Mind* (2006): body schema and body image. Resisting attempts to conflate the two, he defines body schema as limitations determined by the structure of the body– unlike owls we cannot turn our heads to see what is behind us – and body image or how we experience ourselves. The schema is 'hardwired', at least to a degree: the normative body has two arms, limited peripheral vision, and tends to stand on two legs. Body image, on the other hand, is open to frequent permutation based on external and internal cues. The image of the self is different when at the library than at a rock concert, when ill than when healthy. Control parameters are, therefore, both biological and cultural. They do not determine behaviour but are parameters that restrict and influence choices.

Attractor states, in this context, are preferred modes of behaviour, and whenever possible the system will resolve a disturbance in the system by using these. They are similar to what Marcel Mauss defines as *habitus* or Louis Althusser associates with ideology: learnt techniques and ways of being that link personal experience to social and cultural norms. We prefer to walk rather than crawl, define ourselves as introverts or extroverts, conservative or liberal. Attractor states are privileged ways of behaving because they provide some degree of pleasure or freedom from discomfort,[4] and are instrumental in defining a self-image. Because they are learnt and habitual, they tend to be relatively stable and serve as default positions under certain circumstances. The metaphor for defining their power as default settings is a ball in a well. The deeper the well, the more energy is needed to move the ball out of the well, while comparatively less is needed when the well is shallow. Eating with chopsticks or reading from right to left are habits that are incorporated over time and very difficult to break. Others, such as using a new app or acquiring a taste for oolong tea are not as ingrained in experience and therefore do not exert the same degree of influence on behaviour as those that are stronger attractors.

A perturbation is an event that pushes the ball out of the well, destabilising the system. For a period of time, determined by the intensity of the disruption, no attractor state is immediately available to return the system to an approximation of homeostasis. The experience of suddenly losing a partner with whom there has been a long-standing relationship causes significant anguish in part because the ways we have become used to behaving no longer provide the stability (pleasure or absence of distress) we have come to expect. Over time, we most often adapt our behaviour, devising new attractor states that allow us to move on with our lives. Not all perturbations have such devastating effects. Moving from Seattle, where water is expected to be in the West, to Boston, where it is in the East, can be disorienting, but it tends to be of relatively short duration and not traumatic.

Perturbations can also be caused by changes in the internal environment, such as the onset of illness or disability, resulting in increased anxiety or they can give rise to creative solutions.

Through experience behaviours develop in response to different kinds of perturbations. The greater the array of attractor states to draw on, the less time it will take to resolve the disruption. Through repetition certain inputs will give rise to predictable results, requiring a limited amount of energy to affect the response. The state caused by a greater influx of energy is called a phase shift, and requires the movement from one attractor state to another. Runners, when changing speeds, will experience momentary disruptions in breathing until they engage the rate of inhalation and exhalation that is required of their new gait. The more familiar the situation, the quicker the shift will take place, while in new or less frequent disturbances it can take longer to adapt to the change. Furthermore, the more often a phase shift is experienced the less conscious we are of the changes that take place, a sign of our adaptability as a species. In most situations, attention is not paid to the effort it takes to maintain our balance, something that a child needs to focus on intently as it learns to walk.

When silicon oil reaches a certain temperature it shifts from the seemingly random motion of boiling into a honeycomb pattern that is determined, in part, by the viscosity and chemical make-up of the substance.[5] The four aspects of the dynamic systems model are evident: an initial state that is perturbed by changes in the environment (the addition of heat), causing a degree of turmoil as it shifts from one state to another, and is resolved by the appearance of a different attractor state (the pattern) in accordance with the parameters or the physical properties of the substance. This example is useful because it is simple, and variables such as atmospheric pressure and the surface of the container can be accounted for with relative ease. It is more difficult when the focus shifts to human experience and the need to deal with multiple systems. Looking at the fire in the grate, I am aware of the sound and smell, and feel the heat in addition to visual perceptions of the flames. Moreover, I am also aware of the feelings of comfort and discomfort in my body, and whatever concerns I have about what I should be doing instead of sitting by the fire. The accumulated effect of these variables determine to a large extent whether or not I remain engaged in this activity or get up to do something else.

Human activity is extremely complicated. Attempting to understand all the variables that go into thinking about writing this sentence while I get a cup of coffee beggars the imagination. It requires a rapid shift of attention back and forth from getting the drink to formulating the idea. Implicit memory plays a significant role. I know how to get from the computer to the kitchen without thinking about how to walk or where to go. But while

I know what to do, I still have to attend to the amount of coffee in the cup. These physical activities provide a respite from figuring out the best syntax to communicate what needs to be said, although the process of contemplation continues unconsciously. As I reach for the milk, I suddenly have a better sense of how to articulate this thought. To appreciate the processes by which multiple forms of information are brought together in experience, it is perhaps necessary to look at a delimited example that, while far from simple, can provide a model for understanding the complexity of experience. To this end, I examine the relationship between language and gesture in the evolution of thought.

The nexus of language and gesture

We tend to be more conscious of language than gesture, because we consider the former to be the preeminent domain of human beings, that which separates us from other species. The primary reason for valuing speech so highly is our belief in its ability to translate our thoughts into an expressive form that communicates preexisting ideas. We believe this despite the frequency with which language fails us, or we believe it fails us. Those moments when we cannot find the right words, either the words that come to mind are imprecise or our minds go blank, are frustrating because we know what we want to say. Recent work in Neural Theory of Language challenges this assumption by questioning the relationship between language and thought. 'Common sense' tells us that we have an idea and we search for the appropriate terms to communicate it. The difficulty with this formulation is that it assumes a homunculus (a little person in the brain) who is constructing the ideas and searching for the words. Once such a central authority is removed, the sequence becomes less obvious. Jerome A. Feldman approaches the linguistic process from the position of DST.[6] From this perspective the intent to speak lacks form and gains it only through the emergence of language: finding the words gives form to thought. But the process is a two-way street. The emerging language is put into a dialectical relationship with the intent, what Eugene Gendlin calls the intricacy, 'an always unfinished order that cannot be represented.'[7] It is a 'zigzag' action, with one informing the other, as the intricacy is given linear form and, in the process, meaning.

Feldman argues that the intention to speak gives rise to memories of experiences, previous linguistic expressions, and associations that serve as frames or boundary conditions for the emerging expression. The context, which can include the ongoing flow of conversation, changes in the

environment, and the return of a thought process that had been fulminating over time, constitutes another frame. The interaction between the impulse, the past (cultural and individual memories) and the current situation give rise to a number of alternatives from which the speaker opts for the one that provides the 'best fit', or that which comes closest to satisfying the intent.[8] Mixed metaphors and incomplete sentences in conversation may reveal instances where the emerging language does not adequately fit the intricacy, requiring a shift to an alternative sequence of words in the case of the former or falling into silence until there is a better fit and the expression of the thought can continue. The conclusion to be drawn is that we know what we want to say only as it takes form in language; and as Derrida and others have claimed, there is always an excess, those aspects of the intricacy that do not find expression through language, those linguistic possibilities that are not expressed. As complex as this formulation seems, it is only part of the story. Were we to stop here, it could be assumed that the process of formulating linguistic structures need only take place in the mental spaces of the mind, or between the mind and the environment, eliding once again the role of the body outside of its sensorimotor functions in perception and expression.

Thought can be expressed without language, as any theatre maker, visual artist, musician or dancer knows. The application of paint, the movement across the floor, or a sequence of chords can express profound ideas without the intervention of speech. Indeed, one of the functions of art can be the communication of the ineffable, that which resists translation into linear forms. The same can be said of poetry. Even in the use of language the poetic juxtaposition of words and images strive, most often, to reveal concepts that cannot be articulated as coherently and powerfully in other forms. Interestingly one word that is used across the arts to communicate the use of technique to express non-linguistic ideas is gesture.

However, gestures are perceived to carry little of the burden when it comes to communication, except when they are deictic (pointing to a destination), symbolic (saluting), or a beat to emphasise a point. In performance gestures stand out when used for a specific and premeditated purpose, such as when a politician conveys command of the issues through the emphatic use of gesture, or an actor playing Macbeth reaches for the imagined dagger. Current research indicates a much more central and important function. In recent years scientific research has focused on the use of gesture in conversation. Two psychologists at the University of Chicago, David McNeill and Susan Goldin-Meadow, study the use of hand movements during the act of speaking, and have come to the conclusion that gesture is more than an adjunct to language: 'there is now evidence suggesting that gesture can do more than *reflect* thought – it can play a role in *changing thought*'.[9] This

behavioural research is supported by studies undertaken by neuroscientists of brain activation.

Developmental psychologists Jana M. Iverson and Esther Thelan in a 2005 article in the *Journal of Consciousness Studies* explore the neural substrates underlying the link between speech and gesture in developing a theory about the connections between them. As proficiency in sensorimotor skills is gained and language emerges, synaptic networks between areas become interwoven.

Four lines of research from neurophysiology and neuropsychology provide converging evidence of links between language and movement at the neural level. These studies have revealed that: (i) some language and motor functions share underlying brain mechanisms; (ii) brain regions typically associated with motor functions (e.g. motor cortex, premotor area, cerebellum) are involved in language tasks; (iii) classical 'language areas' (e.g. Broca's area) are activated during motor tasks; and (iv) patterns of breakdown and recovery in certain language and motor functions appear to be closely linked in some patient populations.[10]

With experience neural patterns evolve that increase the likelihood that under certain circumstances areas of the brain associated with speech and movement will be activated simultaneously. This is particularly true with 'language functions associated with naming tasks (e.g. word retrieval, verbal articulation)'.[11] In other words, gestures or the impulse to gesture are complicit in the retrieval of the words necessary to communicate thought. The unravelling of intricacies into speech for the most part occurs without need of gesture because the speaker draws on grammatical structures that have been learnt through cultural interactions and frequent repetition – readily available phrases and constructs. Everyday speech depends on these habitual speech patterns to ensure the flow of conversation, and often gesture is not required. Movements are more likely to be activated when the words that come to mind are not 'best fits' with the thought to be communicated. For instance, we might put fingers to our lips, or brow, as a means of helping us realise what we are about to say is not quite right. In other words, the gesture embodies the difficulty trying to formulate the thought, while signalling that something different is needed.

George Lakoff and Mark Johnson have developed a theory of embodied metaphor. They observe that the metaphors we regularly use to communicate ideas are founded on physical experiences that are held in common by members of a community. One of these is the SOURCE-PATH-GOAL metaphor, defined by an identified starting point and the means to achieve a desired end. This is an experience infants have when they move towards a desired object, for instance when seeking a source of food to resolve the

feeling of hunger. Gestures associated with CONTAINMENT tend to involve the hands moving towards the body, while the frustration experienced when things cease to cohere are usually expressed by movement away. A colleague, when discussing how elements of the curriculum fit together, places the first two fingers of each hand pointing towards each other and rotates them back and forth, as if threading a nut onto a bolt. In each instance there is an associative connection between what is being said and the gesture. What is more, as Amy Cook points out, 'they are staging the metaphor implicit in the discourse', not just 'at the level of the event or subject, but rather at the discourse level'. She finds this interesting because 'since our metaphoric constructions are unconscious [making use of implicit memory], it means that our gestures are working at that same level'.[12]

The argument presented here is that the gesture does not illustrate or augment the spoken word but is instrumental in the formulation of thought and the articulation of discourse. 'As utterances become common and frequently practiced, the motor repertoire that is mapped with the growing language competence also becomes strengthened. The initial biases to move hand and mouth together thereby cascade into a single coupled, communicative system, where the mental aspects of the expression are manifest in movement.'[13] The integration of speech and movement aids the speaker in unravelling the intricacies of what needs to be said by allowing the integrated relationship between the movement and word choice to give rise to the best fit, that is the successful communication of the idea.

Dynamic systems redux

Like the self-surveillance of New and Rogers on the streets of Berlin, were we to track the use and timing of gesture we would find that patterns arise. Frequently used, well-trod paths of routine speech, common words and phrases that flow off the tongue without the necessary assistance of gestures are attractor states, deep wells that provide stability in everyday interactions. These accepted conversational patterns are formed as we learn to become members of and reflect our position in society, that is, the strata to which we belong and the forms of cultural capital to which we have access. Through repetition, chunks of language are reinforced and become habitual, reflecting a variety of non-linguistic forces, ranging from economic status, education, gender, race, ability and ethnicity to more provincial influences, such as disciplinary vocabularies specific to a particular trade, idiomatic patterns of dialects, and forms dictated by fashion. As we gain linguistic competency, the language of gesture is also being learnt, and vice versa. For instance, the

performance gestures that initially reinforced the beat of rap have become habitual movements that reflect solidarity with an appropriate (or appropriated) cultural identification.

Rap and hip hop performers employ a number of hand gestures that serve the dual purpose of marking the beat in the music and serving an iconic function. Snoop Dogg in a music video, 'Gangbang Rookie', performs with ten-year-old rapper, Pilot.[14] They frequently emphasise the beat using hand gestures. With elbows out, and hands in front of their chests or over their heads, the gestures vary from moment to moment, differentiated by the placement of the fingers. Depending on the movement, one or more fingers will be bent in. In one such gesture the thumb is stuck out to the side and the middle fingers are pulled in towards the palm. This action has become associated with the call 'yo!' Used with or without the vocalised phatic, it is used to assert presence and to draw attention. However, it has gone 'viral' and can be seen in any number of cultural venues, frequently in bars and clubs when friends pose for a photograph. Through this appropriation it lost its tone as an aggressive and assertive function, which was evident originally, becoming instead a signal of solidarity among peers. For both the rappers and those who have appropriated the gestures, they have become attractor states, or lexicons of self-identity. They allow for communication that is fluent and rapid, and make social interactions relatively easy, using codes that are both linguistic and extra-linguistic.

Similar gestures are frequent across cultures and among different social strata. A friend enters my home, and as I welcome her I reach out and touch her arm. The words and gestures are guided by what is and is not acceptable to say and do according to the conventions of polite, public discourse. These patterns are conventional, default positions of social engagement, but how they are enacted is dependent on the specifics of the situation. Am I glad to see her after a long absence or saddened by knowledge of a loss she has experienced? These control parameters, our familiarity with each other and her reaction to what is being said for instance, temper my actions, matching language and movement to the dynamics of the moment and set predicates for the next phase of the engagement. Similarly, circumstances such as whether we are indoors or out, whether we are among friends or relative strangers, or whether where we are is noisy or quiet will influence the patterns of speech and gesture I use, as will interoceptive states, whether or not there is tension, degree of fatigue, etc. These parameters provide limits that will affect the words I choose, the movements I make.

As long as interactions use familiar idioms the conversation spins out fluently because the communication follows structures and associations developed over a lifetime and are retrieved with minimal effort and without

conscious awareness. There are other interactions however when the thread of thought cannot be satisfied so easily and a gap appears that needs to be filled. These might be minor occurrences, or more significant moments when we are speechless, when we know what we want to say but cannot find the words. These perturbations require different kinds of response through the nexus of language and gesture. Gestures are not linked to specific words or phrases but operate by associations or, in the language of metaphor, through entailments. Most words have both denotative and connotative meanings; they both mean something specific but are also useful in tangential situations. The word flag, for instance, has a double meaning in English, both a pennant and to tire. However, 'flag' is also used as a symbol of group identity, metonymically representing a tribe or nation, bringing to mind patriotism, power, a mark of difference signifying pride and privilege; or it can be seen as a sign of arrogance, a justification for war, something to be honoured or burned. Alternatively, it is related to waning energy, falling behind, losing potency and so forth. A gesture can assist in the selection of the optimal entailment for the idea to be communicated from a range of linguistic possibilities. As the right word or words emerge there is a shift towards a particular way of expressing an idea that follows the existing path or shifts the meaning from the previous line of reasoning.

Speech, then, is multimodal, in the trivial sense that talking requires sensorimotor activations that link the controlled exhalation of breath and the shaping of the mouth if our thoughts are to be heard, and in the non-trivial sense: through the interweaving of gesture and language we are able to find the best words to communicate the intricacies of thought. Similarly, speech is embodied in a double sense. It takes place in and through the mechanisms of the body; but it is also determined by our relationship with the context in which we are speaking, that is, it bears the marks of past experiences as a social being and the specific context in which we are currently engaged. Actors, in developing characters, will attempt to identify those gestures from the lexicon of the everyday that fit the role they are playing, realising the best choice when the movement provides depth and nuance to the portrayal. This is, of course, a very different situation than those described by McNeill and Goldin-Meadow because the language is predetermined. Rather than finding the gesture that will define the direction of thought, the exploration is for the one that will best communicate the immediate action.

In an adaptation of *The Grapes of Wrath*, I portrayed Granpa Joad, an ornery patriarch, who in the last scene before he dies resists his family's attempts to relocate him. Determined to remain on the land that the character tilled throughout his adult life, I sat down on a rock, insisting that I be left behind. With my arm directed at them, palm down and fingers

curled in, I made two quick flicks, to emphasise that they should go without me, but which also showed the infirmity of the character. What is interesting about this particular move is that while I intended to shoo them away, I did not consciously make the gesture that communicated his weakness. It simply happened. Yet it communicated a more complex set of meanings than the words that went with it. The implication is that the same mechanisms that determine my gestures in everyday conversation are also in play when devising the best means for communicating the action.

The dynamics of the everyday

It is fascinating and instructive to be aware of the gestures that occur in creating a role, or in the course of conversation. The process involved in finding the best fit in speech and gesture supplements the meaning of the words. The triangulation of thought, word and movement coalesce in the moments when ambiguity or the need for nuance create, however briefly, a caesura in the communication; and the communication that emerges from this conjunction has the potential to reveal the speaker's state of mind, her psychological and physiological commitment to what is being said, as well as the manifest content. In the day-to-day we do not pay heed to gesture unless it is particularly expansive or forceful. These actions remain peripheral, seldom reaching consciousness unless paying close attention. This oversight is unfortunate because in these moments of uncertainty we can glimpse the outlines of the creative act.

Gendlin identifies two elements in the process of overcoming indecision: carrying forward (protention) and crossing. Coming to understand a thought is the sequencing of an *implied* meaning that is a byproduct of intention and desire. As the words (traditional phrases and familiar metaphors) fall into place, this meaning is carried forward, ideally gaining in clarity and significance. However, moving forward relates to both past and future. It is laden not only with what has been said, but also what has yet to be said. 'The carried-forward implying is also the present and also the next implying. *The sequence generates itself by means of the carrying forward relation.*'[15] In saying what I am saying, I am not only aware of what I am saying but also implicitly aware of what is yet to be said. I carry forward. If all goes as I hope the carrying forward comes to a full stop, and that which needed to be said is said. Alternatively, it continues into the yet-to-be-said, and a new sentence is formed in an attempt to satisfy the desire to say what has not been said.

This happy condition is lost when the unfolding stops. What is becoming explicit through the carrying forward, the sequencing of language, no longer

matches the intent and desire implicit in the thought. I do not know what to say next. At this juncture a new line of thought is needed to complete the sequence. This does not mean what was being carried forward becomes irrelevant, but that a different thread is needed to finish the process.

> The concept's first implicit juncture 'crosses' with the new juncture, to produce just this next change at this new juncture. We can enter into its effect. Then we find that crossing opens every concept so that it can do more than before. We also find that it opens each new juncture so that there is more there than before. The crossing of two junctures does not bring the lowest common denominator but rather a great deal that is new to both of the two that cross.[16]

When the path that was being carried forward ends prior to the completion of the unravelling, an alternative is needed. The appearance of a new path does not negate what has gone before, but brings together the entailments of each, enriching the process by providing an excess of possibilities. This process is manifest in the gestures that occur and the words that come to mind in working memory until that moment when there is a best fit or the meaning resists expression, the words continue to fail, and an alternative approach to expressing an idea needs to be found.

When the right word or phrase is discovered at the juncture of the crossing, it not only affects what is carried forward, but also, as Gendlin realises, alters however imperceptibly what came before. The implicit meaning that has been emerging from the unravelling of the intricacy of thought is rethought to accommodate the implications of the new resonances. That is, we understand differently what it is we have been trying to say, a discovery that was always a potential but only now obtains currency. As the future becomes clearer the past is rewritten. This process, it seems to me, is the basis of the creative act. As I have attempted to show throughout this essay, finding the best fit depends on the cross modal interaction of gesture and language. They are intertwined in a complex process, playing off each other in striving to unravel the intricacy of thought or, with actors, of portraying a role. As, and if, the act reaches a satisfactory conclusion, certain synaptic connections will be reinforced making future unravelling – the combination of movements and words – of similar thoughts easier to resolve, or a performance easier to repeat.[17] Something has changed, and we understand the world differently.

There is much more to say about wayfaring and its relationship to creativity, and much to be learnt about the processes that make change possible. Looking at the relationship between gesture and language gives us a structure on which to hang a theory based on the always-falsifiable findings of science. A dynamic system is open to being destabilised, but engages these

disruptions by the evocation of previously established patterns developed over a lifetime that allow us to contain and resolve the perturbations to the system. The efforts to contain are not always successful and, through the pleasure and pain of an alienating experience, alternatives emerge that do not evade the implementation of attractor states but make possible negotiations that allow us to move forward differently. Creativity is not the product of inspiration alone, but the result of a struggle to unravel an intricacy using the tools – the techniques, habits and previous experiences – we have at hand. The creative moment is not a new dawn but a new configuration built out of the detritus of history, personal, social and cultural. Like the phoenix rising from the ashes, something new rises from the residue of the past, giving a new form out of existing matter. It is 'the belief that things will grow out of the activity itself and that you will – through work – bump into other possibilities and kick open other doors'.[18] We want to move from A to B directly but because what we desire to say forms an intricacy, there are moments when sense making encounters a caesura, where the unfolding is brought up short. Such a break requires a different path be taken, or as Edward Albee writes in *A Zoo Story*: 'Sometimes a person has to go a very long distance out of his way to come back a short distance correctly'.[19] It is at these moments that we become wayfarers and the potential for a creative discovery is immanent.

Between Faulty Intellects and Failing Bodies: An Economy of Reciprocity in *Wit* and *33 Variations*

Naomi Rokotnitz

Dramatic performance as affective science

Over the last three decades, philosophers, psychologists, biologists and neuroscientists have come to recognise that our bodies produce multiple kinds of knowledge. Reasoning takes place in the brain, of course, and so is as embodied as sense-perception, emotional responsiveness, imagination, memory or intuition. However, these other modes of reception and perception contribute to our 'affective consciousness'[1] and are termed 'embodied' because they do not require logical analysis for their verification; their presence and effects are made manifest in subcortical regions of the brain that function without recruiting conscious thoughts, and in sensory-sites that both apprehend and store feelings (and memories) throughout the body-proper. Many forms of arousal are registered in BOLD (blood-oxygen-level-dependency) signals without particular neurons firing.[2] Embodied responses are regularly moderated, adapted, revised or rejected once consciously considered, but they occur involuntarily, precede conscious intervention and often bypass it altogether.[3] This does not, however, diminish their influence. Far from being an encumbrance upon thought, our bodies generate what we experience as thought through affective-feedback mechanisms.

By 'affect', I refer to a spectrum of experiential phenomena – physical, emotional and/or behavioural – ranging from 'anotic' responses (feelings that function without neocortical involvement or conscious knowing), via 'noetic' responses (based on knowledge, including semantic and episodic memory systems) to 'autonoetic' (higher reflective mental) processes of conscious awareness.[4] This affective-continuum model reinforces the 'embodied cognition' hypothesis, which rejects Cartesian dualism or any

separation between body and mind,[5] and harmonises with the view that exercising and refining our potential for affective responsiveness is an important evolutionary advantage.[6] The 'survival of the fittest' depends not upon overpowering all opposition, but upon adapting in time to changing circumstances.[7]

I have argued elsewhere that drama can be instrumental in fostering such adaptive flexibility precisely because it co-opts the living bodies of both performers and audiences.[8] In the theatre, I maintain, by investigating actors and spectators, we may both generate and gather affective-evidence that cannot be tested in a laboratory. In this chapter, I present an example of such investigation, and suggest how, in conjunction with the other contributors in this book, and in the wider field known as cognitive approaches to literature, we may begin to theorise performance-studies as a form of scientific inquiry. This is both because the humanities can make greater use of science than was for many years supposed and, just as important, may contribute more to scientific studies than may previously have been granted.

The two plays I have chosen to discuss here explore this very trajectory. Margaret Edson's *Wit* (1993) and Moises Kaufman's *33 Variations* (2008) both dramatise the last few weeks in the life of a successful academic who is dying of an incurable disease. Edson's protagonist, Vivian Bearing, professor of literature, and Kaufman's protagonist, Katherine Brandt, professor of musicology, are both world-renowned authorities in their respective fields of study; their intellectual prowess is unequivocal. However, both are brisk, disciplined and demanding, having dedicated their lives to the study of art, and yet restricted their engagement with it to critical analysis. Both women remained dispassionate for most of their lives, having deliberately shunned emotional ties and intimacy with others. The advent of her illness propels each stridently independent woman into a state of dependency upon others. In addition to contending with ever-increasing pain, physical disintegration, invasive clinical examinations, and fear of death, each woman is also forced to reflect upon her professional and her personal life choices, and upon the dynamics of intra-and inter-corporeality. Biology, psychology, technology and art are intertwined in both the subject matter of each play and its dramatic presentation, creating a productive economy of reciprocity.

My interest here is primarily the anotic, pre-reflective, embodied dimensions of affect, and the crucial role these play in determining and changing both somatic identity and philosophical (autonoetic) conceptions. Filtering my analysis of the plays through current research into embodied receptiveness, empathetic 'motor equivalence', and physiotherapy, I explore how dramatic performance may demonstrate the value of bodily forms of apprehension and communication. I further contend that, despite their apparent

similarities, Edson and Kaufman offer their audiences two radically different kinds of experience. While Edson's play is both compelling and thought provoking, the performance of the body in Kaufman's play is more likely to cause his audiences to undergo an existential reconfiguration.

Wit

When the curtain first rises, Vivian is revealed wearing a baseball cap.[9] Her baldness designates her immediately as a cancer patient. She is treated by Doctor Kelekian and his ambitious research fellow, Jason. While Kelekian's routine rounds on the ward include 'clinical' attention (*Wit* 30), meaning some personal interaction with the specimen of humanity under his examination, Jason considers this minimal courtesy a 'colossal waste of time for researchers' (35). The irony attending the fact that Jason took one of her classes on Metaphysical Poetry during his undergraduate training, and found it 'more like boot camp than English class' (49) is not lost upon Vivian. She fully understands that she contributed to the evolution of Jason's bedside-philosophy. In her class, Vivian treated Donne's *Holy Sonnets* as an 'intractable mental puzzle', characterised by 'ingenuity, virtuosity, and a vigorous intellect' (31); she taught her students to appreciate Donne's 'brilliant mind' (31), picking apart Donne's qualms regarding God's benevolence; but she never engaged with Donne's anguish. Thus, she assisted Jason in deploying his 'aggressive intellect' (31) while stifling his compassion. Jason eagerly diagnosed Donne with a medical (rather than metaphysical) affliction he termed 'Salvation Anxiety', and marvelled that the sonnets are not an attempt to solve this anxiety but, instead, a total immersion in it. Both these insights constitute 'great training for lab research' (50) as, to his mind, research is not a commitment to finding a cure that may save his patients but the skill of 'quantify[ing] the complications of the puzzle' (50). Jason read Donne's agonised expressions of spiritual searching and artistic creativity as though they were scientific data; Vivian focused upon 'verbal swordplay' (45), ignoring one of the most important themes of the sonnets – love – thereby reinforcing both her own and Jason's emotional disengagement.

The action of the play takes place in a hospital room, as dictated by Vivian's clinical isolation. However, the setting is also representative of her attitude to her scholarship and her personal life: Spartan and solitary. The bare hospital room accentuates the gestalt Vivian has experienced in the weeks that directly preceded the opening of the play, and which have created a chasm between the professor Jason recalls from class and the patient he now sees before him. Confined to the cancer ward, Vivian suddenly

perceives her previous existence as sterile. Edson also stipulates in her stage directions that the doctors wear white coats throughout the play. In performance, this fidelity to hospital regulations also accentuates two inter-connected symbolic implications. First, although lab coats have practical uses, securing a germ-free environment, their uniformity is designed to designate the wearer as a doctor of medicine. The coat is a visible mark that this person is currently acting in the capacity of a physician rather than an individual with personal preferences. Thus the hospital replicates the stage: both make use of costumes to clarify role distinctions, and both provide the setting for performances.

Over-empathising with patients may prevent doctors from maintaining the distance necessary to treat them, and a certain dulling of emotions is sometimes necessary for decisive actions.[10] Nonetheless, through experiencing Jason's professional competence and his empathetic incompetence, Vivian recognises her own deficiencies: while she was a rigorous scholar, she was deaf to her students' personal pleas, remaining entirely unmoved by their individual or collective troubles, just as she brushed aside Donne's. Her strictly logical view of justice therefore determines that, to her mind, she cannot justifiably expect kindness now that she is in need.

Jason does not consider kindness to be one of his duties, and he supposes Viven shares his no-nonsense attitude. She did – until she fell ill. While he finds it mildly uncomfortable to give his ex-professor a pelvic exam, he is oblivious to her humiliation. At the same time, Vivian does not allow herself to register the full force of her mortification but, instead, describes it to the audience through the use of an apt pun: 'degrading' (*Wit* 19). She evades her emotional turmoil by focusing upon her wit. While she is beginning to sense that her approach to life has been faulty, her habitual behavioural patterns are so inflexible that, even under tremendous stress, she cannot conceive of an alternative mode of response. Throughout the play, Vivian disrupts audiences' suspension of disbelief by commenting upon her story and its dramatic presentation: 'It's not my intention to give away the plot, but I think I die at the end' (2). As a literary scholar and skilled performer in the lecture theatre, Vivian is accustomed to pronouncing on such matters. But her running commentary impresses upon viewers the extent to which she is a spectator in her own life. She is so far removed from herself that she can report with wry humour on her own pain, and present her disease as instructive: 'it is highly educational. I am learning to suffer' (19).

Edson underscores this tendency by suggesting that the cast should number only nine actors. The technicians, fellows, and students double up and, even more pertinent, Dr Kelekian and Mr Bearing (Vivian's father) are performed by the same actor. This theatrical device is often deployed

to dissolve the boundaries between various subject-positions. Without the use of words, audiences are subliminally alerted to the possibility that each role in the play can become another. Many doctors are also fathers; any technician may potentially contract a disease and become a patient; all teachers began as – and continue to also be – students. Each character's current role is, in great measure, arbitrary. Professor Vivian Bearing is now subjected to Jason's authority. Degrading indeed.

Edson's characters are discerning, and perceive most of these ironies themselves. But they do not betray the emotional responses Edson assumes their behaviour will elicit in her audience. Edson evidently trusts that spectators of the play will perceive the characters' blind-spots through attunement to the embodied receptiveness so clearly lacking among those on stage. This sophisticated dramaturgy-of-affect allows the playwright to remain – as her title suggests – in the realm of wit, while simultaneously undermining her characters, demonstrating instead the benefits of embodied communication. How is this done and to what effect?

Embodiment

Without disregarding the specificities of individual bodies – all humans have bodies.[11] The evidence provided by these bodies is foundational to an accurate assessment of our environment. As Shaun Gallagher and Dan Zahavi assert:

> Bodily behaviour, expression, and action are essential to (and not merely contingent vehicles of) some basic forms of consciousness. Mental states do not simply serve to explain behaviour; rather, some mental states are directly apprehended in the bodily expressions of people whose mental states they are.[12]

Some experiences are registered in our actively analyzing conscious minds; others write themselves into the very fibres of our physical selves.[13] Since mind and body are 'not separate and distinct ontological kinds', it is time to articulate 'an account of embodied meaning that emerges as structures of organism-environment interactions or transactions'.[14] Our cognitive profile is 'essentially the profile of an embodied and situated organism';[15] the brain is 'just a part (albeit a crucial and special part) of a spatially and temporally extended process' of co-operation between brain, body and environmental aids.[16]

Of particular importance to this present study is research into our inborn inclination to imitate, indeed simulate, actions we observe others

perform.[17] This capacity for 'motor equivalence'[18] allows us to utilise our shared motor schemata to interpret the actions of others – in life and on stage. The meanings of a dramatic performance arise from its embodied effects just as much as its discursive registers, and performative communication depends upon empathetic resonance. The term 'empathy' dates back to nineteenth century aesthetic theory but has expanded to encompass a wide array of conceptually distinct phenomena.[19] Daniel Batson has recently examined eight of these.[20] I adhere to the definition of empathy as 'a complex form of psychological inference that enables us to understand the personal experience of another person through cognitive, evaluative and affective processes'[21] allowing us to resonate with another agent through body-based simulation which provides 'experiential insights into other minds'[22] as well as 'pain, touch, or tickling'.[23] Mapping the neural correlates of this resonance[24] corresponds in interesting ways with mirror-neuron studies and provides evidence that empathy is an innate capacity, hardwired into our cognitive architecture. However, emotional correlation does not equal emotional contagion. Although humans have 'the tendency to automatically mimic or synchromise facial expressions, vocalisations, postures and movements with those of another person',[25] empathy does not by any means guarantee sympathy, as the history of torture attests. Nonetheless, although empathy need not lead to sympathy, sympathy is best achieved through eliciting empathy.[26]

Personal dispositions to empathy vary,[27] yet Edson can trust that, despite Vivian and Jason's emotional inhibitions, audience members will respond – through our mirror resonance systems – to the physical cues of the performance. Moreover, her uncompromising display of a body in pain not only elicits automatic empathic identification but implicates each member of the audience in the action observed on stage.By witnessing Vivian's ailment, treatment and death, we also participate in both her violation and her experience of it, becoming accomplices to both perpetrators and victim, replicating Vivian's own bi-directional movement.

Thus, Edson's meta-dramatic performance techniques continually create objective correlatives for her discursive agenda. Chief among these is her stipulation that Vivian's central-venous-access catheter be slung over her left breast. This directs the audience's visual focus towards her breast, symbolically emphasising her systematic denial of her femininity, her thwarted maternity, and her neglect of human emotion. By accentuating the breast region (heart) over the arm (action) she reminds us that, while Vivian was always a woman of action with little time for sentiment, her disease is inducing in her a process Nietzsche famously termed 'a re-valuation of values'. The left breast also carries religious connotations pertaining to the

wounding of Jesus at Calgary. Regardless of religious persuasion, most people feel for the suffering body of Jesus and recoil in moral aversion from the cruelty of his crucifiers. Similarly, audiences empathise with Vivian's suffering body, are disturbed by Jason's manner, and become increasingly distressed by the brutality of the clinical trial to which she is subjected. Lamont goes as far as to compare the IV pole to a pilgrim's staff, and the hospital curtains to stages of the *Via Dolorosa*.[28]

Vivian can even be seen as a martyr figure, if we consider that she is not informed in advance that the grueling course of experimental chemotherapy she is to undertake cannot possibly cure her. Her 'informed consent' (*Wit* 5) is a sham. However, when she realises that this excruciating torture cannot save her, she still continues to endure it, as a means to the only accomplishment she ever thought valuable: 'a significant contribution to knowledge' (5). Fearing that her life was wasted in many ways, she gains a sense of purpose and of self-directed agency by advancing scientific research. In a warped extension of her life-long cerebral existence, which ignored her body in favour of what she imagined to be intellectual rewards, she sacrifices that body to science. She seems to feel she deserves to be used, even abused. She does not cry 'why hast thou forsaken me?' – she knows all too well why she finds herself alone.

Edson's adept use of theatrical symbolism won her the Pulitzer Prize, and renders her play a heart-wrenching experience. Its climax comes when Jason discovers Vivian unconscious, and calls in the 'blue code' team. Nurse Susie shouts 'She's DNR', but Jason's instinctive response is 'She's Research!' (*Wit* 54). Susie shouts 'cancel code', but the team '*throw* VIVIAN'S *body up at the waist and stick a board underneath her for CPR*' (54). Jason soon realises his mistake, but he and Susie have to physically struggle against the ultra-focused coders before they are able to make themselves understood. Edson thus dramatises the extent to which the undeniable realness of the flesh overrides all other modes of perception. Once Vivian's stoic manner is dissolved, once she can no longer shroud her vulnerability, Jason can finally see her pain. Once he witnesses the defilement of her body by the coders, he also finally registers his own violence. Breathless, overcome with the enormity of his injustice towards Vivian – as patient and as corpse – he can only whisper 'oh, God' (56).

This dynamic is crucial. In the final moments of *Wit*, primacy is finally awarded to Vivian's *body*. The moment the coders abandon this body, Edson also abandons strict realism and allows Vivian to sit up in bed. The movements Vivian performs are not detected by the hospital staff, but we observe how she removes her cap, slips off the hospital bracelet and gown that accompanied her illness and, for the first time in the play, unveils herself:

revealing herself to herself and to the audience. In her death she becomes reconciled with the embodied nature of her personhood; that instant 'she is naked, and beautiful, reaching for the light' (56). The play ultimately acknowledges that an altered relatedness to one's body incurs a change in the modalities of being, but laments that, for Vivian, that only occurs in death.[29]

One cannot blame Vivian, or any other terminal patient, for the late detection of her disease. But one may infer that Vivian had ceded no credibility to her materiality. If she had been attuned to the symptomatic changes of her body, she may perhaps have been able to prompt an early diagnosis. Only in death does Vivian learn that, as Martha Stoddard Holmes reminds us, sensitivity to the 'tactile sensations of the inner body, as opposed to its inaccessible sights and sounds'[30] may actually save one's life. As The National Ovarian Cancer Coalition (NOCC)'s 2005 'Walk for the Whisper' event urged: *It Whispers, So Listen.*[31] Holmes rightly urges that while much of the conversation between the brain, the interior, and the exterior occurs without our awareness, 'we can and must intervene in the parts to which we do have access. Above all, we need a public culture of the body that can prompt individual acts of reception, recognition and self-advocacy.'[32]

Wit may go some way towards advancing such a culture and yet Vivian's acceptance of her body occurs at the very moment that she leaves it lifeless on the CPR table. Does this imply that, finally rid of oppressive physicality, she may now pursue the purely spiritual existence she always sought? Or that now she has become an integrated body-spirit? What is the meaning of this seemingly theist gesture? The last words spoken in the play are Jason's: for the third time he sighs 'Oh, God' (*Wit* 56). While everyone involved has learnt an important lesson in medical ethics, are we to surmise that they have also learnt a lesson in spirituality? Would that imply that audiences are encouraged to respect one another's bodies in this world, or the next?

The ending of the 2001 HBO film of *Wit* (with Emma Thomson as Vivian) is markedly different from the play, and seems to favour a dualist view of the body-spirit. As Elizabeth Klaver describes it:

A close-up shot shows Vivian's dead face undergoing an enlightening process until the image of death is slowly erased by the superimposition of her live face. At the same time, Vivian's voice recites John Donne's poem with the final line, 'Death, thou shalt die.' Here is evidence that death is surely defeated even by death, for the mind, anima, or spirit lives on after the flesh succumbs. Interestingly, the film clearly signals through color code that the passage Vivian experiences is not a resurrection back into life: Vivian's dead face is in color, the postmortem image in black and white.[33]

However, according to the materialist position, because the brain continues to live for some time during the process of clinical death, it is quite possible that the light, or Jesus, or angels seen by those who have survived clinical death is nothing more than the brain's hallucinations as it is slowly starved of oxygen. This interpretation, then, suggests that what we see going 'toward a little light' in *Wit*, or hear reciting the Donne poem in the film, is the visionary, embodied product of Vivian's flesh in its final, agonal moments.[34] I would argue that Edson's image of a beautiful naked body in motion is in itself indication of a spiritual dimension with which she hopes to impress the audience as they leave the theatre.

Being-toward-death

33 Variations can be viewed as providing resolution to some of the tragic themes raised in *Wit*.[35] In the 15 years between premieres (1993–2008), the anatomical dissection-table model of the body, which can be traced back to the seventeenth century and characterises Kelekian and Jason's conception of their patients in *Wit*, underwent radical revision. Changing bio-ethics paradigms have contributed to a shift in medical professionals' attitudes towards their patients' psychological conditions and emotional needs.[36] In *33 Variations,* it is assumed without contestation that Katherine can choose among treatment courses; that she knows she is being monitored rather than treated, since her illness is incurable; and that she has the right to decide how she will die. Kaufman's engagement with terminal illness focuses upon the patient's. His play suggests that the deconstruction of the body by illness may facilitate a reconstruction of the self, giving birth to a new subject position that can produce knowledge of a kind that could not, perhaps, be tapped by the healthy agent. While Vivian's death is marked by a sense of tragically wasted possibilities, Katherine's death is marked by a sense of completion. This is largely due to her fostering the existential attitude Martin Heidegger terms 'being-toward-death' discussed below.[37]

When Katherine discovers she has Amyotrophic Lateral Sclerosis (ALS), the rapid deterioration of her health and the inescapable demands thrust upon her by her physical disintegration, force her to inhabit the body she hitherto almost ignored. As opposed to Vivian, Katherine is afforded the time required to correct her unbalanced favouring of the intellect over the senses before she dies. One of the central ironies of *33 Variations* lies in that the most honest work of its protagonists, Ludwig van Beethoven and Dr Katherine Brandt, is accomplished towards the very end of their lives,

when they are fully conscious of their imminent demise. Death becomes a motivating cognitive tool, suggesting that learning to trust the body, and learning from that body, does not cease when that body begins to fail.

For Heidegger, following Kierkegaard and Nietzsche of course, those modes of existential choice that adequately express and reveal the structure and possibilities of human existence are 'authentic'; while those modes that disguise, ignore or misrepresent such possibilities are 'inauthentic'. Throughout *Wit*, Vivian remains inauthentic. Similarly, at the opening of Kaufman's play, Katherine is not yet ready to face the implications of her recent diagnosis. Naturally, we are all aware that, in principle, we will die some day: 'Factically, one's own Da-sein is always already dying, that is, it is in a *being-toward-its-end*.'[38] However, in the inauthentic condition, one '*knows* about the certainty of death, and yet "*is*" not really certain about it'.[39] This allows Katherine to dive headlong into the research required for a new monograph, investigating why Beethoven, already deaf, spent a substantial portion of his precious last years writing 33 variations of a waltz written by Anton Diabelli. Katherine knows that, by this stage, Beethoven 'has very little time left. And yet he chooses this mediocre waltz as his next project' (33V: 9); she is not yet aware that it is her own condition that prompts her interest in this very same waltz.

Katherine travels to the Beethoven Archives in Bonn, a journey she undertakes for her research, but also so as to distance herself from her only daughter, Clara, with whom she has a fraught relationship. She thinks highly of Clara's natural gifts but is frustrated and disappointed by her character. Because Clara is 'piercingly observant and original in her thinking' (33V: 65) and yet refuses to stick to any particular profession for long, Katherine expects she will 'always be mediocre at everything' (14). Kaufmann creates an analogy between Katherine's view of her daughter and of Diabelli's 'mediocre' waltz. She is mistaken about both because she is trapped by a narrow definition of value. Clara's view of life is quite different from her mother's. She excels at every career she tries out, and leaves the moment she is convinced of her success. For her, that is 'a life better lived' (50). Katherine cannot see this. Piercing the invisible wall between them is accomplished only when Clara redefines herself in her mother's eyes through impacting her research. On the day Clara leads Katherine to view Diablelli's waltz and Beethoven's obsession with it from a different perspective, Katherine is also finally able to accept and respect her daughter's life-choices.

Crucially, this transformation is prepared by Katherine's disease. Due to her experience of illness and pain, Katherine is forced to reconstitute and redefine herself. As Manuella Consonni claims, 'the radical nature of the experience [of pain] does not cancel knowledge but redeploys and

sharpens it [...] giving rise to an entirely different way of perceiving the world and comprehending the events that take place in it'.[40] As Katherine's epistemological boundaries shift, her cognitive scope, bound to her failing body, unveils a new typology of knowledge. Grappling with her unruly body forces Katherine to abandon previously set structures. Once her material self can no longer accommodate its past forms, it precipitates a new conception of self that is able to take on Heidegger's challenge of an authentic 'Being-toward-death'.

During her research in the Beethoven Archives, Katherine notices a stain on the priceless manuscript paper. The archival expert, Dr Gertie, explains that 'it's probably soup. He loved soup' (33V: 34). A short intermission follows, in which Beethoven shouts at his housekeeper for preparing a 'putrid, fetid, rancid, rotting trough of swill' (35). This provokes some comic relief, but also carries profound implications. We are not allowed to forget that Beethoven's genius was bound to his human body. The needs, desires and failings of that body cannot be ignored, either by him or by Katherine. The soup not only imposes its presence upon the composition, but becomes an inseparable part of the puzzle she is trying to piece together; just as Katherine's own failing body will be instrumental in her own inquiry.

The theme of embodied receptiveness and gestural communication is interlaced throughout the play, but it reaches its height when Katherine's body is exposed to the audience in a scene in which she has to take off her top for an x-ray examination. In the Broadway production, Katherine, played by Jane Fonda, was seated on a cold, bare, metallic table; her feet did not reach the ground, making her seem small and vulnerable. The session requires her to turn left and right. Not only is she half-naked and alone, but the merciless flashes of light and loud sounds seem tortuous. When it becomes apparent that she finds the experience harrowing, a further analogy is established between her pain and that of Beethoven who, in the previous scene, experiences excruciating ringing in his ears as he advances towards deafness. Pain is presented as so acute that no intellectual strength may override it, and both characters' existential condition is reduced to the physical awareness and mental distress that accompany this invasion of their bodies.

This condition is reminiscent of Vivian's helpless writhing towards the end of *Wit*. Further yet, connections can be traced between the two academics, stripped of the protective outer layers of clothes and of title (the respectable professor becomes terminal patient, or even lab-rat). However, at this moment in *33 Variations*, Katherine hallucinates Beethoven. He comes in, silently, and sits on the gurney behind her. Katherine slowly leans back on him, her head resting on his broad shoulders. Kauafman's directions make his intended implication clear: '*she finds a modicum of peace and comfort*

in the subject of her obsession' (33V: 58). But it also connects Katharine and Beethoven as bodies. Suffering cannot be eliminated, but it may become meaningful, as illness makes for kinder, more sympathetic bodies.[41] Interestingly, it is soon after their bodies touch that Katherine finds the will to face her condition authentically. As Heidegger explains: Being-toward-death is 'a being toward an eminent possibility of Da-sein itself.'[42] Once Katherine becomes truly one with what Einat Avrahami terms 'the idiosyncratic validity and veracity of concretely situated, embodied experience',[43] and once Katherine recognises, quite literally, that inter-corporeal communication is a source of comfort, she is also able to take control of what remains of her life.

The epistemic advantages of embodied receptiveness

Tiffany Field, Director of the Touch Research Institute in Miami, holds that many people in society today suffer from a shortage of tactile stimulation, a phenomenon she refers to as 'touch hunger'. As Field points out; 'Touch is ten times stronger than verbal or emotional contact, and it affects damned near everything we do. [...] We forget that touch is not only basic to our species, but the key to it.'[44] While Edson dramatises the pain, the fear and the terrifying isolation to which Vivian is subjected, her play only hints at measures that may have alleviated her distress. The audience learns by default, through engagement with characters whose shortcomings are tragically obvious. In *33 Variations*, however, Kaufman dramatises the curative power of touch. Nurse Mike not only practices physiotherapy upon Katherine, he teaches Clara how to treat her mother. Initially, 'neither [woman] wants to touch the other' (33V: 72) but, with Mike's guidance, treatment becomes a collaborative effort. Through being forced to touch, Clara and Katherine move past their habitual antagonism, experiencing instead empathetic engagement.

Touch has been a part of the healing process in many civilisations and cultures throughout the centuries. However, recent clinical studies show that 'it is possible to experience moments of pleasure in the midst of being a severely ill patient at an ICU and through this experience also gain hope'.[45] Many hospitals include reflexology or other forms of touch-therapy in their care programme.[46] The practice of 'tactile touch therapy', specifically, has been shown to be extremely effective. Tactile touch involves slow stroking with firm pressure, mainly performed with the flat of the hand with fingers close together. Even when administered behind a curtain in a crowded ICU, it has been described by patients as creating an 'imagined room of togetherness', which provides 'the opportunity to focus on oneself' in an

environment of calm, caring security.[47] Vivian is never offered such solace; Katherine is. Moreover, the effects of therapeutic touch extend far beyond her immediate well-being.

Part of the tragedy of *Wit* is that, until the very moment of her death, Vivian is unable to respond to intimacy. When Nurse Susie tries to reach out to her, Vivian is unable to overthrow her cynicism. Her acceptance of Susie's overture is marred by wincing at her own instinctive desire for tenderness: 'I can't believe my life has become so … *corny*' (*Wit* 44). At the same time, this scene enables Vivian to see that many of life's truths are disarmingly simple. As Vivian becomes progressively debilitated, she is forced to admit that 'Now is a time for simplicity. Now is a time, dare I say it, for kindness' (45). Edson conveys to her audiences that while struggling and suffering are arduous, letting go can be quite simple. When Vivian is in such great pain that she is heavily sedated, she is visited by her PhD adviser and admired mentor, Professor E. M. Ashford. Contrary to what audience members may expect from what Vivian recalled of her earlier in the play, the elderly woman appears almost as a fairy-godmother. She has come to town to visit her great-grandson implying that, as opposed to Vivian, she managed to juggle her academic ambitions with a family life.

Ashford takes out the book she brought for her little great-grandson, and reads it to Vivian, who is beyond the stage at which she may cringe at this infantile regression. Instead, she submits to the overwhelming comfort of human warmth and nestles into Ashford's lap in a state of relaxed abandon. Ashford's story is about a bunny rabbit, adding yet another irony to Edson's play, for it was a story about bunnies that initially led Vivian as a child to pursue the course that later led to her scholarly path (*Wit* 26). Although this inner child has been long-checked by adult concerns, Ashford knows that childish simplicity is truly 'wonderful' (53). The story of the bunny is also 'a little allegory of the soul' (52) and, in place of Donne's convoluted puzzles, it relays to its reader (and Edson's viewers) the unconditional tenderness inherent in a parent's love. Audiences are led to surmise that, if Donne had only seen love as simple, he could perhaps have accepted God's fatherly indulgence with less friction; Vivien may have allowed it into her own life.

Bodily contact allows for a different kind of disclosure, a different mode of knowing. Touch 'provides us with an often-overlooked channel of communication', and plays 'an important role in governing our emotional well-being'.[48] Vivien is not afforded the time to live out this epiphany. However, in contrast to Vivian's isolation both before and after hospitalisation, the exercises Mike prescribes cause Katherine and Clara to both touch and synchronise their breathing, effecting 'a momentary truce' (33V: 74). This metonymic invocation stands for their physical and imaginative identification and

solidarity, and points to a connection through powerful emotional resonance that encourages co-operation and, at least in part, fends off the potential objectification and marginalisation of the terminal patient. Controlling one's breath is, of course, central to Eastern traditions of meditation. In addition to the obvious physiological effects of an unobstructed and energising flow of oxygen, this act also symbolises a new state of expansive readiness, or availability of body and spirit.

Touch is an epistemological tool: it provides valuable experiential knowledge. By extension, performing touch, in life and on stage, does not merely relay already-formed thoughts – it is, in itself, a form of alternative thinking. In *33 Variations*, physical therapy does not function as a miracle cure; it cannot allay all doubts and fears; it cannot override the swift progression of Katherine's disease or its inevitable outcome. Yet illness and therapy both 'force intimacy' (104), and intimacy can ground Katherine's spirit in the very real knowledge of the embracing presence of dependable companionship and love surrounding her.

Relatedness and elevation

Death is insurmountable, but the life that precedes death is the central focus of this play. Philosopher Andy Clark argues that humans learn through interaction with their environment, having evolved to exploit 'any mixture of neural, bodily, and environmental resources, along with their complex, looping, often nonlinear interactions'[49] in order to inform and supplement understanding, as well as compensate for limitations. Interaction appears to be a defining characteristic of embodied cognition. Isolating oneself is, by extension, a form of debilitation. Indeed, psychologist Jonathan Haidt locates 'relatedness', as the most profound conduit to happiness.[50] Stoic asceticism may defend us against frustration and disappointment, but it also extinguishes the possibility of genuine happiness. In addition to dramatising these very arguments, *33 Variations* also demonstrates that the experience of death is largely determined by each individual's attitude to, and preparedness for, its eventual arrival. As Heidegger asserts, authentic awareness of the ineluctable allows one to view the possibilities clearly and, instead of experiencing 'a lostness in chance possibilities urging themselves upon us', we may actively choose among them.[51]

33 Variations suggests that choice may lead to a liberating sense of joy, eliciting the emotion Hiadt terms 'elevation'.[52] The 'glowing feeling' experienced by participating in various religious rites, or by doing – or even witnessing – selfless good deeds and compassion, is a specific kind

of emotion (with attendant physical properties, such as dilation in the chest) that creates a sense of calm well-being, hope and brotherhood, and inspires us to be virtuous. Elevation is a manifestation of the embodiment of spirituality, creating 'feelings of love, trust, and openness, making them more receptive to new relationships'.[53] This seems to me to be precisely what Kaufman aims to inspire through his play. Kaufman extends Edson's image of a beautiful naked body reaching for the light to encompass a holistic and illuminated body-mind-spirit. *33 Variations* teaches the value of embodied receptiveness through skillful dramatic presentation, and also causes viewers to simulate the very feeling of elevation facilitated by their own embodied cognition. We leave the theatre feeling elated, and disposed to be more sensitive and kind to our fellow humans.

Part Three

The Multimodal Actor

Introduction: The Multimodal Practitioner

Rhonda Blair

Since the latter 1990s theatre and dance practitioners have been applying current research in the cognitive sciences and affect theory to practice in the performance studio and in the classroom and, more recently, the energy has started moving in the other direction as well: scientists are using elements of performance practice and theory to inform their work. Because the cognitive sciences deal with fundamental aspects of human existence and experience, providing a materially grounded engagement with what it means to be human and how we operate, they have become a necessary part of how to understand theatre, dance and performance. Categories of body, emotion, feeling, mind, memory and action, among others, are increasingly being viewed as aspects of an embodied dynamic human process that is both unitary and permeable. While we may shift perspectives or emphases when we speak about, say, thought, feeling or gesture, in cognitive science this becomes only a way of directing our particular point of focus or attention (to use language employed by both scientists and Konstantin Stanislavsky) to engage one aspect of the complex 'happening' which is each of us. The science is moving us through a paradigm shift, as generally defined by Kuhn and as taken up by Joseph Roach specifically in relationship to acting in *The Player's Passion: Studies in the Science of Acting*. As with all major shifts, what has been called the cognitive turn is redefining, among other things, what the 'self' is; what it might mean not just to have, but to *be* a body; and how the self operates in relationship to other. This research is fundamentally redefining how we understand performance practice.

Both cognitive science and affect theory are umbrella terms with considerable overlap. Both encompass various aspects of psychology, neuro-science, psychiatry, anthropology and linguistics, among other disciplines, and are informed by various philosophical approaches. Their fluidity and capaciousness present challenges to specificity in research. Affect theory applies variously to the study of fundamental categories of emotion and to

studies in the social flow of emotion, attitudes and motives between and among people; it can involve social, behavioural, cognitive and biological sciences. Cognitive science encompasses specialisations including cognitive psychology, cognitive linguistics, neuroscience, neurolinguistics and cognitive anthropology, among others.

A fundamental challenge of working interdisciplinarily and, often, multi-modally lies with language. Uses of the same word to mean different things, uses of language to speak in generalised terms, to slip out of being held accountable for specificity, to make leaps of association, to assume similarities or resonance where they might not be is a challenge in engaging applications of research responsibly. The following is an attempt to lay out some aspects of the terrains to help readers negotiate some of these complexities with a bit more clarity.

Cognitive science(s)[1]

Cognitive science's findings call for us to leave behind some earlier approaches to and understanding of performance, while also productively enriching and supplementing our work through the applications of new findings and methodologies. Indeed, some of the most important work since the 1980s has been done at the intersection of science and, e.g. philosophy or anthropology, and in performance studies since the mid-1990s. I begin with a caveat, because it is easy to misappropriate complex material such as that produced by scientific research; we must be mindful of being non-expert, and of the dangers of misunderstanding or mistranslating what we read. Further, it is important to keep in mind that there is often disagreement among experts in the science disciplines, much as there is among performance studies scholars and practitioners.

Cognitive science's roots lie in the early discoveries of neuroscience, beginning with Paul Broca's 1861 discovery that a particular area of the brain was linked to speech production, and in Wilhelm Wundt's 1879 founding of an experimental psychology laboratory; interestingly, while it was important historically that the latter marked a separation of psychology from philosophy, in the last quarter century the integration of the science with phenomenology has been crucial to advancing the field. Throughout the twentieth century, other disciplines that would contribute to the rise of cognitive science came into play. In the first two decades, Ivan Pavlov, Ivan Sechenov and other conducted research in reflexology, an early form of behavioural psychology that was a serious attempt to understand the relationship among bodily movement and response, feeling and thought;

these men were also a significant influence on Konstantin Stanislavsky and Vsevolod Meyerhold. In the same period the seeds for what would become the modern discipline of linguistics were planted. These included the work of semioticians Ferdinand de Saussure and Charles Sanders Pierce, as well as the technical study of poetic language done by formalist Viktor Shklovsky and other Russian literary critics. This project was continued by Roman Jakobson, who developed a structural analysis of language and who participated in devising ways of applying structural analyses to fields such as anthropology and literary analysis. At about this time another discipline that would play a part in the development of cognitive science arose: computer science. The first freely programmable computer was invented in 1936, and, as the machines operated with increasing sophistication and speed, computer scientists hypothesised that the computer's binary processes were analogous to the functioning of the human brain. These fields provided the basis for what was to become cognitive science. In the latter 1950s, a group of computer scientists interested in artificial intelligence, psychologists, philosophers and linguists – most prominently, Noam Chomsky – came together to study the acquisition and processing of knowledge (this was in part to resist the reductive Skinnerian behaviourism of the time). This first generation cognitive science (roughly the 1950s to the 1980s) generally did not address physical aspects of how the brain works.

At the same time, neuroscientists were identifying physical sites for aspects of cognition (I use the term in a broad sense here of referring to brain operations that include not just conscious functions, but those below the level of conscious awareness). More and more select functions could be connected to specific brain locations. It was observed that brain anatomy could be altered by experience or behaviour (e.g. the size of string musicians' cortices devoted to the hands is larger than that of non-musicians).[2] By 1970 a neurological basis for memory, marked by an alteration in neural structure, had been discovered. By the end of the decade positron emission tomography (PET scans) made it possible to take pictures of activity in the brain. In 1990 the invention of functional magnetic resonance imagery (fMRI) provided images of dynamic neural processes that were anything but computer-like. The discovery of mirror neurons in monkeys in 1996 energised research in neural simulation systems in humans, and generated still more questions about the nature of the self, imitation, empathy and action. The binaristic model was jettisoned, given the hard evidence that neural operations were more complex and dynamic than could be accounted for by computer-like on/off switches.

What is sometimes called the second generation of cognitive science arose in the 1990s as cognitive scientists, neuroscientists, linguists and

philosophers, among others, began to look at scientific findings in light of phenomenological and epistemological frameworks to begin to see mind as a manifestation of the body, inextricably linked to its environment. This second phase is attempting to identify, among other things, how consciousness arises and its relationship to language, emotion, and our interactions with the world, as an embodied process. Although we do not know all of the steps by which 'matter becomes imagination' (to use a phrase from neuroscientists Gerald Edelman and Giulio Tononi),[3] how elements of consciousness and behaviour relate to brain function is becoming clearer. Neuroscientist Antonio Damasio comes at the problem of consciousness through his somatic marker hypothesis, 'somatic marker' being a term for describing how body-states become linked with conscious responses to or interpretations of them.[4] As with other views cited here, body, feeling and intellect are viewed as aspects of a single, if complex organic process. In this view, the brain creates strings of associations that arise in the body first as an emotion (here meaning a physiological state of the body), which is translated into a feeling (a conscious 'registration' of a body state), which leads to behaviour that may or may not be associated with reason or rational thought. These markers become our repertory of responses for guiding reactions to new situations. Particularly pertinent is Damasio's assertion that reason in the fullest sense grows out of and is permeated by emotion, and that emotion is consistently affected by reason and conscious cognition. Some neuroscientists theorise that who we are and how we function are based largely upon the development of specific neural patterns, or synaptic connections. Neuroscientist Elizabeth Wilson describes cognitive processing as 'the spread of activation across a network of interconnected, neuron-like units,'[5] i.e. 'Knowledge is implicit, stored in the connections rather than the units', in the paths from neuron to neuron.[6] Neuroscientist Joseph LeDoux, in *Synaptic Self: How Our Brains Become Who We Are*, argues that our selves are in fact a product of our synapses. From this perspective our sense of our self is at bottom a product of the gaps between our neurons that are bridged by chemicals or an electrical impulse. In this model, nature (genetic make-up) and nurture (experiences) are merely different ways of doing the same thing – wiring synapses in the brain that manifest as who we are.

The self can be said to be composed of memory to some degree and in a number of ways, and these sciences are requiring increasing degrees of rigour from us when we use terms like 'sense memory', 'emotion memory', or 'muscle memory'. Fundamentally, a memory is the reactivation of a neural pattern established by the initial experience, an intensely dynamic and changing event, conditioned by the different circumstances – of environment and body – every time it is 'recalled'. Object-retrieval metaphors for dealing

with memory are rife, and it is easy to think of memory as being stored in a neuron, but the fact is that no object is retrieved and there is not a specific neuron for a specific memory. For any memory, a synaptic pattern needs to be reactivated through a neurochemical process, i.e. 'if you take a memory out of storage you have to make new proteins (you have to restore, or recon-solidate it) in order for the memory to remain a memory'. Possibly the most radical corollary of this is that '*the brain that does the remembering is not the brain that formed the initial memory*'.[7] Each experience, each thought we have changes us. It changes our brains ... With each memory, we are in fact re-membering – putting back together – a variation on a neural pattern within a new organic context.[8]

The self can be seen in some ways as what arises out of the dynamic neurochemical processes we experience and register as we interact with our environments. This 'ecological' view of the development and function of cognition is also evident in the work of Edelman and Tononi, who hold that higher brain functions, including consciousness, are conditioned by and require interactions with the world and other people, i.e. mind is a result of reciprocal interaction between perceptual and proprioceptive experience, between external and internal environments, such that what happens in one influences what happens in the other. Only physical processes are needed to explain consciousness, and consciousness arose only because of a very specific evolution of the physical human body in response to environmental changes both in the natural world and in the organisation of human commu-nities. Rejecting the concept of the closed circuits of binary logic as the basis for understanding cognitive processes, embodied cognition is viewed as an open, non-linear system that is subject to perturbations from an array of different sources.

More recently, 'situated cognition' has been used to encompass terms such as 'embodiment, enactivism, distributed cognition, and the extended mind'.[9] This approach generally views mind in three modalities:

> First, cognition depends not just on the brain but also on the body (the embodiment thesis). Second, cognitive activity routinely exploits structure in the natural and social environments (the embedding thesis). Third, the boundaries of cognition extend beyond the boundaries of individual organisms (the extension thesis). [...] Without the cooper-ation of the body, there can be no sensory inputs from the environment and no motor outputs from the agent – hence, no sensing or acting. And without sensing and acting to ground it, thought is empty.[10]

Cognition is embodied, i.e. not separable from our physicality. Cognition is embedded, i.e. it depends heavily on off-loading cognitive work and

taking advantage of affordances, or potentials, in the environment, and, as such, it is very much a result of 'ongoing agent-environment interaction'.[11] Cognition is extended, i.e. 'the boundaries of cognitive systems lie outside the envelope of individual organisms, encompassing features of the physical and social environment [...] In this view the mind leaks out into the world and cognitive activity is distributed across individuals and situations.'[12]

This situated view of cognition is in some ways modeled on mathematics' dynamical systems theory, which is used to describe the operations of complex dynamic systems of interaction. In this view, because states of a cognitive system depend as much on changes in the external environment as on changes in the internal one, it becomes as important for cognitive modelling to track causal processes that cross the boundary of the individual organism as it is to track those that lie within that boundary. In short, insofar as the mind is a dynamical system, it is natural to think of it as extending not just into the body, but also into the world.[13]

To cite philosopher Evan Thompson, mind is 'an embodied dynamic system in the world', not a 'neural network in the head';[14] our world 'is not a prespecified, external realm, represented internally by its brain, but a relational domain enacted or brought forth by that being's autonomous agency and mode of coupling with the environment.'[15] The relationship between the organism and the world is one of 'dynamic co-emergence',[16] i.e. 'cognition unfolds as the continuous coevolution of acting, perceiving, imagining, feeling, and thinking'.[17] The organism engages in *autopoesis*, or self-making, within an *ecopoetic* situation; the self is not made without being made by and also making its environment.[18] As William Clancy writes, we cannot locate meaning in the text, life in the cell, the person in the body, knowledge in the brain, a memory in a neuron. Rather, these are all active, dynamic processes, existing only in interactive behaviours of cultural, social, biological and physical environment systems.[19]

As intuitively right as this might seem, it is important to note that some cognitive scientists reject the idea of extended cognition as framed by the dynamical systems perspective, one argument being that the standard argument for pushing the boundary of cognition beyond the individual organism rests on conflating the metaphysically important distinction between causation and constitution. 'It is one thing to say that cognitive activity involves systematic causal interactivity with things outside the head, and it is quite another to say that those things instantiate cognitive properties or undergo cognitive processes.'[20]

This is a prime example of the need for rigorous conceptual and evidentiary clarity when proposing to derive meaning from the research.

Affect theory(ies)

As with cognitive science(s), affective sciences and affect theory are terms that are used in widely, even wildly varying ways particularly in terms of the latter. The affective sciences are generally those whose research involves taking into account affective aspects (e.g. emotions, feelings, attitudes, mood) in studying individual and collective behaviour. Concerned with a variety of approaches to affect, affective science encompasses disciplines such as psychology, sociology, neuroscience, biology, history and linguistics, among others; these are, of course, also areas engaged by cognitive science, so it might be useful to think of the interdisciplinary domains of cognitive science and affective science as having overlapping interests and objects of study, but with sometimes differing foci, tools, and vocabularies.

Affect theory, perhaps like feminist theory, is, I believe, best understood as affect theories, a myriad of approaches to studying and understanding flows of affect, often from psychological, sociological, or political perspectives. The way that the word 'theory' is used in the humanities, as in the term 'affect theory', would likely be 'hypothesis' in the sciences. This distinction is important. Scientists develop a hypothesis about a problem or object of study, devise experiments and observations to test the hypothesis, and arrive at a theory only after the research has borne measurable and repeatable material results, i.e. survived the standard of falsifiability (and even then a theory may be contested, e.g. for the way in which the information is interpreted or reframed by new information). Although focusing on the same phenomena, the disciplines of affective theory start from different backgrounds and perspectives, and use very different tools, both instrumental and analytical. There is still much disagreement about e.g. the differences between affect and emotions, what affects and emotions precisely are, and how they should be understood, particularly in terms of whether they are primarily bodily or consciously registered.

My reading in affect theory has been limited (my work engages areas of cognitive science), but, because there is a developing dialogue between the two areas, I offer some very basic background. Affect theory exists in two dominant modes. One of these derives from the work of Sylvan Tomkins, sometimes credited with founding the field with *Affect, Imagery, and Consciousness* in 1962. In his psychobiology of differential affects, Tomkins argues that affects are definable, nine unvarying categories describing body states connected to the biological – and only the biological – aspects of emotion: interest/excitement, enjoyment/joy, surprise/startle, anger/rage, fear/terror, shame/humiliation, dissmell, and disgust. These, in Tomkins' vocabulary, are distinct from emotions, which connect to the level of

consciousness and are complex and often hard to define. (This is a prime example of the need for care with vocabulary when engaging this work, since others, e.g. Damasio, use the word 'emotion' to describe preconscious, physiological and biological body states.) For Tomkins, affect refers to the particular biological response that occurs when a set of genetically determined, 'hard-wired' mechanisms are stimulated or triggered. These affective responses are conditioned to some degree by our situatedness, or, as Gregory J. Siegworth and Melissa Gregg state in their introduction to *The Affect Theory Reader*, 'these wires are by no means fully insulated nor do they terminate with the brain and flesh; instead they spark and fray just enough to transduce those influences borne along by the ambient irradiation of social relations'.[21]

The other dominant mode of affect theory, which Gilles Deleuze defined as an ethology of bodily capacities, derives from Deleuze's and Félix Guattari's *A Thousand Plateaus: Capitalism and Schizophrenia* in 1980 and, more significantly, Deleuze's *Spinoza: Practical Philosophy* in 1988. It is arguably this thread that has recently been dominant in affect theory. The definition of affect here differs significantly from Tomkins'; as described by Brian Massumi, neither 'affect' nor 'affection' denotes a personal feeling (*sentiment* in Deleuze and Guattari). *L'affect* (Spinoza's *affectus*) is an ability to affect and be affected. It is a prepersonal intensity corresponding to the passage from one experiential state of the body to another and implying an augmentation or diminution in that body's capacity to act. *L'affection* (Spinoza's *affectio*) is each such state considered as an encounter between the affected body and a second, affecting, body (with body taken in its broadest possible sense to include 'mental' or ideal bodies).[22]

In Deleuze's view, affects are independent of the person, insofar as they are not under the person's control, and they are something that occurs between people, rather than discretely within an individual. Working in the tradition of Spinoza, Deleuze 'locates affect in the midst of things and relations (in immanence) and, then, in the complex assemblages that come to compose bodies and worlds simultaneously'.[23]

A shorthand for understanding these two takes on affect is that Tomkins' works 'inside-out', with affect being that which 'puts the drive in bodily drives', while Deleuze's works 'outside-in', affect being 'an entire, vital, and modulating field of myriad becomings across human and nonhuman'.[24] But this is just the beginning, for there are at least eight important and varying terrains addressed in affect studies, including interests in: phenomenology and post-phenomenologies of embodiment; technological interventions into the organic, e.g. cybernetics, bioengineering; non-Cartesian philosophical traditions; psychology and psychoanalysis; political work, e.g. connected

to feminisms, queer theory, and disability studies; resisting the dominance of language in humanistic studies; using affect studies to rethink critical discourses on the emotions; and pluralistic approaches to materialism in the sciences.[25]

If this sounds fluid, it is. Among the key goals of affect theory is 'to address what transpires in the affective bloom-space of an ever-processual materiality', for the purpose of always 'moving beyond one after another "materialism"'.[26] 'Contingency', 'ineffability' and 'futurity' are representative of key terms in the field. Again, to cite Gregg and Siegworth:

> No wonder then that, in theory, the 'what' of affect often gives way to matters of 'how' in the rhythm or angle of approach: thus, why a great may theories of affect do not sweat the construction of any elaborate step-by-step methodology much at all, but rather come to fret the presentation or the style of presentation, the style of being present, more than anything else.[27]

This fluidity can have valuable social and political uses, but it also means that affect theories are typically not theories in the scientific sense, but rather interesting, exciting, even useful hypotheses about how things work that may or may not be borne out by eventually-examined material evidence. Lawrence Grossberg, a founding affect theorist, says:

> I do think that affect can let you off the hook. Because it has come to serve, now, too often as a 'magical' term ... I think there is a lot of theorizing that doesn't do the harder work of specifying the modalities and apparatuses of affect, or distinguishing affect from other sorts of non-semantic effects, or, as I said, analyzing the articulations between (and hence, the difference between, as well as how one gets from) the ontological and the 'empirical'.[28]

This lack of specificity is present not only in affect theories; some using cognitive science are also guilty of making leaps with research, e.g. as in the sometimes wildly extrapolated and ungrounded uses of mirror neurons as a concept.

There is a tension between affect theory's desire to examine and thereby help shift material conditions and the call to move 'beyond one after another "materialism"'. There is also perhaps, in this framing, the danger of replicating a version of the Cartesian split between body and mind, stuff and feeling; however, leading affect theory scholars are generally clear to state that this is not the way the work is to be taken (counter to Ruth Leys argument in 'The Turn to Affect: A Critique'). My bias for cognitive sciences over affect theories is no doubt showing, and I wonder to some degree how

affect theory differs from older rhetoric studies, insofar as it often engages flows of feeling in 'non-quantifiable' ways (my thanks to Marla Carlson for this insight and question).[29] That said, there is no doubt something appealing and at times useful in the field's insistence upon a space of play.

Some implications for the practitioner

This project has immense implications for our understanding of what it means not just to have, but *be* a body; these fields engage imagination, emotion, constructions of self, interrelationships, memory and consciousness, among other things. Current cognitive science dislocates a number of things, among them familiar constructs of identity, feeling, and selfhood that have been dominant for decades, and any belief that culture and biology are separable. At the same time we must be cautious about our applications of the science and honest about our motives for doing so. Science has long informed our engagement with theatre and performance, but there are limits to the relationship and caveats about applications of the former to the latter. Scientists use a reductive approach – verification through repeatable experimentation that accounts for all of the variables involved in the experiment; the process is inductive. In the arts and humanities, theorising (or, more accurately in terms of science's vocabulary, hypothesising) is typically deductive, based upon the examination of texts and historical artifacts, the observation of performances, or the assessment of the experiential through a particular critical, philosophical, or political framework, which often involves a good degree of subjective interpretation. The inductive nature of science demands that it be reductive, looking at specific, even microscopic objects such as 'a single type of neuron in a specific part of the brain'.[30] Underpinning the sciences are principles of falsifiability and repeatability. Theories and things presented by science as facts are proven by results that are repeatable, experiment after experiment, and that are always subject to being disproved when a new experiment produces different results, i.e. even science is highly contingent, and involves its own kinds of subjective assessments of evidence. This is of course foreign to performances studies' reveling in the complex and contradictory aspects of our objects of study. Interestingly, when scientists bring together the results of a broad range of experiments to reach general conclusions, more variables come into play across the experiments and often makes conclusions more speculative, i.e., the broader the assertion, the further scientists move into conjecture and hypothesis and away from science. For this reason, among others, those of us in performance and theatre studies must engage primary and secondary

scientific research, which raises the challenge of educating ourselves in the terrain of these sciences and the standards by which they operate. Summary articles in recognised journals are useful points of entry because they provide a context for and condensation of research on particular topics, including competing arguments and claims; we must engage or at the very least acknowledge these competing claims, if we are to have a hope of being responsible in our appropriations and applications.

Different kinds of evidence, ranging from the neural to the linguistic and behavioural, are useful for different aspects of performance and theatre studies, but cannot be applied whole cloth. Among the things those working with this material have been learning is that one must be cautious in using research on the neural level to explain anything in the realm of the experiential or conscious. For example, the discovery of mirror neurons in monkeys did not immediately mean that humans had mirror neurons or that they functioned identically in humans, or that the discovery of neural simulation in humans meant that we are intrinsically empathetic. One must be clear about what is presented as scientific theory, i.e. an explanation that accounts for observable phenomena, following processes of repeatability and falsifiability, and what is speculation, i.e. *possible* explanations for phenomena which have not yet been borne out by experimentation. It is important to discern between data and conjecture. One must be sensitive to contradictions and disagreements among the scientists' explanations of what they have discovered by experimentation and how they are interpreting it. One must be clear about the differences among the various cognitive science disciplines in terms of methodology and parameters for truth claims, e.g. there are differences in the processes and perspectives of cognitive linguists and neuroscientists. One must be respectful of the power – conscious or otherwise – of metaphor and the intrinsic human tendency to think metaphorically and analogically, and the fact that we 'live in the blend', as Amy Cook has written. Sometimes these associational leaps are apt, and sometimes not, growing as they do out of experience, habit, and desire. Having made this last caveat and acknowledging that the use of science *qua* science can be profoundly important, the use of science as a springboard to engage theatre, dance and performance can be incredibly rich – but this potential for creativity and for experiential and intellectual efficacy is different than making a claim that what we do has the efficacy or 'truth' of science.

The chapters in this section treat embodied practice in relationship to performance from three different perspectives. In 'Embodied Memory and Extra-Daily Gesture', Neal Utterback describes the findings of an experiment he conducted with actors, gesture and memory, in which he explored the

efficacy of different modalities – suppressing the actor's permission to use gesture while memorising a text, assigning a specific gestural 'score' to an actor for memorising a text, and allowing the actor freedom in finding and using her own gestures while memorising a text. In '*Footage:* Surface Feelings', Martin Welton describes research he is doing with choreographer Clare Whistler on how embodiment is experienced through the feet, and how the foot's 'surface knowledge' profoundly affects our sense of our selves and our situatedness as we move from a 'natural' outside environment into the studio. In 'The effect of theatre training on cognitive functions', Gabriele Sofia looks at the neurobiological processes underpinning our action and perception control, and relates these to the work of neuroscientists who have used theatre techniques to treat people suffering from Parkinson's disease and found them to be particularly effective, i.e. the exchange is a 'two-way street' that benefits both disciplines. (I encourage you, while reading these latter two, to be aware that the authors are using the term 'body schema' in ways that are different.) The three chapters are models of how different kinds of work at the intersections of performance and cognitive science can enrich our understanding of memory, movement, touch, space, and sense of self. The provide insight into what it means to act, what it means to move, and ultimately how we are as human beings.

Embodied Memory and Extra-Daily Gesture

Neal Utterback

An actor friend of mine at a major American graduate acting programme complained to me that he has trouble memorising text and that through all of his training no one had ever really given him substantial advice on how to do so. After a long discussion about his personal technique he finally explained that he often works on text in bed before sleeping. What about that scenario, I wondered, might be interfering with his memorisation? Recent research in embodiment within cognitive science is continually showing us that the body and mind are fully integrated as one unit. While the sciences are beginning, more and more, to see the connection between the body and memory and, in particular gesture and memory, much more discussion of this connection needs to be had among theatre scholars and practitioners.[1] It is common to hear actors complain that it is difficult for them to memorise text prior to rehearsal. However, very little advice or training is typically geared towards aiding actors in the acquisition of skill. This may be in large part due to the fact that we still know precious little about how the human agent maximally accomplishes this task.

Memory is at the heart of everything we do in and out of the theatre. As Anne Bogart writes in *A Director Prepares*: 'The act of memory is a physical act and lies at the heart of the art of the theatre. If the theatre were a verb, it would be "to remember".'[2] Yet memory gets far less attention in our acting theories than it should given how profound it is to our total experience. Certainly actors rely heavily on their memory systems whether to recall text, blocking, or, simply, the location of the theatre and what time to show up to perform or rehearse. Certainly theorists like Lee Strasberg expect the actor to be able to recall events from her life to tap into emotionally relevant material.[3] But neither Strasberg nor most other theorists give any falsifiable evidence in support of how this is done. Additionally, while there is an increased interest in daily gestures within cognitive science, there is little examination of extra-daily, theatrical gestures used by actors.[4] In this chapter

I will reveal, through empirical study, that gesture is remarkably important to how and to what degree of success the actor is able to store and remember text. Memory is a physical act. I will show that gestures aid in the acquisition of text for the actor and restriction of the hands actually produces a degraded performance of that text.

Using the theories and methods of cognitive science will afford me advantages in the observation of theatrical, performed phenomenon, specifically that of gestures. Moreover, those observations will be rooted in repeatable measures with quantifiable results instead of the subjective or folk assumptions we have been previously reliant upon. In his 2007 paper 'Falsifiable Theories for Theatre and Performance Studies', Bruce McConachie expresses concern that our major theories of acting cannot stand up to the same rigorous falsifiability that good science can.[5] He writes: 'By falsifying provisional theories and constructing alternatives that better account for the evidence, scientists gradually forge new possibilities that offer more robust explanations.'[6] Acting theory has little to in the way of falsifiable theories. We have, as artists, by and large been able to bypass such scrutiny by saying, 'it's art'. However, I would argue that art still is predicated on the same physical properties that science is. An actor does not get to disregard gravity just because she's an artist. This chapter, and the larger project of which it is a part, is a direct answer to McConachie's call. I am not offering the findings from these studies as objective truth but rather as a beginning of a project of falsifiability in acting theory. Certainly, science is not nor will it likely become the sole means by which theatre, in general, and acting theory and training, in particular, is judged; as Joseph Roach has eloquently shown: performance and science have always made strange bedfellows.[7] We need to re-examine our current assumptions about acting theory, and gesture's role in performance using the science and scientific practices available to us. Moreover, while most actors might argue that acting is not a science, as Declan Donnellan suggested, we can use scientific methods to better understand the interactions that occur within the actor herself and between the actor and audience.[8] By borrowing empirical methods from the sciences we actually open up entirely new ways of understanding our work. Adding these tools to our repertoire offers us richer insights and, perhaps more importantly, makes us accountable. Certainly not all of our work will be able to be tested, but certainly many in the sciences have begun to test gesture in daily conversation. Now it is our turn to test gesture under extra-daily performance.

To construct extra-daily narratives, actors (and acting agents in daily narratives) traffic in time and space. While most acting theories involve some discussion of gestures, actors (especially young novice ones) have

tremendous difficulty moving past self-conscious, over gesticulation. As John Lutterbie writes in *Toward a General Theory of Acting: Cognitive Science and Performance*, young actors often have the most difficulty trying to figure out what to do with their hands unfortunately, many directors and teachers do not have much to offer the novice by way of advice.[9] Often, intentional gestures on stage are only choreographed when a specific gestural functions seems necessary to the dramaturgy. Cognitive research is continuing to show us just how important gestures are and, more importantly, why deeper investigation is needed for us as theatre makers and theatre educators. In this paper I will discuss the two empirical studies I performed looking at gestures and memory. In each subjects were asked to memorise Shakespearean sonnets under various conditions. In the first instantiation of the study, students were tested to see whether being seated at a table or being able to freely move around the room had an effect on memory. In the second study they were tested to see whether and to what degree gesture was playing a specific role. They were tested under one of three conditions: seated, free-moving, or choreographed gestures. Both studies, approved by Indiana University's Internal Review Board, were organised as a pilot to investigate the functionality and cognitive mechanics at play with actors in memorising text. I wanted to investigate first what role the body was having under different trial conditions. The hypothesis was that those that are able to freely use their bodies would actually encode text with greater success than those who do not have active use of their hands.

In the first memory study, two trials (seated, standing) were conducted separated by a week between each trial. The trials were randomly selected as to which sonnet was given in the standing versus the seated condition. I used Sonnet 106 and 110, each 110 words long, because I hoped that they would be less familiar to the actors than other sonnets.[10] In the first trial they were asked to remain seated at a desk. In the second trial – performed a week later and, in most cases, at the same time – the same subjects were given the other sonnet. They were directed into the same rehearsal room as before only this time they were asked to remain standing (see Figures 4a and b). In both cases, when they returned to the main room they were instructed to stand on a mark in front of a research assistant with a Flipcam™ and recite the sonnet. Undergraduate student actors were recruited from Introduction to Theatre, Acting, and Script Analysis courses. The students were given extra credit (15 points) as an incentive to participate and all had other, non-study volunteer opportunities for extra credit.

Text was coded based on the expectation of verbatim recall on the original sonnet.[11] Plural substitutions were accepted in both trials as a correct word (i.e. ' … and lovely *knight*' was accepted although the correct

text was '*knights*') but tense mistakes were not accepted (i.e. ' ... And beauty *made* beautiful old rhyme' was not accepted for the correct *making*). Plural usages were only taken because in some instances it was difficult to tell, based on acoustics, articulation, or recording limitations, whether the participant was using the plural or not. So, as a blanket allowance, plural and singular substitutions were included. Likewise modern replacements (*spend* for *spend'st*) were not accepted. Missed or replaced words were taken on a one-to-one basis while any added words were counted individually as additional mistakes. If the subject stopped and corrected the text the additional words were not counted (although one could argue that the expectation of verbatim-ness would negate the ability to self-correct and all words spoken would count as single instances of spoken text; however, in this study I chose to simply go with the new, corrected text for simplicity's sake). For example:

> Original Text: Where art thou Muse that *thou* forget'st so long,
> Spoken Text: Where art thou Muse that *thy* forget'st so long,
> Count: -1 because the word was simply replaced, one-to-one
> Original Text: To *speak of that which* gives *thee* all thy might?
> Spoken Text: To *which* gives *thou* all thy might?
> Count: -5 since each word was matched until there were residual mistakes made and the greater number was recorded.

As expected, subjects were able to recall more correct words in the standing condition versus the seated. The study ended up with N = 18 subjects (15 females, 3 males) who volunteered from a T100 Introduction to Theatre or T101 Script Analysis course for undergraduates. No interview process was conducted to determine whether the subjects referred to themselves as actors or how much training or experience they had in performance. Admittedly this may have been a confounding variable and in the next iteration of these tests I plan to make some degree of allowance for this. I used a paired sample T-test to process the results of the coded text. When subjects memorised the text standing they recalled more words (M = 18.83, SD = 6.64) than when they were seated (M = 12.61 SD = 5.96) and was statistically significant t (17) = 3.122, p < .05, two-tailed (see Figure 5, Table 1).

In the next memory study, I tested individual subjects under one of three conditions. All subjects were given the same sonnet, in this case Sonnet 106, but were given then randomly assigned condition of either restricted hands, free gestures, or specifically choreographed gestures.[12] For the restricted subjects, they were asked to hold a book (actually the *Riverside Shakespeare*). This type of restriction, I thought, would be more naturally occurring, as opposed to holding a rod or other unusual tool. However, as I will show,

regardless of the restriction the results reveal the same impairments. In the choreographed condition subjects were given three specific lines and actions. For line three, 'And beautiful making beautiful old rhyme', subjects were asked to place both hands, one on top of the other, over their heart on the word, 'beautiful'. On line five, 'Then in the blazon of sweet beauty's best', they were to brush both hands across their face as if opening a curtain. And finally, on line nine, 'So all their praises are but prophecies ... ' they were asked to circle their right hand in the air as if it were a searchlight. The choice of placing a choreographed gesture at those points was random – the words don't necessarily contain more or less critical content than others. However, since the gestures weren't written down anywhere, I expected that three gestures would be more than enough to remember. Additionally, I tried to choreograph metaphorical gestures that might offer some kind of link to meaning to the assigned words. However, it should be noted that the gestures were subjectively mine and prescribed to the actors as a director might. Plus, the gestures were front-loaded in the sonnet because subjects in the previous studies rarely memorised anything past line ten.

The study included N = 43 subjects (15 males, 28 females).[13] For this study I coded only positively uttered words, regardless of order (even though they were instructed to memorise verbatim). As in the above case, the only exception made was in plural and mispronunciation of unfamiliar words such as 'wights', which some subjects pronounced 'weights' or 'whites', respectively. Since the word was not primed in anyway with a pronunciation, which may have added emphasis from the administrator, I included either as a positive utterance. To measure the results I used a One-way ANOVA on SPSS. The results were quite interesting. I had assumed that the choreographed instance would have resulted in more correct words than the free condition. However, the choreographed condition resulted in significantly poorer results than even the restricted condition: $F_{(2, 38)} = 7.624$, $p < .05$ (See Figure 6, Table 2). Once again the free condition resulted in significantly more words remembered than the restricted condition, but the choreographed condition seems to be adding additional cognitive front-loading. It is my analysis that the choreographed gesture seems to drawing attention away from the assigned task. Rather than acting as a spatial marker (i.e. the gesture-word pairing aiding each other), the subject seems to have to share working memory for two arguably arbitrary tasks. There is no subjective 'meaning' to the gesture because the subject had no opportunity to self-generate meaning.[14]

Even when we don't consciously make an intentional gesture it seems our bodies have an understanding of the organic, intended meaning. The gesture helps to shape meaning through the body and allows us to understand

concepts of the world. As Wu Choon and Seana Coulson illustrate, subjects shown videos of speech accompanied by gesture have better comprehension than people who only hear speech.[15] This is especially true for issues of locations, categorisation and other richer information that might not be explicit in the syntax. Donna Frick-Horbury conducted a study looking at the recall of concrete and abstract words through either a self-cued scenario (viewing one's own self-generated gestures) or other-cued (viewing someone else's gestures). As expected, the self-cued group had greater recall for both word types than other-cued groups. One hypothesis Frick-Horbury uses to account for this is by saying that gestures are temporally related to speech production and by disallowing or otherwise bypassing that movement pattern a motor connection is missed.[16] Self-generated gestures, as opposed to observed or choreographed gestures, have the special power of being active in the world for the individual agent. Self-generated gestures aid the agent in remembering words over long periods of time, for example, a rehearsal process.[17] The body remembers itself. Memory, then, is not merely the mental activity confined to an isolated brain but a rich interaction of body within a contextualised world. Gesture allows the body to *do* the words, to quite literally shape it and give it form in and through the body.

Whether people consciously or unconsciously understand that the body is making meaning, or potential meaning, they clearly rely on the body as a cue for meaning by fusing elements of context and performance qualia with the actual shape and form of the gesture along with an associative text. The gestures are aiding the speaker's understanding of meaning. I would argue that as the meaning, text or story is more firmly secured in more stable short-term memory the body requires fewer gestures. Or, the gestures become a kind of shorthand (pun intended) for the text. In their 2002 paper, Wolff-Michael Roth and Daniel V. Lawless write: 'when students interact with the physical world to produce phenomena, they produce new sensorimotor schemata that come to be expressed in gestures, which are subsequently transformed into increasingly abridged gestures.[18] Just as language can be compressed to find economical shorthand, so, it seems, can gestures. An initially complex gesture sequence can be shortened and abridged to represent a more complex concept as the actor understands and remembers the larger concepts and elements of a story or text. In a previous study I conducted, subjects were asked to remember a story, first from a first-person and then from a third-person perspective, and retell it from memory. The original goal of that study was to examine perspective taking in fictional narratives. However, an unexpected side-effect was that, as the story became more and more familiar the number of gestures produced decreased and the time required to tell the story likewise decreased (see Figure 7 Table

3a and b). For me, these results clearly indicate a major sea-change in how I approach acting theory and training. Not only do we need more falsifiable evidence in support of our theoretical positions but also as we continue to teach and train young artists we must recognise that there is far greater connectivity between the body and memory. We typically see acting broken down in what most might consider mental activity (script analysis, scene work, etc.) and those activities that are otherwise presumed to be the domain of the body (movement classes and such). However, such a breakdown might actually work against the holistic and integrated nature of the human agent. Regardless of the acting methodology, all are predicated on the elicitation of memory at some level. The actors have to remember blocking and text but are also always drawing on (just as 'normal' people do) the memory of past personal experiences to interpret and understand theatrical moments. Audiences are remembering their own experiences in and out of the theatre in order to unpack the blends created in a theatrical event. Theatre can be said, then, to always be about memory and memory is not merely the domain of the brain or, rather, a brain without a body. As my gesture study seems to show, memory is of the body.

Who we are as conscious selves is a story we tell ourselves. I am a story I tell myself. Those stories rely on our ability to remember the details. But just as our sense of self is a story so, too, is our memory. Our memories are not stored firmly in some warehouse but are, instead, a dynamic process, an ever-evolving story.[19] To be human is to be a storyteller. While some story-telling is obvious, i.e. theatre, we often don't recognise the ubiquity of stories because they are so integrated into our lives and sense of selfhood. Our understanding of the world and our stories of our self are the same thing.[20] Our sense of self is within a storyline that is compressed, just as in any other literary or dramatic form, by virtue of forgetting and sheer storage capacity. In fact, it is likely that our ability to bind memories is a function of our ability to tell stories. Telling others our stories, with gesture and word, helps us shape and secure our memories in time and space. Kay Young and Jeffrey L. Saver write: 'To be without stories means ... to be without memories, which means something like being without a self.'[21] Play-acting, storytelling and performance are not simply entertaining; they are the foundation of all human experience. That experience is, as we have seen in countless examples, a creative process by nature. Within that creative process, just as we saw in the blending of actor and role, the body is ever-present and crucial to the entire process.

Gestures help us shape meaning in the world. As I have shown above, meaning is rooted directly in memory. Whether it is simply remembering lines or blocking or drawing on personal narratives to invent new blends

and other creative acts all of our work in the theatre can be said to be about memory. My studies have shown how interconnected gesture and memory is. Others working in the theatre have found similar findings. In the their paper 'The Non-Literal Enactment Effect: Filling in the Blanks', Helga and Tony Noice show that verbal phrases are better remembered when some form of physical movement – even incongruous movement – is associated with them. Under the cohesive heading of 'subject-performed task' (SPT) they explain that goal-oriented memory aids in the binding of memorisation – such as the kind actors routinely have to do. However, they point out that most of the research in SPT has been in verbal phrases such as 'lift the pen' with an accompanying action; in other words, literal verbal-motoric co-occurrences. However, the Noices have found similar effects in non-literal forms. Referring to self-accounts of actors, the authors note that performers frequently feel like they have a greater handle on material when there is physical connectivity. The authors spoke with actors who had performed together in a production and asked them to recall moments from that production three months later. They found that the actors were able to better recall moments that had some form of physical-spatial relationship to text as opposed to sitting or stationary.[22] In another study the researchers had two groups (sitting, moving) of undergraduate actors attempt to memorise a scene – involving themselves fully in the circumstances of the scene – to see which group better memorised the scene. Without exception the moving groups outperformed the sitting groups. Based on my results I would add to say that, while I certainly believe this to be true, I would imagine that if the actors were able to generate a movement sequence on their own first and then have that physical activity refined they would remember those moments even better. But even in the short-term, actors who are able to self-generate gesture and other physical activity will have a greater remembrance and, thus, connectivity to text. Regardless of how we consider the theoretical function of the actor, at the end of the day, her job is highly dependent on memory.

In daily conversation, gestures are by-and-large unconscious (we do them when we're on the phone and no one is looking) and they serve as a kind of tool that aids in thinking.[23] Therefore, gesture is by no means some isolated motor activity but deeply intertwined with a holistic embodied and contextualised cognitive process. Susan-Wagner Cook adds to David McNeill's stance on growth points – the emergent locus of the gesture-linguistic dialectic – by saying that our thoughts, 'crucially mediated by gestural loops in the physical world', are literally and figuratively moved forward in the world by the body.[24] Likewise, Shaun Gallagher adds that even when a gesture may not seem to be adding anything particularly useful

to the furthering of, say, a conversation it is likely that they are adding to the cognition of the speaker.[25] I contend that gestures act as a tool of the extended mind just as the notebook and smart phone do. They have a visuospatial, spatiotemporal dimension (i.e. I can see and feel them), and they are intrinsically linked to internal thoughts and ideas in real time and space. They engage with the mind and the environment and often act as an intermediary between the two, negotiating, spatially, meaning. My subjects in both studies were able to remember statistically more words correctly because they were able to proactively, self-generate gestures in co-ordination with thoughts about those words and the external task (i.e. memorisation of a sonnet). Hands touch the world, we use them to feel and explore and, as it turns out, to express and remember. Think, learn, feel and remember: these are the basic foundations of the cognitive human agent. Clearly gestures are valuable tools for actors. We use them to make sense of text and story. We use them shape meaning in the world. Gestures have a profound effect on our ability to memorise text and construct meaning. They become a kind of extension of our mental activity. Props can serve likewise. Thinking does not merely happen inside my head but throughout my body, which is interacting physically with the world. My hands are extensions of my cognitive processes.

In conclusion, the picture that continues to develop is one that supports a holistic interplay between the external world and the internal one. The body is not simply the house for the brain that moves through a world but each is inextricably knit up with the other in a delicate balance. Gestures not only help us form meaning and understanding as we engage in the world, they are providing a cognitive prop that assists in the encoding of memory. As a lifelong actor and acting student I have actually never been taught how to memorise. I have been given tips and folk wisdom but no one could adequately tell me how memory worked and to what degree the rest of my body was integrated. My study, provided as my own first steps towards a deeper understanding of the complexity of the embodied human agent, can easily be applied to our classroom and rehearsal laboratories. We must move our acting theories and pedagogy into a realm where statistical evidence, and not mere anecdote, informs our teaching and training. We need theories of acting that accommodate the tremendous dynamism and fluidity of the actor's emergent selfhood and embodied memory.

Please memorise the text in bold and be prepared to perform it in front of the camera. You should memorise it verbatim – be as precise with the words and their order. As you memorise the text please *remain seated* at the table. My assistant will remain in the room should you have any questions. You will have *two minutes* to memorise the text; however, if you feel confident with the text before the end of that time let the assistant know and he/she will bring you back in.

Figure 4a Instructions for memorisation of sonnet, seated.

Please memorise the text in bold and be prepared to perform it in front of the camera. You should memorise it verbatim – be as precise as possible with the words and their order. As you memorise the text please *remain standing* though you are certainly free to move about the room as you wish. You will have *two minutes* to memorise the text.

Figure 4b Instructions for memorisation of sonnet, standing.
Instructions provided for actors memorising sonnets as part of the Gesture Memory Study.

	Paired Samples Test							
	Paired Differences							
			Std. Error Mean	95% Confidence Interval of Difference				Sig. (2-tailed)
	Mean	Std. Deviation		Lower	Upper	t	df	
Pair 1 Stand – Seat	6.2222	8.45441	1.99272	2.01794	10.42650	3.122	17	.006

Figure 5 Results of initial study that reveal how standing subjects outperform seated ones in memorisation of prescribed text.

ANOVA

Score

	Sum of Squares	df	Mean Square	F	Sig.
Between Groups	3089.210	2	1544.605	7.624	.002
Within Groups	7698.546	38	202.593		
Total	10787.756	40			

Descriptives

score

	N	Mean	Std. Deviation	Std. Error	95% Confidence Interval for Mean		Minimum	Maximum
					Lower Bound	Upper Bound		
Restricted	13	24.8462	17.12623	4.74996	14.4969	35.1954	6.00	59.00
Free	16	36.4375	15.33610	3.83402	28.2655	44.6095	13.00	66.00
Choreo	12	15.4167	7.69248	2.22063	10.5291	20.3042	4.00	28.00
Total	41	26.6098	16.42236	2.56474	21.4262	31.7933	4.00	66.00

Multiple Comparisons

Dependent Variable: score Tukey HSD

(I) group	(J) group	Mean Difference (I-J)	Std. Error	Sig.	95% Confidence Interval	
					Lower Bound	Upper Bound
Restricted	Free	−11.59135	5.31471	.087	−24.5530	1.3703
	Choreo	9.42949	5.69797	.236	−4.4669	23.3258
Free	Restricted	11.59135	5.31471	.087	−1.3703	24.5530
	Choreo	21.02083*	5.43552	.001	7.7645	34.2771
Choreo	Restricted	−9.42949	5.69797	.236	−23.3258	4.4669
	Free	−21.02083*	5.43552	.001	−34.2771	−7.7645

*The mean difference is significant at the 0.05 level.

Figure 6 In a follow-up study, standing subjects were tested under one of three scenarios. They were asked to memorise text with either restricted hands, choreographed gesture, or were allowed to freely gesture at will. As this table shows, subjects that were able to freely gesture outperformed subjects in either of the other two conditions.

NAME	3rd	1st
Amber	2:54	2:47
Andjela	1:04	1:00
Carrie	1:06	1:14
Charnette	1:14	1:15
Erica	1:13	1:32
Gi	1:34	1:46
Josh	1:33	2:08
Prisma	1:38	1:50
Rachel	1:07	1:14
Richard	0:59	1:07
Sarah	0:46	0:56
Tim	1:30	1:50
Tricia	0:30	0:53
William	1:28	1:37
AVERAGE	**1:19**	**1:30**
STDEV	**0.0231 85308**	**0.0221 01044**

NAME	3rd	1st
Amber	24	26
Andjela	23	14
Carrie	8	11
Charnette	35	18
Erica	19	12
Gi	1	3
Josh	14	9
Prisma	18	13
Rachel	21	17
Richard	18	12
Sarah	8	13
Tim	10	7
Tricia	3	5
William	12	8
AVERAGE	**15**	**12**
STDEV	**9**	**6**

Figure 7 Tables 7a and 7b shows the results of an earlier perspective study that reveals how subjects produced fewer gestures in less time in the recreation of a fictional narrative. This study shows that gesture helps associate meaning and aids in cognitive loading of material.

Footage: Surface Feelings

Martin Welton

This chapter reflects on a process of making, rather than of giving, or showing performance. Indeed, at the time of writing (March 2013), the 'show' has yet to happen. Space (and perhaps also the reader's interest) does not allow for the elaboration of a methodology that premises the process of a practice over its iteration as performance per se. Nevertheless, it is important to highlight two parallel perspectives that this focus on process over performance allows, and that feed, ultimately, into a discussion of the status of sensory knowledge relative to a critical account of a creative practice. The first of these is a disavowal of 'the body' as an image schema in what is largely a discussion of embodiment as it occurs at, and is experienced through the feet.[1] The second is a premising of the significance of surface knowledge to this 'footed' understanding of embodiment over the profundity or depth it is sometimes used to invoke.[2] In either case, however, it is not my intention to signal this footed understanding as separate, or cut off from other modes or systems of corporeal knowledge. Indeed, as I will argue, looking and locomotion are as significant as cutaneous touch to pedestrian embodiment.

In 2011, the choreographer Clare Whistler and I were given a research and development grant by LCACE (London Consortium on Arts and Cultural Exchange) for a performance project entitled *Footage*, that was – and at the time of writing still is – partly an effort to explore these perspectives practically. This chapter is accordingly a discussion based around a process of making that is still in train, rather than one that is completed. As my concern here is primarily, and quite literally, with surface impressions, the reader will note that the distance that is presumed to come with reflection is somewhat absent, and that the discussion is contingent, in part, on events that are yet to happen. The discussion of *affect*, such as it is, is therefore also undifferentiated to some degree. In writing about affect, I must, at this stage, clarify my use of that ambiguous term, and in doing so, actively seek to distance that usage from that of the burgeoning field of affect theory recently, and witheringly, critiqued by Ruth Leys.

Running along an intellectual axis from Tomkins to Deleuze, Leys suggests, a set of interconnecting theories of affect in the critical discourse of humanities and social science share a central proposition that it 'is a matter of autonomic responses that are held to occur below the threshold of consciousness and cognition and to be rooted in the body' and are therefore predicated upon 'noncognitive, corporeal processes or states'.[3] While Leys is highly critical of the selective uptake of empirical science in the critical theory of the humanities, there is a shared agreement she suggests, between the affect theory sketched above, and that of contemporary neuroscience, insofar as both hold that 'there is a gap between the subject's affects and its cognition or appraisal of the affective situation or object … The result is that action and behavior are held to be determined by affective dispositions that are independent of consciousness and the mind's control.'[4] Although I part company with Leys' ultimate appeal to psychoanalysis as a model by which to bridge affect and appraisal, I share with her a sense of unease in the reductive move by which affect becomes shorn of intentional content in its reduction to pre-cognitive bodily states. In the discussion below, my use and understanding of the term is more informed by the 'vitality affects' identified by the psychologist Daniel Stern than the 'preindividual bodily capacities' of contemporary affect theory. Stern proposes that vitality affects include aspects of the states and expressions described as emotions in English (or what he terms 'categorical affects'), but argues that they are also more extensive:

> Vitality affects are also experienced in other events that are not neces-
> sarily associated with categorical affects: how you get out of your chair,
> button your shirt, walk. Or, how the pieces of a memory tumble (subjec-
> tively speaking) into a recollection. Or, how a string of ideas grows and
> branches. For example, a 'rush' of anger or of joy (a categorical affect), a
> rapid flooding of light (a sensation), the resurgence of a musical theme
> (a perception), an accelerating sequence of thoughts (a cognition), a
> shot of narcotics (a physiological reaction) can all feel like 'rushes'.[5]

Affect, I argue accordingly, is the 'feel' of the flow or vitality of what happens – the way it feels, the sense of how it goes.[6] As I have discussed elsewhere, there are both critical and creative advantages to blurring feelings *of* performing, with feelings *about* it.[7] Rather than determining species, struc-tures or systems of affect as they might be abstracted from experience for the purpose of inspection and analysis, I am concerned with how it is constituted within practical forms of knowing in line with what Harry Heft describes as: 'an activity which traces out lines of potential structure in experience'. As he suggests, this needs to be determined from within practical undertakings:

'structure is not imposed on experience'.[8] I will discuss these shortly, but first, by way of setting the scene, and of inviting the reader to enter into the kind of reflection that I hope the practice under discussion engages and enacts, I would like to invite you to come for a walk in the woods.

Turn off the road and follow the forestry path up the hill.

Now, here, where a stream has cut a little ravine, turn right, and head up the slope. Do you see how the trees seem to have parted in front of you? Although the ground is thick with fallen leaves and sticks, there is a way of sorts. It passes between two earth banks and climbs up through the thickness of the forest ahead.

Take off your shoes and socks. Still warm from walking, the tickling of the twigs and leaves on your skin comes mingled with a moist coolness.

Walk now, and find yourself strangely slower, more cautious, and maybe nervous, than your shod self was before. Feel the give of earth and leaf and branch as your foot presses down, and the sudden sense of give-and-take obscured by shoes. As you stand among moss, leaves and the broken bits of trees which make up the forest floor, you are not only on, but wrapping around, folded over, and pressing against them. Transferring your weight up or down, the folds and clefts of your skin – and the muscles, bones, and nerves under it – respond to the pressures of points and curves beneath, to wrap around or rest against them.

This is the feel of your foot feeling the floor, although it is not like the flat matt-black one in my studio. Here in the woods there is no underlying surface on which the plants and their detritus simply sit. There are surfaces upon surfaces, supporting, juxtaposing, penetrating one another. The press of a sharp stick up into your shoe-softened heel is only the latest manifestation of this.

Walk up the hill, and then turn and watch me follow, trying to do the same. I try, but can't, and not only because your walk is more measured, more elegant than mine, but also because of the way in which this floor resists repetition. Barefoot, it invites each step to be trod anew, although the path is itself an ancient way along which apprentice boys and foremen walked to the forges which ran up the valley, making cannon shot and firebacks from pig-iron. This place was made by feet in ancient times, and you and I, and these trees, are new-comers. So we must walk carefully, cautiously, each step a new exercise in balance and the potential for retreat, or of seeking out alternatives. Surface judgements.

You stop, brush the mud and leaves from your toes, and put your socks and shoes back on. 'Why are we doing this?' you ask, and because we have been working together on it for a while, I try to tell you, although, as usual, I start with someone else's thinking.

'What would it mean,' asks the philosopher Daniel Heller-Roazen 'for touch to be the root of thinking and for thinking in turn, to be in its most elevated form a kind of touch?'[9] Furthermore, what would it mean for an organ of touch, other than the hand, to be included in this equation?

The italicised text above is part of the performance text being prepared for *Footage,* to be performed by Whistler and myself in 2013. Some of the early experimental phases of the project form the subject of this chapter's discussion. Both these experiments, and the critical enquiry of this chapter, are concerned with tracing out the experiential knowledge manifested by touch, and, furthermore, by a particular mode of touch – a pedestrian, foot-focused one – within the practical context of gathering and devising material for performance.

In developing *Footage,* Whistler and I have held a series of workshops at Bunce's Barn, a seventeenth-century barn and its surrounds in the countryside around Ashburnham, near Battle in East Sussex, where she holds an artist's residency. In its concerns for feet, the environment, and local, or 'site-specific' knowledge, the project has some correspondence with other recent trends in performance scholarship and practice that have sought to shift discourse and production out of theatre buildings, and into more socially and geographically determined conditions of placework or 'wayfinding'.[10] The recent preponderance of studies and performances of walks might be thought to be engaged with this, were it not for the fact that, despite the significance for those concerned being *on* their feet, there is relatively scant attention given *to* them, in terms the specificity of their direction, location or sensation. Furthermore, the pedestrianism this scholarship and practice seeks to advocate often represents a disenchantment with an urban, metro-politan lifestyle.[11] The manifold, but 'tactile sterility' of the surfaces of the built environment and its mechanised transports are supposed to be at odds with the more 'in-depth' experiences offered by walking in countryside or in wildernesses.[12] In *Footage,* by contrast, Whistler and I are not seeking to establish or transpose a theatrical practice into nature. Quite the reverse. In our workshops at Bunce's Barn and its surrounds, we are gathering sensa-tions, and developing ways of moving that are environmentally informed, in order to restage them in the 'unnatural' environment of the studio. The performance that the project develops is intended to be studio-based, using a 'blank' or 'neutral' floor, so that the tactile impressions of footwork in the countryside are rendered anew – re-embodied as well as re-enacted.

However, it is not my intention, here, to separate the built, or studio environment from those that are presumed to be more 'natural'. In many respects the East Sussex countryside that surrounds Bunce's Barn is one that is man-made. This is apparent in the way in which farming and forestry

have shaped the woods and fields around it, but also in the vestiges of light industry from the eighteenth and nineteenth centuries that the land still bears. Our work at Bunce's Barn involves building up a repertoire of movement and imagery drawn, principally, from a pedestrian contact with the environment. As I will argue, while this is based upon a predominately sensory and affective set of impressions (in both literal and metaphorical terms), the foot-work involved is a matter of stepping or standing, can also be considered as a practice of attentiveness.[13] It is this attentiveness then, that is being applied to the 'neutral' floor-space of the studio in the composition of a new performance work.

The 'blunting' of pedestrian touch in shod societies Tim Ingold argues, leads to a cultural ordering of head over heels, and also to sensations of 'groundlessness'.[14] Taken together, he suggests, these both further or facilitate perspectives of intellectual abstraction as a view of the earth from above, and a subjectivity that is already and always at one remove from the environment that supports and sustains it. In the performing arts, by contrast, the signifi-cance of an embodied sense or affect of *groundedness* is taken as one of the received wisdoms of their professional practice.[15] A common-sense under-standing of the significance of this feeling of the ground is articulated by the theatre director Mike Alfreds when he writes that it 'supports and gives power to the set and to the actor ... The floor creates a dynamic space on which action will be played out'.[16] While an observation like this may well be common-sense within the shared assumptions and working-language context of professional practice, it appears questionable when placed under scrutiny. How does an inert body – the floor/stage/ground – give power or energy to a live, animate one? What sort of energy and transfer process is actually taking place? How does an inert surface create 'dynamic space'? Isn't this sort of appeal to groundedness akin to metaphysics?

In order to address this, and to try and reposition the empirical signifi-cance of pedestrian touch as a practical form of knowledge, it is necessary to observe that part of the sort of objection sketched out above, is itself based in a kind of metaphysics, albeit one that has been a cornerstone of Western intellectual culture for more than three centuries. Under this so-called 'Cartesian perspective', perception, action and environment are deemed ontologically separate, and although it has become commonplace to dismiss the division of mind and body that Descartes is regularly blamed for, appeals to 'the bodymind' or 'psychophysical performance' serve to reinforce their atomisation as much as they seek to spirit it away.[17] Even as these terminological fusions seek restitution for a bodily role in meaning-making, they risk continuing to present ways of knowing (perceptions) previously attributed to the categories 'body' or 'mind', as either contained

within the skin, or within what Raymond Tallis has called 'the intracranial darkness' of the skull.[18]

Furthermore, attributing meaningful knowledge to a hybrid such as 'the bodymind' is to perpetuate the abstraction of this psychophysical entity from the environment that its perceptions are reputedly about. '[O]ur experiences are not things that happen in our heads,' Anthony Chemero argues, 'they happen in animal-environment systems.'[19] In making this sort of observation, Chemero aligns himself with developing interests across a range of scholarly disciplines, in the significance of body-environment relations to meaning making. Variously described as 'the enactive approach to perception', 'the embodied mind', or in Chemero's case 'radical embodied cognitive science', these span intellectual perspectives regularly thought to be antithetical, such as cognitive science and phenomenology. A common point of reference for many of them, however, is James Gibson's Ecological Psychology, and in particular, its central thesis concerning the role in perception and action of what he called 'affordances'.[20] Although my own work strays some distance from the disciplinary strictures and methodo-logical concerns of cognitive science, as it does from phenomenological hermeneutics, I too find in Gibson's theory of affordances (and in much of the recent thinking that has developed from it), a means of understanding perception in terms of a body-environment nexus.

So, what then, is Gibson's theory of affordances, and how can it be applied in terms of performance practice? In some respects, the theory of affordances is a theory of perception. However, where many accounts of perception are concerned with how meaningful knowledge is extrapo-lated from it and then represented, the theory of affordances argues, counter-intuitively, that it already contains both information and its modus operandi. In doing so, it militates against a passive account of perception as simply the receipt of sensory data, and casts it, instead, as a form of environ-mentally directed sensorimotor action. The various objects and features of the environment Gibson argued, are not only discriminated from among a given field in terms of judgements, beliefs or hypotheses about them, but also in terms of what they might 'afford' the observer by way of action; their 'value' is also at least partially relative to that possible action. Thus, to know that a surface is smooth and stable, is also to know that it affords walking on; to know an occluding surface is also to know that it affords concealment; to know a graspable part of a large object, is to know that it affords the carrying of it (as a handle) and so on. A common misreading of this, as Chemero has argued, is to suggest that affordances are thus features of the environment and its objects. Confusingly perhaps, Gibson proposed, an affordance is 'equally a fact of the environment and of behavior. It is both

physical and psychical, yet neither. An affordance points both ways, to the environment and to the observer.'[21]

In attempting to demonstrate this, and to substantiate what he calls 'Affordances 2.0', Chemero gives an example of the perception of a book by 'dynamic touch' – the kind of exploratory 'hefting' that gives information as to its size and weight:

> [T]o perceive the book by dynamic touch, you have to heft it; that is, you have to intentionally move it around, actively exploring the way it exerts forces on the muscles of your hands, wrists, and arms. As you move the book, the forces it exerts on your body change, which changes the way you experience the book and the affordances for continued active exploration of the book.[22]

The perception here – haptic touch – is active, in that you have to move the book to effectively gauge its size and weight. While the information concerning size and weight belongs to the book, it is also a property of your hefting of it. Understanding the book's size and weight in this way Chemero argues, is also a means of understanding *how* to heft it. This does not require the kind of 'mental gymnastics' beloved of many cognitive theories of perception he suggests. One does not need to form a mental picture of the object in order to know what to do with it. The detail is already there 'picked up by mechanoreceptors in the muscles and tendons of the hand, wrist, and arm.'[23]

Whether as Chemero's '2.0' version, or as what he terms Gibson's earlier and original '1.0', the theory of affordances suggests that we already sense possibilities for action and reaction *within* the sensorimotor systems that constitute perception, as well as within the environmental objects or features that it is ostensibly information about. This, Chemero claims, amounts to a 'phenomenological realism': 'What we perceive, which is to say what we experience, are relations between ourselves and our environments. Our perception of affordances, which is to say our perceptual experience, is also a relation, this time between ourselves and our affordances.'[24] Affordances go some way to explaining how a dynamic touch – such as an exploratory feeling of the floor with a bare foot – can enable a spatial sense in which an inert property such as a stage, to be experienced as part of an animate sensibility. This need not involve the rendering of metaphysical energies to the ground that the foot picks up, if, as the theory of affordance suggests, what we experience are the dynamic properties of the *relation* between foot and floor, rather than of one or the other.

Although the performing arts remain one of the few milieux where daily practice is regularly a barefoot undertaking, the majority of rehearsal studio

floors and theatre stages are neutral, stable places, an inevitable consequence of the range and distribution of the practices they are required to support. The feedback presented to performers by them might thus be regarded as somewhat 'neutral', inasmuch as are required to offer a regular and consistent infrastructure of support on which the 'world' of performance is overlaid. Being consistent, it can be allowed to fade into the background or fringes of conscious awareness as focus shifts towards the technical detail of the superstructure of performance above. Similarly, the foot that 'grounds' the body it supports upon the infrastructure of the studio floor or stage must be a stabilising property that rises into focal attention only when it is deployed expressively.[25] As a result the foot is ordinarily subsumed as part of 'the absent body' – the term coined by Drew Leder to describe the body's habitual recession from conscious awareness, other than in instances of dysfunction.[26]

That being said, the notion that it is 'the body' that manifests itself as presence or absence within attentive practice is problematic. Other than in highly specialised instances, such as certain forms of meditation, or the relaxation exercises of Method actor training, it is unusual to pay attention to or through one's body in its entirety.[27] Indeed, given the physical passivity that often marks such undertakings, one might begin to ponder the utility of 'the body' as a descriptive category with relevance to practice. Either, as Leder argues, it is necessarily in retreat from an attention that extends outward from a part of it – hand, foot, eye and so on – or else it is only partially apparent as that attention is drawn to some aspect of it as a constituent element of action. This is not to say that a foot, for example, is therefore somehow figured in awareness as separate or disembodied, but, rather, that one's attention is channeled or focused to and through it as an organ of sensation.

What the creative process of *Footage*, and this chapter, are thus concerned with is the confluence in one's feet of this sensation and attention, as a means of knowing and adapting to an environment, and with their attempted reconstitution as a theatrical practice. In moving from the countryside to the studio, Whistler and I are concerned with how the footwork of performatively directed experiences in the former might constitute what the anthropologist Thomas Csordas has called 'somatic modes of attention'.[28] By identifying, and then attempting to recall them in (or as) performance in a different context, we are concerned with how the world perceived through the feet might 'appear' differently, in the sense of both experience and its staged representation.

In either case, the process also involves an attention to the detail of surfaces, rather than looking for, or assuming depths 'hidden' behind what

might be more immediately apprehended. At Bunce's Barn, Whistler and I work barefoot on the landscape. The forest path we have been walking on is little-used, other than by woodland animals. It is marked by dykes left on either side after the way itself was worn down. Whether this was by feet, or by water is unclear. In the performance currently developing from this process, Whistler and I speculate that it was the latter, incorporating into the text details of nineteenth-century life in the woods around Ashburnham documented by her ancestor, the Reverend Rose Fuller Whistler, an amateur local historian and archaeologist. Although apprentice-boys and workmen may have trudged up and down it a century and a half ago, as described earlier, the way is no longer clear, but covered in fallen leaves and sticks.

Beginning to walk in unfamiliar territory habitually involves looking at the ground in front of you. This is a matter of looking out for obstacles, but also of trying to place the movement of one's feet within a sense of the 'optic flow' by which 'visual kinesthesis' (one's visual awareness of one's own movement) 'specifies locomotion relative to the environment'.[29] Subsequently, walking barefoot on it requires an unusual attention to balance, as part of what Ingold and Vergunst describe as 'an accomplishment of the whole body in motion'.[30] Walking barefoot over broken ground, however, also requires an attention to the movement of the soles and skin of one's feet, as it brings them into contact with irregularities of surface. Where the 'smooth tactilities' of city streets and stages allow an animate sensitivity of the feet to surfaces to recede from awareness, walking barefoot on broken ground places it significantly in them, drawing together visual kinesthesis with a sensitivity to surfaces.[31]

In one experiment, Whistler and I tried to disrupt this sensory nexus by deliberately looking upwards into the canopy of the trees overhead as we walked. The sudden slowing, hesitant, and off-balance effect of this served partly to underline, but also to trouble, the legitimacy of Gibson's claim that 'locomotion is guided by perception. Not only does it depend on perception but perception depends on locomotion inasmuch as a moving point of observation is necessary for any adequate acquaintance with the environment'.[32] As the moving point of observation shifted overhead, this, together with a suddenly oddly fixed head position (i.e. craning upwards), made walking difficult, not only because we couldn't see where were going, but also because one became proprioceptively aware of what one was seeing as irrelevant to one's movement. Although we were still seeing, it was analogous, in some respects, to walking while wearing a blindfold, although even then, the sighted have a tendency to angle their head and upper-torso towards the floor as if continuing to try and look and feel where they are going. The tendency towards exploratory feeling – haptic or active touch – that blindfold movement draws out, was also present in our upwards looking

walk, although it was a fully visual experience. That both of us found it also somewhat dizzying is again, perhaps testimony to the extent to which, in normal movement, looking and locomotion are correlative.

However, this play with walking and looking on the forest path is only one form of barefoot work Whistler and I have experimented with. In front of the barn itself is a bricked platform, that in the autumn becomes grimy and slippery with damp moss and dirt. Presenting itself as a sort of stage before the *skene* of the barn, the cold, slippery smoothness of the surface of its bricks, and the roughness of their edges and joints facilitated some quite different sorts of footwork. As well as stepping, the feet can also glide, tap, point, drag, trace, and in a limited way with the toes, can grab, hold and punch. Where walking drew attention to the affordances present in the forest to locomotion and exploratory touch, the more limited movement we have explored on the bricks has also drawn out the extraordinary range of tactile sensations available through the foot.

Surface sensitivity, Maxine Sheets-Johnstone argues, is a matter of 'cutaneous stimulation' and of 'animate sensitivity', of moving and being moved. It is, she proposes 'a sensitivity that by turns may express itself in curiosity, explorations, recoilings, quiverings, affections, hastenings, hesitancies, accelerations, avoidances, persistence and much more. Surface sensitivities resonate dynamically precisely because they are alive with meaning'.[33] As ticklish – and tickled – children we are perhaps most aware of the acuity of this pedestrian tactility. As adults – ever in a hurry to put on socks and shoes – the finesse of this touch is rarely called into conscious use. Indeed, in Mark Paterson's wonderful cultural history *The Senses of Touch*, the feet, other than in passing references to walking and to skin, are barely mentioned at all.[34] Furthermore, part of the finesse of this pedestrian touch, when it is drawn into awareness, is that it has a quite different relationship to the rest of one's body than does, say, that of the hands. The extent to which the feet ordinarily support, and bear the weight of one's body means that any alternative use of them must be undertaken quite delicately.[35]

Through improvising with different sorts of footwork on the bricks, Whistler and I have, in part, been developing a range of gestures and movements we are now in the process of choreographing. Once again, however, my concern is less with the efficacy or aesthetic quality of that choreography, than with the manner in which these improvisations have also drawn out and developed a quite particular sort of sensitivity. While Csordas' figuring of somatic modes of attention is a relevant explanatory model for this, I am wary of drawing the attention involved too close, or too deeply into the body. Sliding one's foot delicately across a sheen of water that lies on smooth bricks together a manifold of sensory details – wet, cold,

sheer – which are experienced precisely *at* the surface of the skin of the sole of your foot. 'The skin,' writes Michel Serres 'is a variety of contingency: in it, through it, with it, the world and my body touch each other, the feeling and the felt, it defines their common edge ... I mix with the world which mixes with me. Skin intervenes between several things in the world and makes them mingle.'[36] The admixture of affect and touch in this feeling of the floor, I want to argue, is surely what underlines the common sense of Alfreds' suggestion that there is potential for a dynamic exchange of energy between a performer and the ground. The latter is not only a surface for support which *affords* movement and activity of one kind or another, but it can also be *felt* in a variety of ways, as a co-presence in the attentive act of performing. To feel the floor as wet, cold and sheer, is also to feel oneself so correlatively. The admixture of affect and touch in the delicacy of the slide of your foot, is at once a reaction to the surface conditions, a perception of them, a cognitive recognition of what to do with them, and correlatively, the beginnings of emotions of pleasure or nervousness.

Although the work of *Footage* is still in a developmental stage, as with Chemero's Radical Embodied Cognitive Science, I have sought to follow Gibson's lead in respect of the premise of the theory of affordances, that movement in the world is fundamental to understanding what to do in and with it. This is as true of the movement in the 'world' of performance, as it is of the world at large. However, as I have also latterly sought to suggest, the preponderance of attention that this gives to locomotion runs the risk ignoring the tactility that enfolds it. One does not simply move, but does so *in* clothes, *through* the air, and *over* and *in contact with* surfaces, according to their relative affordances, and experiencing, also, their relation to one's flesh. An active exploration of this, through performative experiments like those of *Footage*, is not only a (re)examination of affordances available to and through one's feet. It is also an effort to explore what Heller-Roazen calls the 'company' we keep with ourselves[37] – the ongoing sense of a sensuous life that is both more and less than ourselves as it engages and is taken up by a world beyond our bodies. 'Through an awakening of our own flesh,' Sheets-Johnstone argues, 'we open ourselves to a profound understanding of what it means to be animate ... [this] understanding is not tucked away in our brains but inheres in the morphological structure and sensuous densities of our own bodies.'[38] And, I would add, in that of the woods, bricks, barns and stages of the world that are the stuff of our feeling.

The Effect of Theatre Training on Cognitive Functions

Gabriele Sofia

Introduction

The increasing number of interdisciplinary approaches which employ cognitive neuroscience to study the performing arts requires a paradigm shift: from an interdisciplinary *approach* to an interdisciplinary *collaboration*. In other words, employing the instruments provided by neuroscience is no longer sufficient to analyse some aspects of the relationship between actor and spectator. If, since the 1990s, the dialogue with cognitive neuroscience has definitely provided the 'theatre cultures'[1] with useful suggestions and instruments of analysis, the contribution of such theatre cultures to neurosciences is still doubtful. In fact, how can the encounter with theatre help and change neuroscience?

One of the most evident problems emerging from such an interdisciplinary platform consists in theatre scholars' *caution* in approaching the neuroscientific field, whereas neuroscientists often believe they know *quite well* how theatre works. In this way, the real potential contribution of theatre practice remains mostly unknown to neuroscientists. Therefore the interaction between theatre and neuroscience risks being reduced to a unidirectional – often hierarchical – relationship moving from the so-called 'exact' sciences towards theatre studies. Until this gap is filled, there will be only an incomplete dialogue, a chrysalis unable to become a butterfly. Thus, we are required to wonder, in systematic terms, what contribution theatre cultures can provide to cognitive neuroscience.

When neuroscientists need theatre cultures ...

On the occasion of the first edition of the International Conference 'Dialogues between theatre and neuroscience', organized by the Department of Art and Theatre History of Sapienza University of Rome in Spring 2009, a team of neuroscientists made the following intervention during the conference:

> Working with individuals with Parkinson's disease, we realized that theatre practice is surprisingly and incomparably effective. We monitored the improvements and obtained statistically important results. Notwithstanding that, we still cannot understand *why*, at a neurobiological level, theatre's efficacy is so strong. For this reason we have come to this Department of Art and Theatre Studies: we want to ask for your help in order to understand how theatre practice affects human cognition.[2]

These words belong to the neurologist Nicola Modugno, who, in research started in 2006 in collaboration with the neurophysiologist Giovanni Mirabella and his team, discovered that patients with Parkinson's who attended theatre workshops showed a constant improvement on all clinical scales. This conclusion resulted from monitoring two groups of patients with Parkinson's for three years. In the first of the two groups, the medical treatment was accompanied by a weekly theatre workshop, whereas in the second group the medical treatment was accompanied by physiotherapy for the same amount of time. The outcomes were quite surprising because, at the end of the three years, all the evaluation scales showed a clearly different level of progress between the two groups, in favour of the group attending the theatre workshop.[3]

The workshop was led by the theatre company Klesidra, directed by Imogen Kusch. A huge range of exercises constituted the training for the participants. Some exercises were linked to rhythmic skills and body co-ordination, others to vocal elasticity, breathing and the singing skills. Some tasks dealt also with posture control and facial mimicry. Then, a specific section of the workshop was dedicated to the storytelling, and the construction of theatre scenes starting from the tales of the participants. At the end of each year, a show, written by the participants, was staged.

From a clinical point of view, the neuroscientists noticed that the workshop obliged the patients to improve their social skills because of the interpersonal co-operation that every theatre activity required:

> Both during the performance and off the set, patients have to interact continuously, so they are forced to socialize. The strict coupling between

motor control and ability to manage social situations makes theater an ideal playground to motivate patients deeply. In turn, this might allow a more stable improvement of clinical disability and Quality of Life (primary end points) of Parkinson's Disease patients.[4]

According to this, theatre activity was first of all a way to struggle against the feeling of isolation frequently reported by Parkinson's Disease patients: 'thanks to all these elements, active theater deeply motivates patients, allowing them to regain self-confidence and to develop higher self-control'.[5]

At a first stage, the neuroscientists noticed that the efficacy of theatre activity was related with the high capacity to treat the non-motor problems, solving a typical paradox of traditional treatment:

Despite this evidence, nonmotor features are usually under-recognized and undertreated because attention is paid to motor symptoms that are treated with dopaminergic drugs. This approach can lead to the paradoxical discrepancy between an objectively good control of motor disturbances and an increasingly negative feeling of well-being reported by the patient. Thus, to achieve global improvement in personal well-being, complementary approaches are needed, but only a few have been explored.[6]

From this point of view, the final data has shown how theatre could represent an extraordinary complementary approach. The problem was that, apart from the statistical relevance, neuroscientists still had no explanation of the efficacy of theatre workshops in treating Parkinson's Disease.

This was one of those rare and fruitful moments in which the needs of neuroscience perfectly matched those of theatre studies, giving rise to a shared project aimed at understanding how theatre training affects cognitive functions.

The neurobiological level of the actor-spectator relationship

Whereas since the 1980s theatre cultures have been focusing their studies on the *relationship* that the performer (may he be an actor, a dancer or a mime, etc.) can establish with the spectator,[7] little neuroscientific research on performers has taken into consideration the importance of the live co-presence of actor and spectator during the performance.[8] An empirical and systematic research focusing on the efficacy of theatre's *relational* potentialities is consequently yet to be carried out.

But is it possible to study the neurobiological level of this particular intersubjective relation? Research into the mirror neurons mechanism[9] could help us in answering that question. Although this mechanism has been for a long time regarded as a system, Giacomo Rizzolatti has recently shifted from this conception to a wider model considering mirror neurons as the *basic brain mechanism*, localized in several brain areas and connecting sensory information with the motor system. Therefore, the mirror neurons mechanism consists of nerve cells that activate when a person executes an action as well as when he observes the same action performed by someone else. This means that we activate the same motor neurons both to perceive and to perform an action. Our motor system shapes not only our actions but also our perception and therefore our cognition. This is what we call *embodied cognition*.[10]

Of course this does not mean that we repeat every action that we see, but that seeing someone executing an action activates the correspondent motor areas in our brain, which resonate with other brain areas, inhibiting in most cases the distal execution of the action. This activation of the mirror mechanism nevertheless alters the biochemical balance of the body-mind system and provides some important information about the observed action. Rather than a 'mirroring' it is a 'resonance' of actions, which, as such, assumes different forms and dynamics depending on the observer's body-mind system, on his own experiences, his motor vocabulary, his attention mechanisms and his current emotional state, etc. This resonance is precisely what allows us to implicitly comprehend the observed action, without any 'deliberate cognitive operation'.[11]

Studies of the mirror mechanism highlight that observing an action *is already* an action, a refined act that allows the concurrent or successive learning and thus depends on the attention-action mechanisms activated by the observer. There is no standard untouched perception. Perceiving an action implies the activation of all the individual's abilities, both the imaginative and associative as well as the motor abilities. In order to explain such a complex process, Eugenio Barba defined the actor's action as able to resonate inside 'the biographic caves of every single spectator'.[12]

Furthermore, the analysis of the mirror mechanism recalled the question of the intention of action. Recent studies suggest that the expression 'resonance of an action' should not be referred to the resonance of the single motor acts, but to the goal to which these acts are directed and organized.[13] Such an interpretation would agree also with the evolutionary thesis that tries to explain why this kind of mechanism belongs to human beings and to primates. The immediate comprehension of the others' intention is a powerful element of defence and survival. Recognizing the others'

intention allows us to optimize all the processes of interaction, exchange and collaboration with other human beings. If, every time that we interact with somebody, we needed an explicit cognitive effort in order to decode his intention, we would have to elaborate such a great quantity of information that any simple interaction would be extremely slow and lumbering. On the contrary, we are always engaged in an embodied anticipation of the others' goals, in a sort of 'intentional attunement'[14] as defined by the neuroscientist Vittorio Gallese.

The 'performative body schema' hypothesis

If we focus more on the processes that underpin our action and perception control, we can realise that the predictive attitude of our cognition cannot be exclusively related to the mirror mechanism. Several neuroscientists, such as Alain Berthoz, have often pointed out that our brain operates in an antici-patory and *projective* way.[15] This conception is related to the organization of the body-mind system as aimed at operating unceasingly hypotheses and forecasts about the surrounding context. During any action or perception process any part of the body is organized according to the agent's intentional mechanism. This kind of organisation requires different mechanisms to be coordinated in order to prepare the action: directing one's own gaze, balance-managing, side movements, etc. The 'classic' example is: if I have to take a glass from the table, my fingers will organise in order to successfully grab the glass *before* my hand actually touches it. And I will not be completely aware of the motor processes that I need to attain the aim of the action. This sort of preparation concerns a lot of our everyday activities. In scientific terms, some of the neuromotor processes that rule our body-mind's pre-reflexive organisation according to an intention are defined as *body schema*. Shaun Gallagher, one of the experts who has tackled this aspect in depth both at a scientific and a phenomenological level, provided the following definition of *body schema*:

> A non-conscious system of processes that constantly regulate posture and movement – a system of motor-sensory capacities that function below the threshold of awareness, and without the necessity of perceptual monitoring.[16]

Thus, the body schema is a process as a result of which we are not required to explicitly think of any single motor act. We can actually focus our explicit control only on our intention, which will be later organised by the body schema in an unconscious and pre-reflexive way. So, there is no conscious

access to the body schema. Although it is related to our conscious intentions, the body schema remains 'phenomenologically hidden'. Moreover, this implies that the body schema is also engaged in anticipating and preparing the chain of actions, in order to increase their agility and fluidity:

> If the behaviour monitored through the body schema does not necessitate conscious control, it is not reducible to a mere reflex either. Such behaviour can indeed be precisely modulated according to the conscious intentions entertained by the agent rationally and consciously. For instance, if a subject holds out his or her hand to reach a glass of water to drink, the subject's hand forms a grip adapted in size to this goal automatically and in an anticipated way.[17]

All these anticipatory operations are involved in the motor understanding of the others' actions. In theatre, this happens when the spectator tends to anticipate the actor's action by an immediate and pre-conscious process, so that one forecasts the result of the action.

For the actor this is a double-edged weapon. In fact, on the one hand, he or she develops a good control and command of his own actions, so that he or she can lead the spectator to have precise expectations and then surprise him.[18] On the other hand, the spectator's immediate tendency to anticipate the actor's actions makes difficult – for the actor – to render the stage events as 'unexpected'. Such an anticipation would spoil the surprise as well as the spontaneous effect. This mechanism is more evident if we consider that the theatre actor shows on stage his whole body, whose mechanisms must then be completely controlled, as they are either directly or indirectly involved in performing an action. In fact, a lesser control of himself, due for example an inadequate training, may let some parts of the body – not directly involved in the action – either behave incoherently with respect to the action or even anticipate the following one.[19]

Here we find the fundamental question: how can the actor control all these processes, which can be traced back to the body schema, if the same actor, like every human being, has no conscious access to the body schema? In order to answer such a question, we must previously remember that we all continuously update and shape our body schema in accordance with our everyday experience. The more a pattern of actions activates, the less effort is needed to activate it again. The frequent activation of the same pattern allows us to activate it without a conscious effort. Let us consider, for instance, the cognitive effort required to learn to drive a car. During the first attempts, the pattern of simultaneous activation of our limbs is activated by an explicit effort and through a quite complicated execution. Experience allows these patterns to activate with progressively less effort, until the actions are

embodied as pre-reflexive mechanisms. At that point our conscious control is no longer engaged in 'how to drive' but focused on 'where to drive' or on the several other thoughts that constantly pass through our mind. Repeated experience adapts our body schema to the interaction with the car and the road.

We now return to the actor. In order to prevent the spectator from making inconvenient forecasts about his actions, the actor is required to develop a control different from his everyday body schema. We can define it as 'performative body schema'. This latter is employed in order to meet the bonds of theatre relationship,[20] to stimulate and to avoid the spectator's anticipation depending on the circumstances. It is through rehearsals and his repeated and constant training, that – despite of the absence of any conscious access – the actor becomes able to *embody* a different body schema, that we can call a *performative body schema*. The hypothesis of the *performative body schema* may denote not only the actor's global implicit knowledge drawn from his experience, but also the peculiar non-linguistic thought, the so-called *thinking in motion*,[21] that every performer can detect in his own acting. This point recalls Maurice Merleau-Ponty's conception of the *savoir du corps*, as suggested by Emmanuel de Saint Aubert:

> The body-schema also involves the question of the *savoir du corps*: what the body knows, what it knows about itself and the primary form of this kind of 'knowledge'. The body knows and knows *itself* at the same time, according to a narcissistic attitude that englobes the world and the others into its own circular process.[22]

A preliminary answer

Returning to the question of the theatre's effect on Parkinson's disease patients, we can identify the *performative body schema hypothesis* as a first, preliminary answer. The *art*-ificial construction – precisely realized by *art* – of motor and psychomotor routines different from those adopted in everyday life can provide the patients with action strategies alternative to those damaged by the disease. If, in other words, patients increase their *savoir du corps* thanks to theatre activity, they will also increase the number of possible solutions to situations of difficulty. However, the question could also be put as follows: why is this effect given by theatre and not by any other physical activity? Precisely because theatre activity does not have any exterior object to which one's own body schema can be shaped – as occurs, for instance, in the mentioned example of driving a car or in the process of

learning to play an instrument – but it rather works on creating a totally new body schema based on a new relationship of the actor with himself ('the body knows and knows *itself* at the same time') and with the others (the partners and the spectators). With regard to such a new self-knowledge, Pamela Quinn, an American dancer affected by Parkinson's disease at the age of 40, wrote:

> I recognized that in addition to the medications I was taking (which are essential), the greatest resource I had was the understanding of the body that my life in dance had given me. Those of us who spend our lives working with the body are learning how to speak to the body: how to question it, coax it, finesse it, scold it, trick it if necessary.[23]

What is this 'body that my life in dance had given me' other than a *performative body* schema? In this sense, Jean-Marie Pradier's answer, during the Third International Conference 'Dialogues between theatre and neuroscience' (2011) on the possible therapeutic value of theatre, does not sound surprising nor unexpected: 'Not that art is therapeutic, but its absence is pathogenic!'

The empirical research

Since it must integrate allocentric information to the egocentric, the body schema is not a system localised in a precise brain area, but is a mechanism, a process widespread through the whole body. For this reason it is quite complicated to plan experiments that tackle it globally. The analysis of the difference between an actor's and a non-actor's body schema requires a previous identification of the differences emerging from the processes of the *embodied cognition*. The Neurobehavioral laboratory directed by Dr Giovanni Mirabella at the Sapienza University of Rome has carried out research on *embodied language*.[24] This was aimed at finding some exploratory indications about the way in which human motor cognition is modified by the actor's training. The experiment was based on the main question: does the embodied language activation differ from actors to non-actors? In order to answer this question, some non-invasive cognitive tests were submitted to a group of actors and a group of non-actors with the same age and the same level of education.[25]

Although the experiment is not yet completed, the early results show that the two groups tend to differ not exactly for the *embodied language* but for their *attention mechanisms*. However the research is still in progress and requires a greater number of individuals to be tested. If confirmed, these

preliminary results testify for the first time that the embodiment mechanisms differ from actors to non-actors.

Conclusion: Theatre as training of human relationships

I have dwelled upon the 'technical' aspects of the actor's work, in order to show how the theatre relationship requires a precise bodily discipline that could have a great pedagogical value apart from the goal to which it is directed, be it artistic, therapeutic, social educational, political, cultural, communicational, etc. According to the definition of the actor as 'an athlete of the heart' provided by Antonin Artaud among his considerations on what he called 'affective athleticism',[26] theatre can be considered as a 'gym' of human relationships. This simile is less arbitrary than it seems: as the gym allows us to train through specific exercises which can bring some benefit to our everyday lives but which *rarely reproduce* or *simulate* our everyday life, so does theatre activity train human relationships through a practice that *does not have to reproduce* or *simulate* the everyday situations and relationships. On the contrary, theatre's peculiar strength lies in providing *another* reality that makes it possible to work on the ability of creating relationships:

> The work of the actor does not consist in learning, but in discovering. Not the actor as social metaphor or metonymy, but the actor as reality beyond theatre, who is confined and kept in the theatre space and who employs the theatre space as *contrainte* to exist and to express.[27]

This kind of 'reality beyond theatre' requires the actor to build extra-daily body techniques that, thanks to brain plasticity, could eventually substitute or replace daily mechanisms, since these latter are damaged, as in patients with Parkinson's disease. If we focus on our initial question about the nature of theatre's contribution to neurosciences within an interdisciplinary *collaboration*, we find three elements of reflection in order to develop future interdisciplinary interactions:

First, over the centuries several theatre traditions have contributed to realise a system of knowledge aimed at forming 'professionals of intersubjective relationships': the actors. Knowing these methods can be helpful in treating the diseases affecting the social skills as well as in analysing how the human being organises his own intersubjective relationships.

Second, although the experimental evidence is still at a starting point, we are allowed to think that theatre training causes remarkable neuromotor alterations. Whereas in the artistic field such alterations allow the actor to be efficacious on stage, at a rehabilitative level these same alterations

may represent alternative neuromotor strategies in order to make up the deficit due to the disease. Moreover, unlike other motor activities, theatre practice involves all the individual's levels of organisation, from the strictly biomechanical to the emotional and affective. In all likelihood, the great holistic aspect of such a practice stimulates brain plasticity in a more complete way, accelerating mechanisms of recovery and creation of alternative cognitive strategies.

Third, a further, more general, point concerns the possible contamination between the director-pedagogue and the scientist's research activity. The director-pedagogue constantly creates new contexts that modify the actor's scenic behaviour and enable him to alter and embody new dynamics within a certain lapse of time. Such a director develops an extremely refined pedagogical preparation. If the neuroscientist wants to investigate learning mechanisms, knowledge of the director-pedagogue's practice can provide him with a reasonably accurate method of realising effective experimental settings.[28]

Of course the achieved level of research cannot yet provide immediate results but nevertheless makes possible the scientific and epistemological progress *shared* by the different disciplines, insofar as, using Edgar Morin's words, 'any question raised by a discipline cannot be solved within this same discipline'.[29]

Translation by Gennaro Lauro

Part Four

Affecting Audiences

Introduction: Spectating as Sandbox Play

Bruce McConachie

This short chapter will introduce some of the general cognitive dynamics of spectating and briefly note the three chapters to follow. As you will read, each of the chapters focuses on a type of theatre that is more participatory and immersive than conventional, in the sense of audiences watching a dramatic narrative with actors on a stage playing fictional characters. While parts of the three chapters discuss theatrical events that touch on the usual audience dynamics, they also feature actors as guides of spectators and as facilitators of audience participation and learning, roles not usually played directly in dramatic performances. One of the chapters to come, for example, examines autistic children as spectator-participants who interact in a specialised environment with performer-facilitators working 'in-' and 'out-of-character' with puppets and props. These chapters present a significant and useful challenge about spectating. Among the questions posed by the example above, for instance, is how do the children figure out when they are supposed to understand the performer-facilitators as fictional role-players to be observed or as direct facilitators of an interactive experience involving them? And how are they able to make the leap between these modes of spectating activity?

Seen from a wider perspective, however, the spectatorial multitasking practised by these children with a range of autistic difficulties is only one of several cognitive operations that general audiences do all of the time, typically with the same ease and pleasure. Even a conventional performance of a realist play by professional actors on a proscenium stage may involve several modes of activity for the audience. Within ten minutes of such a performance, a spectator may: (i) experience the shifts in tension and emotion of a long exchange between two characters in the dramatic fiction; (ii)) appraise the contest between the two actor/characters in the scene and sympathise with one of them; (iii) wonder about the extent to which the director or the actors may have chosen the pace and shape of this duet; (iv) recall that you have seen the actress who performed the dialogue a couple of times in the past and also sympathised with the character she was

playing; (v) notice that a third actor just making his entrance has been given a long, winding flight of stairs by the scene designer down which he artfully stumbles; (vi) laugh after the actor rolls down some steps near the bottom but manages to land on his feet as he hits the floor; (vii) catch the shift in lighting that emphasises his landing; (viii) check your programme to try to read the name of the lighting designer in the dim auditorium; (ix) react in sudden disgust to the person sitting next to you who begins coughing loudly; (x) smile weakly at the spectator on the other side of you whom you bumped when you moved away from the cougher.

At first glance, this quotidian list of ten audience activities (to which could easily be added two dozen more items) during a ten-minute piece of conventional theatre seems very different from the kinds of activities that spectators at an immersive and/or participatory theatrical event may enjoy. But there are important commonalities that shape both experiences of spectatorship. Although some theorists and practitioners claim otherwise, conventional and immersive modes of spectating share the same foundations. For example, both engagements involve important differences between the roles played by performers and those taken up by spectators. Both sets of spectators also anticipate that their bodily and emotional relationships with the performers will result in experiences that are worthwhile and enjoyable. Third, spectators understand that they must help to maintain an environment in which performer-spectator relationships can flourish. Related to this, to heighten the advantages of spectating, spectators in both situations are engaged in witnessing the actions of the performers as well as in direct interactions with other spectators. Finally – and this commonality undergirds each of the other four – spectating is active. To gain the benefits of spectating, spectators must pay attention, interact with the performers, and do their part to maintain the social standards and material conditions that allow the performers to continue. Among other things, this understanding of spectating should put to rest the notion that audiences are or ever really could have been 'passive', as some have asserted.

These commonalities among spectating of all sorts and the underlying importance of action for the range of modes that spectating may entail will centre my discussion. This knowledge also shapes my choice of an overarching theory for this section of the book. I will rely on the paradigm of Enaction, also termed dynamic systems theory, to describe and explain the major activities that spectators practice. This paradigm is gaining traction in the biological, cognitive and social sciences as a better way of explaining animate behaviour than previous theories centred on biological determinism, the computer modelling of cognition, or discourse-based constructions of society and history. One central premise of this approach, backed by ample

scientific evidence, is that evolution organised our perceptual processing primarily for action, not for simple reaction, information-gathering, or for constituting mental representations. According to medical psychologist Andreas K. Engel:

> Perception ... is a constructive process whose operations are highly selective. Perceptual acts define, first of all, relevant distinctions in the field of sensory experience, and this occurs by virtue of the cognitive system's neural and bodily organisation, as well as 'top down' factors ... such as previous learning, emotion, expectation, or attention. Cognition, on this account, is not neutral with respect to action, but arises from sensorimotor couplings by which the cognitive agent engages with the world.[1]

As well as providing numerous scientific studies that back up this proposition, Engel finds significant parallels between this general understanding of perception and the work of pragmatists like John Dewey and phenomenologists such as Merleau-Ponty. Engel's linking of perception to action undermines two common approaches to theatrical perception among performance scholars. First, interacting with performers does not remove spectators from the impulse to act and impel them into reveries, memories or fantasies. Second, spectators do not use their perceptions to collect signs from the stage action, re-present these complexities in their 'mind's eye', and store them for later processing. In short, the perception-action system advanced by proponents of the Enaction paradigm departs in significant ways from the psychoanalytic (both Freudian and Lacanian) and the semiotic (both Saussurean and Peircean) traditions. As Enaction philosopher Andy Clark notes: 'The brain should not be seen as primarily a locus of inner descriptions of external states of affairs; rather, it should be seen as a locus of inner structures that act as operators upon the world via their role in determining actions.'[2] This is not to say that watching a play cannot engage our fantasies or invite us to look for meaningful signs; both operations are possible, but as explanations they are seriously incomplete. Not only are psychoanalytic and semiotic approaches inadequate for participatory and immersive performances, they cannot account for much of what occurs when people engage in spectating during theatre of any kind.

An Enaction approach to spectatorship necessarily begins with the assumption that the capabilities that involve perceiving the performances of others must have evolutionary roots that play out in normal childhood development. Because making and watching theatre and other kinds of performance events occurred very recently in the history of our species, we know that there could not have been enough evolutionary time for humans

to develop and pass down to their ancestors a special module in the human brain uniquely suited for enjoying and understanding performances. The question for evolutionary psychologists, then, is what were the genetic building blocks upon which the advanced activities necessary for performing and spectating might have been founded. The most likely candidate is the activity of play, which probably dates from several million years ago and is common among many species of higher mammals.[3] Biologists interested in animal play recognise that playing allows all young animals, including human pre-schoolers, to recognise, repeat and refine patterns of activity that help them to survive. Most typically developing children can usually engage in make-believe play activities when they get to be about two-and-a-half years old. One psychologist videotaped his young daughter playing roles with her friends in imagined fictions that they improvised and enjoyed together. She and her friends both enacted the roles of 'mother' and other adults when they played house, for example, and also switched easily among acting and spectating in the midst of their play.[4] That most children enjoy both roles in their make-believe play is suggestive evidence for an understanding of enactive performing and spectating based in the gradual evolution of play.

The likely evolutionary linkage among play, survival and performance implies an ecology of spectating. As we know from observing children in make-believe play and from watching adults in theatre auditoriums, modes of spectating are highly context-dependent; each has its specific ecological niche. That is, the shape of the room (perhaps a cramped play space or a small theatre in the round), the material possibilities for interaction within it (maybe several hand puppets, plus several rows of seats blocking direct access to the stage for most spectators) and the social 'rules of the game' (such as 'no hitting' and 'turn off your cell phones') are important in shaping play and spectatorial witnessing and participating. Put another way, the activities of spectating, like childhood playing, are always embedded in a material and social situation. Not only are spectators effectively 'coupled' with performers and other spectators, as Engel's phrasing suggests, their perceptions are also 'coupled' with the material possibilities and constraints of the immediate environment. Like children in a sandbox, spectators will see options and blockages for potential interactions and meanings in their surroundings. To quote Clark again, '[I]n the light of all this, it may ... be wise to consider the intelligent system as a spatio-temporally extended process not limited by the tenuous envelope of skin and skull',[5] From an Enaction perspective, perception, like the rest of cognition, is not only embodied and embedded, it is also ecologically extended. Spectators use their material and social surroundings as well as their bodies and brains to take action and make meaning during a performance.

This insight heightens the importance of attention in spectating. Because perception is pro-active and highly selective, attention must be more than conscious awareness. Visual attention for spectators is a lot like a follow-spot with an easily adjustable opening that can take in an entire scene or tightly focus on that pair of dueling pistols over the mantel in the parlor (when, say, the performance of the evening is *Hedda Gabler*). Likewise, attentive auditors can listen to the flow of dialogue for general meaning or pick out specific images or words. Why is there so much conversation in *Hedda* about women's 'hair', for instance? Beyond attending to the immediate fictional action on stage, spectators also pay attention to possibilities for future action; who might fire those pistols above the mantelpiece and why? Because spectators are aware that the material arrangements of the space on stage afford and constrain the possibilities for movement and action by the performers, they will attend to the placement of furniture, steps, walls and curtains with this knowledge. Ibsen calls for a small upstage room in *Hedda* that is generally open to downstage actor/characters and to the audience, but may also be curtained off from sight. This particular sandbox affords some semi-private intimacy for Hedda and Lovborg in their early scene together and also allows Hedda to shoot herself behind the curtains while other characters are conversing downstage near the end of the play. Cognitive scientist James J. Gibson, an early proponent of extended cognition and parts of the Enaction paradigm, termed such ecological arrangements 'affordances', moving the verb 'afford' into a noun. According to Gibson, people primarily perceive objects in their surroundings in terms of the actions they or others can take with them.[6] The major affordance of a toy shovel in a sandbox, for instance, is digging in the sand. Likewise, audiences immediately perceive that Hedda's pistols afford shooting.

When spectators first enter a space dedicated for performance, they begin to use their extended cognition to figure out the affordances of their environment. Will this be a production in which I sit in one seat for most of its duration or might I be invited to move about and perhaps even participate with the performers? As a young student of theatre, I attended a performance of *Dionysus in 69*, Richard Schechner's 'environmental' adaptation of *The Bacchae*. Today, such a production would be termed 'immersive' and 'participatory' (and, given the nudity, probably 'in-yer-face' as well) by most critics. The reputation of the production had preceded it, of course, so my friends and I had some idea of what to expect. But I was not ready to be hoisted over the head of one of the larger male actors soon after I entered the space, spun around a few times like a pinwheel, and plunked down to sit on a low platform in the middle of what was obviously going to serve as the performance space for the evening. Nonetheless, attentive theatregoer that

I was, I knew already that the actors of *Dionysus* would attempt to immerse me in the ritualised swirl of the production and that I would probably be invited to participate physically in some of their forthcoming actions. I was not incorrect. I also saw that the performers would have to accommodate their movements to the new affordances of the space – those spectator bodies placed, as I was, in the midst of their sandbox.

While the spectators and performers managed the material affordances of their interactions well enough during *Dionysys in 69*, the social contract underlying the performance was poorly handled. In all performance situations – whether in night-club comedy, an orchestral concert, or in immersive-participatory theatre – spectators want to know what is expected of them and most are happy to comply. As a part of this, they pay attention to signals from the actors that seek to inform them as to when they are performing in a way that is meant to be witnessed as fiction and when they are working directly as non-fiction facilitators to advance other interactive goals. Apparently Schechner and his company had read too much Artaud and believed that earnest ritual could overcome this inherent doubleness in all performance situations. After many of the actors had fully undressed to engage in the birthing of the god Dionysus (a nude male actor pulled through the spread legs of squatting, naked females in the company), several spectators were invited to join the ritual by similarly stripping and participating. The actors, however, did not guide the spectators concerning appropriate limits for their participation, with the result that one male spectator on the night I was present groped two of the female actors. For their part, the women, despite their obvious anger and embarrassment, took no direct action, perhaps because their characters were supposed to be caught up in the ritual. I remember feeling ashamed for the women actors and angry at Schechner for effectively strong-arming audience participation ('you're not cool if you can't take your clothes off and join in'), without antici-pating and preventing the kinds of problems that *Dionysus* in performance engendered.

The point is that all performances that induce enjoyable spectator-performer interactions rest upon an implicit or explicit social contract; because actors and spectators want to be 'coupled' together in performance situations, both must come to understand the norms of such interplay and strive to work within them. As any daycare teacher can attest, playing together in a sandbox requires necessary protocols. This is not to say that the conventions of the game must be fixed and known beforehand; clearly, many contemporary immersive and participatory performances rely on spectators' ability to learn and adapt to new norms of engagement as the performance proceeds. Just as clearly, though, as Lyn Gardner has noted, artists practising

interactive theatre 'are going to have to find ways to create experiences for their audiences where risks can be taken without causing audience anxiety to rocket'.[7] In one of the essays to follow, we will see that one immersive theatre company was not altogether successful in facilitating a trust-inducing environment that allowed for and encouraged spectator risk-taking.

The mutual cognitive coupling of actors and spectators can result in numerous satisfactions during a performance. The most obvious and significant of these for spectators is usually emotional engagement. Although the term 'affect' generally includes emotions, feelings and moods, I will narrow my focus primarily to emotions – generally understood by scientists as responsive brain-body systems directed towards people or objects – because emotions are the most relevant index of spectator enjoyment and meaning-making. Good performance situations provide a safe space in which actors and spectators can explore many of their emotional vulnerabilities and needs without embarrassment. Despite the lack of agreement on a definition of 'emotion', most neuroscientists and psychologists divide primary from secondary emotions in their experiments and discussions. Primary emotions are more primitive, in the sense of providing us with systems of response and behaviour that draw on several million years of evolution to ensure individual survival and procreation. Secondary emotional systems appear to have evolved more recently, when sociality and the benefits of mutual cooperation were becoming more important for our survival.

As I did in *Engaging Audiences*, I will rely on the work of Jaak Panksepp, widely celebrated among his neuroscientific colleagues for his rigorous empirical experiments, as the basis for my understanding of emotions. Panksepp's main criterion for an emotional system is 'whether a coherent emotional response pattern can be activated by localised electrical and chemical stimulation along specific brain circuits, and whether such arousal has affective consequences as measured by consistent approach and avoidance responses'.[8] In his *Affective Neuroscience,* Panksepp provides copious evidence for seven distinct neurobiological emotional systems. His terms for these systems, which he puts in upper-case lettering for emphasis, are: SEEKING, FEAR, RAGE, PANIC, LUST, CARE and PLAY. All have lower-level emotional states as well, such as 'anxiety' in the FEAR system and 'loneliness', a less extreme form of PANIC. Panksepp also shows that the primary function of these emotional systems in humans and other mammals is

> to coordinate many types of behavioral and physiological processes in the brain and body. In addition, arousals of these brain systems are accompanied by subjectively experienced feeling states that may

provide efficient ways to guide and sustain behavior patterns, as well as to mediate certain types of learning.[9]

Like many scientists working on mammalian emotions, Panksepp distinguishes between emotional systems, which are entirely unconscious, and feelings, which can occur when the chemical and behavioural results of our emotional systems rise to consciousness.

For a good overview of secondary or social emotions, I have drawn on the work of Antonio Damasio, whose understanding of emotion is generally consonant with Panksepp's. His list of social emotion systems includes humiliation, pride, sympathy, shame and embarrassment. As in Panksepp's understanding, primary and secondary emotions for Damasio are sparked by internal or external stimuli, which lead to the activation of dedicated neuronal networks in the brain, which then play out in the body through hormonal response, increased blood flow to specific body parts, and changes in muscle tone, etc. Evolution primed us to produce emotions as a way of making meaning for ourselves to enable our survival. The approach and avoidance responses triggered by emotions effectively appraise the body of dangers and possibilities in the immediate environment or within the self. Damasio is clear that our emotional responses also undergird and make possible what we usually think of as higher-order reason. As he puts it, 'our sensory patterns signaling pain, pleasure, and emotions become [mental] images', the actual stuff of our feelings, which, in turn, prompt 'complex, flexible, and customised plans of response' in our consciousness, which may then be 'executed as behavior'.[10] Although culture and individual identity shape the social expression of emotion, especially regarding social emotions, the most primitive parts of our brain have hard-wired us for emotional response and, in the theatre, our emotions as spectators usually guide our moment-to-moment and long-term goals.

From an Enaction perspective as well, emotions shape intentional action. In his engagingly titled book, *How Brains Make Up Their Minds*, Walter J. Freeman states:

> Our actions emerge through a continuous loop that we can divide into three stages. The first stage is the emergence and elaboration within our brains of goals concerning future states. The goals are in nested layers, ranging from what we do in the next few seconds to our ultimate survival and enjoyment of life. The second stage of the loop involves acting and receiving the sensory consequences of actions and constructing their meanings. In the third stage, we modify our brains by learning, which guides each successive emergent pattern. These three stages are accompanied by dynamic processes in the brain and body that

prepare the body for forthcoming actions and enable it to carry them out. My view is that we observe and experience these preparations as emotions.[11]

With regard to spectating, audience members generally go to the theatre with the aim of enjoying themselves, along with achieving other goals shaped by their culture and their individual desires. They enter a particular sandbox, pay attention to the material and social circumstances within it, and begin acting in ways that they believe will help them to achieve their goals. In the continuous feedback loop generated by actions, responses, learning and new actions, spectators primarily rely on their emotions to shape their responses.

An important key to emotional response in the theatre is empathy. From the perspective of current cognitive science, empathy is generally defined as mind reading – the attempt by one person to understand the intentions, emotions and beliefs of another. Rooted in our evolutionary heritage as social animals, empathy helped our evolving species to survive and flourish by facilitating social cohesion and cooperation. Because we are often in social situations when attuning ourselves to their emotions of others and reading their minds is important for achieving our goals, empathy is ubiquitous and commonplace; we deploy it (mostly unconsciously) all the time. Empathy works in our imaginations, as well; planning what you will say to a significant other and imagining his or her facial reaction is an exercise in empathy.

As these examples suggest, empathising is crucial for spectators attempting to negotiate and understand both the theatrical and the dramatic levels of all performances. For example, upon entering what they know will be an immersive production, spectators will certainly listen to the instructions given to them by performer-facilitators, but they will also try to attune their own intentions and emotions to those of the facilitators to ease their future interactions with them. On the dramatic level, spectators will frequently use empathy to read the intentions and beliefs of actor/characters on the stage. In the Helena-Sonya scene of the third act of *Uncle Vanya*, for example, Chekhov invites his spectators to take the perspectives of both of the actor/characters as they attempt to probe each other's emotions and intentions for signs of each other's affection for Doctor Astrov. In this scene (as in performances of many other plays from Shakespeare to Kushner), spectators enjoy empathising with actor/characters who are themselves empathising with other actor/characters as a part of the ongoing dramatic conflicts in the action. Many sandbox situations encourage us to empathise with other empathisers, both by attuning our intentions to theirs and by taking their perspectives on the task at hand.

Like 'emotion', current scientific definitions of 'empathy' range widely. Some psychologists researching empathy advocate a 'theory of mind' (ToM) approach to its cognitive dynamics. ToM research began in 1978, when two psychologists tested chimpanzees to discover if one chimp believed that other primates had minds like its own, i.e. if chimps had a 'theory' about other chimp minds and could begin to see the world from the other's point of view. While most researchers agree that chimpanzees can process some low level tasks through perspective-taking, they have found that humans are much better at it than other primates. In fact, we cannot stop ourselves from reading others' minds in our attempts to orient ourselves in ongoing social relationships. In this sense, however, the 'theory' part of ToM is misleading. Most scientists agree that empathy is largely unconscious and proactive; humans and other animals do not consciously adopt some kind of 'theory' and then mentally apply it others.[12]

My take on empathy derives from the work of neurobiologist and phenomenologist Evan Thompson, who understands it from an Enaction point of view. For Thompson, empathy can occur in four stages, each building upon those beneath it. Thompson terms the first stage 'senso-rimotor coupling'.[13] This type of empathy relies on the recent discovery of 'mirror neurons' in monkeys and evidence that strongly suggests that humans have much the same capabilities as their primate relations. In brief, networks of neurons in our brains effectively 'mirror' intentional motor activity produced by another person and perceived by the empathiser. If one person watches another grasp a door handle, for example, the same group of neurons in the empathiser's brain is activated as in the grasper's brain; neuro-logically, it is as if the observer had grabbed the door handle himself. By working through our perceptions, bodies and minds, our networks of mirror neurons unconsciously attune us to the actions of each other. As Thompson notes, the mutual mirroring that occurs in sensorimotor coupling first begins in early childhood, when infants mirror the intentional facial expres-sions of their caregivers. Mirroring continues throughout our lives, forming the basis of many of the unconscious affective links that help us to bond with others and to shape co-operative ventures together.

In normal human development, sensorimotor coupling leads to a second, more complex form of empathy, which Thompson terms 'imaginary transposition'.[14] As the name suggests, imaginary transposition allows the empathiser to attempt to place her or himself into the mind of another; it is similar in most ways to what some psychologists of empathy term ToM and others call 'perspective-taking'.[15] By about 12 months, the normal toddler can use several cognitive skills, plus the knowledge and memory that the child has gained from mirroring, to engage in imaginary transposition. This

involves the toddler's recognition that other humans are intentional agents 'like me'. In this way, the developing child can put her/himself into the mind of a nearby adult and, later, can even imagine what an adult may be thinking, feeling and intending when that person is absent. For Thompson, sensori-motor coupling and imaginary transposition are the first two of four stages of empathy. The third involves a young person's self-reflexive knowledge that social others are attempting to understand his or her emotions, beliefs and goals, at the same time that she or he is engaged in similar empathising with others. The fourth may lead the empathiser to a kind of golden-rule ethics, which induces empathisers to treat other empathisers with fairness and respect.[16]

There is no guarantee, however, that empathising spectators will succeed in embodying and understanding the emotions and beliefs of actor/characters, performer-facilitators, or even fellow audience members. Thompson recognises that the road from infant sensorimotor coupling to the heights of golden-rule empathy is usually uphill and rocky. Because we are social beings, empathetic processing, especially at the third and fourth levels of Thompson's stages, never occurs in a familial, cultural or historical vacuum. Audience members interacting with others in the theatre rely on their individual and social memories of people, situations and locations to orient them within the present moment of every performance. While collective memories are never monolithic, some may be widely shared and these invariably colour audience expectations and emotions. Prejudices based in race, class, gender and/or nationality, for example, may influence a spectator's initial reaction to a performer and misshape or even radically inhibit a fair-minded empathetic response. In some performance situations, initial cultural prejudices based in long-term memories may give way to recent memories generated by the performance itself – working memories about actor/characters, facilitators, dramatic events, etc. that are sparked and reworked during a performance event. All performances, after all, provide opportunities for fresh insights, which can occur when emotions, appraisals and new memories lead to the consolidation of new concepts; this is what psychologists usually call learning.

But not always. Sometimes initial cultural stereotypes prevail and spectators project their prejudices onto the actor/characters and the dramatic events of the performance. When *A Streetcar Named Desire* premiered on Broadway in 1947, New York attitudes against the American South and the common belief that women were much more susceptible than men to psychological problems combined with suggestions in the script, Elia Kazan's directing, and Jessica Tandy's performance of Blanche DuBois to undermine the sympathetic response that Williams's intended for his protagonist. Not

only did the critics respond to Tandy's Blanche as a deluded neurotic, they also called her a home-wrecker (for apparently trying to break up her sister's marriage) and even branded her a 'nymphomaniac' (for attempting to seduce her husband, Stanley). As subsequent productions of Williams's masterpiece over the next 60 years would show, the New York critics were wrong about how most audiences would respond to playing in the same sandbox with Blanche DuBois.[17]

In another sense, though, the 1947 critics and the audience they represented were simply protecting their values and goals against a production that seemed to attack them. Believing that war veterans like Marlon Brando's Stanley and his wife had a right to settle into domesticity, that unmarried women like Blanche might be film noir *femme fatales*, and that the gothic traditions of the South could doom women to neurosis and treachery, they responded as their northern popular culture of movies, radio programmes and novels had educated them do and as the production initially encouraged them to perceive. While a few of the reviewers expressed some sympathy for Tandy's Blanche, most feared what she represented and rejected her as immoral, even disgusting. In short, they and the general audience used their emotions to make meanings out of Kazan's *Streetcar* that were right for their individual, cultural and historical goals in 1947. Significantly, the same critics and similar spectators enjoyed Harold Clurman's direction of the road show of *Streetcar* starring a more sympathetic Uta Hagen paired with a sinister Anthony Quinn in the summer of 1948. Clurman managed to avoid the cultural pitfalls of *Streetcar* for the postwar audience and his actors guided spectators to other emotions and meanings that spoke to different goals.[18] The larger point here is that spectators will usually generate emotions and meanings in performance sandboxes that seem correct and useful to them in terms of their goals at the time. To classify their interpretations as 'right' or 'wrong' with regard to authorial intentions or formal categories of genre is certainly possible, but also misses this point.

The length and intensity of dramatically generated emotions are crucial factors in shaping the emergence of meanings for spectators. The drawn-out suspense motivated by FEAR that shapes most of the performance of a murder mystery, for example, will be much more important than a fleeting laugh. Whether emotions are widely shared among an audience or engage only pockets of spectators here and there in an auditorium also plays a significant role in spectator experience. Psychologists have written about the thrilling effects of 'emotional contagion', when spectators embody and spread an emotion that is usually generated by an action on the stage. Probably based on the immediacy of mirror neuron attunement, the shock of PANIC, for instance, can grip an audience and leave individual spectators gasping

for breath afterwards. When the driving rhythm of a rock musical locks in motor and emotional responses among rapt listeners, psychologists usually characterise the response as 'entrainment', a longer-lasting form of emotional contagion. Entrainment causes the facial muscles, heart rates and emotional systems of entrained spectators to respond in syncopated rhythms.[19]

Although few theatre critics have had much to say about the duration of emotions in performance, Enaction theorists recognise that timing and intensity are often crucial factors in shaping the emotional experiences and, consequently, the emergence of meanings for spectators. Cognitive film critic Carl Plantinga, in his *Moving Viewers: American Film and the Spectator's Experience*, builds upon cognitive psychological and neuroscientific insights to chart several types of spectatorial emotional response to characters and situations over time.[20] Most of his insights are easily transferrable from films to live performances in the theatre. While Plantinga has little directly to say about movies that might provide a rough parallel to immersive-participant theatre, most of his categories can be applied to those experiences as well. Plantinga has good evidence that audience members experience some of their most intense and long-lasting emotions while watching major actor/ characters adjust to significant shifts in a fiction's narrative. Although Plantinga understands that empathising with actor/characters is a significant cause of emotional response, he recognises as well that spectator curiosity (what Panksepp would term SEEKING) and memory also pull us in to the problems of characters in dramatic situations.

Hamlet, for example, plans his 'mousetrap' with Horatio and the Players in order to 'catch the conscience of the king' and we in the audience will SEEK to know if his plotting will succeed. Plantinga terms this response to a turn in the narrative a 'direct' type of spectator emotion and, because the story of *Hamlet* takes many more twists and turns during its unfolding, spectators will experience many other direct emotions along the way. More significant and longer-lasting than direct emotions are what Plantinga calls 'global' kinds of emotional responses. These are audience responses to major narrative developments that generally take several scenes, perhaps even the entire play, to work through. What will happen to Hamlet's CARE for Ophelia? Will the RAGE that the prince should feel against Claudius finally motivate him to avenge the killing of his father? 'Direct' and 'global' emotional responses are based primarily in narrative, but also may involve empathy and memory as we watch the actor/characters adjust to changing circumstances.[21]

In addition to responding to narrative developments, spectators also form empathetic relationships with discrete actor/characters and these couplings establish the basis for the social emotions of either 'sympathetic

or antipathetic responses', according to Plantinga. That is, audiences take the well-being and goals of specific actor/characters as their object and respond to them accordingly in the moment-to-moment byplay of their interactions. Both kinds of responses depend upon empathy because spectators must have some understanding of the goals and beliefs of an actor/character before judging him or her to be sympathetic or antipathetic. In *Hamlet*, spectators may experience both sympathetic and antipathetic responses to Polonius, Laertes and Gertrude, for example, at various moments in the performance. Even Hamlet should probably arouse some antipathy in his first two scenes, when he is depressed, aimless and surly with others. When spectators change their minds about their appraisal of a character – when, for instance, we begin to feel more positive about Gertrude's actions after the closet scene – spectators may experience a reaction against themselves for their first response. We have all metaphorically kicked ourselves for not seeing qualities in a person or actor/character that, in retrospect, we believe we should have seen. Plantinga calls such responses 'meta-emotions' and such self-correcting occurs often in emotionally complex plays like *Hamlet*.

In addition to direct, global, sympathetic/antipathetic and meta-emotions, Plantinga notes that performances often involve spectators in what he terms 'local' emotions. These are brief and intense, usually sparked by an effect that evokes surprise, disgust or other kinds of shock. The immediate shock of a local emotion may lead to emotional contagion throughout an audience. Depending upon how it is staged, the audience's first sight of the ghost in *Hamlet* will probably deliver some shock and awe. You might be building a narrative about toy cars and roadways in your sandbox and sympathising with those playmates that are helping you in the project, when all of a sudden the new kid on the block, in a jealous RAGE, throws sand in your eyes. Your angry reaction would be another instance of Plantinga's 'local emotion'.

All of the emotional responses discussed so far occur while spectators are experiencing the flow of the fiction – while they are 'living in the blend', to use Fauconnier and Turner's terminology. As we have seen, however, audience members often step back from their involvement in the fictional action; they unblend their actor/character integrations to enjoy performances in other ways. Plantinga calls these 'artifact' emotions, implicitly referring to the celluloid artifact that constitutes the material reality of a film. Examples of 'artifact' emotions in film viewing include the admiration a spectator may feel for the cameraman after watching a long and involved tracking shot or perhaps a response of disappointment in the realisation that a normally good actor turned in a mediocre performance. While appropriate for film spectating, the term 'artifact emotion' does not translate well for live theatre. A better designation might simply be 'theatrical emotion', which implicitly

distinguishes between the theatrical level of a production, involving actors, directors, playwrights, etc. and the dramatic level, which requires actor/ characters interacting within a fictional world. Theatrical emotions could follow from a spectator's appraisal of the performer playing Hamlet or of a labyrinth put together by the designer of an immersive theatrical experience.

While the three chapters in this section of the book rely on some of the scientific insights I have noted in this Introduction, all are focused on specific productions that require a close analysis of the relationships forged between performer-facilitators and spectators who are immersed and participating in a performance. The first two writers, in fact, provide different perspectives on the same production, Lundahl & Seitl's *Rotating in a Room of Images*. Josephine Machon describes her experience of this theatre piece through the lens of '(Syn)aesthetic analysis', a methodology she developed to account for some of the dynamics of immersive theatre. In his 'Politics in the Dark', Adam Alston uses Damasio, Plantinga and other scientists to link emotional response with political persuasion in his analysis of *Rotating*. Finally, Melissa Trimingham draws on her work with autistic children at the University of Kent to discuss the importance of recognising the haptic dimension of thought in analysing children's interactions with people and objects. Machon, Alston and Trimingham significantly advance our understanding of spectator participation as sandbox play.

(Syn)aesthetics and Immersive Theatre: Embodied Beholding in Lundahl & Seitl's *Rotating in a Room of Images*

Josephine Machon

Introduction

This essay will examine the (syn)aesthetics[1] of immersive theatre by analysing the forms and processes in Lundahl & Seitl's *Rotating in a Room of Images* (2011), a 15-minute experience for one audience-immersant, which I experienced at Battersea Arts Centre's 2011 One-on-One Festival. Using this work to illustrate certain defining features of immersive theatres, I will draw on (syn)aesthetics to articulate the quality of experience undergone during a Lundahl & Seitl event.

A technical assistant checks my audio equipment and outlines the ways in which I will be safe during the proceeding encounter. I enter the room on my own to behold ivory drapes suspended from ceiling to floor. Through my wireless headphones I am guided to observe my surroundings, beguiled yet ever so slightly put on edge by the ethereal, childlike voice in my ear, as if sitting on my shoulder, breathing at my neck. My auditory companion is then joined by a film of a child projected onto a drape ahead of me. The space suddenly shifts to total blackout, I'm instructed to hold my hand out and it is immediately – gently and precisely – taken hold of by a seemingly disembodied, graceful, trustworthy being. I am both captured and captivated by the playful, tactile interaction; 'her' fingers to my fingers and palm; delicately dancing hands causing me to float, twirl, my body buoyant, not traversing an area but swirling in space. In the same moment that she leaves, subdued lights come up, a chiaroscuro state. The drapes have shifted to create corridors (these seem to change each time the experience shifts from light to total blackout – only retrospectively do

I realise it must have been me that was changing my locale via that disorientating dance). I am guided to turn around by the playful voice in my ear and am startled by a fleshly ghost, a live performer behind me dressed in seventeenth-century garb. Darkness again and dancing and then translucent projections of more of these characters. The voice directs me to look around and live versions are behind me; they feel unreal not only because they are reminiscent of Velázquez portraits but more because they are moving barely perceptibly, strange smiles on their faces; a disquieting tableaux vivant, haunting, intriguing, kind. I feel dimension shifting through this play across the live and mediated image, the reconfiguration of space, accentuated by the repeated transition from gentle light to total darkness in which I am submerged and for which I am in a state of readiness as it brings with it the delightful dance with the disembodied hand. My state of readiness involves a tangible sensation of waiting for that physical connection in the absence of that touch; always there in the pitch dark, always in artful conjunction with her childlike voice in my headphoned-ears. Lights up and the drapes have established what feels like a long, long corridor at the end of which is a tantalising image, my ghostly compatriots, framed by an arched doorway that is closed to me as I run to join it. I am made aware that I now have to take my leave. I exit the experience with that artworld-fragment seared on my retina as afterimage. It remains with me now, like the visual traces of a dream, just as that fleeting touch lies present, a corporeal memory in my hands and limbs ...

(Syn)aesthetics

(Syn)aesthetics, from 'synaesthesia' (the Greek *syn* meaning 'together' and *aisthesis*, meaning 'sensation' or 'perception'), is a theory that describes both a style of performance and a mode of analysis for that performance. It draws extensively upon the neuroscientific research of Richard E. Cytowic alongside that of V. S. Ramachandran and E. M. Hubbard, John Harrison, Cretien van Campen and Vincent Walsh. (Syn)aesthetics also appropriates ideas and descriptions from the early twentieth-century cognitive research of A. R. Luria. These scientific approaches, combined with theories drawn from art, literature, performance and philosophy, produce a rich, sensual terminology to describe the experiential nature of certain performance practices. Drawing on my more recent research into 'immersive' practice I have turned to a range of critical perspectives

including those of, philosophers Gaston Bachelard and Gilles Deleuze, social anthropologist, Kathryn Linn Geurts, social geographer Doreen Massey and leading architect Juhani Pallasmaa. I highlight this to emphasise that my approach to analysing the experience of performance work fuses outlooks from different disciplines, all of which return to the body to elucidate human interpretative faculties. This combination of theories helps to articulate the multidimensional, intersensual nature of appreciation that an individual undergoes during and following immersive experiences; a fusion of sensual perspectives that explain these processes of analysis alongside what it is to be an embodied audience member. Within this combination the scientific studies can help to identify and describe the quality of experience undergone, as much as the aesthetic forms explored and executed. In mixing neuroscientific findings with philosophies from other fields, (syn)aesthetics explores the perceptual pleasures of the experience of the arts and, in turn, the art of the holistic way humans respond to experiential theatre.

In defining the specific terms of analysis of (syn)aesthetics, the sensual language of the science has helped explain and describe the way in which an audience member appreciates certain types of visceral performance. Here 'visceral' defines those perceptual experiences that affect a very particular type of response where the innermost, often inexpressible, emotionally sentient feelings a human is capable of are manifested. Simultaneously it describes the strong emotional and/or physiological effect of the upheaval of our viscera. Immersive performance events that directly activate this combined quality of the visceral thereby affect an individual in a manner that makes her aware of the fusion of the cerebral and corporeal. As well as accepting that the elision of the somatic/semantic within sensory perception is a natural occurrence in human perception, (syn)aesthetics highlights how certain work draws attention to *the process of being aware* of this shifting.[2] Furthermore, the neurocognitive research that underpins this performance theory helps to articulate the very human experience of 'knowing' that is instinctive and noetic.[3] It serves to reinforce the fact that human perception shifts between realms; between the sensual and intellectual; between the literal and lateral. These realms are defined by their outcomes for each individual, distinguishable by a *felt* appreciation of making-sense/*sense*-making; 'making sense' in a semantic and cerebral fashion and '*sense* making', understanding through somatic, embodied perception via *feeling* (both sensory and emotional). This play with the duality of the word 'sense' is fundamental to (syn)aesthetics.

Synaesthesia and (syn)aesthetics

'Synaesthesia' in neurological terms defines a fusing of sensations where one sense is stimulated which automatically and simultaneously causes a stimulation in another of the senses; an individual may perceive scents or words for certain colours, or a word as a particular smell, or experience tastes as tangible shapes. Synaesthesia is thus the production of a sensation in one part of the body resulting from a stimulus applied to, or perceived by, another part. This fusing of certain senses can be coupled with a combining of cognition and consciousness which can result in unusual powers of perception and memory. Consequently, synaesthesia defines a human capacity for perception that shifts between hearing, taste, tactility, hapticity, vision, smell as well as across literal and lateral cognitive capabilities.[4] In addition to the neurological delineations, the 'aesthetics' of '(syn)aesthetics' incorporates the subjective creation, experience and criticism of artistic practice. My reworking of the term as '(syn)aesthetics', with a playful use of parenthesis, to define a style and sympathetic analytical discourse, fuses ideas held within the neurocognitive terminology with those surrounding the aesthetics of performance practice.[5] The parenthesis is also intended to distinguish this performance theory from the neurological condition from which it adopts certain features, as well as emphasising the 'syn' to highlight various notions of slippage and fusing together in arts practice and analysis. (Syn)aesthetics adopts and adapts terminology and frames of reference from scientific studies of the condition of synaesthesia in order to clarify its own parameters for defining and interpreting the arts in general and immersive practice in particular. Quintessential diagnostic features help to describe the quality of experience undergone by an audience member when appreciating the work in the immediate moment and in subsequent processes of recall and analysis.[6]

Extensive research has been conducted into synaesthesia that provides evidence to support this as a physiological condition that is primarily *experiential* and *affective*.[7] The cross modal nature of the condition ensures that the individual *is aware of* integrated perception in the moment that it occurs. It is this holistic nature of perception that is important to (syn)aesthetics. Current research in the area presents strong arguments for synaesthesia being present and active in all human perception from birth but, whereas the majority of humans filter this out and learn to separate sensual experience, only a minority retain this unusual perceptual ability. Arguably, the process of isolating sensation within perception and analysis is artificial, the product of learning to distinguish between the senses in order to simplify experience. Humans generally accept that taste cannot be disassociated from smell

for example, and when it is, it is a reductive experience, yet we rarely acknowledge or celebrate the potential of fused sensual experience in other areas of interpretation. As Cytowic puts it, all humans are synaesthetic but 'only a handful of people are consciously aware of the holistic nature of perception',[8] and Ramachandran and Hubbard argue that 'we all have some capacity' for synaesthetic perception.[9] Walsh and Catherine Mulvenna agree that it is possible that the 'supernormal integration' of synaesthesia can both offer insight to and be an extension of 'normal perception'.[10] From this research it is possible to infer that there is the potential for each of us to retain a synaesthetic memory and an ability to relocate this fused perceptual awareness with a given trigger, such as that offered by immersive practice as I will go on to illustrate. Following this, in (syn)aesthetic appreciation of experiential performance work individual audience members are enabled to reconnect with a (latent) synaesthetic potential. By this I intend that a quality of perception is activated and *felt*, affecting both perception and cognition in the immediate moment, the traces of which are rekindled in any subsequent recall and analysis. Here then the potential of the corporeal memory to influence interpretation becomes paramount.

Cytowic's comprehensive diagnostic conclusions are invaluable as they help to define the experiential quality of the audience response to (syn) aesthetic work.[11] First, the sensations experienced are involuntary, they cannot be suppressed but are elicited, and the intensity can be influenced by the situation they occur in, usually with some emotional resonance. Second, the sensations can draw on a noetic 'knowledge that is experienced directly' which can provide 'a glimpse of the transcendent'. The noetic has an 'ineffable quality' in that it makes manifest a complex experience that defies explanation, most simply understood as 'the "a-ha" of recognition'. Cytowic details how synaesthetic experiences can be both distracting and difficult to cope with and can also cause ecstasy and be viewed as an achievement. Important to note is that synaesthesia is 'an additive experience' where the combination of senses creates a more complex experience for the perceiver allowing a 'multisensory evaluation'. Furthermore, the experiential nature of synaesthesia that evidences 'the force of intuitive knowledge' is crucial in affirming how immediate, personal experience 'yields a more satis-fying understanding than analysing what something "means"' and accepts, celebrates even, 'other kinds of knowing'.[12]

To experience synaesthetically means to perceive the details corporeally. Luria documents how 'synaesthetic sensations' produce states within an individual where 'there is no real borderline between perceptions and emotions' and sensations are 'so vague and shifting it is hard to find words with which to convey them'. Of great significance to (syn)aesthetics is Luria's

highlighting of the power of the imagination within a synaesthetic response. Synaesthetic imagination has the ability to 'induce changes in somatic processes' and disrupt 'the boundary between the real and imaginary'. Whereas most individuals have in place 'a dividing line between imagination and reality', in those who experience synaesthesia this borderline has 'broken down'. This condition engages a perceptual faculty that experiences concepts that the majority can 'only dimly imagine' with a palpability that 'verge[s] on being real'.[13] Here the synaesthete's experience inhabits 'two worlds at once, like being half awake yet still anchored in a dream'.[14] Luria highlights the fact that this play with the imagination allows 'transition to another level of thought',[15] corroborating Cytowic's notion of noetic capabilities in synaesthetic perception.

Cytowic and Luria highlight the impact of 'hypermnesis' to synaesthetic perception. This defines mental reminiscences that reactivate the object or experience of the original perception with affective clarity. Put simply, the memory of previously perceived moments is palpable. A quality of hypermnesis is fundamental to (syn)aesthetic interpretation where the original visceral experience remains affective in any subsequent recall. Any ensuing intellectual analysis is influenced by this affective state; the analysis and articulation of that analysis becomes invested with that rich and *felt* quality of experience.

Descriptions of the cognitive condition define (syn)aesthetic qualities of experience undergone by an audience member during immersive performances. In the most intense cases (syn)aesthetic interpretation comes close to theories surrounding drug induced synaesthesia where a temporary synaesthetic perceptual experience is achieved via the influence of an external/ internal hallucinogenic force;[16] here the external force is the immersive performance itself. Fundamental to such an audience response is 'primitive sensitivity' the affective quality of recall and the experiencing of such work via an 'overall sense' where the somatic response dominates the semantic and *draws attention to* the fusing of sense with *sense*. A 'multisensory evaluation' establishes an 'additive experience'[17] within a complex appreciation process. Accordingly, (syn)aesthetic appreciation *reminds* us of the fusion of senses in apprehension, makes us *attend to* the combined somatic/semantic in the immediate moment of the artistic experience and/or subsequent to the event. Here *sense*-making is prioritised; semantic sense may modulate but cannot replace the underlying and prior sensory relations to meaning making. From birth the human capacity for semantic meaning making resides in *experience*, the limbic system being key to the experiential memory required for (re)cognising and comprehending concepts as much as speech. In short, synaesthetic cognition describes (syn)aesthetic appreciation in that

it is affective and experiential; semantic sense cannot be disassociated from somatic *sense* and the experience of this causes us to attend to this rather than ignore it, as is often the case in day-to-day activity.

To experience (syn)aesthetically means to perceive the details corporeally. The *felt*, embodied analysis of the performance experience occurs both in the live moment and subsequent to the event. This accentuates the 'presentness' of human sensory experience, where 'presence', to borrow from Elaine Scarry's explication of the word, directly correlates to its etymological roots; 'from *prae-sens*, that which stands before the senses'.[18] Further to this the Latin root form of 'present' accounts for a state of *being* or *feeling* and emphasises the tactile proof of this in *praesent*, 'being at hand' (from *praeesse*; *prae*, 'before' and *esse*, 'be'). By emphasising the meanings of presence and present, in the immersive context, the state of stirring *praesence* felt by a participating individual in such (syn)aesthetic events refers back to this full meaning and usage.

Also significant to the (syn)aesthetic appreciation process is the breaking down of the boundary between the real and the imaginary to provide a perception of hidden states. The ineffable explains the '(syn)aesthetic-sense', a term coined to define the fusion of cerebral and corporeal cognition within (syn)aesthetic work where the holistic, sentient human body, 'responds with the "a-ha" of recognition' and experiences an 'aesthetic validation that cannot adequately be put into words'.[19] This highlights a certain dreamlike inhabiting of two states within the appreciation of (syn)aesthetic work. The (syn)aesthetic-sense defines the intuitive human sense that makes sense/ *sense* of the inarticulable. It is brought about in performance practice where immersive techniques express ideas, thoughts, emotional experience, psychological states and so on, that are beyond the bounds of conventional communication, and consequently make the intangible tangible.[20] For a performance to be wholly (syn)aesthetic there must be this element of attentive cognition; a (re)cognition within appreciation. This can be unsettling, alarming even and/or delightful, perhaps exhilarating and liberating. Such an experience prioritises an individual and innate experience in interpretation.

Crucial to (syn)aesthetic appreciation is the way in which such a special perception becomes unusual due to the unsettling and/or exhilarating nature of the process of becoming aware of the fusion of senses within interpretation. With (syn)aesthetic practice and appreciation there can be a breaking down of the boundary between the real and the imaginary. These alert processes require a degree of interpretative (re)cognition by the audience which returns to an innate knowledge, the pre-knowledge of instinctive sentience. *Feeling* the ideas, experiences and states of the performance *in*

the moment can force the audience into perceiving the state presented anew. The effect of such a response can ensure that the individual holds onto the moment they have experienced and remembers this feeling corporeally in any subsequent interpretation of the work, thereby drawing on human powers of hypermnesis. In this way the *experience* of the work is the most important factor in appreciation and impacts on any subsequent intellectual processes of analysis; a visceral cognition via this corporeal memory. It is this fusion of the felt and the understood in making sense/*sense* of intangible, complex ideas that is crucial to (syn)aesthetic appreciation. This visceral experience remains affective as a corporeal memory in any subsequent recall; resultant cerebral analysis is influenced by this affective state and is invested with that rich and felt quality of experience. Rational reflection becomes part of, or is secondary to, the visceral experience. Often this results in a comprehension of the work that does not engage intellectual sense but enjoys and/or understands the work on a deeper, embodied level without necessarily being able to describe or explain this. The sensory intellect follows its own rules of logic that is both separate from and often intrinsic to cerebral intellect; think about the human 'fright, flight or fight' instinct here or 'gut reactions' and the idea is immediately clear.

Cytowic and Lurias' diagnostic features in particular are not only useful in explaining the quality of experience within the appreciation of (syn)aesthetic work, they also serve to clarify certain features of the performance style, reinforcing the emphasis on the slippage and exchange between practice and analysis. The (syn)aesthetic performance style is concerned with harnessing the full force of the imagination and in breaking down boundaries between the 'real' and the imaginable. It uses graphic images, palpable forms and visceral words to (re)present ideas and experiences. (Syn)aesthetic performance practice is always imaginative in form and usually interdisciplinary in execution.[21] It fuses various disciplines to create its own hybridised language that ensures the work produced is multidimensional and layered in form, inviting the audience to become active, sentient recipients of the work. (Syn)aesthetics embraces performance work which constantly resists and explodes established forms and concepts and is always open to developments in contemporary practice and analysis.

Immersive theatre is exemplary of the (syn)aesthetic style; one particular (while diverse) strand of this visceral practice. Although it shares common features with qualities of experience to be had in other affective performance work, immersive theatres are different in form, primarily in relation to audience interaction and consequently in the nature of experience undergone. In short, it is the separated auditorium/stage, audience/performance nature of reception that prevents other kinds of visceral performance

from being wholly immersive. Where an event is wholly immersive the audience-participant is always fundamentally complicit within the concept, content and form of the work and always sentiently engaged with the immersive world; integral to the sensual heart of the work as a living part of the form and aesthetic. This enables artist and audience together to move to new territories within the live performance exchange in a mobile, tactile manner. Consequently, immersive theatres create a space for reinvigorating human interaction, however 'fictionalised' the encounter might be. At the very least this practice causes an audience member *to attend to* the exchange occurring in the moment.

Immersive theatres and experiential form

Immersive theatres activate intense, holistic responses to the emotional and philosophical content of the work; to narratives that texture it and themes that underpin it. Immersive theatres exploit the imaginative possibilities that exist in the sensual realm of live performance. Although heterogeneous in form there are central features that go some way to identifying how immersive the experience is. In brief, the event must establish a unique 'in-its-own-world'-ness, which is created through an adept exploration of space, scenography, sound and duration within interdisciplinary (or hybridised) practice. This goes beyond the 'world of the play' of more traditional experiences to encompass a physical, as much as an imaginative, realm in which the audience-participant is haptically incorporated. Bodies are prioritised in this world; performing and perceiving bodies; the latter belonging to the audience members whose direct insertion in and interaction with the world shapes the outcomes of the event. Finally, a 'contract for participation' is shared between the audience member and the artists in order to allow full immersion in the world. This may be explicit in the form of written or spoken guidelines and agreements shared prior to entering the space; implicit within the structures of the immersive world that become clear in a tacit fashion as an individual journeys through the event; or a combination of the two. These 'contracts' invite varying levels of agency and participation. The level of immersion experienced is ultimately influenced by the artist's intention and expertise in the execution of the work.

Immersive practice shifts between artistic forms and performance disciplines, just as it shifts between the somatic and the semantic and foregrounds the unique potential held in the 'liveness' of the live moment. Engaging the fullness and diversity of sensory awareness is a central feature of this practice. Not simply at the extreme of the Artaudian idea of the senses

being assaulted but also a subtle awakening of the senses within the evolving encounter. Crucial to immersive practice is the fact that there is no focus on one particular sense, rather a play within the realm of the senses.

Praesence in immersive theatres

The live experience of immersive performance colludes in a continuing, immediate and haptic exchange of energy and experience between the work and the audience and accentuates the *praesentness* of human sensory experience. A vital component of immersive theatre is the fact that it revels in the liveness and consequent live(d)ness of the performance moment. To clarify, whatever forms the imaginative journey through the event takes – via fusions of physical performance, scenographic design, sound, technologies and interactive audience participation – what is clear is that the sensual worlds created exploit the moment-by-moment power of live performance involving direct human contact. Immersive practice harnesses the lasting ephemerality of performance as an artistic medium of expression. 'Lasting ephemerality' highlights a paradoxical experience that this work can offer where the live performance is fleeting and only of the moment, never to be repeated in any form, yet it also lasts in the receiver's corporeal memory of the event; a pleasurable and/or disquieting impression that remains. 'Live(d)' intends to emphasise the way in which, in experiential performances, the performing bodies and perceiving bodies that connect within the duration of that event are charged by the sensual aesthetic and the specific energies of the piece in a live and ongoing present, as much as the performance itself might communicate lived histories and shared experiences. 'Live(d)' embraces the idea of the performing and perceiving body as living, tactile and haptic material; interacting to establish a constant praesence in the live performance moment. The embodied experience underpinning immersive practice foregrounds this praesent exchange within the live performance moment and encompasses the fact that the human body is itself a tangibly 'lived' being (physiological, social, cultural, historical, political and so on). Consequently, this arousing form works to expose the *lived* nature of the representations.

Immersive theatres are quintessentially (syn)aesthetic in that they manipulate the explicit recreation of sensation through visual, physical, verbal, aural, tactile, haptic and olfactory means within the real-time, site-responsive experience of the event (via scents, textures, sounds and so on). Through physical proximity in the space and a play with dimension via scenography and haptic interaction the kinaesthetic and proprioceptive senses are also

exercised in an unusual manner. These features can then be accentuated and made doubly experiential via an individual's corporeal memory which may trigger and/or charge the moment via the traces of an equivalent lived, sensate experience within the perceiving individual. Traditionally theatre has prioritised the aural and visual. Often the endeavour to draw the individual audience member into a revitalised awareness of the full scope of the senses and certainly the prioritisation of alternative senses (such as touch, hapticity or smell) in the process of narrative construction and thematic interpretation is vital in this work and a primary concern of the artists producing the work. Within immersive practice, sound and vision are accentuated in ways that reach beyond traditional theatre scenarios, offering differing approaches to re-imagining the aural and visual experience for an audience-participant in an event. Such play with the multidimensional capacity of the full human sensorium allows for a new protocol of interaction and exchange to establish itself; reconnecting an individual with her or his own body as much as connecting an individual with other bodies. The reawakening of the holistic sentience of the human body allows for an intensely immediate and intimate connection and interaction within the performance event.

Immersive practice can activate an intuitive sense that draws on noetic understanding. Such a special perception taps into primordial bodily receptors and causes the audience-immersant to *feel* the ideas, experiences and states of the performance in the moment. The effect of such a response can ensure that an individual holds onto the moment she has experienced and remembers this feeling corporeally in any subsequent interpretation of the work. Wholly immersive theatre experiences bring about a palpable immediacy; breath-by-breath attention within the event, firmly located in the body. This live(d) experience of immediacy allows for an encounter with an intense sensation of '*being* in the moment', being *praesent* in the moment. Immersive practice reawakens embodied consciousness and reminds an individual that this sentience is a primordial underpinning in our evolved cerebral interpretative faculties. Arguably, Western, technologically driven, lives have become alienated from holistic appreciation in daily routine. Immersive theatres address this lack and encourage a feeling of 'aliveness' to enter back into the perceptive faculties.

Lundahl & Seitl's immersive practice provides useful illustration of how the immersive form can reawaken praesence and its analytical powers in interpretation. Their work plays in between haptic spatialities; the physical and virtual, imaginative and actual, internal and external. The experimentation with embodied space breaks down barriers between the perceived contradictions of the internal/external binary to establish a continuum of felt and thought experience. As the opening account illustrates, by emphasising

tactile contact, hapticity and immediacy Lundahl & Seitl's particular style of immersive practice explores relations between people, space, time and artwork, siting/citing the event corporeally.

The (syn)aesthetics of Lundahl & Seitl's work

Christer Lundahl and Martina Seitl formed Lundahl & Seitl in 2003. Based in London and working across Europe the company creates immersive events with a strong foundation in research and process. Employing audio-instruction and a unique interactive dance between performer-guide and audience-immersant, Lundahl & Seitl investigate space, time and perception, collaborating within the areas of architecture, fashion, cognitive neurology, classical music, sound composition and visual art. Lundahl clarifies how a desire to question perception underpins Lundahl & Seitl's practice:

> [O]ur work exists not only in visual art but also in the theatre as well as in choreography and science; we're challenging that interface. Our practice is also a spiritual exploration, a journey of the universe and human consciousness ... Our medium is sensory illusion; taking apart sensory input from a visitor and putting it back again. I think there's a lot in what, in neurology, is called the multisensory binding problem; how is it that we have one unit, one coherent sensory experience of reality from all the sensory input that is fragmented, chaotic, a lot of things going on at the same time?[22]

Lundahl & Seitl explore ideas around free will, intuition and sensory awareness and the affective nature of the imagination in relation to how humans experience art. This is illustrated in a recent work, *Rotating in A Room of Images*, as described above. Lundahl & Seitl refer to their audience-participants as 'visitors'; a term that owes as much to the visual arts (visitors to exhibitions) as it does to performance, suggesting an active invitee who will be taken care of and treated as a willing guest within the event. It is also a term that emerges from their choreographically interactive form. Seitl's choreography has developed over time from early explorations involving long rehearsal processes that 'took the performers into a deep state of *being* – within the self.'[23] As a consequence of these extended workshops Seitl realised that for an audience member to feel that same quality of experience then she or he needed to participate in that same process; a reversal of the traditional performance experience so that the affective nature of the work might be actually experienced, *moved*, within the body. The audience

member 'would take on the blindfold and we would explore similar but more refined exercises ... they're not audience anymore but *visiting the experience* ... and the performer was the facilitator of that'.[24]

Seitl identifies how examining the principles upon which the performer might communicate through physical contact led to the following discovery:

> Absences were felt much stronger than presences so we started to call it 'choreographing absences'. It was important the way a touch started and how it disappeared, and how that would emphasise the absence ... If we wanted to give a timeless feeling or to give a feeling that the hands were disembodied, that they didn't belong to a physical body, we could communicate this ... through Laban movement analysis where everything is limited down to weight, space, time and flow.[25]

This demonstrates how this work is firmly rooted in a haptic methodology that relies on tactility and sound to activate imagination and interaction. Seitl's methodology for interactive movement between performer and visitor involves the most delicate experience of touch and guidance where you submit to the sensation of floating in the space. The idiosyncratic nature of the touch reminds the visitor-immersant in the work that the perceptual experience of the body as a whole is tactile and experiences tactility as a fusion of internal and external sensation; attends to the perceptive faculty of bodily kinaesthetics involving proprioception. This interaction with the visitor corresponds to a highly sensitive, intuitive response from the performer developed from the dynamic initiated within the exchange on first contact. This involves facilitation by the performer-guide to 'attune together to establish trust',[26] which the performer can then manipulate as the piece progresses. This quality of movement inspires attentive *being* within the visitor; a subtle awakening of the senses within the evolving encounter and an awareness of attending to the waiting as much as anticipating the movement. For Seitl, the timeless quality of these moments accentuates the ongoing present, plays with anticipation, encourages that individual to experience being within and between her own body, another's body and the artistic experience. In relation to the choreographed absences 'you know that soon there will be physical interaction because you're in the middle of an absence ... therefore some people feel a heightened sense of presence, the kinesphere around the body'.[27] This praesent-absence itself prioritises embodied knowledge; requires both parties follow the body's lead and give into its haptic and intuitive capabilities.

In this way, Lundahl and Seitl encourage their visitors to inhabit the space in which the event occurs in a variety of ways and in so doing activate the 'interior architecture' of the imagination. Lundahl expands, 'in that moment

of suspension you're experiencing space around you, an interior architecture of that space'.[28] Seitl highlights how the interplay of the sensual and choreographic design of *Rotating in a Room of Images*, enables the visitor to feel as if part of the space; to become aware of the edges of the body fusing with the kinesphere. This piece exploits the power of haptic perception (extending tactile touch – skin against skin – into haptic awareness involving kinaesthesics and proprioception). It also triggers the sensation of haptic vision that can come about through the sensual aesthetic of the immersive world; the visual and imaginative apprehension of space and image is influenced by the haptic and aural interaction with the praesent/absent guides who dance with and speak to you. Here the elision of the senses activates a wholly (syn)aesthetic approach both in the styling of the work and in the subsequent individual response to that work by the audience-visitor. The internal *attending to* one's own haptic awareness layers the experience of the piece in the immediate moment and textures the quality of the recall not simply in the remembering in order to describe 'what happens' during the event but also as tangible, embodied analysis in the interpretation of the ideas that underpin the work. How do we *experience* art? What is the impact of art? How and why does it remain within us? An overriding feature in this interaction between visitor and visual/physical/imagined image, is the Lundahl and Seitls' interest in locating 'where *in themselves* they *experience* art';[29] drawing the visitor into an embodied questioning of how we perceive, remember and archive artistic experiences – as living, tactile and haptic material.

The interplay of the senses directly impacts on the nature of immediate perception and the subsequent embodied memory that one has of this piece in recall and analysis. The shifting of perception that occurs when sight is removed and space is reconfigured, forces the visitor to attend corporeally to dimension and perspective. It activates kinaesthetic and proprioceptive awareness through hearing and motion and consequently encourages vision to become haptic through the interaction of projections and live tableaux, all of which is enhanced/disorientated by the visitor's manipulated movement in space. Audio and video technologies enhance and direct the imaginative and immersive journey through the work, accentuating rather than distancing the sensual involvement of the visitor. The intimacy of the voice in the ear is a playful entity that guides and wreaks mischief upon the visitor in her journey through the work. The ludic play of the aural is key to unlocking a visitor's imagination; it overturns expectation; surprises, delights and disturbs. The (syn)aesthetically intertwined nature of audio-enhanced-motion draws upon a kinaesthetic and proprioceptive interplay of the tactile, haptic, sonic and visual senses. The intimacy of this sound

in/as imaginative space becomes integral in/as experience and accentuates the (con)fusion of interiority and exteriority within the world of the event. Sound and vision in this piece become tangible, textured and spatial in a (syn)aesthetic manner.

In this way *Rotating in a Room of Images* demands that the audience-visitor attend to the nature of perception; acknowledges the elision of *sense*/sense in the pleasurable playfulness of the tactile contact and in the submission to intuitive and proprioceptive powers of perception in the pitch darkness that envelop the tangible imagery. Consequently, when engaging with this experience and with any subsequent analysis in appreciation of the work, an individual is made aware of the praesent ways in which she is perceiving, aware of the ways in which attention to environment and her place as part of that environment is (re)cognised. This work plays with(in) memories of paintings as much as it activates memories of sensation in the body. The manipulation of sight through blackouts reinvigorates the full sensorium while stimulation through 'disembodied' physical interaction heightens the sensation of touch, hapticity, intuition. The activation of the imagination through aural means via the intimacy of the headphones plays between mental and actual vision and touch. At the points where sight is returned, you are encouraged to look and look again, textured by the praesent quality of being that has been enhanced by the waiting-for-interaction. The notion of embodying the space is extended to imaginative, mental space as the visual/physical imagery remains palpably dwelling in the room as much as in the mind's eye; an optical/'haptical' afterimage. The visitor becomes aware of embodied beholding; responding physi-cally to the unexpected bodies as artistic apparitions and simultaneously attentive to the situations and ideas that are presently-absent, absently-praesent in the space. In this way the work exposes the (syn)aesthetics of the experience.

The visitor in *Rotating in a Room of Images* is enabled to give embodied attention to the ways in which perception comes to bear through the multi-sensory ways in which one is experiencing the work; prioritising hapticity and hearing while playfully manipulating vision. It draws attention to praesence and participation in the moment. This is accentuated by the ways in which the piece gently immerses a visitor in the world through verbal and physical guidance. With these subtle acts of preparation the sensory awareness of an individual's relationship to space, to praesent/absent others in that space, is activated in a heightened manner. From the outset the visitor's imagination and proprioceptive senses are mustered to enable an act of intuiting through the event; a tangible immediacy is thus affected *and affective* within the work in a wholly (syn)aesthetic manner.

Conclusion

The live(d) experience of praesence, the participant's whole body responding within an imaginative, sensual environment, is the pivotal element of a Lundahl & Seitl immersive experience. *Rotating in a Room of Images* makes the visitor aware of the perceptual fusion of the cerebral and corporeal. It is experiential and affective and consequently triggers awareness of a supernormal crossover of the senses in holistic cognition. This piece is constructed to enable the visitor to attend to the elision of the somatic/semantic within sensory perception and accentuates the process of being aware of this shifting between realms in the moment of experience as much as in any proceeding analysis. It underscores the human experience of 'knowing' or *feeling* that is instinctive and noetic. As the opening account testifies, this is most intriguingly illustrated by my visceral response to the ghostly praesence of the tableaux vivant; the live(d) moments and the lasting memory of these moments tap into a deep well of experiential responses to artistic imagery and is palpable in my intellectual analysis of this. Through this affective memory I make sense/*sense* of the archive of art history that I hold within my subconscious imagery and my more (im)mediate sensual memory. The way in which my imagination was made active during the experience influenced my somatic processes of cognition. Enhanced by the alert state of being necessitated by the sightless dance my perception of the tableaux vivant hovered between the real and imaginary. The live(d) sensation of this in the moment was like inhabiting a dreamworld made real by my conscious readiness to engage. In the moment and in retrospect this fusing of perceptual realms gently guides transition to another level of embodied thought in analysis.

Within *Rotating in a Room of Images* the visitor is fundamentally complicit within the concept, thematic content and form of the work. I was sentiently engaged with its idiosyncratic world and becomes a living part of the form and (syn)aesthetic. The visitor cannot escape from the fact that she is forced to perceive the details corporeally. I willingly submitted to this due to the safe yet playful way in which I was physically engaged with the piece. In particular the live(d) performance exchange accentuates tactility and hapticity. Consequently, I delighted in the way in which the fusion of touch, proprioception, kinaesthetic awareness, hearing and haptic-vision, layered the immediate comprehension of the work. This in turn ensured that my subsequent analysis was influenced by this additive experience and became a richer process of appreciation as a result; the combination of the senses created a more complex experience in interpretation allowing a multisensory evaluation in analysis. *Sense*-making is thus prioritised in the moment and

its after effects; semantic sense modulates but does not replace the underlying sensory relations in appreciation of the work as a whole.

Haptic perception is crucial to this immersive world. The haptic immediacy of the experience remains affective in the corporeal memory of the work which has an influential bearing on any intellectual interpretation in a wholly (syn)aesthetic manner. As described above, this piece first impacted on me as a delightfully disorientating, ephemeral moment. It was beautifully evocative of an artistic haunting; the sensation that I had been inserted into a dream. It has surprised me by lasting within me, leading to a more detailed questioning of the ideas around perception and art appreciation. The quality of touch and haptic engagement remains embedded in my corporeal memory. The *feeling* of that unique interaction through the hand and the ear has endured, just as the chiaroscuro tone and texture of the striking tableaux vivant remain as a vivid afterimage, a subliminal residue. The sensation of praesent being and the experience of embodied beholding undergone during the piece is distinguishable within this lasting memory; a *felt* appreciation of making-*sense*/sense-making; a total immersion in the lasting ephemerality of the experience of art. In this way this piece is exemplary of a (syn)aesthetics in practice and analysis.

Immersive events such as Lundahl & Seitl's *Rotating in a Room of Images* can remind an individual that the human capacity for meaning making resides in experience. The potency and pleasure of this piece is the fact that it is the integration of the senses in motion – sight, hearing, tactility, hapticity – that activates a holistic cognition of the work. It is *experience itself* that communicates the underlying theme and concept; to question how and where in our bodies we experience art. The 'knowledge' imparted during this piece is shared in a wholly somatic manner; ideas that are felt and understood (syn)aesthetically. In turn this reminds us that the languages of science and art are not separate entities but fundamentally entwined, despite being presented in different ways. Any sensual discourse, such as that offered in (syn)aesthetics, foregrounds the pleasures of this interrelationship. It shows how scientific reasoning can be implicit and demonstrated within artistic action and appreciation. Equally, it reinforces the fact that artistic elucidation helps to make *sense*/sense of the way in which the human body works; how it creates, responds, interprets ... experiences.

Politics in the Dark: Risk Perception, Affect and Emotion in Lundahl & Seitl's *Rotating in a Room of Images*

Adam Alston

It is a well-known fact among theatre scholars that the word 'theatre' derives from the Greek *theatron*, meaning 'a place for seeing' or 'a place for viewing'. Maaike Bleeker writes that to see 'is also associated with insight, revelations, prophecy, second sight, and magic. […] Seeing always involves projections, fantasies, desires and fears, and might be closer to hallucinating than we think.'[1] But what happens when theatre takes place in the pitch-black? What insights and revelations occur and what projections and fears are exposed? Significantly, how might immersion in the dark affect an audience and how might this impact on an audience's capacity to act in relation to their being acted upon? In short, what kind of politics takes place in dark theatre spaces?

I will be looking at the production of risk, affect and emotion in Lundahl & Seitl's immersive performance for an audience of one, *Rotating in a Room of Images* (2007); more specifically, I will be analysing my own experience of this work, addressing how risk perception might contribute to the production of affect and emotion, in turn treating affect and emotion as potential participatory risks. This chapter regards the mining of personal experience in participatory theatre as a useful and potentially informative method for setting about analysis of performer-audience dynamics. As with others in the field approaching this kind of work, I employ a 'critical intimacy' in approaching *Rotating in a Room of Images* 'from a position of engagement'.[2] Imbrication within a performance event as a participant does not bar the capacity to make critical observations; eventfulness, after all, is a fundamental part of both witnessing and examining explicitly participatory and less participatory theatre and performance.

Approaching performance from a position of engagement underscores and values the importance of subjectivity. This is an especially significant acknowledgement in seeking to both represent and analyse an experience

of participatory forms of theatre. The experience of *Rotating in a Room of Images* recounted and examined in this chapter stands, I believe, in productive contrast to that of Josephine Machon's also explored in this part of the book. The productivity of this contrast testifies to what critical intimacy might emblematise; for instance, where Machon reflects on her own anticipatory acts as an audience member in this performance in a context of gentility and trust, I consider such acts in a context of risk by unpacking my own experience of this work. However, the juxtaposition of these chapters is not antagonistic, but complimentary in the context of critically intimate approaches to performance. I will not attempt to document 'The Experience' of this performance; rather, the observations and theorisations contained in this chapter refer to a small part of a plurality of possible experiences, each demanding different critical tools and points of focus.

The first of this chapter's two primary claims is that risk perception, affect and emotion might be usefully theorised as being entwined in this performance; the second is that a series of restrictions on participatory agency arise from this entwinement that characterise the interrelations between risk perception, affect and emotion as political. Limits on my own capacity to exercise agency will consequently be acknowledged and examined. Perhaps this might provide a sobering counterpart to the freedoms that might otherwise be associated with participatory theatre.

I am interested in how cognitive science, especially cognitive psychology and neuroscience, might inform an approach to theorising these two claims. However, in doing so, I would like to draw attention to C. P. Snow's famous 1959 Rede Lecture, 'The Two Cultures'. In this lecture, Snow identified a split between science and the humanities in Western thinking.[3] He supported equal claims to significance and validity between the two and believed that these claims should find adequate institutionalisation in the educational system.[4] The methodology employed in this chapter bears in mind Snow's observation and cause which not only remain valid, but increasingly significant in the context of metamorphosing disciplines such as theatre and performance studies, as well as recent threats to those disciplines.[5] There is fruitful space to consider how cognitive science might enrich an approach to, for instance, the production of affect and emotion in performance. However, it is important not to ignore or belittle the value and insight that the humanities have traditionally offered theatre and performance studies. With this in mind, I will be citing research arising from cognitive science over the past forty years, but especially over the past two decades, as a means of informing, but not explaining, an approach to the production of affect and emotion in *Rotating in a Room of Images*: an approach largely documented in the first section of this chapter, 'The production of affect

and emotion'. My approach to risk perception, detailed in the second section and applied to an analysis of *Rotating in a Room of Images*, will draw on the psychological research of Paul Slovic, in tandem with Antonio Damasio's neurological research into decision making. A concluding section evaluates these findings in political terms, drawing on a cognitive reading of agency detection.

The production of affect and emotion

I attended *Rotating in a Room of Images* at the Battersea Arts Centre's One-on-One Festival in 2011. On entering the space of this performance, I was asked to wear headphones which whispered instructions, mostly dictating when and where to move in the performance space. The space itself was made up of sets of white drapes, forming corridors. The lights faded to complete darkness before those whispers encouraged me to stand. When the lights faded back up, the orientation of the white drapes had shifted 90 degrees. The lights faded back to black and the voice in the headphones prompted me to reach out a hand as another hand, that of an unseen performer, took hold, somehow guiding me, the blinded, forward. In moments of light, a pair of performers were visible in varying tableaus and proximities; in moments of darkness, a sense of threat permeated the space, countered only by the hands of unseen others acting as guides. This game of hide and seek, of intermittent light and dark, of metamorphosing spaces, of stumbling and being guided through the pitch-black, continued in various guises for the 15 minute duration of the performance.

What interests me about this piece was my capacity to act as a participant, in relation to my being acted upon: in other words, a politics of participation. Immersion in pitch-black has the potential to produce affects and emotions which are powerfully felt. In this case, the processes which will become the subject of enquiry are the causes of trepidation and fear which I felt when stumbling forward in the dark. The suggestion is not that fear must have consequently been produced in all other participants (Machon's chapter in this book suggests as much); rather, the suggestion is that exploring some possible causes of affect and emotion production might usefully contribute to an understanding of the politics of participation in this work. Focus will largely be placed on one aspect of this performance: the experience of and movement within a pitch-black theatre space. In particular, fear and trepidation will be identified in terms of affect and emotion, assessing how the production of both might impact on a theorisation of how agency operates. But what is an affect and what is an emotion?

Historically, scholarly responses to these questions demonstrate an endless grasping towards the origins of affective and emotional experience, as well as the deployment of different terminologies and definitions across disciplines and fields. This is also where disciplinary limitations rear up for the theatre and performance studies researcher largely depending on the retrieval of insights premised on the experiments of others. But what can be offered are working definitions which, following a comment from Rhonda Blair at the Affective Science and Performance symposium which forms the basis of this book, demonstrate not a 'doing' of science but a 'using' of it. There are methodological issues with this 'using', but issues which do not block the productive exploration of insights.

Joseph LeDoux has been influential in examining the production of fear. He suggests that fear results primarily from activation of a part of the brain called the amygdala. It is fear that, for me, at least, was produced in this performance, albeit a mild and even exciting form of fear manifested in trepidation. The amygdala, claims LeDoux, activates behaviours such as freezing, fleeing or fighting, 'autonomic nervous system (ANS) responses (changes in blood pressure and heart rate, piloerection, sweating), and hormonal responses' which may include the release of adrenaline into the bloodstream.[6] The ANS and hormonal responses, taken together, are described by LeDoux as 'visceral' responses affecting internal organs and glands.

Visceral processes, as described by LeDoux, have a hand in the production of affect and emotion, but they do not tell the whole story. To pinpoint what produced trepidation in *Rotating in a Room of Images*, it is worth defining and distinguishing affect and emotion. As I hope to demonstrate, this means that a language can be developed which might aid performance analysis while also opening up space to address how cognition impacts on both, especially cognitive processes of relevance to the production of individualised responses.

For Carl Plantinga, visceral processes are the nuts and bolts of affects, defined as 'felt bodily states'.[7] This is to be distinguished from emotions which, for Plantinga, are 'a type of affect that involve a higher degree of cognitive processing' and 'are clearly identified as intentional mental states'.[8] It is worth pointing out that this definition does not banish cognition from affective processes, provided that cognition is understood in the broadest possible sense as describing 'any kind of mental operation or structure', including and especially those which are unconscious.[9] The word 'unconscious' seems to refer here to what John Kihlstrom describes as the 'cognitive unconscious'; this refers to all mental activity which occurs without our being aware of it. In other words, most cognitive activity is unconscious.[10]

Where affect might be said to constitute a 'low road' towards the production of felt bodily states,[11] emotion involves a more complex form of

cognitive appraisal.[12] As Mark Johnson suggests, emotional responses are 'bodily processes (with neural and chemical components) that result from our appraisal of the meaning and significance of our situation and consequent changes in our body state, often initiating actions geared to our fluid functioning within our environment.[13] So while both affect and emotion are subject to an 'embodied mind' – an understanding of mind, briefly, that merges perception with conception – and while both might move us toward some kind of action, the role of appraisal has a much firmer hand to play in the case of emotion.[14]

There are two, related reasons why I have underlined the role of cognition in both affect and emotion. The first reason relates to the political implications. As noted, different degrees of cognitive activity significantly contribute to the identification of affective and emotional sources. But there remains a common cognitive ground to such identification, despite the different degrees of cognition. As Magda B. Arnold and J. A. Gasson suggest, 'an emotion or an affect can be considered *as the felt tendency toward an object judged suitable, or away from an object judged unsuitable, reinforced by specific bodily changes according to the type of emotion*.[15] In other words, both affect and emotion motivate, whether the result is movement or freezing. At this early stage of the chapter, then, a paradoxical quality of agency is introduced, so long as agency can be seen to relate to the wilful motivation to do something and the capacity to act upon that motivation. However, it should be noted that affect and emotion do not by necessity *determine* action: there are other conscious and unconscious processes that may interfere with any such determination, even with regard to nuancing reflex and facial expression.[16]

The second reason, which underlies the first, is a consequence of how individuality is figured in both. I believe it is a mistake to think of either affect or emotion in terms of hard-wiring alone. Damasio acknowledges that emotions, particularly the so-called 'primary emotions' that have been the concern of evolutionary biologists and psychologists,[17] have biologically determined elements as a consequence of evolutionary history, but there is also the 'reality that learning and culture alter the expression of emotions and give emotions new meanings.[18] Individuality and autobiography are not banished from an approach to emotion which draws on cognitive science; quite the contrary. Social experiences should inform enquiry into emotion, addressed in tandem with what Bruce McConachie calls 'genetic endowments.[19]

The same seems to be true of affect, particularly in the light of Arnold's research into 'affective memory'. Arnold gives the example of a rider seeing a horse which once threw him or her and how this may cause 'immediate

apprehension in the unlucky rider. These reactions can only be based on the remembered joy or pain'.[20] It is this kind of remembering that, for Arnold, constitutes affective memory. She goes on to account for how affective memory moves on from a process of remembrance to an imagining of subsequent affective impact and an estimation of its potential harmfulness, either conscious or unconscious.[21] To sum up: through a set of embodied cognitive processes such as these, affect and emotion are revealed as distinct processes distinguished by the degree of cognitive activity in play, which nonetheless share a common ground in cognition.

There are three points that I wish to highlight in this understanding of affect and emotion: the first is that affect and emotion are potentially entwined, especially given the fact that affective responses are a constituent part of the emotional 'high road'; the second is that instinctual or evolved processes only tell a part of the story in the generation of affective and emotional responses. Given the insights offered by cognitive science, individuality and autobiography contribute to identifying affective and emotional stimuli, as well as attributing meaning to those stimuli which is likely to impact on how they might be felt. The third point is that both affect and emotion influence thought and behaviour and thus create limits within which agency is likely to operate; the key word here is 'influence', as opposed to 'determine'. Another key word is 'limit': agency is not necessarily removed from the equation, it is only tempered.

So how might this apply to *Rotating in a Room of Images*? My ability to move freely through the space was restricted by the white curtains, implying that there was a path to be followed, as well as a vast number of inputs such as a 'horizon of expectations' brought into the space and an awareness of and aptitude for participatory protocol.[22] However, I want to focus on how affect contributed to the negotiation of agency in this performance. As demonstrated above, in assessing this contribution it is important to recognise evolved instinct, but it is also important to recognise the impact of affective memory and the inputs of individuality and autobiography that influence what might be identified as potentially threatening or otherwise affectively meaningful.

The closing off of vision promoted an imaginative engagement with an unknown outside, where imagination – that force which, for Johnson, is at the very heart of a meaningful encounter with the world – becomes an affectively resonant factor premised on the cognitive processes of anticipation, expectation, estimation and evaluation.[23] In one sense, as darkness descended, my capacity to act upon agency diminished as dependency on an unseen other to be led through the space emerged. But, in another, by virtue of the fact that I was simply there in the dark, my participation was

almost hyperactively creative, producing against the backdrop of darkness a host of imagined stimuli pertinent to the production of affect and emotion and therefore pertinent to the operation of agency. Like the child fearing monsters under the bed at night, I was positioned by the performance in such a way that affective and emotional sources could be called forth from the shadows, ultimately manifested in trips and stumbles through the space.

In the context of pitch-black aesthetic space, affect became something to latch onto, in terms of attention and orientation, despite of its paradoxically disorienting qualities.[24] The invitation to move in pitch-black was met with hesitation, but what emerged from this hesitancy was a nodal point in which affect, its more complex emotional form and a largely imagined outside – one which I go on to identify in terms of risk – appear entwined. I contend that this entwinement can tell us something about the politics of participation.

Risk, affect and emotion

To grope in the dark in *Rotating in a Room of Images* was to anticipate, or expect and imagine what the future will hold: what if I walked into a wall? What if something were to jump out at me? It was in these moments of encountering an uncertain future that the presence of risk and vulnerability were *felt* most strongly as something acting on participation. This notion of something that is merely perceived – that is, risk – acting on participation is complex: it relates to a meshing of risk perception, affect and emotion.

Although it might, risk does not necessarily equate to the threat of physical harm. Paul Slovic identifies risk as a phenomenon which is 'subjectively defined by individuals who may be influenced by a wide array of psychological, social, institutional and cultural factors'.[25] This means that just about anything can be perceived as risky, provided that perception relates to an evaluation of future-oriented uncertainty. At the heart of risk perception is a 'distinction between reality and possibility'.[26] It is this distinction, this gap between the present and an anticipated future, which seems to go hand in hand with how affect and emotion are produced in the pitch-black in *Rotating in a Room of Images*: an imaginative iteration of possibility, in a context of uncertainty, based on affectively and emotionally charged risk perception.

It is useful to borrow an observation of Brian Massumi's to illustrate how this definition of risk might relate to *Rotating in a Room of Images*.[27] Massumi asks his reader to think of a suitcase which is suspected to be full of anthrax found at an airport, which turns out to be nothing more than

a suitcase leaking flour; nonetheless, the affective and emotional realities produced within individuals by that suitcase, such as fear or anxiety, can bring into being their own material realities in a given environment. These 'material realities' may include SWAT teams, news helicopters, road blocks and the like. Massumi's observation might just as well be applied to *Rotating in a Room of Images*. An object of risk perception, such as the risk of someone leaping out from the dark, or of walking into a wall, might turn out to be without, or with minimal threat to safety; a group of performers or stage hands who knew exactly where to lead me on a pre-determined path through the space reduced the threat of physical harm to a minimum. Nonetheless, the affective and emotional realities produced, including fear and trepidation, brought into being other material realities in the present. An example here was the manner in which the performer-audience relationship unfolded through fumbles and stumbles as well as my affected carving of routes within the routes which were already designed prior to entering the space. All this supposes that my encounter with risk, as an affective presence culminating in the emotional expressions of fear and trepidation, impacted on interaction: with the performers, but also within the pitch-black space. In other words, an encounter with risk exerted affective influence not only over participation, but also over the performance given the way that I was subsequently rendered a 'hyperactively' creative subject.

What is being dealt with here is a theoretical entwining of risk, emotion and affect: an entwining which finds justification in neuroscience. Damasio recognises that there is a neurological base to risk perception, or at least the capacity to act upon such perception. In different terms, as indicated below, he argues that the human capacity to act effectively on risk perception is partly dependent on a part of the brain that inputs emotion into decisions. He contends that damage suffered by his patients to regions of the brain associated with decision making, including the prefrontal region, produced 'a disturbance of the ability to decide advantageously in situations involving risk and conflict and a selective reduction of the ability to resonate emotionally in precisely those same situations, while preserving the remainder of their emotional abilities'.[28] Damasio is suggesting that that there are neurological links between risk perception and emotion, manifested in a reduced capacity to make effective decisions in patients suffering from damage to the prefrontal region of the brain.

However, there are also numerous other factors contributing to risk perception. These multiple factors include processing of cultural background, affiliation with socio-political institutions (including personal values and social values), cognitive-affective inputs (including reference knowledge and personal beliefs) and heuristics of information processing.[29] It is the

cognitive-affective inputs that are of special relevance to this chapter. Recall Arnold's example of the rider encountering a horse that has thrown him or her as a means of illustrating affective memory: it now emerges that what was being dealt with in that discussion was risk perception. The perception of risk is what triggered 'immediate apprehension'.

Revisiting and integrating the observations and claims put forward in this chapter so far: the production of fear or trepidation and perception of risk, in the context of my own experience of *Rotating in a Room of Images*, demanded an appraisal of the dark as being risky. That appraisal may well be strongly influenced by past experiences of the dark, including the emotional resonances attributed to those experiences (following Damasio), as well as those multiple factors impacting on risk perception just outlined. This means thinking about risk perception, affect and emotion not just in terms of hard-wiring, but as processes relating to the individual in numerous and profound ways. It should now also be clear how risk might be approached as being potentially productive of affect in a performance like *Rotating in a Room of Images* and how risk perception, affect and emotion potentially interrelate.

I have already established how affect and emotion influenced agentic capacity: but affect and emotion might also be regarded as risks for participating audiences that subsequently produced comparable effects. By participating in a performance which produced and amplified affective and emotional responses, I was opening up to a submissive diminishment of control over my own behaviour. It is in this sense that I find it useful to think of affect and emotion as risks, provided a partial loss of control is recognised as promoting vulnerability. This political concern is the subject of the remaining section.

The politics of participation in *Rotating in a Room of Images*

The bulk of this chapter has been geared towards establishing how agency functions within specific parameters and how these parameters are contingent on exposure to different inputs, of which we might count the perception of risk in relation to affect and emotion. The remainder of the chapter concerns itself not just with how I, as a participant, was acted upon, but also with exploring one particular space left open for action within these parameters.

As noted after borrowing from Massumi, risk perception does not in the first instance change the material reality of a given environment, but it can change the ways in which that environment is perceived and consequently

interacted with; it can provide a stimulus for the participant to alter the creative trajectory of a performance. This observation will now be nuanced by considering how agency might be detected. It may be that an implicitly creative subject is at the heart of agency detection: a point that could well position the detection of agency as an expression of agency.

In *Rotating in a Room of Images*, I found myself anticipating what *could* appear from the dark. Drawing on cognitive development studies, Justin L. Barrett argues that this kind of anticipatory process is an innate disposition. He comments on this disposition as a need to seek out or attribute agency 'where further reflection might lead to a different evaluation', referring to that disposition as the Hypersensitive Agency Detection Device, or HADD.[30] Along with the anthropologist Stewart Guthrie, he suggests that such a disposition is likely to have evolved for survival reasons, for it is better to assume that, for instance, a rustling in the bushes is a predator than to forego that assumption and risk attack.[31] In this instance, HADD attributes agency to something in the bush that might not have posed a risk, but that does not stop risk being assumed: an assumption manifested in the production of, for instance, fear and the visceral responses accompanying that production which prepare us for flight or defence. HADD may account for why environments, generally speaking, occasionally seem infused with risk. If the thesis is accepted, then humans are predisposed to render objects of perception as 'risky' via an attribution of agency.

It may seem counterintuitive, given this thesis, to claim that agency detection functions also as an expression of agency. However, the plot thickens if this assertion is evaluated in the light of the claims put forward in this chapter. We might add to this disposition Arnold's notion of affective memory, together with Damasio's recognition of developmental inputs in the identification of emotional sources and an attribution of meaning to those sources, framed in the light of risk perception, affect and emotion being entwined. Framed as such, then the attribution of agency to uncertain threats is really the projection of an anticipation or expectation. That process of attribution, in a fascinating twist, comes from an affected or emotionally involved anticipating subject. In *Rotating in a Room of Images*, then, the increasingly fashionable notion in theatre studies, largely derived from Jacques Rancière's essay 'The Emancipated Spectator', of thinking about spectatorship as an implicitly active process is granted weight, but in a way that recognises the corporeality of this activity.[32] This assertion does not frame that activity as being the product of instinctual and evolved processes alone – although those processes do have a role to play – but, rather, foregrounds affective memory and individuality as powerful inputs. Acknowledging attributions of agency in a context of uncertainty is itself

an expression of agency premised on individuality, especially if affects and emotions triggered by risk perception end up prompting negotiation of alternative courses of action.

In conclusion, in my own experience of *Rotating in a Room of Images*, acts of anticipation in a context of uncertainty played a vital role, imagining various threats to be lurking somewhere in the unknown: albeit an imagining which may well be premised on amplifying the threat of another person simply being proximate. Risk was perceived as permeating the space, but the perception of this permeation was the consequence of disposition, on the one hand, and imaginatively projecting into that space, on the other. When considered as an affective presence, my relationship to risk was political given the influence it exerted; it controlled as much as spurred thought and action. An encounter with risk perception, affect and emotion, as inter-related phenomena, can consequently be seen as an encounter with the capacity to interact with a given situation: an encounter with the limits of agency, as well as a potential minimisation of those limits. In other words, risk perception, affect and emotion can be seen to impact on how we might theorise a politics of participation.

Touched by Meaning: Haptic Effect in Autism

Melissa Trimingham

The question of how a performance comes to 'mean' for an audience is intimately connected with how the world itself comes to 'mean' for us. How might we untangle the inner sense of self, our consciousness, our thoughts, from the insistent physicality of our bodies, from the material contours of space the body rubs against, the protean outlines of the objects that inhabit it? These questions are brought sharply to our attention when we encounter an autistic child who does not seem to 'share' their world with us or find our meanings in the everyday objects surrounding us. Phenomenology gives insight into our contingent existence and immersion in the material world and our ability to 'intend' it or bring it into consciousness; but at the start of the twenty-first century philosophy is richly supplemented by both psychology and affective cognitive neuroscience. The sea change in cognition, which is gradually ousting models of 'Good Old Fashioned Artificial Intelligence',[1] is understanding that the mind does not 'represent' an unchanging world outside the body (i.e. an individualist and mentalist model) but 'makes' the world in an ever changing embodied knowledge and experience of it.[2] Intersubjective approaches to cognition (intersubjectivity being 'the sharing of experiential content ... among a plurality of subjects'[3]) develop further this new 'enactive' or 'embodied' cognitive science.[4] This is significant in regard to autism. The autistic person's knowledge of the world develops very differently to our own, showing differences in empathy, communication and imagination, to varying degrees.[5] The autistic child as an active participant in theatre, studied here through a specially structured immersive performance, gives insights into thought, empathy, imagination and socialisation developing through the quotidian objects we handle: the often discarded plasticity that is lain upon, manipulated, shaped, stroked, chewed or stamped on from our earliest days.

My context is the playful, imaginative performance space offered to autistic children in Imagining Autism, an Arts and Humanities Research

Council funded project run by the University of Kent, UK, 2011–14.[6] In this project the participants (aged between 8 and 11) encounter the blunt plasticity of scenographic spaces: under the sea or up in space, beneath the city, or surrounded by a forest, or deep in the Arctic, all built within an indoor tented structure, or 'pod'. Children visit the 'pod' for 45 minutes or so in small groups of up to four children once a week for ten weeks. They experience each environment twice, and respond to a world peopled with masked characters and puppets, filled with light, sound and sensory elements, and are a participatory 'audience' to a performance couched firmly within a contemporary performance model rather than drama therapy. This means for example that each environment uses a loose and iterative narrative and there is no attempt to sustain the 'as if' rigorously or consistently (children are free to enter and exit if they wish; performers' costumes can be borrowed, tried on, disgarded). The performance is much closer to continuous play. Facilitators (in and out of costume) try to follow the children's cues, respond in the moment, and not lead the action unnecessarily. They also use 'sabotage' techniques to prompt the children away from 'stimming' or obsessive behaviours (for example, sitting on a trampoline so the child cannot use it and has to find a strategy to do so or has to do something else); sabotage can also prompt the children to take control of the piece (a sudden catastrophe such as an Arctic storm may cause the performers all to freeze …). Many of the objects encountered by the children are integral to and meaningful within that environment and include puppets (for example a glove puppet woodpecker, a 'Bunraku' style Alien), material textures (leaves, paper snow), 3D props of all sizes (a dinghy, a treasure box, a tree), UV sensitive puppets; and costumes (Foxy, the Snowman). There are also virtual 'objects' such as live feed, images and projections, which are not the focus here, but which add crucially to the environment's immersive qualities (for example, on a boat ride before the storm hits and the boat is 'wrecked', there are projections of seagulls, waves and dolphins and, as the children 'swim' underwater, mermaids under the sea). Importantly, various objects act as 'loose elements' and are more fluid and open to interpretation- tubes of various sizes, cloth, bubble wrap and microphones. Aware of controversy over embodied approaches not only within cognitive neuroscience[7] and the related fields of distributed cognition, ecological psychology and autism studies, Imagining Autism offers a performance perspective originating from outside these disciplines. The account offered here is founded on the practice of 'doing' alongside autistic children: facilitating, performing, puppeteering, observing. Some of these children are, I believe, enabled to make their own 'acts of meaning'[8] through using objects, as simultaneously

they partake in, and help to shape, albeit in a tiny way, the culture from which the objects emerged.

Objects and their handling have featured very little in cognitive science, even in the relatively new embodied approaches to the discipline pioneered by Francisco Varela *et al.*[9] Cognitive linguistic studies of the way we think, notably Fauconnier and Turner's work on conceptual blending,[10] have in the words of Chris Sinha, 'largely preserved the traditionally mentalist and individualist assumptions of classical cognitive science' excluding the 'socially collaborative, culturally and materially grounded nature of the human mind'.[11] In psychology, objects do feature, notably in the theories of Piaget and Vygotsky.[12] But as Rodriguez and Moro point out, even in current research around objects and cognitive development

> babies are frequently situated in a context (usually the laboratory) on their own, their (active) *actions* on the world are neglected in favour of their (passive) *reactions* to the stimuli presented to them ... In such contexts the child becomes 'a big solitary looking eye' who *does not transform* anything in the world but only *reacts* on his own towards what is being presented. [13]

Piaget of course placed great importance on interaction with objects for sensory-motor and conceptual development but as Chris Sinha points out, the object in Piaget's essentialist world is a 'curiously abstract thing, lacking semiotic and fictional value, any object being substitutable for any other object'. The object becomes 'an Object with a capital, a ground for, but not a vehicle of, meaning and value'.[14] On the contrary, it is the specificity of each object, rather than 'an Object with a capital', that brings about, in Bruner's phrase, an 'act of meaning': objects are vehicles of meaning, they are 'objects in a storied world'.[15]

Objects as 'vehicles' of meaning feature strongly in distributed cognition, which provides a suitable but rather too sophisticated model for the phenomenon I am examining. Distributed (also called extended) cognition describes how our mind 'extends' into the environment, particularly objects, in order to think.[16] Edward Hutchins for example describes how complex tasks are achieved in navigation by a team using instruments.[17] The team who are working together (in Hutchins case, sailing a large ship up a canal) think together by drawing continually on information read from their shared instruments. This is distributed cognition – when mind can be described as feeding off, partially contained by, and manifesting itself in objects within the environment.[18] In regard to *Imagining Autism*, the complexity of Hutchins's distributed cognition does not manifest itself except at the most sophisticated level of group play.[19] More commonly, individual participants

display their own singular and solitary use of objects, and only gradually enter into tentative intersubjective encounters. I want therefore to focus on situated cognition[20] at what might be termed a more basic developmental level than the full-blown distributed cognition that Hutchins describes, and I shall do so by way of folk psychology.[21]

Folk psychology 'is the term of art [sic] for dealings between people in which the objects dealt in are subjective. These subjective mental objects are beliefs, desires and in their most developmentally advanced level, conjunctions of beliefs and desires.[22] Bruner describes folk psychology ('common sense') as a 'set of more or less connected, more or less normative descriptions about how human beings "tick", what our own and other minds are like, what one can expect situated action to be like, what are possible modes of life, how one commits oneself to them ... a system by which people organize their experience in, knowledge about, and transactions with the social world.[23] Sinha gives a clear example of the way the neurotypical draws on folk psychology to explain to themselves why a friend might rush past on a station platform without a greeting or invitation for coffee, attributing it 'to his desire to catch the next train coupled with his belief that the next train is about to depart.[24] The crucial point is that access to folk knowledge is commonly learnt via concrete objects we encounter: the 'norm' emerges from continual interaction with 'objects in a storied world' and that resulting actions and understandings do not depend on us 'reasoning it out' in each and every instance, but on us embodying this knowledge.[25] Objects are in the first instance encountered as children without knowledge of their embedding in social and cultural contexts[26] but such knowledge clings to objects because of the way we handle and use them, and gradually this knowledge is acquired by (neurotypical) children. The problem is of course that this 'storied' world, where objects are steeped in meanings, seems to pass autistic people by.

James Gibson, a self-described ecological psychologist, is best known for his embodied approach to the mind, insisting on the development of the mind through the body and the environment it interacts with. Gibson's notion of 'affordances' however relates to the bare physical properties of objects.[27] 'The affordances of the environment are what it offers the animal, what it provides or furnishes, either for good or ill.[28] Objects have, in the words of Michael Tomasello,[29] Gibsonian 'natural' or sensory-motor affordances that 'offer themselves up' to the body, and it is these sorts of affordances that Gibson described: the animal (or human) acts on affordances within what Gibson dubs their 'niche' in the world, so that they shape their niche and their niche shapes them.[30] This is indeed one feature of objects within the environment of Imagining Autism. For example soft bubble wrap is 'rollable upon', a hard stick is 'graspable', loose paper pieces are 'throwable'.

However affordances, both in the pod, and of course in the world outside it, can be and are more than simple sensory-motor opportunities, and link intimately to folk psychology. Such richer affordances can be dubbed, after Tomasello, 'intentional'.[31] Intentional affordances are offered by objects when they are embedded within folk psychology, socialising and enculturing the child in their play and early interactions with their carers. It is the transition from and interplay between natural and intentional affordances that characterises some of the most interesting object play in Imagining Autism'.[32]

Our first object of interest is a costume, and one that, within its context of the Forest, is, for the neurotypical, one rich with 'folk' meanings- Foxy: chicken stealer, perhaps, or the wily escaper, but here an imposing 'lady' fox, someone perhaps to be wary of, tall, with the beautiful red hair and sweeping brush tail. The costume consists of a ginger coloured long sleeved coat, that is trimmed with fur, closed at the front by a simple tie, and whose full length 'skirt' is very heavily padded from the hips down. At the back hangs a long, trailing, furry, ginger tail. The imposing fox full head mask sits on the top of the head of the wearer with a cloth hanging down to conceal the face beneath it, with a hole to see out of. To wear this costume is a haptically strong experience, because it is weighty and warm, and swings around the lower half of the body, and the tail can be 'swished' by the wearer, or left to trail behind. The figure is very tall and imposing. The sequence I want to study is an 11-year-old severely autistic child, Mary, being 'enfranchised' into our common folk psychology by means of the costume. The sequence I describe illustrates her turning from grabbing the 'natural' affordances of this 'object' in an essentially sensory-motor driven way, into grasping more intentional affordances. This indicates, I argue, her entry into aspects of the folk psychology of the character, 'Foxy'. Mary has very limited communication skills (e.g. speech) at this point in the project.

Mary's encounter with the Fox/costume builds up in stages.[33] She enters the Forest at the start of the session, sees the 'sunlight', leaves, trees; and hears the bird song. She begins to explore tentatively, for example accepting the invitation to pick up the dry leaves and feel their texture, rubbing them between her hands. Foxy enters after a few minutes.

1. Mary watches her move; then Foxy begins to dance to the guitar music. As Foxy turns to and fro, Mary notices the long tail and at once goes behind Foxy to pick it up, and trails it through her fingers, pulls it, and she realises it is attached to the Fox. She clings hold of it as she crosses round to face the front of Foxy.
2. Mary is wearing the ranger's hat. She takes this off and stares at the performer standing with her mask in her hand; Mary takes the mask

from her, stares intently at it, but does not put it on. 'Do you want to wear my coat?' invites the performer, taking off the coat. Mary hands back the mask and puts on the coat, visibly hitching it around her shoulders and her hips. As she walks off she ties the front (tying bows is one of her favourite obsessions).

3. Mary keeps the coat while she engages in various other activities, such as approaching the mole puppet and tweaking its nose. She takes the coat on and off several times, and during this period Mary often wears the mask at a crazy angle on her head with the front cloth (hanging down with a viewing hole) thrown back up and over it, while she explores the forest, not interacting with anyone else.

4. Mary stands with the Fox coat on staring at the performer who at this moment has Fox head on; the performer begins to dance in front of her. Mary begins to follow the moves of the masked performer, picking up energy and speed, swinging the skirt of her costume; she reaches down and lifts her long tail, laughing, and swishing it; the performer, very tall in the fox mask (in orange trousers and T shirt) wiggles her hips, and Mary laughs.

5. Mary, having now taken the costume off, notices her shadow in front of her on the walls of the pod; she begins to dance, wiggling her hips, and watching her own shadow.

I believe what we are witnessing here is Mary developing from grasping the natural affordances of for example the dry leaves, and the long trailing tail that caught her eye, into a deeper cognitive engagement with the costume. I suggest this happens because she 'handles' the costume and it in turn 'handles' her, as she warms to the distinctive haptic properties of both coat and mask. She appears to realise there is a connection between the hat (the ranger's hat she initially wears in 2) and the head mask that she similarly 'plonks' on her head (in 3), but she has little comprehension at first it would seem (or she doesn't care) that she is wearing a (potentially visually transformative) fox's head and not simply a hat (she throws the cloth up and covers it so that she can see freely). She seems however to notice and enjoy its height and weight. Similarly the fox coat is primarily a coat, warm and heavy perhaps but not yet a costume. Gradually however the weight and swing of the coat seem to affect her so that she starts to dance with the masked 'fox' she sees (and has seen dancing in the costume) even to the point of swishing the heavy tail as part of her dance. The costume accentuates the hips for the wearer (as well as the viewer), and Mary laughs when she sees the masked performer wiggle her hips. Later when watching a shadow of her own (now uncostumed) body she appears to remember this and dances, and crucially

imagines dancing as fox, by moving her hips. The repetition of the hip movement seems to indicate that she has taken meaning from that other person in order to understand herself better.

The fact that 'objects' (foxes, hats and dances) are inflected towards shared meanings within society and culture stems from, what is, according to Tomasello, a single cognitive ability that is unique to humans: our ability to understand that others ('conspecifics'[34]) think and feel as we do, otherwise known as Theory of Mind or mindreading.[35] Linked to this is the intersubjectivity between humans that enables cognitive development.[36] 'Theory of Mind', however this is understood, either as a cognitive ability that appears around four years old (Baron Cohen)[37] or as an ability that gradually develops from birth (Gallagher),[38] prompts the making of artefacts to pass on cultural beliefs, and theory of mind is what enables us to 'read' such artefacts. On a more mundane level, articles of clothing for example are imbued with meaning, from the simple fact that hats are worn to more complex instances such as a character costume; and we see in Mary's encounter with Foxy how intersubjectivity enables folk knowledge to be learnt, and natural affordances develop into 'intentional' affordances.

The contribution made by the physical makeup of the costume is significant. Its shape and heavy padding as well as the height and weight of the mask all contribute to Mary's 'affect' here. Olga Bogashina has written on autistic peoples' very different way of sensing the world- both hyper (over) sensitive and hypo (under) sensitive.[39] If we accept the embodied model of cognition, then sensory difficulties are fundamental cognitive issues, impacting on emotion, empathy, imagination- all associated with the triad of impairments in autism. This is because the mind is formed literally by being 'in touch' with the world.[40] From our earliest moments we cannot see until we have felt the contours, textures, edges, corners and surfaces of the world around us – then, for example, we learn to see, as the mind can form an image from the once random patterns of light rays that enter the eye, by using the body/brain memory of feeling, touching, literally rubbing against the world.

From touch, from movement, from interaction with the world and embodying it, we learn to think and function. We lay down the patterns of thought through our physical engagement and experience. Understanding is felt through 'primary metaphors': warmth is affection, big is important.[41] Lakoff and Johnson's theorising is deeply relevant to autistic children: difficulties in learning to think, and hence to embody the world, hamper the development of meaningful speech, empathy, abstract thinking and imagination. One criticism however that has been consistently levelled at both Lakoff and Johnson's seminal study and James Gibson's notion of

affordances is the curiously 'sterile' nature of their descriptions of physical interaction with the world. What is consistently missing is the social and cultural dimension of these encounters, which Chris Sinha and others attempt to analyse, and which characterises Mary's embodiment of the Fox.[42] Failure to access this vast dimension of human experience is exactly what disenfranchises autistic children from participation in our world. It seems it unfolds alongside the embodiment Lakoff and Johnson (and Gibson) describe, and the learning is fused into an experience that cannot be disentangled or separated into distinct divisions between folk knowledge and embodiment.

With this in mind, I would like now to turn to Joseph and his encounters with two objects – one a metal dustbin; and the other an old vacuum cleaner tube. The objects are in the 'Under the City' environment, which the children encounter when the 'school service lift' goes wrong, descends, and gets stuck in an unknown place full of clunking water pipes and rubbish, home to two friendly rats. One rat is an old and well used glove puppet- a manufactured puppet based on a popular TV character in the 1980s – Roland Rat, whose operator (and 'voice') is fully visible; and the other a masked character, Ratty. Joseph has limited speech, and tends to be very quiet compared with his three noisy companions on this trip; he also can be very rough.[43] Two metal dustbins with lids stand next to two bottomless garden waste bins on their sides, used as tunnels. Joseph, John, Henry and Lizzie are playing in this session. There has just been a 'gas scare' where chemicals have supposedly been released into the atmosphere.

> [Joseph crouches down in a metal dustbin]
> **Joseph:** John! [says something indistinct][Ratty puts the dustbin lid on]
> **John:** Joseph! It's horrible in that bin! It could kill you! Joseph's dead!
> **Roland Rat:** Hey steady on! He's only in my bin! [Lid is removed] It's a wonderful abode is that bin! Look! There's modern lighting in there! [pointing at the torch]
> [Joseph stands up as the lid is removed by practitioner. He looks at first confused then he smiles, looks at John and immediately lowers himself into the bin again and the lid is replaced]
> **John:** No!
> **Practitioner 1:** Roland, does it protect you from the chemicals?
> **Practitioner 2:** One, two, three [lifts lid again]
> **Roland Rat:** It certainly does … You're protected from the chemicals in there!
> **Joseph:** See John! You're protected!

John: I smell something! Urgh! [John 'passes out' on the floor. Joseph is standing up in the bin smiling]

Practitioner 1: Guys! John's been affected by the gases!

Joseph: Close me!

Practitioner 1: [meaning John] He's passed out!

Joseph [tries to reach down for the lid on the floor] Make me in the bin shut! [John is 'resuscitated']

Roland: You all right in there Joseph?

Henry: Can I do the bin like Joseph?

Practitioner 1: There's a bin for each of you now [pointing to the upended garden waste bins]. You get in the bin as well? [to Henry who gets in the tube bin]

John: I'd love a bin! That could fit for me! [pointing to Henry's bin]

[John gets in a bin too, next to Joseph]

Joseph: [to John] You can have that!

[Joseph sees Henry has got his bin lid on his garden waste bin and reaches over and takes it back]

Roland: I'll make a killing on the rent [takes lid from Joseph]

[Joseph is smiling, looking up in anticipation, and watching as the bin lid descends slowly down on him]

Roland: Joseph! It takes all sorts! Do you want the roof on there Joseph?

[Joseph gets up again and the action follows in similar vein, Joseph is up and down, and even in and out of the bin: then Ratty collapses with the 'gases]

Practitioner 1: How can we make the Rat better?

Joseph: Get the Rat in the box!

In this extract there are several cognitive shifts that the object (the bin) facilitates. Joseph is in effect empowered by getting inside the bin and not wanting to move. John is a very domineering (if endearing) child, whose attitude to shared play is characterised by his later shouted comment: 'Rule number one! Always listen to John'. Joseph seemed to enjoy the close contact of the bin sides, and the lid continually descending and plunging him into darkness. The bin moreover was metal and heavy (so he did not feel it would tip over but was safe), and the lid fitted snugly, making a satisfying noise as it did so. Joseph got in the bin presumably because he took the natural affordance offered by the container, though we cannot know whether he had in fact already formulated the idea of it being a protective place. Even if this were so, it seems that the interaction with John and the others led him into grasping and developing the possible *intentional* affordances of this object

(intentional in that particular imagined situation). Joseph says: 'See John! You're protected!' and from then on, everything goes Joseph's way, even to the extent of other children wanting to imitate him ('Can I do the bin like Joseph?'). John's dramatic attempt to take control again by passing out in the gas is an unsuccessful ploy to place control back on him, but John himself admits defeat by asking for a bin like Joseph has ('I'd love a bin! That could fit for me!'). Joseph is in the unusual position (for him) of being leader of the action in a play situation. In doing so, he develops his intersubjective skills and, I suggest, (as with Mary) a simple physical, haptic experience is transformed into an 'act of meaning' in Jerome Bruner's sense.

The second object that served Joseph particularly well in this environment is an old vacuum cleaner tube, which he picked up after abandoning his bin.[44]

Roland Rat: Have a sniff!

[Joseph sniffs the end of tube. Joseph then pokes Roland with the
 end of the tube. Roland coughs. Joseph pokes the puppeteer
 momentarily then goes on poking at Roland, who is coughing, and
 both are getting more intense]

Roland: Stinks something horrible!

[a few seconds later, puppeteer/Roland moves to avoid the poking and
 has picked up the other end of the tube. To distract Joseph, Roland
 blows long and hard, loudly and rudely into his end. Joseph moves
 forward with his end to Roland, inviting him to blow in it. Roland
 does so and then has a coughing fit. Joseph is smiling broadly].

Roland: [into his own end of the tube] Helloooooooo! [into the tube]
 You hoo! Hello there! Hello there!

[Joseph puts his end of the tube to his mouth, then his eye, then his
 mouth, and finally his ear, and listens]

Joseph: Are you going to say AAAAH? What, what, what are you
 saying?

Roland: [into his end of the tube] I am Roland Rat.

Joseph: [tube to his mouth] I am Roland Rat!

Roland: [reacts exaggeratedly to this as if it was far too loud] Aaaargh!
 Go on, try again.

Joseph: (puts tube to his ear and shouts] I am Roland RAAAT!

Roland: Aaaaaargh! [Joseph laughs then shouts into the tube]

Joseph: Aaaaargh!

Roland: Help! ...

Joseph: You naughty rat ...

[Joseph has tube to his ear but leans forward to speak to puppeteer,
 making eye contact with her]

Joseph: And you're a ratty see ... rat! [Joseph shoves his end of the tube quite roughly towards the puppeteer's mouth]
Roland: I am a naughty rat! Oh! [in surprise as the tube is shoved to her mouth not the puppet. Joseph at once swops the tube to Roland's mouth and puts his hand on Roland, inviting him to speak]
Roland: Are you a naughty Joseph?
Joseph: No! [Joseph then growls into the tube]
Roland: Aaaaagh! [Joseph laughs and does it again; and again ...]

In this exchange Joseph moves from the simple affordance of picking up a tube, to the limited intentional affordance of using the tube as a tool that 'stinks' (a weapon) to attack Roland, then into more sophisticated intentional affordances of the object, involving an intersubjective exchange with a 'conspecific' (to use Sinha's term). This exchange develops from or is facilitated by the tube being hollow and having two identical ends that can act as both 'receiver' and 'transmitter'. Joseph gradually accommodates to this (see his confusion at first over putting the tube to his mouth, eye, mouth then ear) then uses it quite forcefully to tease Roland. Although the humour is basic clowning and the empathy therefore perhaps limited, Joseph enriches his encounter with this object (and the folk psychology around loud intrusive noises) by initially picking up on the meaning that the puppeteer places on it; then he himself imbues it with his own 'meanings', as the puppeteer helps him to think by means of the object. Interestingly, at one point Joseph makes it clear he realises the puppet itself is an inanimate object when he lurches across to the puppeteer herself ('And you're a ratty see ... rat!'), but he quickly reverts to giving the tube to the puppet. He is clearly enjoying developing the intentional affordances of the tube in this fantasy situation, and perhaps he realises that this 'affordance' (using it to make direct contact with the puppeteer) does not help him as much as involving the puppet.

Both the episodes transcribed here – Mary with her fox costume, and Joseph in his bin and wielding his talking tube – have been chosen because the children showed markedly different behaviour to what had previously been seen. The different levels of empathy and imagination achieved in these short encounters were of a different quality to previous encounters, and it is this that prompted the attempt to analyse exactly what might have been happening to the thought process of these children; and it seems obvious that in all instances, amongst other innumerable possible factors which I have not attempted to speculate on, or identify (for example, the mood of the children, other events that day, other elements of the immersive pod environment, rapport with particular performers) objects played a crucial

role. These objects were haptically distinct and worked their way into the embodied consciousness of each child; but this was so much more than a motor sensory experience. An 'act of meaning' emerged for these children from the mutual 'handling' of these objects by others, who became 'conspecifics' in Sinha's sense: it might be claimed that these children, if only briefly, demonstrated theory of mind, learning to 'mind read' the other. They became aware of the shared cultural and social embeddedness of these objects, in a mutual flow, however brief, where individual consciousness and the extended mind become impossible to distinguish.

Figure 8 An object and an act of meaning: Joseph (right) listens to Roland Rat (left)

Notes

General Introduction

1 Nicola Triscott, 'Performative Science in an Age of Specialization: The Case of Critical Art Ensemble' in *Interfaces of Performance*, Maria Chatzichristodoulou, Janis Jefferies and Rachel Zerihan (eds), Surrey: Ashgate, 2008, pp. 153–66.

2 Honour Bayes, 'Stage Chemistry, the marriage of science and theatre is still going strong', http://www.Guardian.c.uk/stage/theatreblog/2011/mar/09/stage-checmistry-marriage-science-theatre (accessed 20 January 2013).

3 See http://www/reckless-sleepers.co.uk (accessed 15 December 2012)

4 See Albert Einstein, Boris Podolsky, Nathan Rosen, 'Can Quantum-Mechanical Description of Physical Reality be Considered Complete?' *Physical Review*, Vol. 47, No. 10, (1935), pp. 777–80.

5 Erwin Schrödinger, 'Die gegenwärtige Situation in der Quantenmechanik', *Die Naturwissenschaften*, 23 (1935), pp. 807–12, 824–8, 44–9. Translation from Arthur Fine, *The Shaky Game: Einstein, Realism and the Quantum Theory*, Chicago: University of Chicago Press, 1986, p. 65; excepting last two sentences.

6 Andrew Brown and Mole Wetherell, *Trial: A Study of the Devising Process in Reckless Sleepers' Schrödinger's Box*, Plymouth: University of Plymouth Press, 2007, p. 12.

7 http://www.sciencecouncil.org (accessed 20 January 2013).

8 Brown and Wetherell, *op. cit.*, p. 14.

9 *Ibid.*

10 *Ibid.*, p. 8.

11 http://www/reckless-sleepers.co.uk (accessed 15 December 2012).

12 See Brown and Wetherell, *op. cit.*

13 Georg Goldenberg, 'How the Mind Moves the Body: Lessons From Apraxia' in *Oxford Handbook of Human Action*, Ezequiel Morsella, John A. Bargh, Peter M. Gollwitzer (eds), Oxford: Oxford University Press, 2008.

14 Rafael Núñez, 'On the Science of Embodied Cognition in the 2010s: Research Questions, Appropriate Reductionism, and Testable Explanations' *Journal of the Learning Sciences*, Vol. 21, No. 2 (2011), 324–36. See also Howard Gardner, *The Mind's New Science: A History of the Cognitive Revolution*, New York: Basic Books, 1987.

15 See George A. Miller, 'The Cognitive Revolution: a Historical Perspective', *Trends in Cognitive Sciences*, Vol. 7, No. 3, (2003), pp. 141–4.

16 See, for example, Antonio Damasio, *The Feeling of What Happens: Body, Emotion and the Making of Consciousness*, London: Vintage, 2000.

17 See George Lakoff and Mark Johnson, *Metaphors We Live By*, Chicago:
 Chicago University Press, 1980 and *Philosophy in the Flesh: The Embodied
 Mind and its Challenge to Western Thought*, New York: Basic Books, 1999.

18 See Evelyn Tribble and John Sutton's Introduction, this volume, for a
 summary of the critique of Lakoff and Johnson.

19 Gilles Fauconnier and Mark Turner, *The Way We Think: Conceptual
 Blending and the Mind's Hidden Complexities*, New York: Perseus Books,
 2002.

20 Lawrence Shapiro, *Embodied Cognition*, London and New York: Routledge,
 2011, p. 68.

21 Francisco J. Varela, Evan Thompson and Elanor Rosch, *The Embodied
 Mind: Cognitive Science and Human Experience*, Cambridge, MA: MIT
 Press, 1993.

22 See Andy Clark's chapter 'Embodied, embedded and extended cognition'
 in Keith Frankish and William M. Ramsey (eds), *The Cambridge
 Handbook of Cognitive Science*, Cambridge: Cambridge University Press,
 2012. See also *Supersizing the Mind: Embodiment, Action and Cognitive
 Extension*, Oxford: Oxford University Press, 2008.

23 Shapiro, *op. cit.*, p. 68.

24 For further discussion of theory and philosophy of mind, see Shaun
 Gallagher's work, e.g. *How the Body Shapes the Mind*, Oxford: Oxford
 University Press, 2005; *Brainstorming: Views and Interviews on the Mind*,
 Exeter and Charlottesville: Imprint Academic, 2008.

25 http://www.royalsociety.org (accessed 30 December 2012)

26 Honour Bayes, *op. cit.*, (accessed 22 January 2013)

27 Lynne Gardner, http://www.guardian.co.uk/stage/theatreblog/2010/jul/26/
 science-plays-stoppard (accessed 21 January 2013).

28 Jeremy Kareken, *Sweet, Sweet, Motherhood* written in collaboration with
 Lee M. Silver, 2010.

29 See www.snoowilson.co.uk for script and reviews of *Lovesong of the
 Electric Bear*, 2010 (accessed 10 November 2012).

30 *Ibid.*

31 Kirsten Shepherd Barr, *Science on Stage, From Dr Faustus to Copenhagen*,
 New Jersey: Princeton University Press, 2006, p. 4

32 *Ibid.*, p. 4.

33 *Ibid.*, p. 5.

34 *Ibid.*

35 Paul Johnson, *Quantum Theatre*, Newcastle: Cambridge Scholars
 Publishing, 2012, p. 181.

36 Bruce McConachie and Elizabeth Hart (eds), *Performance and Cognition:
 Theatre Studies and the Cognitive Turn*, London and New York: Routledge,
 2006, p. 1

37 Edwin Hutchins, *Cognition in the Wild*, Massachusetts: Bradford Books,
 MIT Press, 1996.

38 Peter Meineck, 'The neuroscience of the tragic mask', *Arion, Journal of the Humanities and Classics*, Vol. 19, No. 1, University of Boston, 2011, pp. 113–58.

39 See Jill Stevenson, *Performance, Cognitive Theory, and Devotional Culture: Sensual Piety in Late Medieval York*, New York: Palgrave, 2010.

40 Evelyn B. Tribble, *Cognition in the Globe: Attention and Memory in Shakespeare's Theatre*, New York: Palgrave, 2011.

41 Mary Thomas Crane, *Shakespeare's Brain: Reading with Cognitive Theory*, New York, 2001.

42 Naomi Rokotnitz, *Trusting Performance: A Cognitive Approach to Embodiment in Drama*, New York: Palgrave, 2011.

43 Teemu Paavoleinen, *Theatre/Ecology/Cognition: Theorizing Performer-Object Interaction in Grotowski, Kantor and Meyerhold*, New York: Palgrave, 2012.

44 Rhonda Blair, *The Actor, Image and Action*, London and New York: Routledge, 2007.

45 John Lutterbie, *Toward a General Theory of Acting*, New York: Palgrave, 2012.

46 Bruce McConachie, *Engaging Audiences: A Cognitive Approach to Spectating in the Theatre*, New York: Palgrave, 2011.

47 Stephen Di Benedetto, *The Provocation of the Senses in Contemporary Theatre*, London and New York: Routledge, 2010.

48 See Nicola Shaughnessy, *Applying Performance: Live Art, Socially Engaged Theatre and Affective Practice*, Basingstoke: Palgrave, 2012.

49 Angus Fletcher, *Evolving Hamlet: Seventeenth-Century English Tragedy and the Ethics of Natural Selection*, New York: Palgrave, 2011.

50 Philip Barnard, 'Bridging Art and Science, Little Pictures and Bigger Ones', University of Kent, (27 March 2013) and personal correspondence with the author.

51 Barnard, for example, expresses concern about the use of mirror neuron theory in dance research and the tendency to overlook the complexities of the neural systems involved; thus in language tasks, the visual cortex is 'banging away' while in lip reading, the acoustic cortex is activated.

52 W. B. Worthen, ' "The written troubles of the brain": Sleep No More and the Space of Character', *Theatre Journal*, Vol. 64, No. 1, (2012), pp. 79–97

53 *Ibid.*, p. 96.

54 *Ibid.*, p. 94.

55 *Ibid.*, p. 94.

56 *Ibid.*, p. 82.

57 *Ibid.*, p. 89.

58 *Ibid.*, p. 91.

59 Raymond Tallis, *Aping Mankind: Neuromania, Darwinitis and the Misrepresentation of Humanity*, Durham: Acumen Publishing, 2011.

60 Alva Noe, *Out of Our Heads: Why You Are Not Your Brain, and Other Lessons from the Biology of Consciousness*, New York: Hill and Wang, 2009.

61 Thomas Bacon, review of Reckless Sleepers 'Schrödinger', 4 November
 2011, http://totaltheatrereview.com/reviews/schr%C3%B6dinger (accessed
 11 December 2012).

62 Paul Johnson, after show discussion, Gulbenkian Theatre, University of
 Kent, 15 February 2013.

63 Mole Wetherell, *Trial, op. cit.*, 7.

64 Liz Moran, email to author, 5 February 2013.

65 *Ibid.*, p. 6.

66 Ian Marshall and Danah Zohar, *Who's Afraid of Schrödinger's Cat? The
 New Science Revealed: Quantum Theory, Relativity, Chaos and the New
 Cosmology*, London: Bloomsbury, 1997, p. 319, cited in Wetherell, *op. cit.*,
 p. 44.

67 Wetherell, *op. cit.*, p. 57.

68 *Ibid.*, p. 30.

69 *Ibid.*, p. 18.

70 *Ibid.*, p. 67.

71 *Ibid.*, p. 72.

72 Johnson, *op. cit.*, pp. 6–7.

73 David Harvey, *The Condition of Postmodernity*, London: Blackwell, 1991,
 cited in Johnson, *ibid.*, p. 7.

74 *Ibid.*

75 Wetherell, *op. cit.*, p. 75.

76 Gallagher, *How the Body Shapes the Mind.*

77 Wetherell, *op. cit.*, p. 1.

78 Pil Hansen and Bruce Barton, 'Research-Based Practice: situating *Vertical
 City* between Artistic Development and Applied Cognitive Science', *TDR:
 The Drama Review*, Vol. 53, No. 4 (2009) pp. 120–36

79 *Ibid.*, p. 122

80 Philip Barnard, 'Creativity, Bridging and Conceptualization', https://blogs.
 montclair.edu/creativeresearch/2011/04/19/creativity-and-bridging-by-
 philip-barnard-and-scott-delahunta/ (accessed 28 March 2013).

81 Philip Barnard, 'Bridging Art and Science'.

82 Jon May, Beatris Calvo-Merino, Scott Delahunta, Wayne McGregor,
 Rhodri Cusack, Adrian Owen, Michelle Veldsman, Cristina Ramponi and
 Philip Barnard, 'Points in Mental Space: An Interdisciplinary Study of
 Imagery in Movement Creation', *Dance Research*, Vol. 29, No. 2 (2011), pp.
 402–30, 404.

83 See Scott Delahunta, Gill Clark and Phil Barnard, 'A Conversation About
 Choreographic Thinking Tools', *Journal of Dance and Somatic Practice*, Vol.
 3, No. 2 (2012), pp. 243–59; Philip Barnard 'Bridging between basic theory
 and clinical practice', *Behaviour Research and Therapy*, Vol. 42 (2004), pp.
 977–1000.

84 Hanson and Barton, *op. cit.*, p. 121.

85 Philip Barnard, 'Creativity, Bridging and Conceptualization', https://blogs.

montclair.edu/creativeresearch/2011/04/19/creativity-and-bridging-by-philip-barnard-and-scott-delahunta/ (accessed 28 March 2013).

86　Jon May *et al.*, *op. cit.*, p. 404

87　Barnard describes his research focus as being 'executive control and emotional meaning' in interacting cognitive subsystems. His bridging schemas have been adapted and applied to a range of psychopathologies to develop understanding of the cognitive-affective mechanisms underpinning a range of conditions (e.g. anxiety, depression, schisophrenia, dementia, anorexia) and the implications for intervention. See http://www.mrc-cbu.cam.ac.uk/people/phil.barnard/

88　Philip Barnard, 'Bridging Art and Science', *op. cit.*

89　See Scott Delahunta et al., *op.cit.*

90　Catherine Loveday with Shona Illingworth, 'Memory, Identity, Performance and Neuroscience', University of Kent, 1 March 2013. Neurospychologist Catherine Loveday discussed her Wellcome Trust funded collaboration with film and sound artist, Shona Illingworth and cognitive neuropsychologist Martin A. Conway. Claire is a woman who has dense retrograde and anterograde amnesia. The project explores new biomedical insight into Claire's condition, gained through research into her use of new sensory operated camera technology to unlock previously inaccessible memories. In parallel, the historical lesions in the physical and cultural landscape of St Kilda, an extraordinary archipelago located off the west coast of Scotland, provide a physical and metaphorical context within which to explore the self-experience of broken memory and dense cultural retrograde amnesia. Illingworth and Loveday discussed how, by creating a multi-layered interplay between Claire and St Kilda, this project sets out to explore powerful synergies between the complex space of the mind, and that of the outside world, and in turn, examined the profound implications amnesia and cultural erasure have on the individual, social and cultural topologies that inform contemporary constructions of identity, place and location.

Introduction

1　Sabine Gehm, PirkkoHusemann and Katharina von Wilcke, *Knowledge in Motion: Perspectives of Artistic and Scientific Research in Dance*, Bielefied: Transcript Verlag, 2007; Jonathan Cole and Barbara Montero, 'Affective Proprioception', *Janus Head*, Vol. 9, No. 2 (2007), pp. 299–317; Dorothée Legrand and Susanne Ravn, 'Perceiving Subjectivity in Bodily Movement: The Case of Dancers', *Phenomenology and the Cognitive Sciences 8* (2009), pp. 389–408; Maxine Sheets-Johnstone, *The Corporeal Turn: An Interdisciplinary Reader*, Exeter: Imprint Academic, 2009; Greg Downey, 'Practice without Theory: A Neuroanthropological Perspective on

Embodied Learning', *Journal of the Royal Anthropological Institute*, Vol. 16 (2010), pp. S22–S40; Lisa Zunshine, *Introduction to Cognitive Cultural Studies*, Baltimore: Johns Hopkins University Press, 2010.

2 David Cressy, 'Foucault, Stone, Shakespeare and Social History', *English Literary Renaissance*, Vol. 21, No. 2 (1991), p. 121.

3 John Sutton, 'Moving and Thinking Together in Dance', in Robin Grove, Kate Stevens and Shirley McKechnie (eds), *Thinking in Four Dimensions: Creativity and Cognition in Contemporary Dance*, Carlton; Victoria: Melbourne University Press, 2005, p. 59.

4 Evelyn Tribble and John Sutton, 'Cognitive Ecology as a Framework for Shakespearean Studies', *Shakespeare Studies*, Vol. 39 (2011), p. 94.

5 Yvonne Rogers, Mike Scaife, and Antonio Rizzo, 'Interdisciplinarity: An Emergent or Engineered Process?', *Cognitive Science Research Paper 555* (2003); Margaret A. Boden, *Mind as Machine*, Oxford: Oxford University Press, 2006.

6 William Bechtel and George Graham, *A Companion to Cognitive Science*, Oxford: Wiley-Blackwell, 1999; Robert A. Wilson and Frank C. Keil, *The Encyclopedia of the Cognitive Sciences*, Cambridge, MA: MIT University Press, 2001.

7 Zenon W. Pylyshyn, *Computation and Cognition*, Cambridge, MA: MIT University Press, 1986; Jerry A. Fodor, *Psychosemantics*, Cambridge, MA: MIT University Press 1989; Jack Copeland, *Artificial Intelligence*, Malden, MA: Wiley-Blackwell, 1993.

8 Tim Crane, *The Mechanical Mind*, New York: Psychology Press, 2003; Steven Pinker, *How the Mind Works*, Harmondsworth: Penguin, 2003.

9 Francisco J. Varela, Evan Thompson and Eleanor Rosch, *The Embodied Mind: Cognitive Science and Human Experience*, Cambridge, MA: MIT University Press, 1991; Edwin Hutchins, *Cognition in the Wild*, Cambridge, MA: MIT University Press, 1995; Andy Clark, *Being There: Putting Brain, Body, and World Together Again*, Cambridge, MA: MIT University Press, 1997.

10 N. J. Enfield and Stephen C. Levinson, *Roots of Human Sociality: Culture, Cognition and Interaction*, New York: Berg, 2006; Andy Clark, *Supersizing the Mind: Embodiment, Action, and Cognitive Extension*, Oxford: Oxford University Press, 2008; Giovanna Colombetti, *The Feeling Body: Affective Science Meets the Enactive Mind*, Cambridge, MA: MIT University Press, 2013; J. Stewart, O. Gapenne and E. A. Di Paolo, *Enaction: Toward a New Paradigm for Cognitive Science*, Cambridge, MA: MIT University Press, 2010.

11 John G. Gunnell, 'Are We Losing Our Minds: Cognitive Science and the Study of Politics', *Political Theory*, Vol. 35, No. 6 (2007), p. 711.

12 Modularity is predominantly associated with Jerry Fodor's *The Modularity of Mind* (Cambridge: MIT University Press, 1983), which actually puts forward a rather limited case for modularity; the argument for so-called

'massive modularity' was put by Peter Carruthers, *The Architecture of the Mind*, Oxford: Oxford University Press, 2006. The best known popular text advancing this thesis is that of Steven Pinker, *How the Mind Works* (Penguin, 2003), and this view was adopted by evolutionary psychology; see Lena Cosmides and John Tooby, 'Origins of Domain Specificity' in L. A. Hirschfeld and S. A. Gelman (eds), *Mapping the Mind: Domain Specificity in Cognition and Culture*, Cambridge and New York: Cambridge University Press, 1994, pp. 85–116. For one of many critiques of this view, see Merlin Donald, *A Mind So Rare*, New York: Norton, 2001. The 'modular', domain-specific view of the human mind has been widely adopted by the so-called 'literary Darwinists': see, for example, Michelle Scalise Sugiyama, 'Narrative Theory and Function', *Philosophy and Literature*, Vol. 25, No. 2 (October 2001), pp. 233–50; for a critique, see Jonathan Kramnick, 'Against Literary Darwinism', *Critical Inquiry*, Vol. 37 (Winter 2011), pp. 315–47.

13	Gilles Fauconnier and Mark Turner, *The Way We Think*, New York: Basic Books, 2008; George Lakoff and Mark Johnson, *Metaphors We Live By*, Chicago: University of Chicago Press, 2008; Mary Thomas Crane, *Shakespeare's Brain: Reading with Cognitive Theory*, Princeton: Princeton University Press, 2001.

14	Pinker, *How the Mind Works*; Antonio Damasio, *The Feeling of What Happens*, London: Heinemann, 1999; V. S. Ramachandran, *The Tell-Tale Brain*, New York: Norton, 2011.

15	Steven Pinker, *The Better Angels of Our Nature*, New York: Viking, 2011.

16	Andy Clark, *Mindware*, Oxford: Oxford University Press, 2001.

17	See Clark, *Supersizing the Mind*.

18	Maxine Sheets-Johnstone, 'Animation: The Fundamental, Essential, and Properly Descriptive Concept', *Continental Philosophy Review*, No. 42 (2009), pp. 375–400.

19	Chris Sinha and Kristine Jensen de Lopez, 'Language, Culture and the Embodiment of Spatial Cognition', pp. 17–41.

20	Jürgen Streeck, Charles Goodwin and Curtis LeBaron (eds), *Embodied Interaction: Language and Body in the Material World*, Cambridge: Cambridge University Press, 2011.

21	Chris Sinha, 'Blending Out of the Background: Play, Props and Staging in the Material World', *Journal of Pragmatics*, Vol. 37, No. 10 (2005), pp. 1537–54.

22	Susan Keen, 'A Theory of Narrative Empathy', *Narrative*, Vol. 14, No. 3 (2006), p. 207.

23	V. Gallese, M. A. Gernsbacher and C. Heyes, 'Mirror Neuron Forum', *Perspectives on Psychological Science*, Vol. 6, No. 4 (2011), pp. 369–407; see also G. Hickok, 'Eight Problems for the Mirror Neuron Theory of Action Understanding in Monkeys and Humans', *Journal of Cognitive Neuroscience*, Vol. 21, No. 7 (2009), pp. 1229–43.

24	For one cautionary note on 'lit-up brains', see C. Klein, 'Images Are

Not the Evidence in Neuroimaging', *British Journal for the Philosophy of Science*, Vol. 61, No. 2 (2010), pp. 265–78.

25 'An Interview with Vittore Gallese,' *California Italian Studies*, Vol. 2, No. 1 (2010); http://www.unipr.it/arpa/mirror/pubs/pdffiles/Gallese/2011/cis_interview_2011

26 Matthew Reason and Dee Reynolds, 'Kinesthesia, Empathy, and Related Pleasures: An Inquiry into Audience Experiences of Watching Dance', *Dance Research*, Vol. 42, No. 2 (2010), p. 50.

27 Maxine Sheets-Johnstone, 'Movement and Mirror Neurons: A Challenging and Choice Conversation, *Phenomenology and Cognitive Science*, 11 (2012), pp. 385–410.

28 Andrea Bender, Edwin Hutchins and Douglas Medin, 'Anthropology in Cognitive Science'. *Topics in Cognitive Science* (2012): 1–12.

29 J. Henrich, Steven J. Heine and Ara Norenzayan, 'The Weirdest People in the World?', *Behavioral and Brain Sciences*, 33 (2–3), pp. 61–83.

30 Tony and Helga Noice, *The Nature of Expertise in Professional Acting*, New York: Psychology Press, 1997; this example is discussed in some detail in Tribble, *Cognition in the Globe*. See also Thalia R. Goldstein and Paul Bloom, 'The Mind on Stage: Why Cognitive Scientists Should Study Acting', *Trends in Cognitive Sciences*, Vol. 15, No. 4 (2011), pp. 141–2.

31 Hutchins, *Cognition in the Wild*'; 'Cognitive Ecology', *Topics in Cognitive Science*, Vol. 2, No. 4 (2010), pp. 705–15.

32 Lawrence A. Shapiro, *Embodied Cognition*, Abingdon: Taylor & Francis, 2011, p. 61.

33 Clark, *Being There*.

34 John Sutton, Doris J. F. McIlwain, Wayne Christensen and Andrew Geeves, 'Applying Intelligence to the Reflexes: Embodied Skills and Habits between Dreyfus and Descartes', *Journal of the British Society for Phenomenology*, Vol. 42 (2011), pp. 78–103.

35 Greg Downey, 'Throwing Like a Brazilian: on Ineptness and a Skill-Shaped Body', *The Anthropology of Sport and Human Movement:A Biocultural Perspective* (2010), p. 297; Daniel H. Lende and Greg Downey, *The Encultured Brain*, Cambridge, MA: MIT University Press, 2012.

36 Bettina Bläsing, Beatriz Calvo-Merino, Emily S. Cross, Corinne Jola, Juliane Honisch and Catherine J. Stevens, 'Neurocognitive Control in Dance Perception and Performance', *Acta Psychologica*, Vol. 139, (2012), pp. 300–8.

37 Michael Kimmel, 'Intersubjectivity at Close Quarters: How Dancers of *Tango Argentino* use imagery for interaction and improvisation', *Journal of Cognitive Semiotics*, Vol. 4, No. 1 (2012) pp. 76–124; Dorothée Legrand and Susanne Ravn, 'Perceiving Subjectivity in Bodily Movement: The Case of Dancers', *Phenomenology and the Cognitive Sciences* 8 (2009), pp. 389–408; Doris J. F. McIlwain and John Sutton, 'Yoga From the Mat Up: How Words Alight on Bodies', *Educational Philosophy and Theory*, forthcoming; Maxine Sheets-Johnstone, 'From Movement to Dance',

Phenomenology and the Cognitive Sciences, Vol. 11, 2012, 39–57; Catherine J. Stevens, Jane Ginsborg and Garry Lester, 'Backwards and Forwards in Space and Time: Recalling Dance Movement from Long-Term Memory', *Memory Studies,* Vol. 4 (2011), pp. 234–50.

38 David Kirsh, 'The Intelligent Use of Space', *Artificial Intelligence,* Vol. 73, (1995), pp. 31–68; James Hollan, Edwin Hutchins and David Kirsh, 'Distributed Cognition: Toward a New Foundation for Human-Computer Interaction Research', *ACM Transactions on Computer-Human Interaction* Vol. 7 (2000), pp. 174–96; David Kirsh, 'Distributed Cognition: A Methodological Note', *Pragmatics & Cognition,* Vol. 14 (2006), pp. 249–62.

39 David Kirsh, DafneMuntanyola, R. Joanne Jao, Amy Lew and Matt Sugihara, 'Choreographic Methods for Creating Novel, High Quality Dance', 5th International Workshop on Design and Semantics of Form and Movement, 2009; 'Thinking With the Body', *Proceedings of the 32nd Annual Conference of the Cognitive Science Society,* Austin, TX, 2010, pp. 2864–9.

40 Andy Clark, 'Beyond the Flesh: Some Lessons From a Mole Cricket', *Artificial Life,* Vol. 11 (2005), pp. 233–44.

Chapter 1

1 AHRC (Arts and Humanities Research Council). 'Science in Culture'. www.ahrc.ac.uk/Funding-Opportunities/Research-funding/Themes/ Science-in-Culture/Pages/Science-in-Culture.aspx (accessed 29 March 2013).

2 Wellcome Trust. 'Arts Awards'. www.wellcome.ac.uk/Funding/Public-engagement/Funding-schemes/Arts-Awards/index.htm (accessed 29 March 2013).

3 *Ibid.*

4 Donald. A. Schön, *The Reflective Practitioner: How Professionals Think in Action,* Basic Books: New York, 1983.

5 See for example Beatriz Calvo-Merino, Daniel Glaser, Julie Grèzes, Richard E. Passingham and Patrick Haggard, 'Action Observation and Acquired Motor Skills: An fMRI Study With Expert Dancers', *Cerebral Cortex,* Vol. 15, No. 8 (2005), pp. 1243–9; Beatriz Calvo-Merino, Corinne Jola, Daniel Glaser and Patrick Haggard (2009). 'Towards a Sensorimotor Aesthetics of Performing Art', *Consciousness and Cognition,* Vol. 17 (2009), pp. 911–22; Emily S. Cross, Antonia F. Hamilton and Scott T. Grafton 'Building a Motor Simulation de novo: Observation of Dance by Dancers', *Neuroimage,* Vol. 31, No. 3 (2006), pp. 1257–67; Laura MacFarlane, Irena Kulka and Frank Pollick 'The Representation of Affect Revealed by Butoh Dance', Psychologia, Vol. 47, No. 2 (2004), pp. 96–103.

6 Dee Reynolds, Corinne Jola and Frank Pollick (eds),'Dance and

Neuroscience – New Partnerships', special issue *Dance Research*, Vol. 29, No. 2 (2011).

7 Christopher Frayling, 'Research in Art and Design', *Royal College Research Papers*, Vol. 1, No. 1 (1993), pp. 1–5.

8 Reynolds et al., 'Dance and Neuroscience – New Partnerships'.

9 Vera John-Steiner, *Creative Collaboration*, Oxford: Oxford University Press, 2000, p. 204.

10 Gilles Deleuze and Felix Guattari, *A Thousand Plateaus*, trans. Brian Massumi. Minneapolis: University of Minnesota Press, 1987, p. 3.

11 See also Marilyn Stember, 'Advancing the social sciences through the interdisciplinary enterprise', *The Social Science Journal*, Vol. 28, No. 1 (1991), pp. 1–14.

12 We discuss this further in Matthew Reason and Dee Reynolds 'Kinesthesia, Empathy, and Related Pleasures: An Inquiry in Audience Experiences of Watching Dance', *Dance Research Journal*, Vol. 42, No. 2 (2010), pp. 49–75.

13 For further discussion see Corinne Jola, Ali Abedian-Amiri, Anna Kuppuswamy, Frank E. Pollick and Marie-Helen Grosbas, 'Motor simulation without motor expertise: enhanced corticospinal excitability in visually experienced dance spectators', 2012. *PLoS ONE*. 7(3): e33343. doi:10.1371/journal.pone.0033343

14 Henri Schoenmakers 'The Spectator in the Leading Role: Developments in Reception and Audience Research Within Theatre Studies', in William Sauter (ed.), *New Directions in Theatre Research*, Munksgaard: Nordic Theatre Studies, 1990, pp. 93–106.

15 Matthew Reason, Dee Reynolds, Rosie Kay,Corrine Jola, Marie-Hélène Grosbras and Frank E. Pollick, 'Spectators Aesthetic Experience of Sound and Movement in Dance Performance: A Multi-Methodological Investigation' (in preparation).

16 Andy McKinlay, Chris McVittie and Sergio Della Sala 'Imaging the Future: Does a Qualitative Analysis Add to the Picture?', *Journal of Neuropsychology*, Vol. 4 (2010), pp. 1–13.

17 Bruce McConachie 'Falsifiable Theories for Theatre and Performance Studies', *Theatre Journal*, Vol. 59, No. 4 (2007), pp. 553–77.

18 Amy Cook 'Interplay: The Method and Potential of a Cognitive Science Approach to Theatre', *Theatre Journal*, Vol. 59, No. 4 (2007), pp. 579–95.

19 Maxine Sheets-Johnstone,'Movement and Mirror Neurons: A Challenging and Choice onversation', *Phenomenology and Cognitive Science*, Vol. 11 (2012), pp. 385–401.

Chapter 2

1 Samuel Beckett, *Waiting for Godot*, London: Samuel French, 1957, p. 26.

2 See Astrid Erll, *Memory in Culture*, Basingstoke: Palgrave, 2011.

3 The French word for 'rehearsal' is 'repetition'.

4 www.athletesoftheheart.org

5 Lisa Blackman and Couze Venn, *Body and Society*, Vol. 16, No. 1, London: Sage Publications, p. 9.

6 *Ibid.*, p. 8.

7 Anna Furse, *Augustine Big Hysteria*, London: Harwood Academic, 1992.

8 Bruno Bettelheim, *The Informed Heart*, New York: Avon Books, 1979, p. 259.

9 Michel Foucault, *Discipline and Punish: The Birth of the Prison*, trans. Alan Sheridan, New York: Random House, 1979.

10 Paul Antze and Michael Lambeck, *Tense Past: Cultural Essays in Trauma and Memory*, New York: London: Routledge, 1996, p. xxv.

11 See Bettelheim *op. cit.*, p. 257 on revolt in the camps.

12 Elaine Scarry, *The Body in Pain: The Making and the Unmaking of the World*, New York: Oxford: Oxford University Press, 1985, p. 35.

13 Though the two fields are currently finding common ground, see for example 'Neuro-psychoanalysis', led by Mark Solms, bringing the two fields together. There is also a new theory developed by Phil Mollon called 'Psychoanalytic Energy Psychotherapy' which is based on the ideas of memories being inscribed in the body.

14 Rhonda Blair, *The Actor, Image and Action: Acting and Cognitive Neuroscience*, London: Routledge, p. 81.

15 For example, one of my own practices, Contact Improvisation, in which two partners move improvisationally through a moving point of physical contact, observing laws of gravity, momentum, inertia and so on in spontaneous, conscious exchange. There are other, mainly improvisational, dance systems in which the dancer is guided or auto guides herself through anatomical and/or poetic images.

16 See Jenny Kumiega, *The Theatre of Grotowski*, London: Methuen, 1985.

17 Anecdotally, I was told by a mutual friend that he originally drew his research into the reflexes from his experience as a child in the war crossing a minefield and following the adult in front of him by impulse, physically mirroring exactly what he was doing to avoid danger.

18 The memory of Nazi occupation of Poland and the camps, the rigours of the postwar Communist regime and the suppression of Catholicism surely informed Grotowski's liberational mission in which human spontaneity, whether trained into the discipline of the actor or eventually shared into chosen groups of improvising theatre and laypeople, were methodically engaged in his research into the latent power of reflexed action.

19 George Lakoff and Mark Johnson, *Philosophy in the Flesh: The Embodied Mind and its Challenge to Western Thought*, New York: Basic Books, 1999.

20 Stephen Rose, *The Making of Memory*, London: Bantam Books, 1995, p. 91.

21 Interestingly, this act of recreation and spontaneity is exactly what performer training methodologies often seek to encourage: how to bring a freshness and sense of rediscovery anew each time the actor repeats a line or a dancer a movement sequence? This is a paradox that Blair explores in her discussion on actors' impulse: 'a score made spontaneous through successful habituation' (p. 80).

22 Peggy Phelan, 'Dance and the History of Hysteria', in Susan Leigh Foster (ed.), *Corporealities: Dancing Knowledge, Culture and Power*, New York and London: Routledge, 1996, pp. 90–105.

23 Bettelheim, *op. cit.*, p. 259.

24 *Ibid.*, p. 94.

25 Stephen Rose, *The 21st Century Brain*, London: Vintage Books, 2006, p. 162.

26 *Ibid.*

27 Phelan, *op. cit.*

28 Ami Klin and Warran Jones, in Peter Fonagy, Linda Mayes and Mary Target (eds) *Developmental Science and Psychoanalysis: Integration and Innovation*, London: Karnac, 2007, p. 6

29 We plan a performance video installation.

30 See Pierre Nora (ed.), *Rethinking France Les lieux de mémoire, 4 Vols*, Chicago: University of Chicago Press, 1999–2010.

31 White Lodge was the hunting lodge of George III and the Queen Mother had resided there, so it has a grandiose aspect with large grounds.

32 Bryan Turner, *The Body and Society: Explorations in Social Theory*, 3rd edn, Los Angeles: Sage, 2008, p. 27.

33 *Ibid.*, p. 108.

34 Susan Leigh Foster, 'The Ballerina's Phallic Pointe' in *Corporealities*, p. 14.

35 Anna Furse, 'Being Touched' in John Matthews and David Torvell (eds), *A Life of Ethics and Performance*, Newcastle: Cambridge Scholars Publishing, 2011, p. 53.

36 Susie Orbach, *Bodies,* London: Profile Books, 2010, p. 134.

37 Shakespeare, *Hamlet*, 3.1.62–3.

38 Orbach, *op. cit.*, p. 58.

39 Nicola Clayton, 'Women in Science: From bird lady to dancing professor', *The Independent* Blogs, 25 July 2011, http://blogs.independent.co.uk/2011/07/25/women-in-science-from-bird-lady-to-dancing-professor/ (accessed 11/04/2012)

40 The project is situated in the new interdisciplinary Centre of the Body at Goldsmiths that I co-direct with medical historian Dr Ronit Yoeli-Tlalim and an advisory board comprising Dr Monica Greco (Sociology), Dr Lisa Blackman (Media and Communications) and Professor Sophie Day (Anthropology).

41 Antze and Lambek, *op. cit.*, p. xix.

Chapter 3

1 Kira O'Reilly, Program note for *Sssshh ... Succour.* For the full note, see
 Keith Gallasch, 'National Review of Live Art: Blood Lines', *Real Time
 Arts*, Vol. 52 December–January 2002, http://www.realtimearts.net/
 article/52/9278 (accessed 14 October 2012).

2 Jeff Foss, 'Radical Behaviorism is a Dead End', *Behavioral and Brain
 Sciences*, Vol. 8, No. 1 (1985), p. 59. Julian Jaynes, 'Sensory Pain and
 Conscious Pain', *Behavioral and Brain Sciences*, Vol. 8, No. 1 (1985),
 pp. 61–3. Wallace I Matson, 'One Pain is Enough', *Behavioral and Brain
 Sciences*, Vol. 8, No. 1 (1985), p. 67. For an extended review of this
 literature, see Jean E. Jackson, 'Pain and Bodies' in Frances E. Mascia-Lees
 (ed.), *A Companion to the Anthropology of the Body and Embodiment*,
 Chichester: Wiley-Blackwell, 2011, pp. 370–87. Also see, Jean E Jackson,
 'Stigma, Liminality, and Chronic Pain: Mind-Body Borderlands', *American
 Ethnologist*, Vol. 32, No. 3 (2005), pp. 332–53.

3 Ronald Melzack,, 'Pain and Parallel Processing', *Behavioral and Brain
 Sciences*, Vol. 8, No. 1 (1985), pp. 67–8. Wall, Patrick D., 'Not "Pain and
 Behavior" but Pain in Behavior', *Behavioral and Brain Sciences*, Vol. 8, No.
 1 (1985), p.73.

4 John D. Loeser, 'Against Dichotomizing Pain', *Behavioral and Brain Science*,
 Vol. 8, No. 1 (1985), p. 65.

5 Ploghaus, Alexander, Lina Becena, Cristina Bonar, and David Borsook,
 'Neural Circuitry Underlying Pain Modulation: Expectation, Hypnosis,
 Placebo', *Trends in Cognitive Sciences*, Vol. 7, No. 5 (2003), pp. 197–200;
 Price, Donald D., 'Psychological and Neural Mechanisms of the Affective
 Dimension of Pain', *Science*, Vol. 288, (2000), pp. 1769–72.

6 Clifford J. Woolf, 'Deconstructing Pain: A Deterministic Dissection of the
 Molecular Basis of Pain', in Sarah Coakley and Kay Kaufman Shelemay
 (eds), *Pain and its Transformations: The Interface of Biology and Culture*,
 Cambridge, MA: Harvard University Press, 2007, pp. 27–35.

7 Howard L. Fields, 'Setting the Stage for Pain: Allegorical Tales from
 Neuroscience', in Coakley and Kaufman Shelemay (eds), *Pain and its
 Transformations*, pp. 36–61.

8 *Ibid.*, p. 59.

9 *Ibid.*, p. 54. Also, for examples of this phenomenon see Thernstrom,
 Melanie, *The Pain Chronicles: Cures, Myths, Mysteries, Prayers, Diaries,
 Brain Scans, Healing and the Science of Suffering.* New York: Farrar, Strauss
 and Giroux, 2010, p. 8.

10 Irene Tracey, 'Taking the Narrative Out of Pain: Objectifying Pain
 Through Brain Imaging', in Daniel B. Carr, John B. Loeser and David B.
 Morris (eds), *Narrative, Pain, and Suffering*, Seattle: IASP Press, 2005,
 pp. 127–63, p. 127.

11 The Numeric Pain Intensity Scale is a basic measurement on which zero

represents no pain and ten represents the worst possible pain. According
to the Joint Commission Resources of Physician Leaders in Pain
Management, it is the most common way to assess pain intensity in adult
patients with normal cognitive function. Like the Wong-Baker FACES
Pain Rating Scale, which is typically used with children, the Numeric Pain
Intensity Scale only measures one dimension of the pain experience, p. 17.

12 Elaine Scarry, *The Body in Pain: The Making and Unmaking of the World*,
 New York: Oxford University Press, 1985, p. 5.

13 Cathy Caruth, 'Preface', in Cathy Caruth (ed.), *Trauma: Explorations in
 Memory*, Baltimore: The Johns Hopkins University Press, 1995, pp. vii–ix,
 p. viii.

14 Fields, 'Setting the Stage', p. 52. Fields explains that even though 'emphasis
 on the ascending sensory pathways remains the dominant theme in pain
 research ... there is a growing interest in studying the neural systems that
 underlie the top-down modulatory factors.'

15 Fields, 'Setting the Stage', p. 44.

16 *Ibid.*, pp. 45–6.

17 *Ibid.*, pp. 45–6. The emotional component of the pain experience also
 involves the limbic system. The motivational and emotional dimensions
 have many overlapping features.

18 *Ibid.*, p. 46.

19 In *An Enquiry Concerning Human Understanding*, David Hume argues that
 causal assumptions are often very useful, but must not be understood as
 the whole picture of what is true. He frames causal knowledge as valuable,
 but incomplete. As a relationship, 'causality' is a story we make up to
 describe how facts relate to each other. We can empirically observe that
 facts change, but because how they change is not a fact but a relationship,
 we can never empirically observe it. Facts on either side of the interaction
 can be measured, but the interaction that happens in-between facts cannot
 be measured.

20 Fields, 'Setting the Stage', p. 53.

21 *Ibid.*, p. 53, emphasis original.

22 Padfield, Deborah, *Perceptions of Pain*, London: Dewi Lewis Publishing,
 2003, p. 23.

23 *Ibid.*, p. 105.

24 Arthur Kleinman et al., 'Discussion: The Dislocation, Representation, and
 Communication of Pain', in Coakley and Kaufman Shelemay, *op cit.*, pp.
 351–60, 354.

25 Loraine Daston and Peter Galison, *Objectivity*, New York: Zone Books,
 2007, p. 17.

26 According to Tracey, physiological measures like heart rate, galvanic
 skin response, and pupil dilation are not reliable because subjects may
 habituate quickly or respond nonspecifically. She adds that measures based
 on behavioural observations like grimacing, limping, or crying out are also

unreliable because such behaviours are especially dependent on social and cultural contexts, p. 130.

27 *Ibid.*, p. 129.
28 Tracey, 'Taking the Narrative Out', p. 129.
29 *Ibid.*, p. 129.
30 Michel Foucault, *The Birth of the Clinic: An Archaeology of Medical Perception*, New York: Vintage, 1994, p. xviii.
31 Daston and Galison, *Objectivity*, p. 395.
32 *Ibid*, p. 391.
33 Gallasch, 'National Review', http://www.realtimearts.net/article/52/9278 (accessed 14 October 2012).
34 Caruth, *Trauma*, p. ix.
35 Shaw Peggy and Suzy Willson, 'Must: The Inside Story' in Jill Dolan (ed.), *A Menopausal Gentleman: The Solo Performances of Peggy Shaw*, Ann Arbor: University of Michigan Press, 2011, pp. 133–58, 143.
36 Jill Dolan, 'Introduction: A Certain Kind of Successful' in *A Menopausal Gentleman*, pp. 1–38, 32.
37 Shaw and Willson, *Must*, p. 142.
38 Caruth, *Trauma*, p. viii.
39 Scarry, *Body*, p. 7.

Introduction

1 There are strong and weak views of embodied cognition – some, like George Lakoff and Mark Johnson, argue that all abstract thoughts are based on physical experiences while others, like Lera Boroditsky and Michael Ramscar, argue that representation does play a role in the manipulation of abstract thinking. See Boroditsky and Ramscar, 'The roles of body and mind in abstract thought', *Psychological Science*, Vol. 13, No. 2, March 2002, pp. 185–9. There are still those who hold to less embodied, more computational models of language and cognition, such as Ray Jackendoff, *Foundations of Language: Brain, Meaning, Grammar, Evolution*. Oxford: Oxford University Press, 2002; and Steven Pinker, *How the Mind Works*. New York: Norton, 1997. For the arguments against these computational and disembodied perspectives and an argument for embodied realism, see George Lakoff and Mark Johnson, *Philosophy in the Flesh: The Embodied Mind and its Challenge to Western Thought*. New York: Basic Books, 1999. For the stronger views of embodied cognition, see: Clark, *Supersizing the Mind: Embodiment, Action, and Cognition*. Oxford: Oxford University Press, 2008; Robbins and Aydede, *A Short Primer on Situated Cognition*. Cambridge: Cambridge University Press, 2009; and Varela, Thompson and Rosch, *The Embodied Mind: Cognitive Science and Human Experience*. Cambridge, MA: The MIT Press, 1993.

2 Alva Noë, *Action in Perception*. Cambridge, MA: The MIT Press, 2004, p. 2.
3 Michael L. Anderson, 'Embodied Cognition: A Field Guide', *Artificial Intelligence* 149; 2003, p. 101.
4 *Ibid.*, 102.
5 David Kirshand Paul Maglio, 'On Distinguishing Epistemic from Pragmatic Action', *Cognitive Science*, Vol. 18, p. 513.
6 Clark, *Supersizing the Mind*, p. 76.
7 See Amy Cook, 'Staging Nothing: Hamlet and Cognitive Science', *SubStance* 35(2), 2006: 87–92 and Bruce McConachie, *Engaging Audiences: A Cognitive Approach to Spectating in the Theatre*, New York: Palgrave Macmillan, 2008: 43.
8 Benjamin K. Bergen, *Louder Than Words: The New Science of How the Mind Makes Meaning*, New York: Basic Books, 2012, p. 4.
9 George Lakoff, *Women, Fire, and Dangerous Things: What Categories Reveal About the Mind*. Chicago, IL: University of Chicago Press, 1987, p. 9.
10 Elizabeth Hart, 'Matter, System, and Early Modern Studies: Outlines for a Materialist Linguistics', *Configurations* 6.3 (1998), pp. 311–43 and Bruce McConachie and Elizabeth Hart, 'Introduction', in Bruce McConachie and Elizabeth Hart (eds), *Performance and Cognition: Theatre Studies and the Cognitive Turn*, London and New York: Routledge, 2006, pp. 1–25.
11 George Lakoff and Mark Johnson, *Metaphors We Live By*, Chicago, IL: University of Chicago Press, 1980; and George Lakoff and Mark Turner, *More Than Cool Reason: A Field Guide to Poetic Metaphor*, Chicago, IL: University of Chicago Press, 1989.
12 On 'mental spaces' see, Gilles Fauconnier, *Mental Spaces: Aspects of Meaning Construction in Natural Language*, Cambridge: Cambridge University Press, 1985. For blending theory, see Gilles Fauconnier and Mark Turner, *The Way We Think: Conceptual Blending and the Mind's Hidden Complexities*, New York: Basic Books, 2002.
13 Mark Johnson, *The Meaning of the Body: Aesthetics of Human Understanding*. Chicago, IL: University of Chicago Press, 2007, p. 132.
14 See Elizabeth Hart, 'Review: The View of Where We've Been and Where We'd like to Go', *College Literature: Cognitive Shakespeare: Criticism and Theory in the Age of Neuroscience*, Vol. 33, No. 1 (2006) p. 233.
15 For applications of cognitive linguistics and blending theory into literature, see Mary Crane, *Shakespeare's Brain: Reading with Cognitive Theory*, Princeton: Princeton University Press, 2001; Mary Crane and Alan Richardson, 'Literary Studies and Cognitive Science: Toward a New Interdisciplinarity', *Mosaic*, Vol. 32 (1999), pp. 124–40; Barbara Dancygier, *The Language of Stories*, Cambridge: Cambridge University Press, 2012; Donald C. Freeman, 'Othello and the "Ocular Proof"', *The Shakespearean International Yearbook*, Vol. 4, Aldershot: Ashgate Publishing (2004), pp. 56–71; Patrick Colm Hogan, *Cognitive Science, Literature, and the Arts: A*

Guide for Humanists. New York: Routledge, 2003; Ellen Spolsky, *Word vs Image: Cognitive Hunger in Shakespeare's England.* Basingstoke: Palgrave Macmillan, 2007; Eve Sweetser, 'Whose Rhyme is Whose Reason? Sound and Sense in *Cyrano de Bergerac' Language and Linguistics,* Vol. 15, No. 1 (2006), pp. 29–54; and Mark Turner, *The Literary Mind: The Origins of Thought and Language,* Oxford: Oxford University Press, 1996. For applications in theatre and performance studies, see Rhonda Blair, *The Actor, Image, and Action: Acting and Cognitive Neuroscience.* New York: Routledge, 2008; Amy Cook, *Shakespearean Neuroplay: Reinvigorating the Study of Dramatic Texts and Performance Through Cognitive Science,* New York: Palgrave Macmillan, 2010; McConachie, *Engaging Audiences;* John Lutterbie, *Toward a General Theory of Acting,* New York: Palgrave Macmillan 2011.

16 Alan Richardson provides a cognitive historical analysis of facial expression theory, looking particularly at the way emotions are exposed on the faces of characters in the work of Keats and Austen in his essay 'Facial Expression Theory from Romanticism to the Present' in Lisa Zunshine (ed.), *Introduction to Cognitive Cultural Studies,* Baltimore, MD: Johns Hopkins Press, 2010, pp. 65–83.

Chapter 4

1 See Eve Kosofsky Sedwick, *Touching Feeling: Affect, Pedagogy, Performativity,* Durham and London: Duke University Press, 2003, p. 38.

2 See Gail Kern Paster, *Humoring the Body: Emotions and the Shakespearian Stage,* Chicago and London: University of Chicago Press, 2004, p. 9.

3 *Ibid.,* p. 20.

4 See Gail Kern Paster, *The Body Embarrassed: Drama and the Disciplines of Shame in Early Modern England,* Ithaca and New York: Cornell University Press, 1993, p. 19.

5 *Ibid.,* p. 19.

6 *Ibid.,* p. 20.

7 Joseph Roach, *The Player's Passion: Studies in the Science of Acting,* Ann Arbor: University of Michigan Press, 1993.

8 *Ibid.,* p. 52.

9 *Ibid.,* 'To enthusiasts like Heywood and Gildon, each of whom had a public relations task to accomplish on behalf of the theater, such a drawback [that the force of calling up and producing the passions could escape the actor's control] did not seem worth mentioning' (p. 48).

10 Paster, *op. cit.,* p. 19

11 See Rhonda Blair, 'How Much is a Loaf of Bread: ASTR Presidential Address (Montreal, 17 November 2011)', *Theatre Survey,* Vol. 53, No. 2 (2012), pp. 299–307. See also Amy Cook, 'For Hecuba or Hamlet: Rethinking Emotion and Empathy in the Theatre', *Journal of Dramatic*

Theory and Criticism, Vol. 25, No. 2 (2011), pp. 71–88; Naomi Rokotnitz, *Trusting Performance: A Cognitive Approach to Embodiment in Drama*, New York: Palgrave Macmillan, 2011.

12 See Roberta Barker, *Early Modern Tragedy, Gender and Performance, 1984–2000: The Destined Livery*, Basingstoke and New York: Palgrave Macmillan, 2007.

13 On blushing, see Corine Dijk, Peter J. de Jong and Madelon L. Peters, 'The Remedial Value of Blushing in the Context of Transgressions and Mishaps', *Emotion*, Vol. 9, No. 2 (2009), pp. 287–91. See also Corine Dijk, Bryan Koenig, Tim Ketelaar and Peter J. de Jong. 'Saved by the Blush: Being Trusted Despite Defecting', *Emotion*, Vol. 11, No. 2 (2011), pp. 313–19. On embarrassment as a sign of prosociality, see Matthew Feinberg, Robb Willer and Dacher Keltner, 'Flustered and Faithful: Embarrassment as a Sign of Prosociality', *Journal of Personality and Social Psychology*, Vol. 102, No. 1 (2012), pp. 81–97.

14 See Ilona E. De Hooge, Seger M. Breugelmans and Marcel Zeelenberg, 'Not So Ugly After All: When Shame Acts as a Commitment Device', *Journal of Personality and Social Psychology*, Vol. 95, No. 4 (2005), pp. 933–43.

15 See Cook, 'For Hecuba or Hamlet', p. 83.

16 See Robin Bernstein, 'Toward an Integration of Theatre History and Affect Studies: Shame and the Rude Mechs's The Method Gun', *Theatre Journal*, Vol. 64, No. 2 (2012), pp. 213–30.

17 See Paster, *op. cit.*, p. 10

18 Thomas Heywood, *A Woman Killed With Kindness*, 8.80–1, in, Kathleen McLuskie and David Bevington (eds) *Plays on Women*, Manchester: Manchester University Press, 1999, pp. 349–416. Subsequent citations in text. What is so fascinating about Heywood's play is how it creates a dramatic narrative from the body. That is to say, the play has a way of suggesting that the bodies themselves are the cause of its tragic story, that one can track the exhibition, rising action, climax and denouement through expression of bodily experience in the play.

19 See Roach, *The Player's Passion*. A lack of control over emotion was bad enough for a man, but for a woman it was almost always associated with 'wantonness and immodesty' (p. 31).

20 See Lena Orlin, *Private Matters in Public Culture in Post-Reformation England*. Ithaca and London: Cornell University Press, 1994. As Orlin nicely puts it, 'the male relationships [in Heywood's play] are … relentlessly contestatory' (p. 165).

21 Elspeth Probyn, *Blush: Faces of Shame*, Minneapolis: University of Minnesota Press, 2005, p. ix.

22 *Ibid.*, p. 13.

23 *Ibid.*, p. x, p. xii.

24 Anne identifies his feelings as disloyal, explaining that her husband loves Wendoll and freely gives him every material thing he wants. She reminds

Wendoll that he is her husband's best friend, and asks him if he is sure he knows what he is saying and to whom he speaks. Her last defence concerns herself, that she dearly loves her husband as much as 'soul's health' (6.109–42).

25 Andrew Fleck, 'The Ambivalent Blush: Figural and Structural Metonymy, Modesty, and Much Ado About Nothing', *ANQ*, Vol. 19, No. 1 (2006), pp. 16–23, 19. Danielle Clark, 'The Iconography of the Blush' in Kate Chedgzoy, Melanie Hansen and Suzanne Trill (eds), *Voicing Women: Gender and Sexuality in Early Modern Writing*, Keele: Keele University Press, 1996, pp. 111–28, 118.

26 *Ibid.*, pp. 16–23, 19.

27 Sedgwick, *op. cit.*

28 Frankford's expression of classical virtue [friendship] undoes his own domestic interest [household]' (Orlin, *Private Matters*, 172).

29 Probyn, *Blush*, p. 14.

30 Anne reveals her part in social relations beyond those of her husband and children when she says at the moment of being found out: 'Here stand I in this place, ashamed to look my servants in the face' (13.149–50).

31 'I charge thee never after this sad day/to see me, or to meet me, or to send/ by word, or writing, gift, or otherwise/to move me, by thyself or by thy friends,/nor challenge any part in my two children' (13.174–8).

32 Probyn, *Blush*, p. 21. Here Probyn is actually speaking about her own experience with anorexia, but the way she describes herself sounds very much like how one might characterise Anne in her resolve to 'never will nor eat, nor drink, nor taste/Of any cates that may preserve my life;/ I never will nor smile, nor sleep, nor rest' (16.100–3).

33 *Ibid.*, p. 63.

34 This is best evidenced by her brother Acton, who came to 'chide' Anne, but whose 'words of hate' were 'turned to pity and compassionate grief' after seeing her face (17.63–4).

35 Roach, *Player's Passion*, p. 42.

36 See Roach, *ibid.*: 'The [actor's] restraint itself, the stifling results in a more forceful evocation of the fires of passion' (p. 3). Significantly, Heywood's play itself dramatises the power of performing through inhibition of passion. Wendoll, Frankford, and Nicholas all have to act as if they aren't moved by passion, and in doing so appear at their most authoritative, although Wendoll arguably fails.

37 *Ibid.*, pp. 42, 55.

38 *Ibid.*, p, 39.

39 *Ibid.*, p, 32.

40 *Ibid.*: '[The actor's] passions, irradiating the bodies of the spectators through their eyes and ears, could literally transfer the content of his heart to theirs, altering their moral natures' (p. 27).

41 Francis Beaumont and John Fletcher, *The Knight of the Burning Pestle*,

Sheldon P. Zitner (ed.), Manchester: Manchester University Press, 2004. ('To the Readers of this Comedy').

42 Mary Thomas Crane, 'What Was Performance?', *Criticism*, Vol. 43, No. 2 (2001), pp. 169–87, 175.

43 *Ibid.*, p. 176–7.

44 See Cook, 'Wrinkles, Wormholes, and Hamlet: The Wooster Group's Hamlet as a Challenge to Periodicity', *The Drama Review*, Vol. 53, No. 4 (2009), pp. 104–19. (106). Cook's use of Crane extends the sense of the kinesthetic in performance as practice in a way that I find extremely helpful, where performance makes actors 'sweat' and builds their muscles.

45 See Roach, *op. cit.* Roach and Crane's understanding of performance in the seventeenth century nicely overlaps in Roach's turn to the language of exercise: 'in theory at least, an actor/orator can master the system of inhibition by diligent practice and exercise' (p. 55).

46 And by acting I mean the performing that takes place within the play to hide that certain characters know more than they should. As Frankford says when Nicholas tells him of his wife's adultery: 'distraction I will banish from my brow/and from my looks exile sad discontent./Their wonted favours in my tongue shall flow;/Till I know all, I'll nothing seem to know' (8.107–11).

47 Roach, *Player's Passion*, p. 4; Paster, *Body Embarrassed*, p. 20.

48 Acton is more explicit about his opinion a few lines earlier, 'My brother Frankford showed too mild a spirit/ In the revenge of such a loathed crime ... death to such deeds of shame is the due meed' (17.16–7).

49 This offers us another way to read the title, and it seems to me that this reading nicely maintains the ambiguity of whose kindness may have killed Anne (I would say Wendoll's, Frankford's and her own for a start), and still makes it possible to read Susan as the other woman 'killed by kindness' in the play, whose hate for Acton is extinguished by his kindness to her brother.

Chapter 5

1 Alva Noë, *Action in Perception*. Cambridge, MA: The MIT Press, 2004, p. 217.

2 See Sophia New and Daniel Belasco Rogers, 'You, Me and Everywhere We Go, plan b', *Performance Research*, Vol. 15, No. 4 (2010), p. 23–31.

3 The critique frequently used to attack the use of science in discussions related to the arts and humanities is the failure of science to address the complexity of experience. 'The charge, at base, is that scientists often describe and model systems that are constituted as much by human engineering as they are by the world. Research systems such as a sealed beaker in a laboratory incubator, or an insulated housing to be sent aloft in a spacecraft, are highly circumscribed and shielded from intrusions. But

outside the beaker or box, in the universe at large, the models may very well fail to apply.' Bechtel, William and Andrew Hamilton, 'Reduction, Integration, and the Unity of Science: Natural, Behavioral, and Social Sciences and the Humanities', in Theo A. F. Kuipers (ed.), *Philosophy of Science: Focal Issues*, Amsterdam: Elsevier B. V., 2007, p. 401. It is the contention of this author that, while acknowledging that they are reductive, some scientific findings have significant explanatory power when applied to human experience.

4 See John Lutterbie, *Hearing Voices: Modern Drama and the Problem of Subjectivity*, Ann Arbor: The University of Michigan Press, 1997, pp. 136–9.

5 A. J. Kelso, *Dynamic Patterns: The Self-Organization of Brain and Behavior*, Cambridge and London: The MIT Press, 1995, pp. 6–8.

6 Jerome A. Feldman, *From Molecules to Metaphor: A Neural Theory of Language*, Cambridge: The MIT Press, 2008, pp. 283–94.

7 Eugene T. Gendlin, 'The New Phenomenology of Carrying Forward,' *Continental Philosophy Review*, Vol. 37, No. 1 (2004), p. 128.

8 Feldman, *op. cit.*, p. 323.

9 Susan Goldin-Meadow, 'How Gesture Promotes Learning Throughout Childhood,' *Childhood Development Perspectives*, Vol. 3, No. 2 (2009), p. 106.

10 Jana M. Iverson and Esther Thelen. 'Hand, Mouth and Brain: The Dynamic Emergence of Speech and Gesture,' *The Journal of Consciousness Studies*, Vol. 6, No. 11–12 (1999), p. 21.

11 *Ibid.*, p. 26.

12 Amy Cook, personal correspondence, February 1, 2013. See Cook, *Shakespearean Neuroplay: Reinvigorating the Study of Dramatic Texts and Performance through Cognitive Science*. New York: Palgrave Macmillan, 2010, pp. 112–22.

13 Iverson and Thelan, *op. cit.*, p. 36.

14 Snoop Dogg, and Pilot. 'Gangbang Rookie,' YouTube, http://www.youtube.com/watch?v=EVtwPMnJ4gk&list=PLF11C09DF29FD83A8 (accessed 17 February 2013).

15 Gendlin, *op. cit.*, p. 146.

16 Gendlin, *op. cit.*, p. 135.

17 An 'aha!' moment is significant only if it is consolidated in memory, if it can be recalled under similar circumstances. This implies a change in neural connectivity, for instance an increase in the number of synaptic buds on a neuron and, therefore, the likelihood a neural pathway will be facilitated in the future – that is, the discovery remembered.

18 Chuck Close, quoted in Maria Popova, 'Chuck Close on Creativity, Work Ethic, and Problem-Solving vs. Problem-Creating,' Brainpickings, http://www.brainpickings.org/index.php/2012/12/27/chuck-close-on-creativity/ (accessed 17 February 2013).

19 Edward Albee, *The Zoo Story* in *The American Dream and The Zoo Story*, New York: Signet Books, 1961, p. 30.

Chapter 6

1 Jaak Panksepp, 'Affective Consciousness: Core Emotional Feelings in
 Animals and Humans', *Consciousness and Cognition* Vol. 14 (2005),
 pp. 30–80; Marie Vandekerckhove and Jaak Panksepp, 'A Neurocognitive
 Theory of Higher Mental Emergence: From Anoetic Affective Experiences
 to Noetic Knowledge and Autonoetic Awareness', *Neuroscience and
 Biobehavioral Reviews*, Vol. 35 (2011), pp. 2017–25.

2 Mary L. Phillips et al., 'Differential Neural responses to Overt and Covert
 Presentations of Facial Expressions of Fear and Disgust', *NeuroImage*,
 Vol. 21 (2004), pp. 1484–96; Jorge Moll et al., 'The Moral Affiliations of
 Disgust: A Functional MRI Study', *Cognitive Behavioral Neurology*, Vol. 18,
 No. 1 (2005), pp. 68–78.

3 Neurologist Antonio Damasio has shown that stimuli are first detected
 in the body; conscious analysis follows later, as a secondary process.
 This chronology does not determine the relative value of each capacity
 but suggests that we may experience feelings and emotions without
 reason – but not reason without emotion. Both are equally integral to
 the processes of decision making (Antonio Damasio, *The Feeling of What
 Happens: Body and Emotion in the Making of Consciousness*, New York
 and London: Harcourt, 1999, pp. 41, 283). For an excellent discussion of
 current theories of emotion see Amy Cook, 'For Hecuba or for Hamlet:
 Rethinking Emotion and Empathy in the Theatre', *Journal of Dramatic
 Theory and Criticism* (2011), pp. 1–17.

4 Marie Vandekerckhove and Jaak Panksepp, 'A Neurocognitive Theory of
 Higher Mental Emergence: From Anoetic Affective Experiences to Noetic
 Knowledge and Autonoetic Awareness', *Neuroscience and Biobehavioral
 Reviews*, Vol. 35 (2011): 2018.

5 Vittorio Gallese, 'The 'Shared Manifold' Hypothesis: From Mirror Neurons
 to Empathy', *Journal of Consciousness Studies*, Vol. 8, No. 5–7 (2001), pp.
 33–50: Paula M. Niedenthal *et al.*, 'Embodiment in the Acquisition and
 Use of Emotion Knowledge' in Lisa Feldman Barret, Paula M. Niedenthal
 and Pioter Winkielman (eds), *Emotion and Consciousness*, New York:
 Guilford Press, 2005.

6 Stanley Cavell, *Disowning Knowledge in Six Plays of Shakespeare*,
 Cambridge: Cambridge University Press, 1987; Ellen Spolsky, *Gaps in
 Nature: Literary Interpretation and the Modular Mind*, Albany, NY: State
 University of New York Press, 1993.

7 Ellen Spolsky argues convincingly that our 'vulnerability' in a
 world characterised by constant flux, is 'just what allows creative
 innovation'('Darwin and Derrida: Cognitive Literary Theory as a Species
 of Post-Structuralism', *Poetics Today*, Vol. 23, No. 1 (2001), pp. 43–62).

8 Naomi Rokotnitz, *Trusting Performance: A Cognitive Approach to
 Embodiment in Drama*, Basingstoke: Palgrave Macmillan, 2011.

9 *Wit* was first performed in 1995 and won the Pulitzer Prize for Drama in 1999.

10 Amy Cook, 'For Hecuba or for Hamlet: Rethinking Emotion and Empathy in the Theatre', *Journal of Dramatic Theory and Criticism* (2011), 11.

11 While I acknowledge that bodies are always, inevitably, also encultured and politicised, I deliberately stay clear of gendering my argument in this chapter, emphasising instead the embodied nature of all humans, of whichever gender, ethnicity, social context or political/religious persuasions. For a survey of feminist fiction on cancer, see Mary K. DeShazer, 'Fractured Borders: Women's Cancer and Feminist Theatre', *Feminist Formations, Vol.* 15, No. 2 (2003), pp. 1–26.

12 Shaun Gallagher and Dan Zahavi, *The Phenomenological Mind: An Introduction to Philosophy of Mind and Cognitive Science,* Abingdon and New York: Routledge, 2008, 148.

13 See David Servan-Schreiber, *Healing Without Freud or Prozac* (London: Rodale, 2004) on forms of therapy that engage the body, accessing our physiology and emotions, without involving conscious, linguistic processes.

14 Mark Johnson, *The Meaning of the Body: Aesthetics of Human Understanding,* Chicago: University of Chicago Press, 2007, p. xii.

15 Andy Clark, 'Where Brain, Body and Mind Collide,' *Daedalus,* Vol. 127, No. 2 (1998), p. 273.

16 *Ibid.,* p. 271.

17 Mimicry is the tendency to synchronise affective expressions, vocalisations, postures, and movements with those of another person (Tania Singer and Claus Lamm, 'The Social Neuroscience of Empathy', *The Year in Cognitive Neuroscience: Annals of the New York Academy of Science,* Vol. 1156 (2009), pp. 81–96). Simulation describes the internal replication of observed action through bodily mechanisms that do not require conscious reflection, but rely upon a shared 'brain-body system' (Gallese Vittorio, Christian Keysers and Giacomo Rizzolatti, 'A Unifying View of the Basis of Social Cognition', *Trends in Cognitive Science,* Vol. 8, No. 9 (2004), 397).

18 Gallese, 'The "Shared Manifold" Hypothesis', p. 47.

19 Hans Herbert Kögler and Karsten R. Steuber (eds), *Empathy and Agency,* Boulder: Westview, 2000.

20 Jean Decety and William Ickes (eds), *The Social Neuroscience of Empathy,* Cambridge, MA: MIT Press, 2011.

21 N. Danziger, M. K. Prkachin and J. C. Willer, 'Is Pain the Price of Empathy? The Perception of Others' Pain in Patients with Congenital Insensitivity to Pain', *Brain,* Vol. 129 (2006), pp. 2494–507.

22 Vittorio Gallese, Christian Keysers and Giacomo Rizzolatti, 'A Unifying View of the Basis of Social Cognition', *Trends in Cognitive Science,* Vol. 8, No. 9 (2004), p. 401.

23 Tanya Singer et al., 'Empathy for Pain Involves the Affective but not the Sensory Components of Pain,' *Science*, Vol. 303 (2004), p. 1157.

24 Pier Francesco Ferrari *et al.*, 'Mirror Neurons Responding to the Observation of Ingestive and Communicative Mouth Actions in the Monkey Premotor Cortex', *European Journal of Neuroscience*, Vol. 17 (2003), pp. 1703–14.

25 Elaine Hatfield, John R. Cacioppo and Richard L. Rapson, 'Primitive Emotional Contagion' in Margaret S. Clark (ed.), *Emotion and Social Behavior, Review of Personality and Social Psychology*, Vol. 14 (1992), pp. 151–77.

26 Rokotnitz, *Trusting Performance*.

27 Watson and Greenbery in Jean Decety and William Ickes (eds), *The Social Neuroscience of Empathy*, Cambridge, MA: MIT Press, 2011, p. 126.

28 Rosette C. Lamont, 'Coma versus Comma: John Donne's Holy Sonnets in Edson's *Wit*', *The Massachusetts Review*, Vol. 40, No. 4 (1999/2000), p. 569.

29 'Modalities of being' refers to Mathew Ratcliffe, 'Existential Feeling and Psychopathology', *Philosophy, Psychiatry & Psychology*, Vol. 16, No. 2 (2009), pp. 179–94.

30 Martha Stoddard Holmes, 'Pink Ribbons and Public Private Parts: On Not Imagining Ovarian Cancer', *Literature and Medicine*, Vol. 25, No. 2 (2006) p. 483.

31 Holmes herself experienced ovarian cancer. In her essay (Martha Stoddard Holmes, 'Pink Ribbons and Public Private Parts: On Not Imagining Ovarian Cancer', *Literature and Medicine*, Vol. 25, No. 2, (2006), pp. 475–501), she provides an erudite self-examination, which considers the predicament of 'knowing without knowing' (477). By 'anatomizing [her] lack of comprehension'(477), she describes the ease with which an educated and articulate woman may remain unconscious of, or even consciously deny to herself, the intimations of her own body.

32 *Ibid.*, p. 497.

33 Elizabeth Klaver, 'A Mind-Body-Flesh Problem: The Case of Margaret Edson's *Wit*', *Contemporary Literature*, Vol. 45, No. 4 (2004), p. 676. Klaver's essay provides an impressive summary of key stages in the history of medical conceptions of the body, as well as the evolution of 'body criticism' and the postmodern discourse surrounding it.

34 *Ibid.*, p. 677.

35 *33 Variations* debuted at the Eugene O'Neill Theatre in New York in 2009, with Jane Fonda in the lead as Katherine Brandt, Samantha Mathis as Clara, Colin Hanks as Mike, Susan Kellermann as Gertie, and Zach Grenier as Beethoven. For a broader analysis of *33 Variations*, which also takes account of the dialogue between Romanticism and Existentialism suggested by the play, the added dimension afforded by the historical

Beethoven's musical innovations, and by the play's exploration of spacetime potentialities, see Rokotnitz, *Trusting Performance.*

36 Einat Avrahami (ed.), *The European Legacy*, Vol. 16, No. 3 (2011). Special issue: 'Medicine and The Humanities'.

37 Martin Heidegger, *Being and Time* (1927), trans. Joan Stambaugh, New York: New York State University Press, 1996, p. 235.

38 *Ibid.*, 1927, p. 235.

39 *Ibid.*, 1927, p. 238, italics in the original.

40 Manuella Consonn, 'Semantic Shift and the Experience of Pain,' Presentation at Scholion: Knowledge and Pain Conference, Hebrew University of Jerusalem, May 2010, p. 3.

41 Jean Decety shows that observation of another's pain 'results, in the observer, in the activation of the neural network involved in the processing of firsthand experience of pain. This intimate overlap between the neural circuits [...] supports the shared-representation theory of social cognition' (Decety and Ickes, *op. cit.*, p. 200). The self-other equivalence seems to be easily bridged by pre-conscious mechanisms that respond empathically, but feeds into conscious mechanisms that foster sympathy.

42 Heidegger *op. cit.*, p. 241.

43 Einat Avrahami, *The Invading Body: Reading Illness Autobiographies*, Charlottesville and London: University of Virginia Press, 2007, p. 14.

44 Tiffany Martini Field, *Touch*, Cambridge, MA: MIT Press, 2001, p. 57.

45 Maria Henricson, Kerstin Segestena, Anna-Lena Berglund, and Sylivia Määtä, 'Enjoying tactile touch and gaining hope when being cared for in intensive care – A phenomenological hermeneutical study', *Intensive and Critical Care Nursing*, Vol. 25 (2009), p. 323.

46 Henricson *et al.* recount studies that show 'women with diabetes whose levels of blood glucose decreased after tactile touch; 'women during the latent phase of labour who 'could relax and recover their strength after tactile massage: 'and patients with anorexia nervosa who felt 'a sense of relaxation and relief;' women with breast cancer who experienced reduced nausea after the treatment; and stroke-patients who made clear progress in terms of reduced incontinence, improved mobility and hygiene when they received tactile massage. None of the studies reported any negative effects of the treatment' (*ibid.*, p. 324).

47 *Ibid.*, p, 325.

48 Gallace and Spence, *op. cit.*, p. 247.

49 Clark, *op. cit.*, p. 259.

50 Jonathan Haidt, *The Happiness Hypothesis*, London: Arrow Books and Random House, 2006, p. xii.

51 Heidegger *op. cit.*, pp. 243–4.

52 Haidt, *op. cit.*, p. 195.

53 *Ibid.*, p. 198.

Introduction

1 Much of this section is derived from Rhonda Blair and John Lutterbie, 'Introduction: *Journal of Dramatic Theory and Criticism's* Special Section on Cognitive Studies, Theatre and Performance,' *Journal of Dramatic Theory and Criticism*, Vol. XXV, No. 2 (Spring 2011), pp. 61–70.

2 Eric R. Kandel and Larry R. Squire "Neuroscience: Breaking Down Scientific Barriers to the Study of Brain and Mind", in Antonio R. Damasio, Anne Harrington, Jerome Kagan, Bruce S. McEwen, Henry Moss and Rashid Shaikh (eds), *Unity of Knowledge: The Convergence of Natural and Human Science*, New York: The Academy of Sciences, 2001, pp. 118–35, 128.

3 Gerald Edelman and Giulio Tononi, *A Universe of Consciousness: How Matter Becomes Imagination*, New York: Basic Books, 2000.

4 Antonio Damasio, *The Feeling of What Happens: Body and Emotion in the Making of Consciousness*, New York: Harcourt Brace & Company, 1999, p. 40 *Unity of Knowledge: The Convergence of Natural and Human Science* 2; also Damasio, *Descartes' Error: Emotion, Reason, and the Human Brain*, New York: Avon Books Inc., 1994, pp. 173–80.

5 Elizabeth Wilson, *Neural Geographies: Feminism and the Microstructure of Cognition*, New York: Routledge, 1998, p. 6.

6 *Ibid.*, p. 160.

7 Joseph LeDoux, *Synaptic Self: How Our Brains Become Who We Are*, New York: Penguin Books, 2002, p. 161, emphasis added.

8 Rhonda Blair, *The Actor, Image, and Action: Acting and Cognitive Neuroscience*, New York and London: Routledge, 2008, p. 73.

9 Philip Robbins and Murat Aydede, *The Cambridge Handbook of Situated Cognition*, New York: Cambridge University Press, 2009, p. 3.

10 *Ibid.*, pp. 3–4.

11 *Ibid.*, p. 7.

12 *Ibid.*, pp. 7–8.

13 *Ibid.*, p. 8.

14 Evan Thompson, *Mind in Life: Biology, Phenomenology, and the Sciences of Mind*, Cambridge, MA: Harvard University Press, 2007, pp. 10–11.

15 *Ibid.*, p. 13.

16 *Ibid.*, p. 60.

17 *Ibid.*, p. 43.

18 *Ibid.*, p. 119.

19 Wiliam J. Clancy, 'Scientific Antecedents of Situated Cognition' in Philip Robbins and Murat Aydede (eds), *The Cambridge Handbook of Situation Cognition*, New York: Cambridge University Press, 2009, pp. 11–34, 28.

20 Robbins and Aydede, *op. cit.*, p. 9.

21 Melissa Gregg and Gregory J. Siegworth, *The Affect Theory Reader*, Durham, NC: Duke University Press, 2002, pp. 5–6.

22 Brian Massumi, 'Foreword' in Gilles Deleuze and Félix Guattari (eds), *A Thousand Plateaus: Capitalism and Schizophrenia*, trans. Brian Massumi, Minneapolis: University of Minnesota Press, 1980, p. xvi.
23 Gregg and Siegworth, *op. cit.*, p. 6.
24 Gregg and Siegworth, *op. cit.*, p. 6.
25 Gregg and Siegworth, *op. cit.*, pp. 7–8.
26 Gregg and Siegworth, *op. cit.*, p. 9.
27 Gregg and Siegworth, *op. cit.*, p. 14.
28 Gregg and Siegworth, op. cit., p. 325.
29 Rhonda Blair, class discussion with Marla Carlson, University of Georgia (Athens, GA) Skype session, Dallas, 7 March 2013.
30 John Lutterbie, *Toward a General Theory of Acting: Cognitive Science and Performance*, New York: Palgrave Macmillan, 2011, p. 10.

Chapter 7

1 Much of this work and the larger body from which this is taken is predicated on the seminal work of David McNeill. See David McNeill, *Hand and Mind: What Gestures Reveal About Thought*. Chicago: University of Chicago Press, 1992; and *Gesture and Thought*, Chicago: University of Chicago Press, 2005.
2 Anne Bogart, *A Director Prepares: Seven Essays On Art And Theatre*, New York: Routledge, 2001, p. 22.
3 Lee Strasberg, *A Dream of Passion: The Development of the Method*, Evangeline Morphos (ed.), New York: Plume, 1988, pp. 69–70.
4 This is, of course, referencing Eugenio Barba's critical work in Barba, Eugenio. *A Dictionary of Theatre Anthropology: The Secret Art of the Performer*, London: Routledge, 1991, which I will return to on several occasions throughout this work. For Barba, a theatrical event is 'extra-daily' because it is framed and, thus, offers the potential for heightened meaning-making.
5 Bruce McConachie, 'Falsifiable Theories for Theatre and Performance Studies', *Theatre Journal*, Vol. 59, No. 4 (2007), pp. 553–77.
6 *Ibid.*, p. 571.
7 Joseph R. Roach, *The Player's Passion: Studies in the Science of Acting*, Ann Arbor: The University of Michigan Press, 1993.
8 Declan Donnellan, *The Actor and the Target*. London: Theatre Communications Group, 2006, p. 89.
9 John Lutterbie, *Toward a General Theory of Acting: Cognitive Science and Performance*. New York: Palgrave Macmillan, 2011, p. 123.
10 William Shakespeare, Sonnets 106 and 110. *The Riverside Shakespeare* 2nd edn, Blakemore Evans (ed.), Boston: Houghton Mifflin, 1997. Sonnets were chosen for the study because they first and foremost came from a

literary/dramaturgical source of fairly universal acclaim. Moreover, two of the lesser known sonnets were chosen so as to hopefully resemble the heightened text an actor might encounter but not be so familiar as to have likely been memorised before. No interview process was conducted to ascertain whether or not the subjects had, in fact, been exposed to either sonnets in any capacity.

11 It should be noted that for this study I coded all of the text and was not able to secure an independent assistant.

12 I ruled out Sonnet 110 because, purely from a subjective observation, it seemed like subjects were getting hung up on the word 'forget'st'. While not part of this specific investigation, it is entirely possible that the word was acting as a kind of cognitive prompt. Not only were they having difficulty remembering the word it is possible the word itself was causing them to actually *forget* the word, 'forget'. Obviously this needs much more research.

13 Likewise, volunteer subjects were taken from Introduction to Theatre, Acting 1, Theatre History, and Script Analysis classes. Subjects were offered 15 extra credit points for participation.

14 As opposed to an 'other-generated' cue, which would include someone else's arbitrary choreography. I will show that when the individual agent is able to generate movement on her own she is clearly able to us her body organically to find meaning and connection.

15 Wu Choon and Seana Coulson, 'Meaningful Gestures: Electrophysiological Indices of Iconic Gesture Comprehension', *Psychophysiology*, Vol. 42 (2005), pp. 654–67.

16 Donna Frick-Horbury and Robert E. Guttentag. 'The Effects of Restricting Hand Gesture Production on Lexical Retrieval and Free Recall', *Journal of Psychology*, Vol. 111, No. 1 (1998), p. 2.

17 Donna Frick-Horbury, 'The Use of Hand Gestures as Self-Generated Cues for Recall of Verbally Associated Targets', *The American Journal of Psychology* 115, No. 1 (2002), pp. 5–9.

18 Wolff-Michael Roth and Daniel V. Lawless. 'How Does the Body Get into the Mind', *Human Studies*, Vol. 25, No. 33 (2002), p. 344.

19 Roger Schank proposes that a dynamic memory system is one that of an open, flexible system that allows for constant, online updating as opposed to a library, for instance, which has a fixed set of information. For the most part, the changes in our memory are not conscious. In *Dynamic Memory Revisited*, he writes: 'Our memories change dynamically in the way they store information by abstracting significant generalizations from our experiences and storing the exceptions to those generalizations.' See Roger C. Schank, *Dynamic Memory Revisited*, Cambridge: Cambridge University Press, 1999, p. 2.

20 Kay Young and Jeffrey L. Saver, 'The Neurology of Narrative', *SubStance*, Vol. 30, No. 1 (2001), p. 73.

21 *Ibid.*, p. 74.

22 Helga Noice and Tony Noice, 'The Non-Literal Enactment Effect: Filling in the Blanks', *Discourse Processes*, Vol. 44, No. 2 (2007), pp. 73–89.
23 See Frick-Horbury 'The Effects of Restricting' 43–62; Clark *Supersizing* 123–5; and Cook 'The Role of Gesture in Learning', pp. 211–32.
24 A growth point is David McNeill's term for the 'psychological predicates' on which the communicative acts are built. See McNeilll *Gesture and Thought*, p. 82; Cook, 'The Role of Gesture in Learning', p. 127.
25 Gallagher, *How the Body Shapes the Mind*, p. 11.

Chapter 8

1 Shaun Gallagher makes a useful distinction between body image and body schema, by describing the former as a body as it appears from within the perceptual field, and the latter as the means by which the configuration and use of a body, shapes the perceptual field itself. See Shaun Gallagher, *How the Body Shapes the Mind*. Oxford: Oxford University Press, 2005.

2 See for example Gail Weiss and Honi Fern Haber (eds), *Perspectives on Embodiment: The Intersections of Nature and Culture*, London: Routledge, 1999; Josephine Machon, *(Syn)aesthetics: Redefining Visceral Performance*, Basingstoke: Palgrave MacMillan, 2009.

3 Ruth Leys, 'The Turn to Affect: A Critique', *Critical Enquiry*, Vol. 37, No. 3 (2011), pp. 443, 437

4 *Ibid.*, p. 443.

5 Daniel N. Stern, 'The Role of Feelings for an Interpersonal Self' in Ulric Neisser (ed.), *The Perceived Self: Ecological and Interpersonal Sources of Self Knowledge*, Cambridge: Cambridge University Press, 1993, p. 206.

6 For more in depth discussions of this perspective see, for example, Alva Noë, *Action in Perception*. Cambridge, MA: MIT Press, 2006; Mark Johnson, *The Meaning of the Body: Aesthetics of Human Understanding*, Chicago IL: University of Chicago Press, 2007.

7 See for example Martin Welton, *Feeling Theatre*, Basingstoke: Palgrave MacMillan, 2012.

8 Harry Heft, *Ecological Psychology in Context: James Gibson, Roger Barker, and the Legacy of William James's Radical Empiricism*, Mahwah, New Jersey and London: Lawrence Erlbaum Associates, 2001, p. 28.

9 Daniel Heller-Roazen, *The Inner Touch: Archaeology of a Sensation*, New York: Zone Books, 2007, p. 295. A similar sort of question is explored by Eve Kosofsky Sedgewick in *Touching Feeling: Affect, Pedagogy, Performativity*, Durham: Duke University Press, 2003.

10 See, for example Roberta Mock (ed.), *Walking, Writing and Performance: Autobiographical Texts by Deirdre Heddon, Carl Lavery and Phil Smith*, Exeter: Intellect, 2009; Mischa Myers, ' "Walk with me, talk with me": The

Art of Conversive Wayfinding', *Visual Studies*, Vol. 25, No. 1 (2010), pp. 59–68.

11 See for example, Gabriella Giannachi and Nigel Stewart (eds), *Performing Nature: Explorations in Ecology and the Arts*, Oxford: Peter Lang, 2005.

12 See for example, Tim Edensor, 'Walking Through Ruins' in Tim Ingold and Jo Lee Vergunst (eds), *Ways of Walking: Ethnography and Practice on Foot*, Farnham: Ashgate, 2008, pp. 123–42.

13 By 'sensory' here, I am referring to the perceptual content of the activities of looking, listening, feeling and so on. As discussed earlier, the 'affective' here refers to the overall sense or quality of 'how it goes' that those more particular perceptions converge with.

14 Tim Ingold, 'Culture on the Ground: The World Perceived Through the Feet', *Journal of Material Culture*, Vol. 9, No. 3 (2004), pp. 315–430.

15 See for example, Debbie Green and Ita O'Brien, 'From Grounded Foot to Leaping Foot', *Theatre, Dance and Performance Training*, Vol. 3, No. 1 (2012), pp. 99–118. A notable exception to this received wisdom is the training system developed by Tadashi Suzuki and his collaborators (see for example, Paul Allain *The Art of Stillness: The Theatre Practice of Tadashi Suzuki*. London: Methuen, 2002). Although it does work directly in developing performers dynamic sense of the relationship between foot and floor as a means of energising performance, as a *system*, it works more with a particular style or approach to stepping, stamping and walking, than with the more 'pedestrian', and environmentally responsive footwork that has informed our experiments at Bunce's Barn.

16 Mike Alfreds, *Different Every Night: Freeing the Actor*, London: Nick Hern Books, 2007, p. 209.

17 As John Searle has argued, even though Descartes' ideas have been regularly dismissed, his vocabulary has proven remarkably enduring. See John R. Searle, *The Rediscovery of the Mind*, Cambridge, MA: The MIT Press, 1994, p. 14.

18 The phrase was used by Tallis in a debate with Matthew Taylor at the Royal Society of Arts in 2011 entitled 'Neuromania: The Possibilities and Pitfalls of Our Fascination With Brains'. Much of the same topic is discussed by him in *Aping Mankind: Neuromania, Darwinitis, and the Misrepresentation of Humanity*, London: Acumen, 2011. His debate with Taylor can be viewed online at: http://www.thersa.org/events/video/vision-videos/neuromania-the-possibilities-and-pitfalls-of-our-fascination-with-brains (accessed 5 October 2012).

19 Anthony Chemero, *Radical Embodied Cognitive Science'*, Cambridge, MA: MIT Press, 2009, p. 201.

20 The theory of affordances is most explicitly laid out by Gibson in *The Ecological Approach to Visual Perception*, Hillsdale, NJ: Lawrence Erlbaum Associates, 1986.

21 Gibson, *op. cit.*, p. 129.

22 Chemero, *op. cit.*, p. 155.

23 *Ibid.*, p. 158.

24 *Ibid.*, p. 201.

25 For a further discussion of infrastructure and superstructure relative to footwork, see Tim Ingold, 'Footprints Through the Weather-world: Walking, Breathing, Knowing', *Journal of the Royal Anthropological Institute*, Vol. 16, No. S1 (2010), pp. S121–S139.

26 Drew Leder, *The Absent Body*, Chicago IL: University of Chicago Press, 1990.

27 For further discussion see David Krasner, *Method Acting Reconsidered: Theory, Practice, Future*. Basingstoke: Palgrave, 2009.

28 'To attend to a bodily sensation' Csordas proposes, 'is not to attend to the body as an isolated object, but to attend to the body's situation in the world ... Attention *to* a bodily sensation can thus become a mode of attending to the intersubjective milieu that give rise to that sensation. Thus, one is paying attention *with* one's body'; 'Somatic Modes of Attention', *Cultural Anthropology*, Vol. 8, No. 2 (1993), p. 138.

29 Gibson, 1986, *op. cit.*, p. 226.

30 Tim Ingold and Jo Lee Vergunst (eds), *Ways of Walking: Ethnography and Practice on Foot*, Farnham: Ashgate, 2008, p. 2.

31 'Smooth tactilities' is a term use by Edensor, 2008.

32 Gibson, *op. cit.*, p. 223.

33 Maxine Sheets-Johnstone, *The Corporeal Turn: An Interdisciplinary Reader*, Exeter: Imprint Academic, 2009, p. 137.

34 *The Senses of Touch: Haptics, Affects and Technologies*. Oxford: Berg, 2007.

35 Instances of specialist practices like ballet might seem to contradict this. However, taken off-stage and 'off-pointe' the case would surely remain the same, inasmuch as technique is, in some respects, as much a habit as are more quotidian movements.

36 Michel Serres, *The Five Senses: A Philosophy of Mingled Bodies*, trans. Margaret Sankey and Peter Cowley, London: Continuum, 2008, p. 80.

37 Heller-Roazan, *op cit.*

38 Sheets-Johnstone, 2009, *op. cit.*, p. 147.

Chapter 9

1 The notion of 'theatre cultures' was proposed by Fabrizio Cruciani and denotes the collaboration between theatre theory and practice: 'Theatre makes sense when it is organically living: when it is not just either performance art and technique or history of performances and theories, but when it becomes *theatre culture*'; Fabrizio Cruciani, 'Il "luogo dei possibili"' in Clelia Falletti (ed.), *Il corpo scenico*, Roma: Editoria & Spettacolo, 2008, pp. 168–71.

2 Nicola Modugno, Intervention at the First International Conference

'Dialoghi tra teatro e neuroscienze', 20 marzo 2009, non-published transcription.

3 For the scientific paper see Nicola Modugno et al., 'Active Theater as a Complementary Therapy for Parkinson's Disease Rehabilitation: A Pilot Study', *The Scientific World Journal*, No. 10 (2010), pp. 2301–13. For a wider and less technical account of the project, see Nicola Modugno 'Oltre il dialogo la simbiosi. Un modello di teatro terapeutico per i pazienti affetti da malattia di Parkinson' in Clelia Falletti and Gabriele Sofia (eds), *Nuovi dialoghi tra teatro e neuroscienze*, Roma: Editoria & Spettacolo, 2011, pp. 43–55.

4 Modugno et al., 'Active theater', p. 2302.

5 *Ibid.*, p. 2312.

6 *Ibid.*, p. 2311.

7 This perspective characterises what, for instance, Marco De Marinis called 'Nuova teatrologia' ('*New Theatrology*'); see Marco De Marinis, *Capire il teatro. Lineamenti di una nuova teatrologia*. Firenze: La Casa Usher, 1988; 'New Theatrology and Performance Studies: Starting Points Towards a Dialogue', *The Drama Review*, Vol. 55, No. 4 (2011), pp. 64–74.

8 Some remarkable exceptions are the experiments carried out by Corinne Jola and colleagues: see Jola et al., 'Arousal decrease in Sleeping Beauty: audiences' neurophysiological correlates to watching a narrative dance performance of two-and-a-half hours', *Dance Research*, Vol. 29, No. 2 (2011), pp. 378–403; Jola et al., 'Motor Simulation without Motor Expertise: Enhanced Corticospinal Excitability in Visually Experienced Dance Spectators', *PLoS ONE*, Vol. 7, No. 3 (2012), p. 333, 43.

9 In the recent years there has been a great number of scientific publications on this subject. For a global review see Giacomo Rizzolatti and Corrado Sinigaglia, *Mirrors in the Brain: How our minds share action and emotions*, Oxford: Oxford University Press, 2008; for a more complete and updated review see Giacomo Rizzolatti and Maddalena Fabbri-Destro, 'Mirror neurons: from discovery to autism', *Experimental Brain Research*, No. 200 (2010), pp. 223–37.

10 See Francisco J. Varela, Evan Thompson and Eleanor Rosch, *The Embodied Mind: Cognitive Science and Human Experience*. Cambridge, MA: MIT Press, 1991; Shaun Gallagher, *How the Body Shapes the Mind*, Oxford: Oxford University Press, 2006.

11 Rizzolatti and Sinigaglia, *Mirrors in the Brain*, p. 127.

12 Eugenio Barba, *On Directing And Dramaturgy: Burning The House*, New York and London: Routledge, 2010, p. 33.

13 See M. A. Umiltà et al.,'When pliers become fingers in the monkey', *Proceedings of the National Academy of Sciences*, Vol. 105, No. 6 (2008), pp. 2209–13.

14 Gallese 2007; Gallese et al., 2007.

15 In the work written by Alain Berthoz in collaboration with the

philosopher Jean-Luc Petit, this concept is often dwelled upon: 'The brain is a predictor, the physiologist willingly asserts. And right away we find ourselves confronted with a striking revision of the classical paradigm, a revision according to which anticipation, instead of being an exception, proves to be the rule for any intelligent behavior.' Alain Berthoz and Jean-Luc Petit, *The Physiology and Phenomenology of Action*, Oxford: Oxford University Press, 2008, p. 19.

16 Gallagher, *How the Body Shapes the Mind*, p. 234.

17 Dorothée Legrand, 'Body Intention and the Unreasonable Intentional Agent' in Franck Grammont, Dorothée Legrand and Pierre Livet (eds), *Naturalizing Intention in Action*, Cambridge, MA: MIT Press, 2010, pp. 161–80, 167. It is interesting to remark that at the beginning of the 1990s Eugenio Barba had already highlighted how important it is that the actor becomes aware of such pre-reflexive mechanisms of action anticipation: 'In the case of an action or reaction, the position of each finger changes as soon as the eyes have transmitted the relevant information, depending on whether we are about to pick up a piece of broken glass or a bread crumb, a heavy dictionary or an inflated balloon. Our fingers, before reaching the object, already assume the muscular tonus suitable to the weight and tactile quality of the object. The manipulatory muscles are already at work. The asymmetry of the fingers is a sign of life, of credibility, manifest by means of the tensions of the manipulatory muscles, which are ready to act according to the weight, the temperature, the volume, the fragility of the object towards which the hand is extended, but also according to the affective reaction which the object elicits in us.' (Eugenio Barba, *The Paper Canoe. A Guide to Theatre Anthropology*, London: Routledge, 1995, p. 25.)

18 This is what Odin Teatret defined as *sats*, that is, a moment of transition from an action to another. Identifying this precise moment, which lies unseen in the everyday life, allows the actor to lead the spectator to make a certain forecast, so that he can eventually decide whether surprising him or confirming the spectator's expectation (*ibid.*, p. 54).

19 Taking into account another example, the first principle of Meyerhold's biomechanics states: 'The whole biomechanics is based on this fact: if the nose works, the whole body works as well.' Vsevolod Meyerhold, 'Principes de Biomécanique' in *Écrits sur le théâtre. Tome II, 1917–1929. Nouvelle édition revue et augmentée*, Lausanne: La Cité-L'Age d'Homme, 2009, pp. 100–3, 100.

20 For instance, every time the actor executes an action on stage, his attention is not only addressed to the goal of his action but also to the spectators' attention. In other words, at the same time the actor has to attend to a 'double task': executing the action and directing the spectator's attention. In this way, performing different body techniques allows the actor to increase his attention skills, which are essential to maintain his continuing relationship with the spectator. Therefore, the improvement of the actor's

body control is aimed at accomplishing his 'double task': doing something and stimulating the spectator at the same time.

21 The notion of *thinking in motion* was proposed in 1988 by John Blacking, the founder of Ethnomusicology, during the seminar 'Theatre, Anthropology, and Theatre Anthropology', organized by the Centre for Performance Research in Leicester, in the autumn of 1988.

22 Emmanuel De Saint Aubert, 'Espace et schéma corporel dans la philosophie de la chair de Merleau-Ponty' in Alain Berthoz and Bernard Andrieu (eds), *Le corps en acte*, Nancy: Presses Universitaires de Nancy, 2010, pp. 123–52, 125.

23 Pamela Quinn, 'Moving Through Parkinson's. When her body rebelled, one dancer fought back', *Dance Magazine*, December 2007.

24 Vittorio Gallese and George Lakoff, 'The Brain's Concepts: The Role of the Sensory-motor System in Conceptual Knowledge', *Cognitive Neuropsychology*, No. 22 (2005), p. 455–79.

25 For further information and technical details of the experiment see Sofia et al.,'Il linguaggio incarnato dell'attore. Indicazioni preliminari di un esperimento pilota' in Clelia Falletti and Gabriele Sofia (eds), *Prospettive su teatro e neuroscienze. Dialoghi e sperimentazioni*, Roma: Bulzoni, 2012.

26 Antoinin Artaud, *Le théâtre et son double*, Gallimard: Paris, 1938.

27 Fabrizio Cruciani, *Registi pedagoghi e comunità teatrali del Novecento*, Roma: Editori & Associati, 1995.

28 Let us consider a specific example. Since 1993 the Maltese director and theatre professor John Schranz has collaborated with the neuroscientist Richard Muscat on several research projects, in particular the creation of the European joint Masters in Science of Performative Creativity (www.ema-ps.com). In a recent article, in which both the experts discussed the mutual benefits arisen from their collaboration, Muscat wrote: 'The size nerve cells is 10^{-6} of a metre. They are microns. This is the sort of work I do in my laboratory, in which I look at particular cells and see how their characteristics change when I would have applied a particular drug. The interesting thing is to see now, because of my work with John, what may happen to these particular cells in the rat if now I alter their behaviour through a form of training which I design in reflection of the behaviour I choose to select from what I see in the performance of the actor' (John Schranz and Richard Muscat, 'What is it to be Human? A Theatre Neuroscience Perspective', *Culture Teatrali*, No. 17 (2007), pp. 89–115). Although wishing to underline the wide gap and difference that separates the work on the actor and that on the guinea-pigs, we cannot disregard the existing dialogue though which exchanging ideas and practices can provide solutions that were so far unexpected and unimagined.

29 Jean Marie Colombani, Jean Marie and Edwy Plenel, Edwy, 'Un entretien avec Edgar Morin', *Le Monde*, 26 November 1991.

Introduction

1 Andreas K. Engle, 'Directive Minds: How Dynamics Shapes Cognition' in John Stewart, Olivier Gapenne and Ezequiel A. Di Paolo (eds), *Enaction: Toward a New Paradigm for Cognitive Science*, Cambridge, MA: MIT Press, 2010, p. 221.

2 Andy Clark, *Being There: Putting Brain, Body, and World Together Again*, Cambridge, MA: MIT Press, 1997, p. 47.

3 Brian Boyd, *On the Origin of Stories: Evolution, Cognition, and Fiction*, Cambridge, MA: Harvard University Press, 2009. According to Boyd, all art is 'a kind of cognitive *play*, the set of activities designed to engage human *attention* through their own appeal to our preference for inferentially rich and therefore *patterned* information' (italics in original) (Boyd, *Origin of Stories*, p. 85). I have explored these connections recently in 'An Evolutionary Perspective on Play, Performance, and Ritual', *TDR*, Vol. 55, No. 4 (Winter 2011), pp. 33–50.

4 For an illuminating summary of Gerstmyer's role-playing experiments with his daughter, see Sutton-Smith, Brian, *The Ambiguity of Play*, Cambridge, MA: Harvard University Press, 1997, pp. 193–4.

5 Clark, *Being There, op. cit.,* p. 221.

6 See James J. Gibson, *The Ecological Approach to Visual Perception*, Boston: Houghton Mifflin, 1979. For recent applications of Gibson's work to theatre studies, see Paavolainen, Teemu, *Theatre, Ecology, Cognition: Theorizing Performer-Object Interaction in Grotowski, Kantor, and Meyerhold*, New York: Palgrave Macmillan, 2012 and Tribble, Evelyn, *Cognition in the Globe: Attention and Memory in Shakespeare's Theatre*, New York: Palgrave Macmillan, 2011.

7 Lyn Gardner, 'Anxiety Theatre', http://www.guardian.co.uk/stage/theatre-blog/2009/mar/02/anxiety-theatre (accessed 13 August 2011). For further discussion of this problem and how researchers are currently understanding it, see Shaughnessy, Nicola, *Applying Performance: Live Art, Socially Engaged Theatre, and Affective Practice*, Basingstoke: Palgrave Macmillan, 2012, pp. 192–201.

8 Jaak Panksepp, *Affective Neuroscience: The Foundations of Human and Animal Emotions*, New York: Oxford University Press, 1998, p. 14. See McConachie, Bruce, *Engaging Audiences: A Cognitive Approach to Spectating in the Theatre*, New York: Palgrave Macmillan, 2008, pp. 93–6, 106–13, for my discussion and use of Panksepp's ideas.

9 *Ibid.*, p. 15.

10 Antonio Damasio, *The Feeling of What Happens: Body and Emotion in the Making of Consciousness*, New York: Harcourt, 1999, p. 55. See also Damasio's, *Looking for Spinoza: Joy, Sorrow, and the Feeling Brain*, New York: Harcourt, 2003.

11 Walter J. Freeman, *How Brains Make Up Their Minds*, New York: Columbia University Press, 2000, pp. 91–2.

12 I have relied primarily on Simon Baron-Cohen, *Mindblindness: An Essay on Autism and Theory of Mind*, Cambridge, MA, MIT Press, 1995, Jean Decety and William Ickes (eds), *The Social Neuroscience of Empathy*, Cambridge, MA: MIT Press, 2009, and Steuber, Karsten, *Rediscovering Empathy: Agency, Folk Psychology, and the Human Sciences*, Cambridge, MA: MIT Press, 2006, and Thompson, Evan, *Mind in Life: Biology, Phenomenology, and the Sciences of Mind*, Cambridge, MA: Harvard University Press, 2007, for insights into empathy.

13 Thompson, *op. cit.* pp. 393–5.

14 Thompson, *op. cit.*, pp. 395–7.

15 See Simone G. Shamay-Tsoory, 'Empathic Processing: Its Cognitive and Affective Dimensions and Neuroanatomical Basis' in *The Social Neuroscience of Empathy*, pp. 215–32.

16 Thompson, *op. cit.*, p. 398, 402.

17 On the response of the critics to *A Streetcar Named Desire*, see my *American Theater in the Culture of the Cold War: Producing and Contesting Containment*, Iowa City, IA: University of Iowa Press, 2003, pp. 93–3 and Philip C. Kolin, *Williams: A Streetcar Named Desire, Plays in Production*, Cambridge: Cambridge University Press, 2000. All theatre reviews of the premiere of *Streetcar* in 1947 by Atkinson, Barnes, Chapman, Coleman, Garland, Hawkins, Morehouse, Kronenberger and Watts may be found in Rachel Coffin (ed.), *New York Theatre Critics' Reviews*, Vol. 8 (1947), New York: Critics' Theatre Reviews, 1948, pp. 249–52.

18 Regarding the critical response to the Clurman-Hagen-Quinn *Streetcar*, see Kolin, *Streetcar*, pp. 33–9.

19 On emotional contagion, see Elaine Hatfield, John R. Cacioppo and Richard L. Rapson, 'Primitive Emotional Contagion' in Clark, Margaret S. (ed), *Emotion and Social Behavior*, Review of Personality and Social Psychology, Vol. 14, Newbury Park, CA: Sage Publications, 1992, pp. 151–77. In *Engaging Audiences*, pp. 92–8, I bring other scientific and historical insights to bear on emotional contagion. Michael H. Thaut discusses entrainment and its effects in listening to music in 'Rhythm, Human Temporality, and Brain Function' in Dorothy Meill, Raymond MacDonald and Donald J. Hargreaves (eds), *Musical Communication*, Oxford: Oxford University Press, 2005, pp. 171–91.

20 Carl Plantinga, *Moving Viewers: American Film and The Spectator's Experience*, Berkeley: University of California Press, 2009.

21 For Plantinga's types and timing of spectators' emotional engagement, see *Moving Viewers*, pp. 48–77.

Chapter 10

1 See Josephine Machon, *(Syn)aesthetics: Redefining Visceral Performance*, Basingstoke: Palgrave 2009; *Immersive Theatres: Intimacy and Immediacy in Contemporary Performance*, Basingstoke: Palgrave, 2013.

2 The somatic, ('affecting the body' or 'absorbed through the body') and the semantic (the 'mental reading' of signs).

3 Noetic cognition, (from the Greek derived, *noēsis, noētikos, nous*, meaning inner wisdom, subjective intellect or understanding) is a knowledge that is experienced directly which can incorporate sensations of transcendence or 'the ineffable' (that which cannot be put into words); experiences that defy explanation yet are *felt* and consequently *feel understood.*

4 I use 'haptic', 'haptically', 'haptical', 'hapticity', (from the Greek, *haptikos* and *haptesthai*, to grasp, sense, perceive, 'lay hold of'), in relation to the performing/perceiving sensual body, alongside tactile as the latter tends to connote only the surface quality of touch.

5 I am not arguing, per se, that (syn)aesthetic works in general, and immersive practice in particular, automatically *induce* synaesthesia, but instead am drawing attention to a quality of experience that exists in appreciation that the language of synaesthesia and accompanying research into the condition helps to articulate.

6 See Machon, *(Syn)aesthetic*, in particular pp. 13–24, for a more detailed explication.

7 See Richard E. Cytowic, *The Man Who Tasted Shapes*, London: Abacus, 1994, 2002. *Synesthesia: A Union of the Senses*, 2nd edn, Cambridge, MA: MIT Press, 2002; V. S. Ramachandran and E. M. Hubbard, 'Hearing Colors, Tasting Shapes', *Scientific American*, Vol. 288, Issue 5 (2003), pp. 52–9; Cretien van Campen, *The Hidden Sense: Synaesthesia in Art and Science*, Cambridge MA: MIT Press, 2008; Vincent Walsh and Catherine Mulvenna, 'Synaesthesia: Supernormal Integration?' *Trends in Cognitive Sciences*, Vol. 10, No. 8, (2006), pp. 350–2; Walsh et al., 'Synaesthesia: Learned or Lost?', *Developmental Science*, Vol. 12 (2009), pp. 484–91.

8 Cytowic, *The Man Who*, p. 8.

9 Ramachandran, 'Hearing Colours', p. 58.

10 Walsh and Mulvenna, *op cit.*, p. 350.

11 Cytowic, *The Man Who*, pp. 76–7; *Synasthesia*, pp. 67–70.

12 Cytowic, *The Man Who*, pp. 78, 121, 229, 92, 167, 7, 14.

13 A. R. Luria, *The Mind of a Mnemonist: a little book about a vast memory*, New York: Cape, 1969, pp. 77, 138, 144, 96.

14 Cytowic, *The Man Who*, p. 119

15 Luria, *Mind*, p. 133.

16 See Cytowic, *Synasthesia*, pp. 100–2, 132 and van Campen, *op. cit.*, pp. 103–14.

17 Cytowic, *Synasthesia*, pp. 167, 92.

18 Elaine Scarry, *The Body In Pain: The Making and Unmaking of the World*. New York and Oxford: Oxford University Press, 1985, p. 197.

19 Cytowic, *The Man Who*, p. 229. Walsh also highlights ideas around the 'a-ha' moment of artistic creativity and experience as his 'Neuroscience and Creativity' TEDx video archive documents.

20 This idea develops on a tactile and haptic level Peter Brook's idea of performance work which makes 'the invisible visible' (*The Empty Space*, Harmondsworth: Penguin, 1968, p. 47).

21 Machon, *(Syn)aesthetics*, pp. 54–81.

22 In Machon, *Immersive*, pp. 175–6.

23 *Ibid*.

24 *Ibid*., emphasis added.

25 *Ibid*., pp. 176–7.

26 *Ibid*., p. 177.

27 *Ibid*., p. 180.

28 *Ibid*.

29 *Ibid*., p. 175.

Chapter 11

1 Maaike, Bleeker, *Visuality in the Theatre: The Locus of Looking*, Basingstoke: Palgrave Macmillan, 2008, p. 18.

2 Liesbeth Groot Nibbelink, 'Radical Intimacy: Ontroerend Goed Meets the Emancipated Spectator', *Contemporary Theatre Review*, Vol. 22, No. 3 (2012), p. 413.

3 C. P Snow, 'The Two Cultures', *Leonardo*, Vol. 23, No. 2/3 (1990), p. 169.

4 *Ibid*., p. 173.

5 In the United Kingdom, at least, the educational system is being significantly influenced by the Research Excellence Framework (REF). The REF is intended as a measure of academic quality in UK higher education institutions (HEI) and attempts to justify public funding in the public interest. At the time of writing, the REF will form the basis of HEI funding decisions following completion in 2014. For the humanities, research results can be difficult to quantify. While the REF may be regarded as an opportunity for humanities subjects to make more use of evidence led-enquiry, it might also be interpreted as a threat to a well-established and valuable set of working practices that are not governed by measurable outcomes.

6 Joseph LeDoux, *The Emotional Brain: The Mysterious Underpinnings of Emotional Life*, London: Phoenix, 1998, p. 291.

7 Carl Plantinga,, *Moving Viewers: American Film and the Spectator's Experience*, Berkeley: University of California Press, 2009, p. 57.

8 *Ibid*.

9 George Lakoff and Mark Johnson, *Philosophy in the Flesh: The Embodied Mind and its Challenge to Western Thought*, New York: Basic Books, 1999, p.11.

10 LeDoux, *op. cit.*, p. 29.

11 Plantinga, *op. cit.*, p. 57.

12 Arnold, *op. cit.*, p. 178.

13 Mark Johnson, *The Meaning of the Body: Aesthetics of Human Understanding*, Chicago IL: University of Chicago Press, 2007, pp. 60–1.

14 Lakoff and Johnson, *op. cit.*, pp. 37–38.

15 M. B. Arnold and J. A. Gasson, 'Feelings and Emotions as Dynamic Factors in Personality Integration' in Magda B. Arnold (ed.), *The Nature of Emotion: Selected Readings*, Harmondsworth: Penguin Books, 1968, p. 203, original emphasis.

16 Magda B. Arnold, 'Perennial Problems in the Field of Emotion' in Magda B. Arnold (ed.), *Feelings and Emotions: The Loyola Symposium*, New York: Academic Press, 1970, p. 176.

17 Antonio Damasio, *The Feeling of What Happens: Body and Emotion in the Making of Consciousness*, New York: Harcourt Brace and Company, 1999, p. 51. See also Ekman, Friesen and Ellsworth, p. 64.

18 Damasio, *op. cit.*, p. 51. See also pp. 54–7.

19 Bruce McConachie, *Engaging Audiences: A Cognitive Approach to Spectating in the Theatre*, New York: Palgrave Macmillan, 2008, p. 4.

20 Arnold, *op. cit.*, p. 174.

21 This underscoring of the role played by cognitive processes is perhaps what distinguishes Arnold's notion of affective memory from Machon's account of corporeal memory also explored in this volume.

22 Susan Bennett, *Theatre Audiences: A Theory of Production and Reception*, second edition, London: Routledge, 1997, p. 98.

23 Johnson, *op cit.*, p. ix.

24 For more on plunging into the darkness in theatre, see Martin Welton, *Feeling Theatre*, Basingstoke: Palgrave Macmillan, 2012, p. 63.

25 Paul Slovic, 'Introduction and Overview' in Paul Slovic (ed.), *The Perception of Risk*, London: Earthscan, 2000, p. xxii.

26 Ortwin Renn and Bernd Rohrmann, 'Risk Perception Research: An Introduction' in Ortwin Renn and Bernd Rohrmann (eds), *Cross-Cultural Risk Perception: A Survey of Empirical Studies*, London: Kluwer Academic Publishers, 2000, p. 13.

27 Brian Massumi, *Parables for the Virtual: Movement, Affect, Sensation*, Durham: Duke University Press, 2002, pp. 57–8.

28 Damasio, *op. cit.*, p. 41.

29 Ortwin Renn and Bernd Rohrmann, 'Cross-Cultural Risk Perception: State and Challenges' in Ortwin Renn and Bernd Rohrmann (eds), *Cross-Cultural Risk Perception: A Survey of Empirical Studies*, London:

Kluwer Academic Publishers, 2000, p. 221. See also Slovic, 'Introduction', pp. xxxi–xxxii.

30 Justin L Barrett, 'Gods' in Harvey Whitehouse and James Laidlaw (eds), *Religion, Anthropology and Cognitive Science*, Durham: Carolina Academic Press, 2007, p. 189.

31 *Ibid.*

32 Liesbeth Groot Nibbelink usefully observes: 'I think it is remarkable that Rancière's distribution of the sensible hardly pays attention to the possibility of corporeal intelligence: knowledge that is present in affects and sensations', Groot Nibbelink, p. 418, original emphasis.

Chapter 12

1 'GOFAI' (or Good Old Fashioned Artificial Intelligence) was first coined by John Haugeland and is a widespread term for artificial intelligence. See John Haugeland, *Artificial Intelligence: The Very Idea*, Cambridge, MA: MIT Press, 1985.

2 See Chris Sinha, 'Blending out the background: Play, Props and Staging in the Material World', *Journal of Pragmatics*, Vol. 37 (2005), pp. 1537–54, 1540–1.

3 Jordan Zlatev, Timothy Racine, Chris Sinha and Esa Itkonen, 'Intersubjectivity: What Makes us Human?' in Jordan Zlatov, Timothy Racine, Chris Sinha and Esa Itkonen (eds), *The Shared Mind: Perspectives on Intersubjectivity*, Amsterdam and Philadelphia: John Benjamins Publishing Company, 2008, pp. 1–38, 1.

4 See Evan Thompson, 'Empathy and Consciousness' in Evan Thompson (ed.), *Between Ourselves: Second-Person Issues in the Study of Consciousness*, Thorveton: Imprint Academic, 2001, pp. 1–32, 2.

5 There is a spectrum of impairments in autism and each child moreover is on their own unique spectrum with differing degrees of difference. See Lorna Wing, *The Autistic Spectrum, A Guide for Parents and Professionals*, London: Constable, 1996.

6 Imagining Autism: Drama, Performance and Intermediality as Interventions for Autistic Spectrum Conditions (October 2010–April 2014) is an AHRC (Arts and Humanities Research Council) funded project that hopes to establish the efficacy in cognitive development terms of applied theatre work with autistic children: the work is subject to a range of quantitative and qualitative measures by psychologists. The Principal Investigator is Professor Nicola Shaughnessy, and Co-Investigators are Dr Melissa Trimingham, Dr Julie Beadle-Brown and Dr David Wilkinson, all University of Kent. See Nicola Shaughnessy, 'Knowing Me, Knowing You: Autism, Kinesthetic Empathy and Applied Performance' in Dee Reynolds

and Matthew Reason (eds), *Kinesthetic Empathy in Creative and Cultural Practices*, Bristol: Intellect, 2012, pp. 33–50.

7 See Evelyn Tribble, this volume.

8 The phrase is taken from Jerome Bruner, *Acts of Meaning*, Cambridge, MA and London: Harvard University Press, 1990.

9 Francisco. J. Varela, Evan Thompson and Eleanor Rosch, *The Embodied Mind: Cognitive Science and Human Experience*, Cambridge MA: The MIT Press, 1991. However a cognitive approach to objects has recently been explored within performance contexts by Teemu Paavolainen, *Theatre/Ecology/Cognition: Theorizing Performer-Object Interaction in Grotowski, Kantor, and Meyerhold*, New York: Palgrave Macmillan, 2012.

10 Gilles Fauconnier and Mark Turner, *The Way We Think: Conceptual Blending and the Mind's Hidden Complexities*, New York: Basic Books, 2002.

11 Sinha (2005), *op. cit.*, p. 1357.

12 See Chris Sinha, *Language and Representation: A Socio-Naturalistic Approach to Human Development*, New York, London, Toronto, Sydney and Tokyo: Harvester Wheatsheaf, 1988, pp. 92–8 and Sinha (2005), p. 1539.

13 Cintia Rodrïguez, and Moro Christiane, 'Coming to Agreement: Object use by Infants and Adults' in Zlatov, Racine, Sinha and Itkonen, *Shared Mind*, p. 92.

14 Chris Sinha, 'Objects in a Storied World: Materiality, Normativity, Narrativity', *Journal of Consciousness Studies: Controversies in Science and the Humanities*, Vol. 16, Parts 6–8 (2009), pp. 167–90, 177.

15 The phrase comes from Sinha, *ibid.* Folk psychology is most commonly rejected by neuroscience. See Andy Clark, *Mindware, An Introduction to the Philosophy of Cognitive Science*, Oxford: Oxford University Press, 2001, pp. 44–5.

16 Some confusion and controversy surrounds these terms, and this claim. See Philip Robbins, and Murat Aydede, 'A Short Primer on Situated Cognition' in Philip Robbins and Murat Aydede (eds), *The Cambridge Handbook of Situated Cognition*, Cambridge: Cambridge University Press, 2009, pp. 3–10 for an attempt at clarification.

17 Edwin Hutchins, *Cognition in the Wild*, Cambridge, MA, London: MIT Press, 1995. See also Hutchins, 'Material Anchors for Conceptual Blends', *Journal of Pragmatics*, 27, 2005, pp. 1555–77.

18 Distributed cognition can also be seen at work in the team of facilitators and performers in Imagining Autism when responding to and with the children in performance. It is not however a model of thinking that operates continually and to the exclusion of all other types: see Gavriel Salomon, 'No Distribution Without Individual's Cognition: A Dynamic Interactional View' in Gavriel Salomon (ed.), *Distributed Cognition: Psychological and Educational Considerations*, Cambridge: Cambridge University Press, 1993, pp. 111–38.

19 This certainly is achieved at times, most commonly with the higher
 functioning children we work with.
20 See note 16. 'Situated cognition' is here used, as Robbins and Aydede
 suggest, as a 'genus' term under which other types of cognition might fall.
21 My analysis of the intersubjectivity in the use of objects between autistic
 children is not intended to comment upon neurotypical cognitive
 development in young children or babies as this is beyond my remit
 and expertise. However my account is undoubtedly couched in terms
 of the 'intersubjectivity' theory of gradual cognitive development
 espoused by Michael Tomasello, Shaun Gallagher, Evan Thompson and
 others (Michael Tomasello, *The Cultural Origins of Human Cognition*,
 Cambridge Mass: Harvard University Press, 1999; Gallagher, Shaun and
 Daniel D. Hutto, 'Understanding others through primary interaction and
 narrative practice' in Zlatev, Racine, Sinha and Itkonen, pp. 17–138; and
 Thompson, Evan (ed.), *op. cit.* (2001) This is in contrast to the 'Theory of
 Mind' espoused by Simon Baron-Cohen, in for example Simon Baron-
 Cohen, A. M. Leslie and U. Frith, 'Does the autistic child have a "theory
 of mind"?', *Cognition* 21, (1985), pp. 37–46 and Simon Baron-Cohen,,
 'From Attention-Goal Psychology to Belief-Desire Psychology: The
 Development of a Theory of Mind, and its Dysfunction' in Simon Baron-
 Cohen, Helen Tager-Flusberg and Donald Cohen, *Understanding Other
 Minds: Perspectives from Autism*, Oxford, New York and Tokyo" Oxford
 University Press, 1993, pp. 59–82. The so-called 'theory-theory' version of
 Theory of Mind is individualist and mentalist in that it stresses the child
 acquiring the ability to read the minds of others at approximately four
 years old by being able to reason behaviour out, using folk psychology
 as 'causal explanatory generalisations' (Thompson, p. 11). The model I
 pursue in contrast is basically processual, gradual, and hard to subject
 to scientific method of experiment and proof; as a result it has met a
 wary reception from some psychologists. See Peter Hobson and Jessica
 A. Hobson,'Engaging, sharing, knowing: Some lessons from research in
 autism' in Zlatev, Racine, Sinha and Itkonen, pp. 67–88.
22 Sinha (2009), *op. cit.*, p. 168.
23 Bruner, *op. cit.*, p. 35.
24 Sinha (2009), *op. cit.*, p. 168.
25 See Sinha's experiments observing very young children using objects
 showing preference for 'canonicality effects' (i.e. normative use as opposed
 to brute affordances offered): Sinha (2009), *op cit.*, pp. 178–81.
26 Fauconnier and Turner point out that 'The child plays with money, toy
 watches, and books, long before having the concepts of buying, telling
 time, and reading' (Fauconnier and Turner, *op cit.*, p. 215).
27 See Paavolainen, *op cit.*, pp. 29–37.
28 James Gibson, The Ecological Approach to Visual Perception, Boston:
 Houg Mifflin, 1979, p. 127.

29 Michael Tomasello, *The Cultural Origins of Human Cognition*, Cambridge, MA: Harvard University Press, 1999, pp. 84–5.

30 Gibson, *op. cit.*, p. 128.

31 Tomasello, *op. cit.*, pp. 84–5.

32 Sensory rooms in special schools, used by teachers and carers as calming places to comfort an autistic child, only offer of course these simple affordances.

33 These stages are taken from footage of the project (in St Nicholas School, Canterbury) but also informed by my notes at the time.

34 Tomasello, *op. cit.*, p. 14.

35 *Ibid.*, p. 7.

36 *Ibid.*, pp. 56–93 and Thompson *op. cit.*, p. 2.

37 Baron-Cohen, Leslie and Frith, *op. cit.*, pp. 37–46.

38 Gallagher and Hutto, *op cit.*, pp. 20–3; see note 19.

39 Olga Bogdashina, *Sensory Perceptual Issues in Autism and Asperger Syndrome Different Sensory Experiences – Different Perceptual Worlds*, London: Jessica Kingsley, 2004.

40 This is embodied cognition: see George Lakoff and Mark Johnson, *The Embodied Mind and its Challenge to Western Thought*, New York: Basic Books, 1999. It is important to note that Lakoff and Johnson's work, although readily embraced by performance researchers such as myself, remains by no means universally accepted by cognitive scientists.

41 Lakoff and Johnson, *op. cit.*, pp. 49–54.

42 See for example Chris Sinha and Kristine Jensen de López, 'Language, Culture and the embodiment of social cognition', *Cognitive Linguistics*, Vol. 11 (2000), pp. 17–41, 20.

43 This is a feature we often noticed in autistic children with limited social skills: when they appear to want to engage but do not know how to do so, they resort to hitting or throwing things.

44 Before getting out, Joseph continued to spend a happy time in his bin observing the scene spread out before him closely, and securely, as the action moved away from him and developed elsewhere.

Select Bibliography

Cognitive and affective science

Baron-Cohen, Simon, Helen Tager-Flusberg and Donald Cohen, *Understanding Other Minds: Perspectives from Developmental Cognitive Neuroscience*, 2nd edn, Oxford: Oxford University Press, 1999.

Barrett, Lisa Feldman, Paula M. Niedenthal and Pioter Winkielman (eds), *Emotion and Consciousness*, New York: Guilford Press, 2005.

Bechtel, William and George Graham, *A Companion to Cognitive Science*, Malden, MA: Wiley-Blackwell: 1999.

Bergen, Benjamin K., *Louder Than Words: The New Science of How the Mind Makes Meaning*, New York: Basic Books, 2012.

Berthoz, Alain and Jean-Luc Petit, *The Physiology and Phenomenology of Action*, Oxford: Oxford University Press, 2008.

Boden, Margaret A., *Mind As Machine*, Oxford: Oxford University Press, 2006.

Carruthers, Peter, *Architecture of the Mind*, Oxford: Oxford University Press, 2006.

Caruth, Cathy (ed.), *Trauma: Explorations in Memory*, Baltimore: The Johns Hopkins University Press, 1995.

Chemero, Anthony, *Radical Embodied Cognitive Science*, Cambridge, MA: MIT Press, 2009.

Clark, Andy, *Being There: Putting Brain, Body, and World Together Again*, Cambridge, MA: MIT Press, 1997.

—*Mindware: An Introduction to the Philosophy of Cognitive Science*, Oxford: Oxford University Press, 2001.

—*Natural-Born Cyborgs: Minds, Technologies and the Future of Human Intelligence*, New York: Oxford University Press, 2003.

—*Supersizing the Mind: Embodiment, Action, and Cognitive Extension*, Oxford: Oxford University Press, 2008.

Clough, Patricia Ticineto (ed.), *The Affective Turn: Theorising the Social*, Durham and London: Duke University Press, 2007.

Colombetti, Giovanna, *The Feeling Body: Affective Science Meets the Enactive Mind*, Cambridge, MA: MIT Press, 2013.

Crane, Tim, *The Mechanical Mind*, New York: Psychology Press, 2003.

Damasio, Antonio, *Descartes' Error: Emotion, Reason, and the Human Brain*, New York: Avon Books, 1994.

—*The Feeling of What Happens: Body and Emotion in the Making of Consciousness*, New York and London: Harcourt, 1999.

—*Looking for Spinoza: Joy, Sorrow, and the Feeling Brain*, New York: Harcourt, 2003.

Decety, Jean and William Ickes (eds), *The Social Neuroscience of Empathy*, Cambridge, MA: MIT Press, 2009.

Deleuze, Gilles, *Spinoza: Practical Philosophy*, trans. Robert Hurley, San Francisco: City Lights Books, 1988.

Deleuze, Gilles and Félix Guattari, *A Thousand Plateaus: Capitalism and Schizophrenia*, trans. Brian Massumi, Minneapolis: University of Minnesota Press, 1980.

De Preester, Helena and Veroniek Knockaert (eds), *Body Image and Body Schema: Interdisciplinary Perspectives on the Body*, Amsterdam and Philadelphia: John Benjamins Publishing Company, 2005.

Edelman, Gerald and Giulio Tononi, *A Universe of Consciousness: How Matter Becomes Imagination*, New York: Basic Books, 2000.

Eich, Eric, John F. Kihlstrom, Gordon H. Bower, Joseph P. Forgas and Paula M. Niedenthal, *Cognition and Emotion*, Oxford: Oxford University Press, 2000.

Enfield, Nicholas and Stephen C. Levinson, *Roots of Human Sociality: Culture, Cognition and Interaction*, New York: Berg, 2006.

Fauconnier, Gilles and Mark Turner, *The Way We Think: Conceptual Blending and the Mind's Hidden Complexities*, New York: Perseus Books, 2002.

Feldman, Jerome A., *From Molecules to Metaphor: A Neural Theory of Language*, Cambridge, MA: The MIT Press, 2008.

Fodor, Jerry A., *The Modularity of Mind*, Cambridge, MA: MIT Press, 1983.

Frankish, Keith and William M. Ramsey (eds), *The Cambridge Handbook of Cognitive Science*, Cambridge: Cambridge University Press, 2012.

Freeman, Walter J., *How Brains Make Up Their Minds*, New York: Columbia University Press, 2000.

Gallagher, Shaun, *Brainstorming: Views and Interviews on the Mind*, Exeter and Charlottesville: Imprint Academic, 2008.

Gallagher, Shaun and Dan Zahavi, *The Phenomenological Mind: An Introduction to Philosophy of Mind and Cognitive Science*, Abingdon and New York: Routledge, 2008.

Gardner, Howard, *The Mind's New Science: A History of the Cognitive Revolution*, New York: Basic Books, 1987.

Gibson, James J., *The Ecological Approach to Visual Perception*, Boston: Houghton Mifflin, 1979.

Grammont, Franck, Dorothée Legrand and Pierre Livet (eds), *Naturalizing Intention in Action*, Cambridge, MA: MIT Press, 2010, pp. 161–80.

Gregg, Melissa and Gregory J. Siegworth, *The Affect Theory Reader*, Durham, NC: Duke University Press, 2002.

Iacaboni, Marco, *Mirroring People: The Science of Empathy and How we Connect With Others*, London: Picador, 2009.

Jackendoff, Ray, *Foundations of Language: Brain, Meaning, Grammar, Evolution*, Oxford: Oxford University Press, 2002.

Johnson, Mark, *The Body in the Mind: The Bodily Basis of Meaning, Imagination and Reason*, Chicago, IL: University of Chicago Press, 1987.

—*The Meaning of the Body: Aesthetics of Human Understanding*, Chicago, IL: University of Chicago Press, 2007.

Kelso, Scott, *Dynamic Patterns: The Self-Organization of Brain and Behavior*, Cambridge, MA: The MIT Press, 1995.

Kögler, Hans Herbert and Karsten R. Steuber (eds), *Empathy and Agency*, Boulder: Westview, 2000.

Lakoff, George, *Women, Fire, and Dangerous Things: What Categories Reveal About the Mind*. Chicago, IL: University of Chicago Press, 1987

Lakoff, George and Mark Johnson, *Metaphors We Live By*, Chicago: University of Chicago Press, 1980, rev. 2003.

—*Philosophy in the Flesh: the Embodied Mind and its Challenge to Western Thought*, New York: Basic Books, 1999.

Lakoff, George and Mark Turner, *More Than Cool Reason: A Field Guide to Poetic Metaphor*, Chicago, IL: University of Chicago Press, 1989.

Lane, Richard D. and Lynn Nadel (eds), *Cognitive Neuroscience of Emotion*, Oxford: Oxford University Press, 2000.

LeDoux, Joseph, *The Emotional Brain: The Mysterious Underpinnings of Emotional Life*, London: Phoenix, 1998.

—*Synaptic Self: How Our Brains Become Who We Are*, New York: Penguin Books, 2002.

Lende, Daniel H. and Greg Downey, *The Encultured Brain*, Cambridge, MA: MIT Press, 2012.

Mascia-Lees, Frances E. (ed.), *A Companion to the Anthropology of the Body and Embodiment*, Oxford: Wiley-Blackwell, 2011.

Massumi, Brian, *Parables for the Virtual: Movement, Affect, Sensation*, Durham, NC: Duke University Press, 2002.

McNeill, David, *Hand and Mind: What Gestures Reveal About Thought*, Chicago: University of Chicago Press, 1992.

—*Gesture and Thought*, Chicago, IL: University of Chicago Press, 2005.

Noë, Alva, *Action in Perception*, Cambridge, MA: The MIT Press, 2004.

—*Out of Our Heads: Why You Are Not Your Brain, and Other Lessons from the Biology of Consciousness*, New York: Hill and Wang, 2009.

Panksepp, Jaak, *Affective Neuroscience: The Foundations of Human and Animal Emotions*, New York: Oxford University Press, 1998.

Patterson, Mark, *The Senses of Touch: Haptics, Affects and Technologies*, Oxford: Berg, 2007.

Pinker, Steven, *How the Mind Works*, New York: Norton, 1997.

Ramachandran, V. S. and E. M. Hubbard, 'Hearing Colors, Tasting Shapes', *Scientific American*, Vol. 288, No. 5 (2003).

Rizzolatti, Giacomo and Corrado Sinigaglia, *Mirrors in the Brain: How our Minds Share Action and Emotions*. Oxford: Oxford University Press, 2008.

Robbins, Philip and Murat Aydede (eds), *The Cambridge Handbook of Situated Cognition*, New York: Cambridge University Press, 2009.

Searle, John R., *The Rediscovery of the Mind*, Cambridge, MA: MIT Press, 1994.

Shapiro, Lawrence, *Embodied Cognition*, London and New York: Routledge, 2011.

Singer, Tania and Claus Lamm, 'The Social Neuroscience of Empathy', *The Year in Cognitive Neuroscience: Annals of the New York Academy of Science*, Vol. 1156 (2009), pp. 81–96.

Sinha, Chris, *Language and Representation: A Socio-Naturalistic Approach to Human Development*, New York: Harvester Wheatsheaf, 1988.

Snow, C. P., 'The Two Cultures', *Leonardo*, Vol. 23, No. 2/3 (1990), pp. 169–73.

Stamenov, Maksim I. and Vittorio Gallese, *Mirror Neurons and the Evolution of Brain and Language*, Amsterdam: John Benjamins Publishing, 2002.

Steuber, Karsten, *Rediscovering Empathy: Agency, Folk Psychology, and the Human Sciences*, Cambridge, MA: MIT Press, 2006.

Stewart, John, Olivier Gapenne and Ezequiel A. Di Paolo, *Enaction: Toward a New Paradigm for Cognitive Science*, Cambridge, MA: MIT Press, 2010.

Sutton, John, 'Distributed Cognition: Domains and Dimensions', *Pragmatics & Cognition*, Vol. 14, No. 2 (2006), pp. 235–47.

Sutton-Smith, Brian, *The Ambiguity of Play*, Cambridge, MA: Harvard University Press, 1997.

Tallis, Raymond, *Aping Mankind: Neuromania, Darwinitis, and the Misrepresentation of Humanity*, Durham: Acumen Publishing, 2011.

Thompson, Evan (ed.), *Between Ourselves: Second-Person Issues in the Study of Consciousness*, Exter: Imprint Academic, 2001.

—*Mind in Life: Biology, Phenomenology, and the Sciences of Mind*, Cambridge, MA: Harvard University Press, 2007.

Tomasello, Michael, *The Cultural Origins of Human Cognition*, Cambridge, MA: Harvard University Press, 1999.

Tomkins, Sylvan, *Affect, Imagery, and Consciousness: The Positive Affects*, New York: Springer Publishing Company, 1962.

Van Campen, Cretien, *The Hidden Sense – Synaesthesia in Art and Science*, Cambridge, MA: MIT Press, 2007.

Varela, Francisco J., Evan Thompson and Eleanor Rosch, *The Embodied Mind: Cognitive Science and Human Experience*, Cambridge, MA: MIT Press, 1991.

Weiss, Gail and Honi Fern Haber (eds), *Perspectives on Embodiment: The Intersections of Nature and Culture*, London: Routledge, 1999.

Wilson, Elizabeth, *Neural Geographies: Feminism and the Microstructure of Cognition*, New York: Routledge, 1998.

Wilson, Margaret, 'Six Views of Embodied Cognition', *Psychonomic Bulletin & Review*, Vol. 9, No. 4 (2002), pp. 625–36.

Zlatev, Jordan, Timothy Racine, Chris Sinha and Esa Itkonen (eds), *The Shared Mind: Perspectives on Intersubjectivity*, Amsterdam and Philadelphia, John Benjamins Publishing Company, 2008.

Performance, the arts and science

Bacci, Francesca and David Melcher (eds), *Art and the Senses*, Oxford: Oxford University Press, 2011.

Banes, Sally and André Lepecki (eds), *The Senses in Performance*, London and New York: Routledge, 2007.

Barr, Kirsten Shepherd, *Science on Stage, From Dr Faustus to Copenhagen*, New Jersey: Princeton University Press, 2006.

Blair, Rhonda, *The Actor, Image and Action*, London and New York: Routledge, 2008.

Blair, Rhonda and John Lutterbie, 'Introduction: Special Section on Cognitive Studies, Theatre and Performance', *Journal of Dramatic Theory and Criticism*, Vol. 25, No. 2 (Spring 2011), pp. 61–70.

Bleeker, Maaike, *Visuality in the Theatre: The Locus of Looking*, Basingstoke: Palgrave, 2011.

Boyd, Brian, *On the Origin of Stories: Evolution, Cognition, and Fiction*, Cambridge, MA: Harvard University Press, 2009.

Brown, Andrew and Mole Wetherell, *Trial: A Study of the Devising Process in Reckless Sleepers' Schrodinger's Box*, Plymouth: University of Plymouth Press, 2007.

Cook, Amy, *Shakespearean Neuroplay: Reinvigorating the Study of Dramatic Texts and Performance Through Cognitive Science*, New York and Basingstoke: Palgrave Macmillan, 2010.

Crane, Mary, *Shakespeare's Brain: Reading with Cognitive Theory*, Princeton: Princeton University Press, 2001.

Delahunta, Scott, Gill Clark and Philip Barnard, 'A Conversation about Choreographic Thinking Tools', *Journal of Dance and Somatic Practice* Vol. 3, No. 2 (2012), pp. 243–59.

Di Benedetto, Stephen, *The Provocation of the Senses in Contemporary Theatre*, London and New York, Routledge, 2010.

Gehm, Sabine, Pirkko Husemann and Katharina von Wilcke, *Knowledge in Motion: Perspectives of Artistic and Scientific Research in Dance*, Bielefeld: Transcript Verlag, 2007.

Grove, Robin, Kate Stevens and Shirley McKechnie (eds), *Thinking in Four Dimensions: Creativity and Cognition in Contemporary Dance*, Carlton; Victoria: Melbourne University Press, 2005.

Hansen, Pil and Bruce Barton, 'Research-Based Practice: Situating *Vertical City* Between Artistic Development and Applied Cognitive Science', *The Drama Review*, Vol. 53, No. 4 (T204) (Winter 2009), pp. 120–36.

Hogan, Patrick Colm, *Cognitive Science, Literature, and the Arts: A Guide for Humanists*, New York: Routledge, 2003.

Hutchins, Edwin, *Cognition in the Wild*, Cambridge, MA, London: MIT Press, 1995.

Johnson, Paul, *Quantum Theatre*, Newcastle: Cambridge Scholars Publishing, 2012.

Kosofsky Sedgewick, Eve, *Touching Feeling: Affect, Pedagogy, Performativity*, Durham: Duke University Press, 2003.

Legrand, Dorothée and Susanne Ravn, 'Perceiving Subjectivity in Bodily Movement: The Case of Dancers', *Phenomenology and the Cognitive Sciences* Vol. 8 (2009), pp. 389–408.

Leys, Ruth, 'The Turn to Affect: A Critique', *Critical Inquiry*, Vol. 37, No. 3 (Spring 2011), pp. 434–72.

Lutterbie, John, *Hearing Voices: Modern Drama and the Problem of Subjectivity*, Ann Arbor: The University of Michigan Press, 1997.

—*Toward a General Theory of Acting: Cognitive Science and Performance*, New York: Palgrave Macmillan, 2011.

Machon, Josephine, *(Syn)aesthetics: Redefining Visceral Performance*, Basingstoke: Palgrave MacMillan, 2009.

—*Immersive Theatres: Intimacy and Immediacy in Contemporary Performance*, Basingstoke: Palgrave Macmillan, 2013.

Malekin, Peter and Ralph Yarrow, *Consciousness, Literature and Theatre: Theory and Beyond*, London: Macmillan, 1997.

McConachie, Bruce, *American Theater in the Culture of the Cold War: Producing and Contesting Containment*, Iowa City: University of Iowa Press, 2003

—*Engaging Audiences: A Cognitive Approach to Spectating in the Theatre*, New York: Palgrave Macmillan, 2008.

McConachie, Bruce and F. Elizabeth Hart (eds), *Performance and Cognition: Theatre Studies and the Cognitive Turn*, London and New York: Routledge, 2006.

Meineck, Peter, 'The Neuroscience of the Tragic Mask', *Arion, Journal of the Humanities and Classics*, Vol. 19, No. 1 (2011), pp. 113–58.

Modugno, N., S. Iaconelli, M. Fiorilli, F. Lena, I. Kusch and G. Mirabella, 'Active Theater as a Complementary Therapy for Parkinson's Disease Rehabilitation: A Pilot Study', *The Scientific World Journal*, No. 10 (2010), pp. 2301–3.

Paavolainen, Teemu, *Theatre/Ecology/Cognition: Theorizing Performer-Object Interaction in Grotowski, Kantor, and Meyerhold*, New York: Palgrave Macmillan, 2012.

Paster, Gail Kern, *Humoring the Body: Emotions and the Shakespearian Stage*, Chicago, IL and London: University of Chicago Press, 2004.

Plantinga, Carl, *Moving Viewers: American Film and The Spectator's Experience*, Berkeley: University of California Press, 2009.

Reason, Matthew and Dee Reynolds, 'Kinesthesia, Empathy, and Related Pleasures: An Inquiry into Audience Experiences of Watching Dance', *Dance Research Journal*, Vol. 42, No. 2 (2010), pp. 49–75.

Reynolds, Dee and Matthew Reason (eds), *Kinesthetic Empathy in Creative and Cultural Practices*, Bristol: Intellect, 2012.

Roach, Joseph R., *The Player's Passion: Studies in the Science of Acting*, Ann Arbor: The University of Michigan Press, 1993.

Rokotnitz, Naomi, *Trusting Performance: A Cognitive Approach to Embodiment in Drama*, New York and Basingstoke: Palgrave Macmillan, 2011.

Shaughnessy, Nicola, *Applying Performance: Live Art, Socially Engaged Theatre and Affective Practice*, Basingstoke: Palgrave, 2012.

Sheets-Johnstone, Maxine, *The Corporeal Turn: An Interdisciplinary Reader*, Exeter: Imprint Academic, 2009.

Spolsky, Ellen, *Gaps in Nature: Literary Interpretation and the Modular Mind*, Albany, NY: State University of New York Press, 1993.

—*Word vs Image: Cognitive Hunger in Shakespeare's England*, Basingstoke: Palgrave Macmillan, 2007.

Stevenson, Jill, *Performance, Cognitive Theory, and Devotional Culture: Sensual Piety in Late Medieval York*, Basingstoke and New York: Palgrave, 2010.

Tribble, Evelyn B., *Cognition in the Globe: Attention and Memory in Shakespeare's Theatre*, New York and Basingstoke: Palgrave Macmillan, 2011.

Tribble, Evelyn and John Sutton, 'Minds in and Out of Time: Memory, Embodied Skill, Anachronism, and Performance', *Textual Practice*, Vol. 26, No. 4 (2012), pp. 587–607.

Turner, Mark, *The Literary Mind: The Origins of Thought and Language*, Oxford: Oxford University Press, 1996.

Welton, Martin, *Feeling Theatre*, Basingstoke: Palgrave Macmillan, 2012.

Zunshine, Lisa (ed.), *Introduction to Cognitive Cultural Studies*, Baltimore, MD: Johns Hopkins Press, 2010.

Index

.